California
Light
1900-1930

Laguna Art Museum
Laguna Beach
in association with
Bedford Arts, Publishers
San Francisco

with essays by

Bram Dijkstra

Janet Blake Dominik

Iris H. W. Engstrand

Ilene Susan Fort

Michael P. McManus

Joachim Smith

Jean Stern

rnia Light
1900-1930

by
Patricia Trenton, Guest Curator
and
William H. Gerdts

This book was originally published by the
Laguna Art Museum, Laguna Beach, California,
in association with the Dixon Gallery and
Gardens, Memphis, Tennessee, on the occasion
of an exhibition of the same title organized
by the Laguna Art Museum.

The exhibition and its national tour were funded by a
grant from The Fieldstone Company, Newport Beach,
California.

Editor: Jeanne D'Andrea
Designer: Dana Levy, Perpetua Press
Photo Editor: Lawrence Reynolds
Photographers: Lawrence Reynolds, Ron Forth
 Allen Francis, Jim Strong, Inc.

Library of Congress Cataloging-in-Publication Data

California light, 1900-1930 / [edited] by Patricia Trenton and William
H. Gerdts ; with contributions by Bram Dijkstra . . . [et al.].
 p. cm.

 1. Painting, American—California—Exhibitions. 2. Painting,
Modern—20th century—California—Exhibitions. 3. Impressionism
(Art)—California—Exhibitions. I. Trenton, Patricia. II. Gerdts,
William H. III. Dijkstra, Bram. IV. Laguna Art Museum (Laguna
Beach, Calif.)
ND230.C3C28 1990
759.194′074′797496—dc20 90-60005
 CIP

ISBN 0-938491-64-4 (paperback, Bedford Arts)
ISBN 0-940872-13-7 (paperback, Laguna Art Museum)

Second printing, 1991

Bedford Arts, Publishers
301 Brannan Street, Suite 410
San Francisco, California 94107-1811

PRINTED IN HONG KONG

FRONT COVER
Guy Rose (1867-1925)
Indian Tobacco Trees, La Jolla (detail). Undated.
Oil on canvas, 24 by 29 inches
The Fieldstone Company
(Plate 104)

BACK COVER
Joseph Kleitsch (1882-1931)
Morning, Laguna (formerly *California*). 1924.
Oil on canvas, 36 by 40 inches
Collection of City of Laguna Beach
(Plate 157)

EXHIBITION ITINERARY

CROCKER ART MUSEUM
Sacramento, California
22 June – 26 August 1990

LAGUNA ART MUSEUM
Laguna Beach, California
12 October 1990 – 6 January 1991

DIXON GALLERY AND GARDENS
Memphis, Tennessee
7 February – 15 March 1991

CONTENTS

SPONSOR'S STATEMENT

IN 1986 THE FIELDSTONE COMPANY provided underwriting for the exhibition *Early Artists in Laguna Beach: The Impressionists*. The positive response to that exhibition has affirmed our commitment to the continuing support of the Laguna Art Museum in its endeavors to present and document the early art history of Southern California. As part of that support, we are pleased to underwrite *California Light, 1900–1930*, a comprehensive exhibition of the paintings of nine artists working in Southern California during those decades. In addition to its venues in California at the Crocker Art Museum in Sacramento and at the Laguna Art Museum, the exhibition will travel to the Dixon Gallery and Gardens in Memphis. It is our hope that this increased exposure of the work of these California painters will serve to affirm their position of importance in American art history.

PETER M. OCHS
Chairman and Chief Executive Officer
The Fieldstone Company

DIRECTOR'S FOREWORD

For more than seventy years the Laguna Art Museum has been home to a fresh-faced and buoyant kind of art that has come to be known as "California Impressionism." This phrase is a misnomer if it implies any but the most tenuous connections to the theory-based art born in France decades before the earliest painting in this exhibition. But it is a phrase that has stuck, filling the need for naming works that clearly share a common identity and common source.

Yet even as this catchall name has come into general use—and by default has entered the American art-historical lexicon—there have been few organized attempts to define its meaning. What *is* California Impressionism, and where did it come from? Who were its major practitioners, where did they get their training, and how does their work relate to that of Impressionists elsewhere in America? What are the shared tenets and impulses affecting this art and our perception of it?

This book and the exhibition it accompanies are among the first attempts to deal with such questions in a scholarly way. Although the essays represent diverse approaches to these questions, from old-line formalist to New Age environmentalist, they are the product of some of the leading minds in the field at this time. If this effort is not the definitive one, that is only because there is still so much work to be done, so small a corps of workers, and so few institutions sponsoring the work. We are proud that the Laguna Art Museum has fostered this serious study in an area too often ignored.

One might ask whether such regional studies are worth the effort. Surely the artistic achievements of these California painters—in what was then a backwater agricultural region—cannot compare to the revolutionary European advances of the same era. But why should they be compared? They are as different in kind as the foods, or songs, or geographies of two distinct cultures.

Speaking for the members and the Trustees of the Laguna Art Museum, I add to Patricia Trenton's acknowledgments my own thanks to the many lenders, authors, and others who made this project a reality. Dr. Trenton herself has earned special thanks for her devotion to quality in every aspect of her dealings with the Museum.

The Museum is deeply grateful to The Fieldstone Company for its substantial financial assistance, and for the caring attention its officers have devoted to this project and to the history of art in Southern California. Few museums have friends so generous and so enlightened.

Charles Desmarais, Director
Laguna Art Museum

PREFACE AND ACKNOWLEDGMENTS

In July 1987 representatives of the Laguna Art Museum contacted the guest curator with a proposal to organize an exhibition of the work of artists active in Southern California from 1900 to 1930. A considerable number of recent publications has recognized these painters, who are often called California Impressionists. How these artists relate to the mainstream of American art and to European prototypes, or how they interrelate, had not been adddressed. Most came with mature styles but divergent backgrounds and interests, yet all were attracted to the ambiance of Southern California with its extraordinary climate and geography. After investigating these painters at some length, we singled out nine of them as the focus of this exhibition. In their day Franz Bischoff, Maurice Braun, Alson Clark, Joseph Kleitsch, Edgar Payne, Granville Redmond, Guy Rose, Donna Schuster, and William Wendt all participated actively in Southern California's community of artists. Their lives seem to parallel those of many European artists who, while alive, fell into relative obscurity. Only years later did their work resurface, and it now enjoys great popularity among collectors.

The common thread that binds these artists is the recognition and depiction of light through color, an interest fostered in part by the dissemination of the color theories of Michel-Eugène Chevreul and Albert Henry Munsell. But, more important for our purposes, these artists were inspired by the clarity and force of the distinctive light of Southern California and by the region's endlessly intriguing motives of hill and meadow, desert and mountain, river and ocean. Their stylistic scope ranged from smooth-surfaced Beaux-Arts realism through Impressionism and Expressionism, as plein-air painting enjoyed a Southern California Indian summer that sustained its warmth and natural energy long after the Cubist revolution had carried mainstream American painting into cooler, more analytic modes of expression. This regional energy was equally resistant to the older, European modes of realism that underpinned the regionalists and the American-scene painters of the 1930s and 1940s.

During this study several questions surfaced. Were there social and geographic factors underlying the longevity of plein-air painting in Southern California? Did regional artistic personalities triumph over persistent national fashions in art? Did cooperative organizations—such as the California Art Club, Contemporary Artists of San Diego, the Laguna Beach Art Association, and many others—provide insular, mirrorlike structures that precluded modernism, at about the same time that the Futurists, Neo-Plasticists, and Surrealists were forming associations to oppose the traditions of painting and

sculpture? And what role did the critics and patrons play in fostering art in Southern California?

In its initial stages this project moved in chronological order, but as new material was found and a cache of historical facts uncovered we found it necessary to reformulate our approach. These added dimensions were encouragement to broaden the scope of the exhibition as well as a challenge to the essayists as the project took shape and began to refocus itself.

We are particularly pleased to have assembled a distinguished group of scholars whose individual contributions will give the reader distinctive viewpoints on the subject. To each of them the challenge was significant, and we believe you will find their essays informative, provocative, and insightful. We are indebted to Edward Maeder, Curator of Textiles and Costumes, Los Angeles County Museum of Art, for his expert and engaging examination of the costumes in the figurative works in the exhibition.

To Jeanne D'Andrea, the editor, we owe a great deal of gratitude for her superb ability to digest, synthesize, and bring to life the plein-air painters. The design and production of the catalogue were under the artful direction of Dana Levy. To Lawrence Reynolds, we extend our great appreciation for assuming the important responsibility of quality control of the photographs. To Western Artists Researchers, Phil and Marian Kovinick, for their resourcefulness and dedication to the professionalism of research, we are most grateful. And to Elizabeth J. Foster we are sincerely indebted for her perceptive copyediting and careful proofreading at every stage.

To The Fieldstone Company, which has underwritten this project, we are grateful for its generosity in pioneering this publication. The company's contribution is an excellent example of corporate responsibility that leads to furthering artistic goals and achievements within a community.

We would be remiss in not acknowledging the cooperation and support of these individuals whose understanding and dedication to the arts were of significant value. We thank Whitney Ganz, David Hoy, Dan Jacobs, Michael Kelley, Glen Knowles, Ray Redfern, James and Linda Ries, George Stern, Tom and Barbara Stiles, and Gregory Young. And we thank John Buchanan, director of the Dixon Gallery and Gardens, for his early collaborative efforts and contribution to the catalogue.

The Laguna Art Museum Board of Trustees, under the presidency of Claudette Shaw, is to be praised for its forward-looking policies, which have made this project possible. Its responsiveness and cooperation were key ingredients in achieving our goals. A special thanks is reserved for trustee Robert H. Ehrlich, whose vision, encouragement, and extra measure of dedication have been most helpful throughout the project.

We are also indebted to the many private collectors, museums, and institutions for their cooperation and assistance in allowing us to exhibit and reproduce their fine works. They are acknowledged individually in the list of plates.

Many individuals have generously supported this project, not only in Southern California but throughout the United States. A special expression of gratitude is extended to them for their invaluable assistance: Bruce Bachman; the late Maurice Bloch; Charlotte Braun White; Alson and Carol Clark; Rena Coen; Arnold Court; James Cox; David Deckelbaum; Stuart Feld; Lois M. Fink; Cheryl Cibulka Gordon; Joanne Greenwald; Evelyn Payne Hatcher; Ida Griffith Hawley; Mark Hoffman; John Howatt; Lester Hurd; Nicolas Kilmer; Ellen W. Lee; Richard Love; Joyce Ludmer; Mary Anne Lyles; Dewitt McCall; Mary McIsaac; Joseph Moure; Nancy Moure; Jonathan Nardone; M. P. Naud; Maggie Nelson; Carol Pearson; Martin Petersen; Ronald Pisano; Harry Robin; Victoria Saunders; Barbara Sayres Harmon; Lucy Schwab; Gretchen Sibley; Tom Singer; Nora Smith; Dan Strehl; Athos Thierry; William Truettner; Marcel Vinh; Ruth Westphal; and Barbara Wilson.

Without the leadership of Charles Desmarais, director of the Laguna Art Museum, and the unstinting support and professionalism of his staff the project could not have occurred.

And lastly, my love and devotion to my wonderful husband, Norman, who supported me every inch of the way through all the vicissitudes of this project. I thank him for his support and generosity.

PATRICIA TRENTON
Guest Curator

LIST OF AUTHORS

BRAM DIJKSTRA
Professor of American Literature and Cultural History
University of California at San Diego

JANET BLAKE DOMINIK
Curator of the Buck Collection
Laguna Niguel, California

IRIS H. W. ENGSTRAND
Professor of History
University of San Diego
San Diego, California

ILENE SUSAN FORT
Associate Curator of American Art
Los Angeles County Museum of Art
Los Angeles, California

WILLIAM H. GERDTS
Professor of Art History
Graduate Center, The City University of New York

MICHAEL P. MCMANUS
Visiting Professor in Drawing and Painting
California State University at Fullerton

JOACHIM SMITH
Painter and Professor Emeritus
California State University at Fullerton

JEAN STERN
Director, Petersen Galleries
Beverly Hills, California

PATRICIA TRENTON
Art Director, The Los Angeles Athletic Club, LAACO, Ltd.
Los Angeles, California

8. Donna Schuster. *In a Garden* (detail)

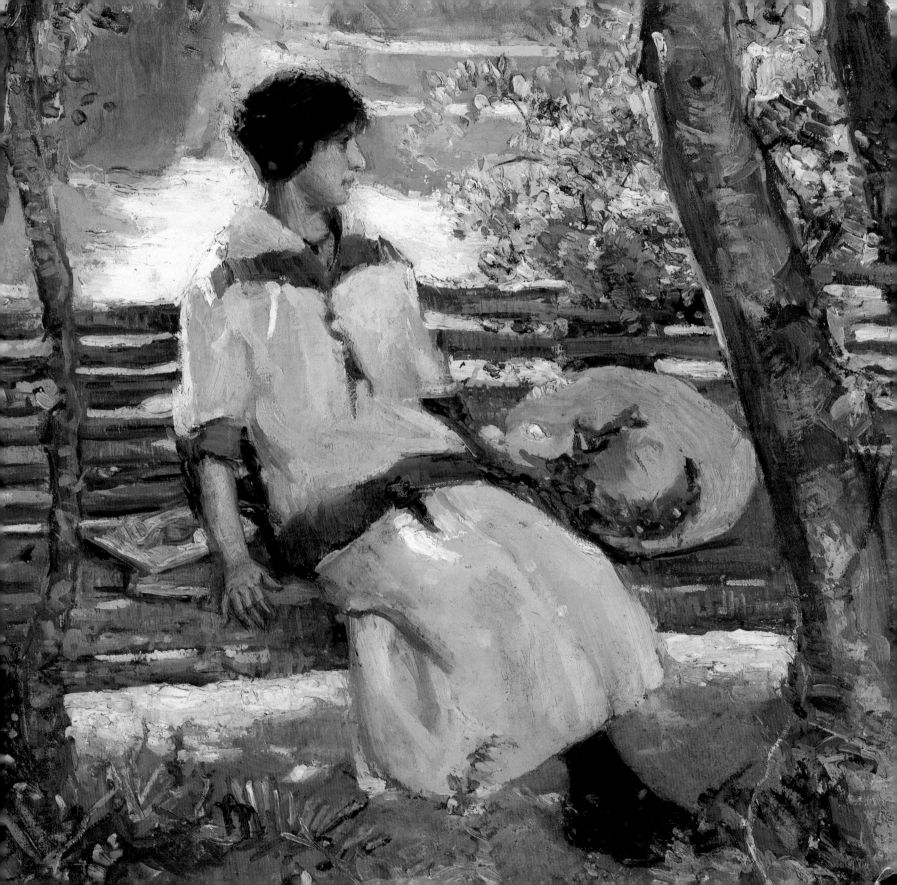

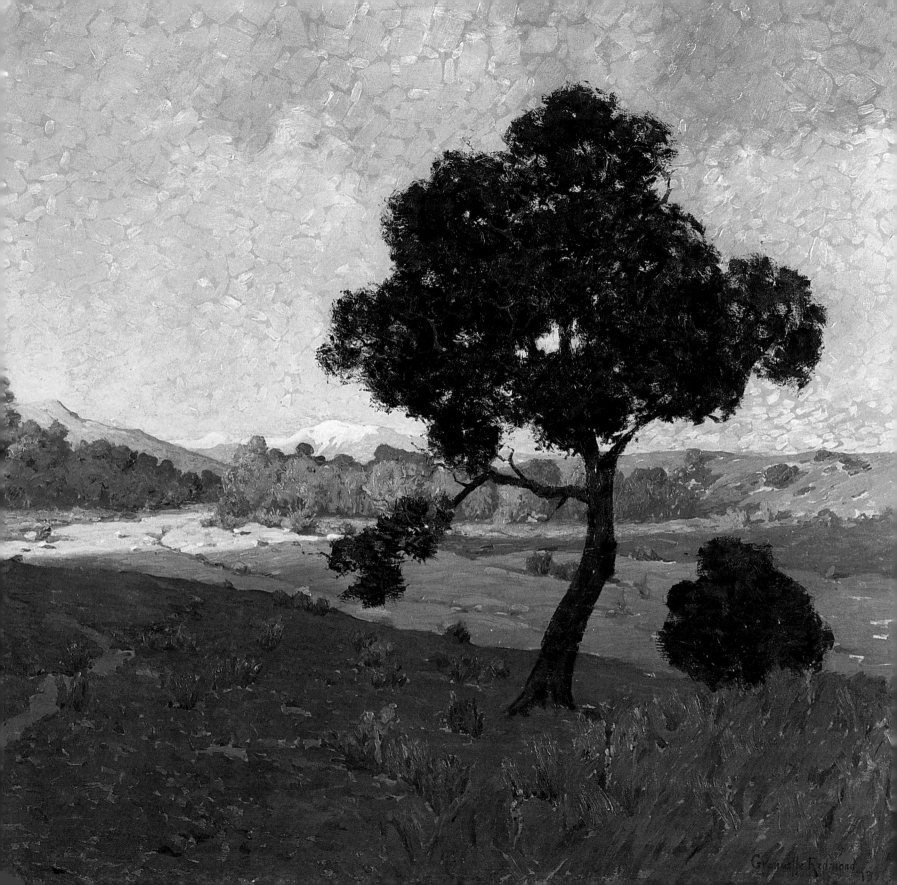

A
FOCUS
ON
LIGHT

*C*alifornia Light, *1900–1930* examines the diverse applications of the Impressionist style in Southern California during the first three decades of the twentieth century. In focusing on the nine painters we have selected, it has become clear that their work embodies the triumph of a stubbornly independent conventionality over the force of Western art's primary thrust as modernism emerged. The regional accomplishment of these artists was to stem briefly the tide of modernism's advance beyond Impressionism through the creation of a beautiful anachronism and then to dwell inside that anachronism. They epitomize the last great vogue of plein-air painting (painting directly from the subject out-of-doors). But, just as they are not so much Impressionists as they are painters who employed the methods of Impressionism, so too they are not so much plein-air painters as they are painters who employed the plein-air method. Some used the outdoors as a mechanic might use a particular tool; others achieved a certain mind set through it and only secondarily were interested in fixing transient visual phenomena through direct observation.

These artists should be viewed against a primary event in the history of American art, the Panama-Pacific International Exposition held in San Francisco in 1915. William Wendt and Benjamin C. Brown served as regional jurors for the exposition. Donna Schuster took a silver medal for her watercolors, and Maurice Braun, Granville Redmond, and Guy Rose exhibited in the American group section. The exposition, its contents, and its reception tend to substantiate the "Lotus Land" vision of California. Set as it was during the First World War, the exposition revealed the anachronism of Impressionism's Indian summer on the California coast. In his *American Impressionism*, William Gerdts states that "the Panama-Pacific [International] Exposition established the preeminence of American Impressionism. The nation, and indeed the Western world, had witnessed its development over the preceding thirty years, but the Exposition enshrined it. Impressionism had become not only domesticated but historicized in America."[1]

To appreciate the extreme character of this anachronism, examine a selection of the European exhibitors in the essentially conservative Panama-Pacific International Exposition: Paul

Opposite: 6 · Granville Redmond · *California Landscape* (detail)

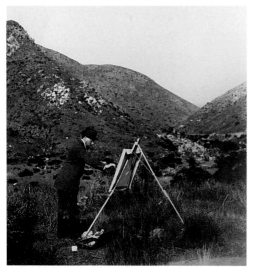

1. *Maurice Braun Painting in the San Diego Back Country.* 1916.

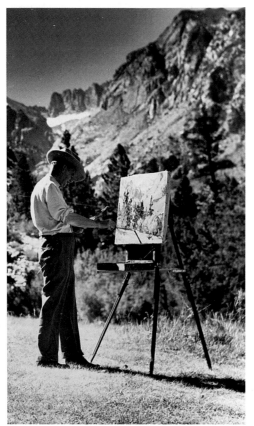

2. *Edgar Payne Painting in the High Sierra.* 1945–46.

Cézanne, Paul Gauguin, Vincent van Gogh, Edvard Munch, and Oskar Kokoschka. Advanced as these artists may look when contrasted with a lingering Impressionism, the historical chasm widens even further when one considers that Symbolism, Expressionism, Fauvism, Cubism, Futurism, Pittura Metafisica, Der Blaue Reiter, Suprematism, Dada, and de Stijl all emerged within a few years of each other, and of the exposition. Given the enormous distance, geographically, emotionally, and psychologically, from the trenches of Europe to the beaches and meadows of California, clearly an element of escapism infused the aesthetic climate of the West Coast. This was willful escapism and not simply a result of ignorance of foreign affairs. Critic Christian Brinton, writing his *Impressions of the Art at the Panama-Pacific Exposition,* in 1916, identified the Expressionists as "the inevitable reaction against Impressionism."[2] Distorting the model of art-historical progress as it does, the prolonged artistic culture of plein-air painting in California is a complication in the evolution of modernist art in America.

The uses to which artists in this exhibition apply the techniques of Impressionism are similarly complex. Maurice Braun composed line, plane, and color in his paintings into a harmonious synthesis that depended as much on theosophical systems of color significance and energy rhythms as it did on the actual configurations and colors of his San Diego County subjects (plate 1). Edgar Payne worked his endless studies of ships and mountains in ways that alternately complement and oppose Impressionist dogma. Constructing detailed scale models of European fishing boats with working sails and riggings, he painted these in his studio with the broken brushwork of Impressionism under conditions of controlled, constant light. Payne's approach to painting mountain landscape was somewhat different. On numerous sketching trips to the Sierra he indeed painted *en plein air* (plate 2). But the methods described in his book, the *Composition of Outdoor Painting* (plate 3) and the particulars of his "documentary" motion picture *Sierra Journey* are as much about bringing schemata, methods, and other composing apparatus to nature as they are about drawing from a direct perception of nature. With this in mind, we might give the critics of Payne's day a more literal reading. Consider *Los Angeles Times* critic Fred Hogue's statement: "When Edgar Payne stands before his

canvas, in the midst of his sketches, brushes and tubes of paint, he becomes a lord, a creator. Mountains rise at his magic touch, with streams tumbling down their slopes and lakes nestling close to their sheltered base." This one is even better: "The artist is transformed into the god of the mountains. He creates them, models them, and adores them, even as the creator of the heavens and the earth."[3]

Without the grandiloquent connotations of deity, these descriptions are fairly accurate. Payne is creating—that is, constructing—the paintings through a process of practical intuition of the sort that Piet Mondrian might have employed while adjusting bands and blocks of color. But the process of drawing correspondences between the three-dimensional visual field and the two-dimensional rectangle of the canvas is not so much in evidence here, nor is the intense, passionate drive to capture the visual essence of some fleeting and very specific optical phenomenon. Payne's process is solidly academic. He described it in three steps: forming the mental concept, making preliminary sketches, and then painting the picture.

Guy Rose and Alson Clark illustrate a familiar common path—that of the American Impressionist as gentleman painter. Rose sprang from a wealthy ranching family in San Gabriel, California, and Clark from a prosperous Chicago family. Both studied in the United States and abroad. Rose traces a career path from study in San Francisco to further study and painting in France and elsewhere in Europe. Clark began as an Art Institute of Chicago student and then moved on to New York, where he studied with William Merritt Chase, and then he studied briefly with Whistler in Paris. In France, Clark associated with Richard Miller, Frederick Frieseke, and Guy Rose. Because of the character of Clark and Rose's colorism, handling, and overall approach to painting directly from the subject, they are regarded as more central to the development of American Impressionism than many of their peers in California.

Stylistically, Clark and Rose worked through the forms of the Barbizons, Romantic Realists, and Tonalists to arrive at individual Impressionist styles aligned with the aesthetics of Claude Monet and Pierre Auguste Renoir. Sociologically, the careers of Rose and Clark are good examples of the cosmopolitan and highly mobile paths of successful American painters of their

era. Rose takes a path on which formal education begins in the Bay Area (at the San Francisco Art Association's California School of Design) and then moves eastward, to Europe. Clark traces an eastward path from the Art Institute of Chicago through New York, to Paris. The geographical paths of the American artists of the Impressionist era are as complex and varied as the artists' works.

For some of these artists, Chicago, San Francisco, and New York were centers, for others they were way stations. The geographical corridors between Los Angeles, San Diego, Taos, and Santa Fe were similarly well traveled. Bischoff, Braun, Kleitsch, and Wendt were all of Northern European origin. Clark, Kleitsch, Payne, Wendt, and Schuster all possessed a Chicago connection. All of the artists included in this exhibition painted in Europe at one time. And all of them settled in Southern California and were affiliated with the Laguna Beach Art Association, forerunner of the Laguna Art Museum.

With the development of railroads in the United States, Southern California artists were able to maintain institutional and commercial gallery contacts in American urban centers while they worked in the pastoral environment of the provinces. After the completion of the transcontinental railway to San Francisco in 1869, Northern California entered the twentieth century with three decades of continuous cultural connection to the East Coast—and to Europe via the East. By the 1880s the Southern Pacific and the Santa Fe lines had joined Southern California to the rail network. Successive land booms in 1906 and the decade of the twenties created a local population on the West Coast of sufficient magnitude to constitute an art-buying public. Two million people moved to California during the 1920s. The southern half of the state absorbed seventy-two percent of them. In this regional American culture, before television and color/sound cinema, painting aspired to both higher spiritual values and lower entertainment values than it does today. Landscapes were a focus for and token of the appreciation of nature in a way that the work of photographers such as Ansel Adams, Minor White, and Eliot Porter is today.

Much of the region's wealth early in the century came from oil and the movie industry, circumstances that generated a new wealthy class eager for the signs and decor of prosperity. The cinema's constant need for scenic artists also cre-

Diagonal Line

Tunnel

Silhouette

Pattern

3. Edgar Payne. "Forms of Composition."

4. *Granville Redmond in His Studio.*

5. *Donna Schuster at Home.*

ated a population of commercial artists with strong aesthetic aspirations. Unitary icons of the spirit were endlessly isolated in nature and then rendered "poetically." Consider the following painting titles from the Building Fund Exhibition of the Laguna Beach Art Association held at Saint Ann's Inn, Santa Ana, California, in July 1927: *Turbulent Sea, Rush of Waters, Rising Tide, Golden Hillside, Drifting Clouds, A Touch of Spring, Morning Glow.* This sort of rhetoric was representative of the milieu, and, significantly, Bischoff, Clark, Payne, Schuster, and Wendt all donated works to this show to raise money for the construction of the Laguna Beach Art Association gallery, designed by Myron Hunt and completed in 1929. This jazz age, pre-Depression art market sixty miles south of Los Angeles was of sufficient strength that these artists could command fairly substantial prices for their work.

The primary characteristic of Southern California daylight is its intensity. Set largely under chaparral desert terrain, this light can be brilliant or glaring, depending on the viewer's attitude and disposition. Coastal and inland conditions only rarely yield substantial fog and atmospheric haze. When this sort of precipitation does arrive it is usually at night and hence less available as a painter's motif. The lack of atmosphere is central to the understanding of the character of Southern California's scenery. The art critic Alfred Frankenstein once described the quality of California light as "a characteristic sub-tropical fact." Light dominates atmosphere in this subtropical environment. The brevity of dawn and dusk contribute to the sense of constant, intense light. The result is a sort of brilliant noonscape—a glaring bright field from mid-morning to late afternoon.

Shadows are bombarded to a middle darkness by the sheer volume of reflected light, and under prolonged scrutiny everything assumes a bleached character. Thus the painters of Southern California are painters of light even more than of color. A clear day spent painting *en plein air* in Orange County rapidly depletes the eye's capacity to make precise chromatic discriminations. The remaining sense of powerful brightness dominates a landscape in which foreground, middle ground, and distant horizon often seem to have equal clarity and lack of distortion.

Climatologist Arnold Court provides a technical insight into the brilliance of Southern Cal-

ifornia's "soft," "white," daylight and its challenge to painters:

To many artists, daylight along the coast of Southern California is "soft" or "white," in contrast to the usual daylight of the northeastern United States. Early Spanish explorers, British navigators, and New England whalers found the air along the Southern California coast hazy or "smoky," apparently because of the greater concentration of sea salts and other marine particles in the lower atmospheres. These particles are left in the air by evaporation of droplets blown aloft from whitecaps and brought ashore by westerly breezes. Along with other particles from vegetation, desert dust, and human activity (in earlier times primarily from cooking fires) these particles are trapped in the lowest few thousand feet of the atmosphere under a persistent marine inversion. Below the inversion, air temperature decreases about three to four Fahrenheit units per thousand feet. But in the inversion layer it increases with height, which inhibits any ascent of the particle-laden air beneath it. The inversion, which is more pronounced than similar conditions along other Mediterranean-climate coasts, extends for more than a thousand miles along the Pacific coast, as part of the overall atmospheric structure, specifically, the circulation around the North Pacific or Hawaiian high-pressure area between California and Hawaii.

The salt particles in this inversion layer cause sunlight, and daylight, to be scattered more extensively than in cleaner air, so that in Southern California the visibility is usually only a few miles. Nearby mountains are less clear and more distant ones are invisible, except on the few days of each year when the rain has washed the particles from the air, or when air subsides straight down to create high pressure, or when a Santa Ana wind blows from the desert areas through the mountain passes and canyons onto the coastal plain. Then the mountains appear in stark detail, shadows are sharp, and daylight is less soft, or white, than usual.

Not enough spectral measurements of daylight in various parts of the country are available to document any differences between California coastal daylight and daylight found elsewhere. The few measurements that have been published suggest that in California shorter waves (violet, blue, green) are more ex-

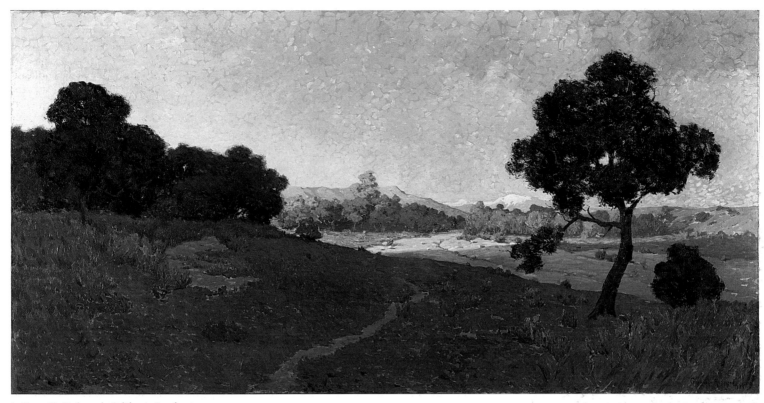

6. Granville Redmond. *California Landscape.* 1907.

tensively scattered than longer ones (yellow, orange, red). This could give daylight a less golden cast than that of direct sunlight, and perhaps explain the "white" character attributed by painters to coastal daylight.

In contrast, a constant theme in Franz Bischoff's work is the conscious play of warm against cool complements. His colors are synthetic in their elegance, speaking more to the increasing organization of color theory and its decorative applications than to nature. Maurice Braun seeks a harmony that is in some ways similar. His palette has little of the characteristic "soft" light of San Diego County, but his compositions are nevertheless startlingly tight, even jewel-like in their decorous unity of value and chroma. The consistency of the effect is decorative, but there is a fine sense of color mood here—a synesthesia that prefigures modernist color in its specificity. Although their approaches to Impressionism differ, Alson Clark and Guy Rose produced work that relates most directly to the French attitudes of the late nineteenth century, creating remark-

ably direct records of the bright aspect of the land. An academic realism, somewhat in the vein of Whistler or Sargent, yields to later colorism in Kleitsch's work. Joseph Kleitsch's evolution as a colorist traces back to his experiments with backlighting and other unconventional light schemes in formal portraiture. Edgar Payne illustrates a primary obsession—to counter the bright flatness of the Southern California landscape through composition. His composition employs the geological mass of hill, cliff, forest, and mountain to organize a painting with a more traditional sense of dark and light arrangement. This tendency, leading away from a neutral naturalism, acts in the work of William Wendt, Franz Bischoff, and Maurice Braun as well. Counseling against this attitude, *Los Angeles Times* critic Arthur Millier advised "choosing small, rather than grand, subjects and seeking for truth of appearance."

Granville Redmond (plate 4), Donna Schuster (plate 5), and Guy Rose succeeded in replicating the flattening glare of Southland light.

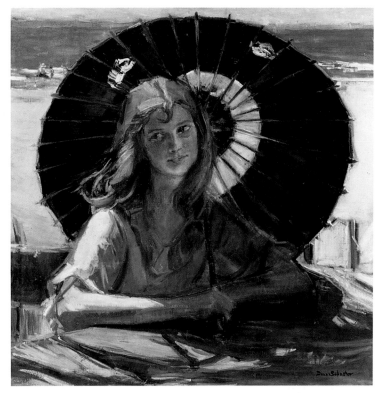

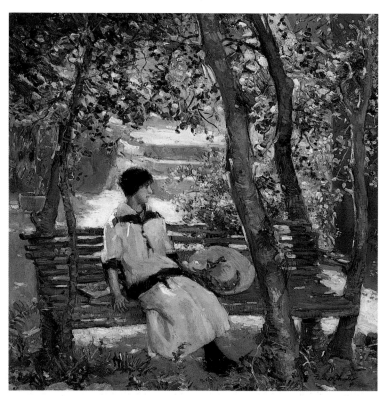

7. Donna Schuster. *On the Beach.* 1917.

8. Donna Schuster. *In the Garden.* 1917.

Their shimmering color mixing set off compositions that act tonally as all-over fields, having little focus in terms of the relationships among dark-light masses (plates 6 and 7). Schuster was always concerned about catching her model in the correct light and often put her canvas aside until the appropriate time of day (plate 8). William Wendt offers an interesting contrast to his peers in the steadfastly nonreactive color arrangements he constructed. Wendt avoided optical mixture, setting nature's earth tones and greens against each other in a way that directly corresponds to the tones of the land. The breadth and boldness of his paint application led to a brush style that is closer to Expressionism than to Impressionism proper. This innovation of handling was coupled with a solid, conservative naturalism in his use of color.

These curious link-ups of conservative and progressive attitudes, along with the recognition and depiction of light through color, were a common thread binding the energies of Southern California artists of the early twentieth century. One wonders how these painters of the early twentieth century would view California light today, as ecologists grapple with conservation and clear air.

MICHAEL P. McMANUS

TO
LIGHT
THE
LANDSCAPE

In all landscape painting, light is necessarily an important and integral factor. Even in nocturnal scenes, the absence of light is a primary pictorial consideration that requires some phenomenological reaction, whether the light is a faint glimmer or a luminous haze, like that in many of Whistler's "nocturnes," or an alternate source, like that in the firelight nighttime paintings of Albert Bierstadt.

Yet the painting of light, or perhaps better the infusion of natural light into the landscape, has its separate history in the painting of outdoor scenes and specifically in the development of American painting. We are now inclined to associate a heightened concern with light particularly with the Luminist movement of the 1850s–'70s, in the work of American artists such as Fitz Hugh Lane, Martin Johnson Heade, John F. Kensett, and, perhaps especially, Sanford R. Gifford. The case for a unique approach to light among the Luminists may even have been overstated, for surely the art of those scenic painters who preceded them also came to terms with the phenomenon of light, and, more pertinent to the present essay, their successors developed their own methods for portraying light and made their own demands for the effects that light should produce.

Barbara Novak has pointed out that for our early landscape painters, from Thomas Cole through the Luminists, light invested material form with a spiritual essence, signaling, as she says, "the newly Christianized sublime."[1] Novak refers to Asher B. Durand, who wrote that he had "more respect for the devout heathen who worships the sun as the visible Divinity, than for the artist whose pictures betray insensibility to the charm of sunlight."[2] And she quotes Thomas Cole, who wrote that the sky was "the soul of all scenery, in it are the fountains of light, shade and color. . . . It is the sky that makes the earth so lovely at sunrise, and so splendid at sunset. In the one it breathes over the earth the crystal-like ether, in the other the liquid gold."[3]

This description of the effects of light suggests even more than the works of Cole himself the achievements of his principal pupil, Frederic Church. One thinks of the "crystal-like ether" of Church's *Andes of Ecuador* and the "liquid gold" of the sunset in his *Twilight in the Wilderness*.[4] For Cole, light functioned either as a component of the dramatic mode, vis-à-vis the shadowy dark, found in works such as *The Clove, Catskills*, or pervasively in the pastoral Claudian tradition of his late *Picnic*.[5] But for Cole, light in itself was not an element to be studied and

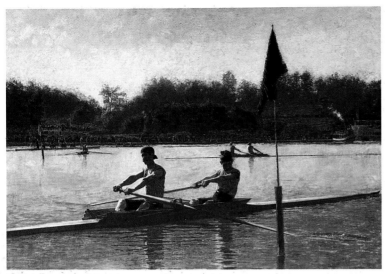

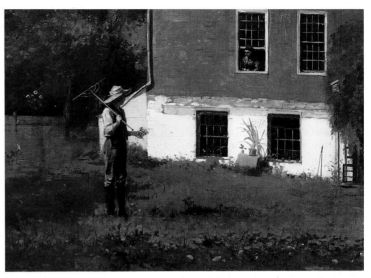

10. Thomas Eakins. *The Biglin Brothers Turning the Stake.* 1873.

11. Winslow Homer. *The Rustics.* 1874.

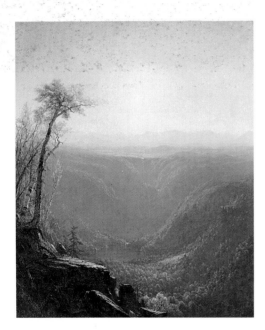

9. Sanford Gifford. *Kauterskill Falls.* 1862.

manipulated except insofar as it might enhance the moral or lyric drama of the total scene. Unlike his English contemporary John Constable, Cole was not interested in achieving a natural unity between sky and land mass through a consistent presentation of the effects of light.

Among the Luminist painters, light, as Novak has written, was "one of the key factors of the mode."[6] One might say it was *the* factor that defined a Luminist painting, although scholars continue to disagree on how it was pictorially expressed and how it functioned. Novak, for instance, stated that "Luminist light tends to be cool, not hot, hard, not soft, palpable rather than fluid, planar rather than atmospherically diffuse."[7] But this would seem to deny Luminist status to Sanford Gifford, arguably the most classic of all the painters now associated with that aesthetic and certainly the one so recognized in his own time (plate 9). John F. Weir, in his essay for the catalogue of the Gifford memorial show held in 1880 at the Metropolitan Museum of Art in New York, noted that: "Gifford loved the light. His finest impressions were those derived from the landscape when the air is charged with an effulgence of irruptive and glowing light. He has been criticized for painting the sun; for dazzling the eye with the splendors of sunlight verging on extravagance."[8] Weir was surely thinking of the

criticism that was hurled at Gifford in 1864 by America's two most perceptive art critics of the period, Clarence Cook, who wrote of Gifford's "vaporous obscurity," and James Jackson Jarves, who described Gifford's tints as brimstone.[9]

We have also come to recognize that Luminism is by no means a uniquely American aesthetic but rather one that was adopted by artists from England to Russia, although it was practiced in some countries more intensely than in others. Are such differences then more attributable to artistic traditions than to natural, phenomenological causes? Does the appearance of Luminist or Luminist-related paintings in American, British, Danish, and Russian art suggest that some factors of Luminist light are intrinsic to the actual light of northern climes, factors found less often, seldom, or never, in various areas of Southern Europe? If at the beginning of the nineteenth century John Constable was concerned with the effects of light through clouds upon the corresponding geography below, the question is now the effect of geography on how the light above is seen.

Yet, although Gifford and many of his Luminist colleagues remained a significant force in American landscape through the 1870s, the aesthetic itself, a somewhat uneasy blend of the timeless solid and the changeable transparent, no

longer remained viable when younger artists and a new generation and class of art patrons were subscribing to influences from abroad, particularly from France, where so many of the younger painters were studying. These artists and patrons began to adhere rather to the aesthetics of Barbizon-inspired art—the art of Camille Corot, Theodore Rousseau, and the "Men of '30," as they were designated.

Considerations of light in the landscape among Barbizon artists, French and American, should not be underestimated, but that interest was not always primary. Certainly they should not be ignored when considering that paradigmatic example of American Barbizon painting, George Inness's *Peace and Plenty* of 1865.[10] Here, the light is exceptional and the date and origins of the picture are significant. *Peace and Plenty* was painted over a picture entitled *Sign of Promise*, exhibited two years earlier, and like Inness's now unlocated *Light Triumphant* of 1862, an American pastoral scene here takes on iconic overtones relating to the conflict of the Civil War. Inness's great canvas is a paean to peace and a recall to fraternal plenitude, blessed by a warm, enriching celestial light, summoning a return to a former innocence that was not to be restored, just as the lost *Sign of Promise* was described by George Lathrop in the *Atlantic Monthly* as a depiction of the triumphant light of a rainbow.[11] Thus, the rainbow of heavenly benediction was replaced on the canvas by the golden light of contentment and harmonious accord.

By contrast, a whole generation of American landscape painters, who had trained in European academies and ateliers under noted and popular artist-teachers, produced works of great beauty in which, indeed, light often *was* a primary factor. Among the French artist-teachers of many American students in the post–Civil War generation, none was more significant than Jean-Léon Gérôme.[12] Gérôme's realist historical and ethnological recreations are well known, and they often appear with extensive landscape backgrounds. But the several scenes he painted of the Egyptian Fayoum, about 1870, are abundant evidence that Gérôme was also a masterful painter of independent landscapes.[13] In such works, both form and light are clear; Gérôme has utilized the hot, even luminosity of Upper Egypt to clarify and sharpen form, not to dissolve it, with the surfaces of building walls and tranquil pools forming reflective mirrors of light.

This heightened approach to light, while maintaining academic standards of accurate drawing amd modeling, was well learned by the young American art students in Paris, and particularly by Gérôme's first major American pupil, Thomas Eakins. This can be seen in the whole series of sculling pictures Eakins painted during the early 1870s, soon after his return to Philadelphia from Gérôme's tutelage. An example is *The Biglin Brothers Turning the Stake* (plate 10) of 1873, in which figures and boat are strongly silhouetted against the glassy, reflective surface of the Schuylkill River, that plane marked out by boats and flags acting as spatial markers across the wide expanse. But the light, as it is in Gérôme's Near Eastern painting *The Prisoner* of 1861, is intense, clear, and overall.[14] Such intensity and clarity are even more apparent in the best known of all of these sculling pictures, *Max Schmidt in a Single Scull*, painted in 1871.[15]

It is no coincidence that at much the same time we find a major reflection of this—what I refer to as the "Glare Aesthetic"—in the painting of Eakins's contemporary Winslow Homer, in works such as his *Rustics* (plate 11) of 1874. This picture was created in the same year that Monet and the other French Impressionists first showed together, exhibiting the full aesthetic of Impressionism. But, although they were concerned with dazzling effects of light, artists such as Homer and Eakins during this decade were not willing to sacrifice solid form and well-defined space, and thus their work is totally *non*-Impressionist. What Homer shared with his French contemporaries was a wish to render sunlight and brighter and more colorful effects. Yielding to the increased interest in recording outdoor visual phenomena, he nonetheless rejected dissolution of form—intensifying tonal contrasts rather than eliminating them.

Moreover, the Glare aesthetic was an international one. A monument to it was the quintessentially pre-Raphaelite picture *Pretty Baa Lambs* by Ford Maddox Brown, painted in England in 1852.[16] We know that the work was painted in the intense heat and light of summer, completely out-of-doors; and certainly one of Brown's purposes was to record the visual phenomena of light and color. But again, Impressionist is exactly what it is not, with its hard outlines, sharply defined forms, intense shadows, and solid modeling. At the same time, the German master Franz von Lenbach was working in

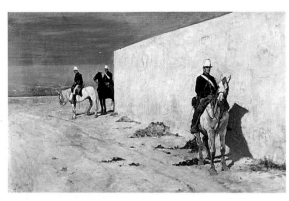

12. Giovanni Fattori. *The Lookouts (The White Wall)*.

13. Frank Duveneck. *Old Town Brook, Polling, Bavaria*.

14. Carl Schuch. *Approaching Storm at Ferch*.

15. J. Frank Currier. *Moors at Dachau*. 1875.

16. Theodore C. Steele. *Pleasant Run*. 1885.

the Italian countryside, painting peasants in heightened, brilliant sunlight, with strong tonal contrasts and brilliant Glare effects. Lenbach often introduced brightly colored umbrellas for flat, reflective planes, which in turn cast strong, solid shadows. The Austrian artist Ferdinand Waldmüller, in his late peasant genre pictures of the mid-century, also utilized the Glare aesthetic, recording intense light, with strong shadows, bright colorism, and often flat, planar, reflective, architectural elements.

As artists in England, Scandinavia, and Russia especially represent the international aspects of Luminism, so Gérôme in Egypt or Lenbach in Italy suggest that the southern or Mediterranean climes were, partially at least, the source of the Glare aesthetic, rather than the grayer skies of Northern Europe. Thus, Italian artists of the 1850s and afterward predictably explored this mode, and it informs many of the pictures of that most innovative group of Italian painters of the period, the Florentine Macchiaioli. One finds these qualities in works by such major figures of the movement as Giovanni Fattori, in his well-known *Rotunda of Palmieri*, for example, in which both figures and architectural forms are reduced to flat, contrasting, and reflecting planes. The aesthetic is even more emphatic in his marvelous *Lookouts* or *The White Wall* (plate 12).[17] Similar effects were achieved during the 1860s by Fattori's colleagues Giuseppe Abbati and Vincenzo Cabianca.

Venice, too, with her warm sunlight and manifold reflecting canals, produced artists who delved newly into light effects, including the almost-Luminist Guglielmo Ciardi, in his almost-Luminist *View of the Giudecca Canal* of 1868.[18] Glare plays a part too a decade or more later, modified by a more naturalistic, tonal approach, in the market scenes painted in the Campo San Paolo by the greatest Venetian artist of the period, Giacomo Favretto. The reflective pavement silhouettes the activities of the marketing peasants, while above them additional light is thrown back from the surfaces and columns of the buildings.

Sunlight, therefore, had become a distinct element of artistic reckoning for many artists after the middle of the century. Significantly, a long discussion titled "Sunshine"—an article in the English periodical *Fine Arts Quarterly Review* of June 1867—pointed to the "grammar of nature which art must master if she would learn the se-

cret of sunshine and how to paint it."[19] Thus Americans concerned with "lighting the landscape," in the last three or four decades of the century, were sharing an aesthetic exploration with their European colleagues, a further indication that they had entered into a cosmopolitan dialogue. This was bemoaned and even denied by the older, still practicing landscape painters of the Hudson River School, such as William Hart, who noted in *The Art Union* magazine as late as May 1884: "I am profoundly grateful that there is no 'school,' in the commonly accepted sense, in this country, save, the sorry importations from Paris and Munich."[20] Unfortunately for Hart, by then those sorry importations were exactly what art in America was all about.

Another approach to the derivations from Paris and Munich in terms of landscape light is a strictly coloristic one. This was the direction assumed by Otto Stark in his seminal article on "The Evolution of Impressionism," published in June 1895 in *Modern Art*, the most advanced art periodical in this country at the end of the nineteenth century.[21] Stark was the only French-trained artist among the coterie of Indiana painters who had been christened "The Hoosier Group" by their champion, Hamlin Garland.[22] Most of Stark's colleagues, like so many Midwestern painters, had studied in Munich, so that he was extremely familiar with the art that derived from both European centers. Stark wrote:

With the Centennial [1876], or shortly after it, however, came a revolution, brought about by some of our best students returning from abroad, or sending their work home. Munich men took the lead, and the pictures and studies of such men as Chase, Duveneck and Shirlaw were a protest against the superficial, gaudy and unreal style then prevalent in American paintings. The marvellous technique, blackness (as we see and understand it now), love of simplicity in subject and treatment, breadth and vigor were a new revelation, and the "popular" painting could not withstand it long. The very faults of the Munich school were virtues, judged by the needs of the times. The blackness, for instance, was at times so pronounced that I well remember a saying, which became notorious in New York, of an artist who, standing before a water color by Currier, another of the American leaders of the period, which represented a road with trees silhouetted against a rainy sky; being asked what they were, answered, "Why, Ivory black of course"; and yet, this blackness and brownness had a mission to fulfill and did fill it, in bringing on a revolt against the wrong color sense of the period. But life means progress, and though the Munich movement had the effect of making us impatient with what it was a protest against, it nevertheless carried within itself that which was to doom it or make it only a round in the ladder of an upward movement in art, rather than a final achievement. A protest against it came very soon, in the so-called gray movement, brought mainly from France, and a more rigid method of drawing was sought after. The fine technique, simplicity and breadth of handling, was retained, but gray predominated as contrasted to the black and browns of the Munich method. This striving for grays was the result of the work carried on out of doors, or the "plein air" movement, which was making itself felt about that period.

This I consider the mightiest movement of modern times. With it came a new conception of nature, not confined to out-of-doors nature alone, for it very soon reacted also upon the work in the studio and in the house. Air and light were sought after as never before. The result of all of this was shown in pictures, beautiful in repose, harmonious in tone, generally without shrill notes of any kind; good in values, in a monotone sense, but still lacking light and colors. Working out of doors, painters could not help being attracted by sunlight, and serious attempts were made at rendering it. With this came still another movement, the so-called "high key" in painting, which meant to paint as light and as near white as the palette would allow, and well do I remember walking through exhibitions where a large percentage of canvases looked like white-washed fences, the paint being plastered on in a manner which reminded one of mortar put on with the trowel of a stone mason. Still it was not sunlight.

Gradually, working almost isolated, derided and scorned, came the color impressionists.[23]

Now, one may smile at the simplistic, sequential development that Stark outlines in anticipation of the triumph of Impressionism, and certainly these movements were neither mutually exclusive nor did each coloristic component of his evolution neatly expire in order to give way to its successor. Yet, Stark's observations are more than a little accurate, and indeed the successive coloristic attitudes in defining the light in the landscape

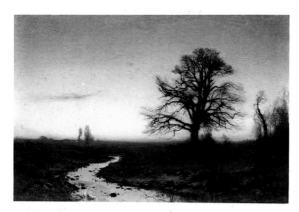

17. Charles Harold Davis. *Evening.*

18. William Picknell. *On the Borders of the Marsh.* 1880.

led to controversial themes in critical circles of the day.

As Stark noted, the "Black" method, indeed, derived from Munich. While Americans had begun studying in Munich during the early 1860s, the "American" Munich school developed after the appearance there of Frank Duveneck, who enrolled in the city's Royal Academy in January 1870. Those artists of the '70s who joined him and studied with him there were primarily devoted to the figure. But in the late 1870s Duveneck and his "Boys" painted outdoors in the summers at Polling and elsewhere in the Bavarian countryside. Works such as Duveneck's *Old Town Brook, Polling, Bavaria* (plate 13), of about 1878, illustrate the informal but strong and dramatically tonal renderings that characterize the landscape work of these artists at the time.

Despite the training sought by these Americans at the Royal Academy, the aesthetic determination seized upon by many of the Americans there in the '70s derived from the radical, *non*-academic circle of the German painter Wilhelm Leibl, himself inspired by the work of Gustave Courbet. Although Leibl and his *Kreis* were primarily figural artists, a number of those associated with him also were concerned with landscape painting, including Adolph Lier and Edward Schleich, and particularly two of the leading German painters of the group, Wilhelm Trübner and Carl Schuch.

Many of the landscape paintings of the 1870s and '80s by Trübner and Schuch illustrate the characteristics of the "Black" aesthetic described by Stark, which in turn passed over to some of the two artists' American colleagues. Among these pictures are the landscapes that Trübner produced at Herrenchiemsee in 1874 and at Wessling in 1876; those painted by Schuch at Olevano in Italy in 1875; those done when he joined Trübner at Wessling the following year; the pictures he painted at Ferch between 1878 and '81; and, later, those he created at Saut du Doubs in Switzerland in 1886–87. Although Schuch today is thought of primarily as a still-life specialist, and for American art as a possible inspiration for William Merritt Chase in Munich, he was equally active as a landscapist, producing *stimmungslandschaft*—"mood landscapes," such as his *Approaching Storm at Ferch* (plate 14), of 1878, in which his dark and dramatic, painterly manner reinforces the bleakness of the scene.

Among the Americans working in Duveneck's circle, John Twachtman, especially, adopted the inky Black aesthetic in his landscapes, initially in Venice where his ragged, informal renderings contrast so much with the traditional interpretation of that bright and sparkling city. Indeed, Twachtman's pupil Caroline Mase later quoted her teacher's ironic reference to "Sunny Venice done under the influence of the Munich School."[24] Twachtman's Venetian pictures were shown in New York at the Society of American Artists in 1879 and 1880, and he brought the Black manner back to his native Cincinnati as well as to New York at the time. But by 1882, Twachtman had concluded that he had carried that aesthetic as far as it could go.

By that year, however, a much more powerful landscape painter, J. Frank Currier, had impressed the American critics and public, dismaying them at the same time with his dark, Black, painterly Munich manner in works such as *Moors at Dachau* (plate 15). His dash and sketchiness left the reviewers of his work at the Society of American Artists totally uncomprehending.[25] Currier's brilliant landscape watercolors had astounded New York the previous year, when seen at the Water Color Society's annual show; but even the most sympathetic and receptive critics such as Mariana van Rensselaer were unprepared for his monumental oil landscapes of the German countryside.[26]

Nevertheless, in Germany itself Currier attracted a host of younger American painters, especially some from the Midwest, who continued to flock to Munich to study, including Theodore Steele, Otto Stark's future colleague in the Hoosier Group. Steele arrived in Munich in 1880, enrolling at the Royal Academy, where he succeeded well enough to win a medal for his *Boatman* in 1884.[27] But under the influence of Currier, who remained a longtime expatriate in Munich after Duveneck and the other Americans of the '70s had gone on to Italy or returned home, Steele turned more and more to landscape. He studied at least informally with Currier at Schleissheim and painted in Currier's Black manner, as in his own *Late Afternoon, Dachau Moors* of 1885.[28] With this aesthetic Steele returned to Indianapolis that year, where the first landscape he did after his arrival was the local scene of *Pleasant Run* (plate 16), Indiana interpreted in the Black manner of Munich. Subsequently, Steele was to reject Munich in favor,

first, of a Barbizon-inspired mode, then a modified Impressionism so admired by Hamlin Garland, and finally a full commitment to that popular strategy by the turn of the century.[29]

As far as mainstream American landscape painting was concerned, Currier's critical debacle of 1882 effectively ended the Black sequence. As Stark noted, it was succeeded by the "Gray" manner—plein-air painting of French origin, and "the mightiest movement of modern times." The Gray movement was part of the enormous heritage from Jules Bastien-Lepage (see plate 86), who though short-lived garnered tremendous admiration and had incredible influence upon English, Scottish, Irish, and Scandinavian artists as well as Americans. He was, and is, primarily noted as a painter of peasant themes, a painter of the *juste milieu*, in which careful, detailed drawing and naturalistic themes were wedded to a painterly technique practiced outdoors. In such works Bastien tended to favor an overall gray illumination, with very little tonal contrast. Less well known are Bastien's pure landscapes, painted in France, on trips to London in the early 1880s, and on a voyage to Algiers in 1884, the last year of his life.

The major centers for the transmission of Bastien's influence were the artists' colonies of Concarneau and Pont-Aven in Brittany, and, fittingly enough, the colony at Grèz-sur-Loing near the Forest of Fontainebleau. At Grèz, Bastien's influence was reinforced by the presence of Jean-Charles Cazin, the only significant French artist to join the foreign painters there. Cazin is another figure whose remarkable reputation in the late nineteenth century is almost totally forgotten today. William Coffin, writing in 1898, noted that "few of Cazin's pictures found their way to the United States until 1884 or 1885."[30] A reference to an exhibition of Cazin's paintings held at the American Art Association in New York, in 1893, noted that "his palette is somewhat limited in range and is laid in a grave key . . . not the sunny country of fair middle France, but the grayer and more sober provinces of the North."[31]

The first sizable English-speaking contingent of artists arrived in Grèz as early as 1876, and it included the American figure painter Will Low and the great Irish artist Frank O'Meara, who painted his masterpiece *Toward Night and Winter* there, in 1885.[32] Later British artists included John Lavery, James Guthrie, and William Stott; among the Americans were Birge Harrison, Willard Metcalf, Theodore Robinson, Bruce Crane, and Edward Simmons. Artists found Grèz ideal for painting, particularly on gray days. Bruce Crane, writing to his father from Grèz in 1882, remarked that "tone is the thing sought for, objects are never modelled, everything is treated as a flat mass."[33] Actually, Crane had gone "gray" before Grèz. A reviewer for the National Academy of Design annual of 1881, writing in the *Studio and Musical Review*, called Crane "a rising young artist. . . . He paints in a gray tone, something after the manner of French art."[34] And Charles Davis, who spent the winters of 1882 and 1883 in nearby Fleury, noted that "the succession of gray days is so continuous . . . that a motif remains about the same nearly four months."[35] After painting at Grèz with Metcalf and other American colleagues early in 1885, Davis confirmed that observation with his two earliest masterpieces of the following year, both entitled *Evening* (plate 17).

Bastien-Lepage's impact was felt more directly by the American artists working at Concarneau, an influence summed up by the English painter A. S. Hartrick in his autobiography: "In every country the most promising youths were frankly imitating his [Bastien's] work with its ideal of exact representation of nature as seen out of doors, everything being painted on the spot in grey light, in order that there might be as little change in the effect as possible while the artist was at work."[36]

Robert Wylie, a Philadelphian and the earliest American to settle in the region, went to Pont-Aven in 1865 and worked there until his death twelve years later. Wylie attracted numerous compatriots, including William Lamb Picknell, who came in 1876. The critic and historian Sadakichi Hartmann characterized Picknell as an artist who joined "the school of open-air workers, and painted his pictures directly from nature. Picknell's *On the Borders of the Marsh* [plate 18]—a November day in a Brittany field, portrays the characteristic gnarled trees, overgrown with ivy and mistletoe, and the broad earthen fences peculiar to the region,—is most vigorous in its treatment and peculiar in the way in which he encrusted the surface of the picture with thick lumps of paint."[37] The great trees and earth fences in this work of 1880 are also enveloped in a clear gray atmosphere, characteristic of that dominant aesthetic. During the 1880s, in both Brittany and later at Annisquam on Cape Anne,

19. Edward Simmons. *Night, St. Ives Bay.*

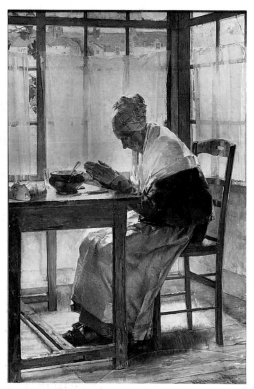

20. Walter Gay. *Le Bénédicité.* 1898.

Massachusetts, Picknell attempted to reestablish some of the conditions of the art colony he had enjoyed in Pont-Aven. He was closely associated with Hugh Bolton Jones, an artist from Baltimore and one of the most critically acclaimed American landscapists of the period. Jones's association with Picknell is especially evident in his *Edge of the Moor, Brittany* of 1877,[38] which analyzes the same distinctive landscape that was the basis for Picknell's major painting three years later.

Bastien-Lepage himself was in Concarneau in the summer of 1883, and he became particularly close to the American painter Alexander Harrison. Harrison's closely toned *The Wave*, of 1884–85, reflects that association. But the American in Concarneau who seems most to reveal the impact of Bastien in his aesthetic, and that of Harrison in his choice of subject matter, is Edward Emerson Simmons. This was especially true when Simmons crossed the English Channel in 1886 and settled at the artists' colony at St. Ives in Cornwall. Turning away from figure painting there, he produced a riveting series of marine pictures, including his *Night, St. Ives Bay* (plate 19) of 1889. Of an earlier, unlocated *Bay of St. Ives, Evening*, exhibited with tremendous acclaim at the Society of American Artists in 1888, the critic for *Art Amateur* noted that Simmons "has also made much out of a difficult subject, a long and wide expanse of gray sea water lit only by a little patch of diffused moonlight. . . . There are many moonrises and moonlights—Phoebe having lately come into favor among these painters, whose sentimentalizing, it must be said, is nearly always better than that of the figure painters."[39] And the critic of the same exhibition for *Art Interchange* also praised Simmons's "vast expanse of gray water," noting that "gray and melancholy days are preferred to garish sunny ones, and twilights and moonlights are in high favor."[40]

The predominance of the Gray aesthetic in the mid-1880s, with its low, even light, was consistently remarked upon, as was its French derivation, at least in landscape painting; when figure artists utilized an overall gray atmosphere to envelop their peasant subjects in interior scenes, critics correctly deduced a German origin. Sadakichi Hartmann wrote that "Edward [*sic*; Hartmann meant Walter] Gay, under the influence of the German gray in gray movement, explored by [Max] Liebermann and [Fritz von] Uhde, painted a series of old women of singular uncomeliness. 'Le Bénédicité,' (plate 20) a shrivelled old woman, sitting praying, with folded hands, before a meagre meal, was bought by the French government. It is a remarkable piece of painting. It has a distinct charm in the delicacy of its grays, as they pass from transparent shadows to the softness of half-tones and the intensity of full light." Hartmann also allied the work of Robert Vonnoh, Charles Sprague Pearce, Daniel Ridgway Knight, and Walter McEwen with the figure painters of the gray-in-gray movement.[41] The German origin for this aspect of the Gray movement had been noticed even earlier by a writer for *The Studio* in 1885, in reviewing *The Two Sisters*, a watercolor by Edwin Austin Abbey.[42] Abbey "follows in the wake of a dozen or twenty other artists, all bent on painting people in front of windows shaded by muslin curtains. The fashion was set in Munich, and has been imported thence to our shores, where Mr. Abbey, Mr. [Robert] Blum, Mr. [Charles] Ulrich and others have tried their hands at the problem and made their solution interesting."[43]

But Gray landscapes were French-inspired and often painted in France itself. The Boston artist Dennis Miller Bunker, who studied with Gérôme in Paris between 1883 and 1885, during summer 1884 painted a series of gray landscapes in the village of Larmor. Bunker's results were noted the following year in a review of the annual exhibition of the National Academy of Design by the writer for *The Studio*—probably its editor, Clarence Cook: "Mr. Bunker's landscapes are all low in tone and the light is managed much in the way that is the fashion now-a-days in so many French studios."[44] But the masterpiece of American Gray painting is found in the strategies that John Twachtman substituted for his earlier Black, Munich manner. Working in France in the mid-'80s, he produced his *Arques-la-Bataille* (plate 21). This work of 1885 has often been analyzed as heir to Whistlerian aestheticism and a reflection of the prevailing Japanese influences in avant-garde art. But while these and other factors are certainly present and while Arques-la-Bataille is outside of Dieppe on the French coast and Twachtman had no known contact with the art colony at Grèz, his masterwork seems a very complete reflection of the Anglo-American Gray aesthetic developed there. This aesthetic is seen at its most profound in *The Ferry* of 1882, by William Scott, the influential English painter working there.[45]

Yet, as Otto Stark had observed, these works, although harmonious in tone, were still lacking light and color. And so there came another movement, "as near light and white as the palette would allow." The Boston painter Philip Hale recognized that the Gray movement now had become formulaic: "But woe be unto our realist, if he paints the foreground of his gray day from the shadow of an umbrella stuck up in the sunny field."[46] The origins of the "White" movement seem more complex and diffuse than its predecessors. Certainly it relates to the overall Glare aesthetic, under artistic exploration as early as the 1850s, but clearly it was reinforced by the tremendously popular—and ubiquitous—art and fame of the Spaniard Mariano Fortuny, the leader of the Romano-Hispanic School, whose work was as well known in France, Italy, and America as it was in his native Spain. Indeed, Fortuny's greatest patron was the American expatriate William Hood Stewart.[47] Fortuny first assumed a position of leadership in French art in 1869, just five years before his premature death, his fame resting in part upon his scintillating manipulation of brilliantly colored pigment and of bright, reflected sunlight (plate 22). In a letter of July 1872 from the American dealer Samuel Avery in Paris to John Taylor Johnston in New York, a major collector and first president of the Metropolitan Museum of Art, Avery noted that "A Fortuny, too got astray during his absence [Stewart's] Goupils sold it to McLean of London (dealer) scene in Alhambra only everything is White."[48]

Fortuny was represented in Paris by Gérôme's father-in-law, the dealer Goupil, and the two artists were close colleagues. Thus it is not surprising that Gérôme's pupil Thomas Eakins would characterize a Fortuny painting as "la chose la plus belle que j'ai jamais vu."[49] Eakins's first major, fully composed painting, done on a trip to Spain in 1870, was *A Street Scene in Seville*, a picture that reflects the brilliance of light in a Glare manner.[50] As we have seen, Eakins shortly thereafter returned to Philadelphia to practice this approach to outdoor light for several years, notably in his *Sailboats Racing on the Delaware* of 1874 (plate 23). Here, the great, flat, white sheets of the sails dominating the composition demonstrate the artist's subscription to this newest treatment of light and light-reflecting surfaces.

Nor was Eakins alone among Gérôme's students in adopting the White glare manner. Comparable effects were achieved in much more exotic locales by Edwin Lord Weeks, an artist noted for his Orientalist and particularly his Indian scenes, such as *The Great Mogul and His Court Returning from the Great Mosque at Delhi, India*.[51] In 1881, Weeks lived in Granada, Spain, in a house that had been Fortuny's home a decade earlier. John Singer Sargent adopted the White aesthetic in paintings done on Capri, and a whole host of Americans working in Brittany utilized such strategies, painting figures in broad sunlight, against white or near-white structures, all in the late 1870s and early '80s. These include Alexander Harrison; David Maitland Armstrong; Helen Corson; Rochester New York's finest painter of the period, Emma Lampert Cooper; and Burr Nichols of Buffalo.[52] In 1882, the critic for the *New York Times* wrote of Nichols's two Breton pictures on display at the National Academy that the artist "has managed to catch the effects of sunlight with memorable skill."[53]

Fortuny's own Spanish background provided him with the ideal geographic and climatic conditions for the exploration of the White aesthetic, and American artists were to follow suit. One of the most intriguing examples of this is the picture of peasant women at a well in Seville by the masterful, Munich-trained Charles Frederick Ulrich, whose Spanish sojourn remains completely undocumented.[54] And in Italy, too, some of the strongly structured paintings of Frank Duveneck, such as his *Italian Courtyard* (plate 24), of 1886, reveal an emphasis on the glare of near-whiteness of tone.

If Fortuny was in part a determining factor in the development of the White aesthetic, its effectiveness was reinforced by the popular Italian artist Giuseppe de Nittis, himself influenced by Fortuny as well as by the Macchiaioli. De Nittis's prominence at the Paris International Exposition of 1878 was noted by Philip Hamerton, where the artist first made "his fame by strange looking but clever pictures of sunny Italian subjects, of which just one, the Route de Brindisi, was exhibited in 1878. Bright color and bright light were tried together, often by means of clear blue skies and light-colored dusty roads, with sharp shadows upon them."[55] It is particularly noteworthy that De Nittis's *Road to Brindisi*,[56] first shown at the Paris Salon of 1872, was acquired by Fortuny's great patron, William Hood Stewart. And

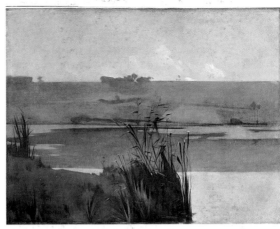

21. John Twachtman. *Arques-la-Bataille*.

22. Mariano Fortuny y Carbo. *Gypsy Caves, Granada*.

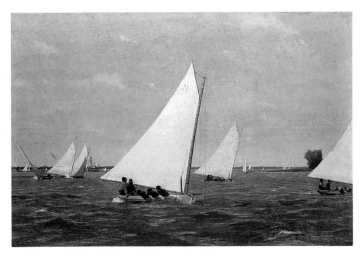

23. Thomas Eakins. *Sailboats Racing on the Delaware.* 1874.

24. Frank Duveneck. *Italian Courtyard.* 1886.

25. William Picknell. *The Road to Concarneau.* 1880.

this, the artist's first major triumph, in turn undoubtedly stands as the primary inspiration for the greatest of all the American White pictures, William Lamb Picknell's *Road to Concarneau* (plate 25) of 1880, one of the most acclaimed paintings of its day. One of the many writers responsive to the canvas noted that "there is in this picture what so many landscape painters fail to reach—that is, sunlight."[57] And almost certainly it was Picknell's triumph that led a writer in the *Art Amateur* of October 1886 to conclude that "the conquest of white is a problem every painter yearns to solve. It is regarded as the highest technical achievement to render white textures in high light and temperate shade with approximate truth. The slightest deflection in the one direction will produce the crude and chalky effect of mere paint and in the other will end in muddiness and opacity."[58] Picknell, naturally enough, continued to capitalize on his success for a decade with other "road" pictures, culminating in his *Road to Nice* of 1890.[59]

"Still," Stark concluded, "it was not sunlight." Sunlight, in his view and that of many others in the 1890s, was the triumph of Impressionism, which first appeared in the work of American artists exhibiting in America in 1889.[60] Yet the transition from pure white to a full chromatic range was first made not by artists but by scientists. As early as March 1860, Ogden Rood, Professor of Chemistry at Troy University, noted that "after momentary exposure to white light subjective colors are induced in the eye, whose tint and duration are dependent on the strength of the impression received."[61] Rood went on, of course, to author the *Students' Text-Book of Color; or, Modern Chromatics, with Application to Art and Industry* in 1879.

During the 1870s and early 1880s, there was a good deal of confusion in the United States about the nature of Impressionism. Often, the movement was identified with quickly sketched works of unfinished appearance and with the strongly Tonal products of the Munich School. Artists as different as Homer, Whistler, Blum, and Currier were referred to as Impressionists by the critics. However, with the gradual appearance of French Impressionist works in American exhibitions during the first half of the 1880s—the earliest public exhibition of such a painting was a Degas pastel shown at the American Water Color Society annual in New York in 1878—a proper identification of the movement was made.

This culminated in the great exhibition sent here in 1886 by Paul Durand-Ruel, the French dealer specializing in Impressionist painting. Shown in New York at the American Art Association, it was later extended to the National Academy of Design. Generating a great deal of critical controversy but also enlisting the patronage of numerous American collectors, Impressionism became a known and much-admired aesthetic.

In addition to the expatriated Mary Cassatt, who had joined the ranks of the French Impressionists by 1879, a large number of American artists joined the movement in the years following the great Durand-Ruel show in New York, although many of them converted to Impressionism while abroad. This was true, certainly, of Childe Hassam, who, soon after he made his second trip to Paris in 1886, abandoned the finished surfaces and strong, dark, Tonal strategies that inform his Gray painting of 1885 *Rainy Day, Columbus Avenue, Boston*.[62] Usually considered one of the finest of his early Impressionist paintings, his *Grand Prix Day* (plate 26) of 1887 is actually a much more complex picture, though it certainly demonstrates his newfound knowledge of and attraction to Impressionism. Light and color are major considerations here, as are the broken, flickering brushwork and brighter colors, particularly apparent in the parasols of the figures and especially in the background row of trees. But the horses and carriages are still quite sharply and academically modelled, and there, blacks and browns are very much in evidence, while the broad sweep of flat pavement is a solid area of reflecting, almost white, glaring pigment. In other words, Hassam has chosen several aesthetic options for treating different parts of the picture, depending on their prominence and the role each has in filling out the whole conception. Hassam's own stylistic course, however, particularly in these crucial, early years in Paris, was not a fixed one. A mode closer to a Barbizon-Tonalist light might serve one scenic interpretation, such as rainy, evening scenes; another, close to Impressionism, might prove more appropriate for other subjects, such as flower sellers and flower gardens. Historians may view the contrast and disparity here as essential differences between a conservative and a progressive aesthetic, or as the artist's inability to seize upon a serviceable aesthetic. For Hassam at the moment, it was a matter of relevant choice.

Even after Hassam's return to America, where he settled in New York City late in 1889, the White aesthetic often merged with Impressionist chromatics, his primary adoption, which he utilized in both his New York City scenes and the summer pictures painted during the early 1890s on Appledore, one of the Isles of Shoals, off the coast of New Hampshire and Maine. These works established Hassam as one of the leading American Impressionists of the day. On Appledore, he became the most renowned figure among the artists and writers who gathered in an informal summer salon presided over by the poet, writer, and gardener Celia Thaxter. And it was Thaxter's garden of poppies and other flowers that inspired what may be Hassam's finest art. But even in his Appledore portrait of Celia, of 1892 (plate 27), while the garden is all flickering, colored Impressionism, the distant sky and sea are painted in a more flat-planed, Glare aesthetic, and Thaxter herself is a brilliant configuration of white.

Numerous other Americans moved from the Black or Gray aesthetic of the late '70s and early '80s to Impressionism a decade later. This was true of the expatriate John Singer Sargent, whose *Luxembourg Gardens at Twilight*[63] of 1879 is one of the most attractive examples of Gray, Tonal painting. Almost a decade later he exchanged these strategies for rich, coloristic Impressionism when he painted his sister Violet engaged in *A Morning Walk* (plate 28) at Calcot, England, in 1888. Julian Alden Weir succumbed to Impressionism only in the 1890s. In the previous decade, in works such as his beautifully Whistlerian *Against the Window* of 1884 almost Munich-like blacks dominate the palette.[64]

A major center for American conversion to Impressionism was Giverny, in France, halfway between Paris and Rouen and the home of Claude Monet since 1883. Four years after Monet arrived, a group of seven American and Canadian artists went there for the summer, and all of them to some degree—some more quickly than others—adopted that modern aesthetic. Moreover, Giverny became home, summer or year-round, to many more American painters and to successive generations. Even in the early twentieth century, a whole new group of American artists became associated as "The Giverny Group," painters often of the figure, sometimes nude, and of gardens, seen in brilliant colors and bright sunshine (plate 29). For Frederick Frieseke, the leader and best-known artist of this

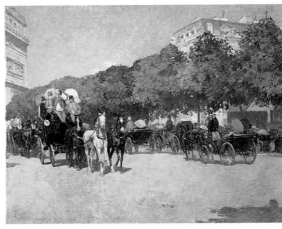

26. Childe Hassam. *Grand Prix Day*.

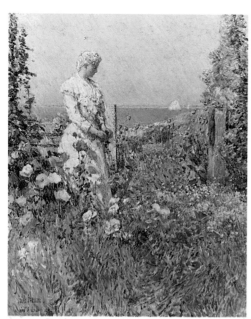

27. Childe Hassam. *In the Garden (Celia Thaxter in Her Garden)*. 1892.

group, light and sunshine were everything: "It is sunshine, flowers in sunshine, girls in sunshine, the nude in sunshine, which I have been principally interested in for eight years."[65]

Born in Owosso, Michigan, Frieseke studied at the School of the Art Institute of Chicago. His quickly won fame at the beginning of the twentieth century almost surely induced other Chicago-trained artists to follow the Impressionist aesthetic, although the significance of Chicago in the advancement and perpetuation of Impressionism in this country is still underestimated. In 1882, Chicago's Academy of Fine Arts was renamed the Art Institute of Chicago, and during that decade the School of the Art Institute developed as the most significant bastion for the training of artists in the entire Midwest. Its curriculum was modeled on those of the art schools in Paris and Munich, where many of the Institute's instructors had studied. Through major collectors such as the Potter Palmers, the city's critical press, and above all the ferment aroused by the art displayed at the World's Columbian Exposition in 1893, Chicago was at the forefront of the establishment of a kind of "homegrown" Impressionism promulgated by the influential writer Hamlin Garland. In addition to providing the training ground for a generation of Impressionist expatriates and for many who practiced the aesthetic after settling in Southern California, a number of Chicago's leading resident artists, both men and women, figure and landscape painters, adopted Impressionist strategies in their art when painting in the leading Midwestern summer art colonies such as Brown County in Indiana and the Ozarks of Missouri. Impressionism was transmitted to their students not only in Chicago but in schools in Milwaukee and in Saugatuck, Michigan.

Some others of the Giverny Group also studied at the Art Institute and followed Frieseke to Giverny, painters such as Lawton Parker and Karl Anderson. Later, other alumni of the school also worked in the French village, including Louis Ritman and Karl Buehr, all of whom shared with Frieseke the same late-Giverny aesthetic. Parker was to spend the last years of his life in Santa Monica and Pasadena, but during his mature career he lived in Chicago and New York, and primarily expatriated in France, returning to this country only after the German occupation of France in World War II.

In addition to working in the Impressionist

aesthetic, Chicago artists, including such talented women as Lucie Hartrath and Pauline Palmer, as well as Frederick Fursman, Carl Krafft, and others, transmitted the movement to other parts of the country. More than a half-dozen painters who began their training in Chicago later became key figures in Southern California Impressionism. William Wendt was one of these. He had studied in the Evening Division at the Art Institute during the academic years 1891–92, 1892–93, and 1893–94, and in 1894 he made the first of a number of trips to Southern California. For a time he was a member of both artistic communities, establishing a growing reputation in Chicago, but enjoying the paintable beauty and majesty of the Southern California landscape at all seasons of the year. He finally established permanent residence in Los Angeles in 1906, and by this time he had adopted the bright colorism and broken brushwork of Impressionism. Within a decade, however, he had transformed his approach into a more powerful one, with a more restricted palette and bold and blocky brushstrokes, scaled to the size of the paintings themselves. Indeed, Wendt's later, more rugged manner was especially appropriate to his monumental canvases that interpreted the large, rolling hillsides in the clarity of midday light, and was similar to that of other Southern California artists, a manner distinctive to the region and practiced by other painters, such as Edgar Payne.

Guy Rose was the earliest native Southern California Impressionist and also a member of the Giverny Group. He had been in Giverny and painted there as early as 1890, soon after the village was "discovered" by American artists. But it was not until 1904 that Rose settled there, joining Frieseke as a resident artist, and like him working out-of-doors, often concentrating on figures in wooded and garden settings and on views of the Epte River, which flows through the town. Frieseke visited California in 1911, and he did several canvases in the Pasadena garden of a friend. One of these, *A California Garden*, was exhibited the following year at the Pennsylvania Academy of the Fine Arts. In 1912, Rose returned to this country and two years later settled in Pasadena, where he became associated with the Stickney School. He was probably the finest of all the California Impressionists at the time, turning in these later years more to pure landscape work, much of it painted around Monterey.

Rose, in turn, induced Richard Miller in

1916 to join him at the Stickney School. Miller was still another of the Giverny Group, a painter initially from Saint Louis, rather than Chicago. While in Giverny for a decade and a half in the early years of the twentieth century, Miller achieved a reputation second only to Frieseke's, and their work was often quite similar. Paintings by the two artists were often exhibited together and were critically aligned. Although Miller remained in Southern California for only about a year, he painted a number of his finest pictures of women in Pasadena gardens (plate 30), especially in the garden of the art patron and watercolorist Eva Scott (Mrs. Adelbert) Fenyes. A painter of international reputation, Miller was inevitably quite influential, and his impact can probably be seen in the figural work of such painters as his colleagues Rose, Jean Mannheim, and Clarence Hinkle, who moved from San Francisco to Los Angeles at the time of Miller's Pasadena sojourn, as well as the still little-known William Cahill. Miller's combination of dappled color in bright sunlight with strong draftsmanship brought a new note to Southern California Impressionism. One of Southern California's leading art writers of the period, Mabel Urmy Seares, wrote of Miller that "his influence at a critical moment in California's art was potent and widespread."[66]

Probably the other most influential Impressionist painter of national renown to visit and work in California at this time was Childe Hassam, though his stay was much briefer than Miller's. Hassam had been West earlier, visiting his close friend and patron, Colonel Charles Erskine Scott Wood, in Portland, Oregon, in 1904 and again in 1908. He painted magnificent landscapes of Oregon's Harney and Malheur deserts, but there is no indication that he traveled via California. In 1914, however, in preparation for the Panama-Pacific International Exposition in San Francisco, where Hassam was represented by a room of pictures and by *Fruits and Flowers*, a figural mural in the Court of Fame, he painted at least ten landscapes in Northern California— scenes of Sausalito, Monterey (see plate 110), and San Francisco itself, in the simplified and decorative Post-Impressionist manner that dominated his aesthetic at the time. Hassam was also well represented at the Post Exposition Exhibition held in San Francisco in 1916. While the impact on local California artists of his presence and his paintings in 1915 and '16 shows has not yet been completely ascertained, Hassam's work is known

to have attracted the attention of five of the young artists who were soon to constitute the Oakland Society of Six.[67] More than a decade later, in winter 1926–27, Hassam made a warm-weather tour across the southern United States, reaching Los Angeles late in February 1927, and also visiting and working at Santa Barbara and further south at Point Loma and Coronado. A drawing for Hassam's etching of *Contours of Los Angeles* is dated 28 February 1927. On this visit, his production seems to have been drawings and etchings, rather than paintings.[68] Some of Hassam's California pictures were included in a show of twenty-six of his works held in San Francisco at the Legion of Honor two years later, in February 1929, but such paintings would seem to date from his visit to Northern California over a decade earlier.[69]

Alson Clark arrived in Southern California later than his colleagues, Wendt, Rose, and Miller, but he too accounts for the transmission of Impressionism from Chicago to Giverny to Los Angeles. Born in Chicago, Clark studied at the School of the Art Institute. His best-known early works are powerful, dark cityscapes and landscapes. A constant traveler, he used Chicago as his base while he journeyed throughout Europe. At the end of the first decade of this century he was at Giverny, where he was exposed to the tenets of Impressionism practiced there by Frieseke, Rose, and the others, and while not a member of the Giverny Group, by 1910 he had adopted the high-keyed colorism of Impressionism exemplified by his *Summer, Giverny* of that year (plate 31). His best-known paintings of this decade are from another part of the world, a series of depictions of the excavation and construction of the Panama Canal, painted on a trip to that area in 1913 and exhibited at the Panama-Pacific International Exposition in San Francisco two years later. In 1919, Clark first visited California, and by January 1920 he had settled in Pasadena. In 1921 he assumed a position at Stickney School, where Rose was then director. As a result of Rose's ill health, Clark replaced him at the end of the year. Clark's paintings of this period were brightly colored landscapes, beach scenes, and views of the old missions. In his best-known figure painting of the period, a depiction of his wife, *Reverie* (formerly *Medora on the Terrace*) (see plate 136), of 1920, he again reveals the aesthetic concerns of the Giverny Group. This work is allied to the monumental female image

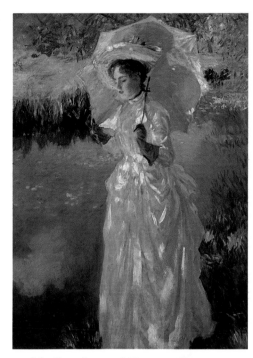

28. John Singer Sargent. *A Morning Walk*. 1888.

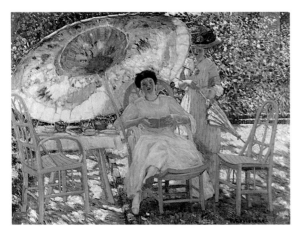

29. Frederick Frieseke. *The Garden Parasol.* c. 1909.

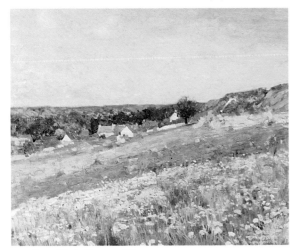

31. Alson Clark. *Summer, Giverny.* 1910.

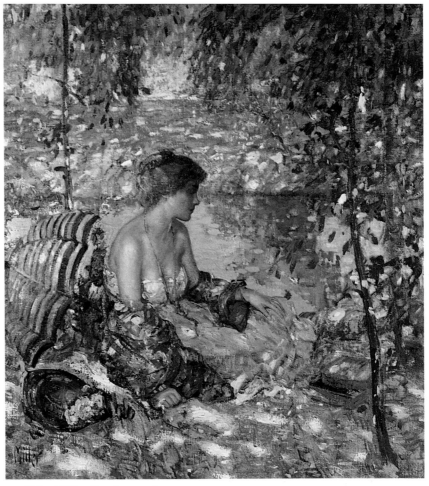

30. Richard Miller. *Reverie.* c. 1916.

set in a sunlit garden, the favorite theme of Frieseke and Miller.

What should be stressed here too is that these artists from Giverny—Rose, Miller, Frieseke, and Clark—found in California an environment of ease and relaxation similar to the one they had enjoyed in France, one in which the aesthetic concerns they had adopted and shared in Giverny could again be focused on brilliant, colored sunlight. The light of Southern California, of course, is harsher and more blinding than that of Northern France, similar rather to that of the Mediterranean, which led these painters to even brighter and broader Luminist strategies, sometimes approaching the effects of the Glare or White aesthetics. To explore and exploit these tactics fully, these California artists and their colleagues moved away from enclosed gardens and quiet streams to broader landscape panoramas, to old towns and buildings glistening in the sun, and to pictorial conceptions often more casual and spontaneous than those that they had contrived in France. This was more than two decades after Otto Stark had concluded his survey of the aesthetics of light with the triumph of Impressionism. But as the Indiana artist had also written in his essay: "This movement of color impressionism has proved itself to be a revolution by its staying qualities, and the influence it has had upon art and artists. . . . I consider that we are not at the end of it; beautiful work has been done, but still more beautiful is to come."[70] He probably would not have been at all surprised to find that some of it came from California.

WILLIAM H. GERDTS

THE HIGH COST OF PARASOLS

Images of Women in Impressionist Art

Impressionism has become an international obsession among collectors. For the privilege of owning just one major work by Monet, Degas, or Renoir, corporations and even some private investors are willing to spend sums of money sufficient to build and fill an entire museum with outstanding paintings in styles that are currently less desirable.

At nearly $25 million, Monet's *In the Field* (*Dans la prairie*) is, at this writing, the most expensive Impressionist painting ever purchased at auction, topped only by several works of van Gogh and Picasso as the most expensive painting ever. American Impressionist paintings, too, are among the highest-priced works on the market.

Economic transactions of this magnitude cannot be dismissed as eccentric whims of the super-rich. Such transactions, moreover, have little to do with aesthetic judgment: when we call an object priceless we indicate that its cultural importance is beyond monetary valuation. When we then pay a fortune for it anyway, we are making a statement about ourselves, not about the object in question, which is now merely a vehicle for our ego—or our business acumen.

The art we choose to admire is always expressive of our ideals of self-identity: not of what we know we are, but of what we would like ourselves to be. The greater the distance between our ideals of self and the reality of our existence, the more fiercely we covet the art that expresses the state of being we long for but feel we cannot attain.

The art market moves according to patterns of supply and demand to feed these dreams. Calculated investment by business people and corporations becomes a factor only when the demand far outstrips the supply. Once this happens, the particular segment of the art market involved shifts from the barter of dreams to wholesale speculation in commodity futures.

Commodified art like paper money is an agreement concerning value that is meant to facilitate the convenient, temporary disposition of accumulated wealth. Normally the value of commodities is determined by their usefulness. But art, or rather, what at any given moment we consider to be art, has no immediate use value: it cannot be cooked and eaten or turned into footwear. Yet art always expresses a set of moral impulses. The commodity value of a specific work

of art, its currency as an object of desire, therefore, depends largely on continued support from the dominant cultural ideology for the values underlying the art in question.

A society in search of order and financial stability tries to protect its money from undue loss of value by elaborate sets of government regulations and control mechanisms. Commodified art depends for its growth in value on a combination of increasing scarcity and increasing personal desire. Increasing scarcity, however, is of importance only as long as personal desire continues to increase, or at least remains stable. If the level of personal desire for a particular genre of commodified art were to decrease substantially, not even the art's increasing scarcity could keep its value from plummeting.

If the moral-emotional complex of values in a society undergoes a significant shift, a style of art previously coveted and regarded as "timeless" will lose its function as a major object of desire and hence most of its commodity value. This will happen in a more or less radical fashion, depending on the rigidity of the artwork's intrinsic constitution as a created object expressive of specific moral values. Works with a certain ambiguity of moral content are less likely to be dismissed completely.

Critics, who make it their business to reinterpret works of art or literature, might be described as members of an informal committee of cultural ecology. Our society gives them the task of salvaging acceptable doctrine from the artistic products of past ages for use within our current ideological environment. When the critics abandon a certain work of art as no longer worthy of their attention, this means that it has, for the time being, lost its cultural usefulness as an emblematic object expressive of a widely sanctioned, and hence strongly desired, ideal of selfhood.

Historical evidences of shifts in the socioeconomic function of specific styles in art are legion. For instance, writing in 1908 in *The Forum*, the artist and art critic Arthur Hoeber assailed what he saw as the public's willful ignorance of the qualities of American art. He pointed out that in the 1870s Americans favored "the simpering art of the Duesseldorf school, and paid vast sums for Meyer von Bremen and others of his cult. Later, fashion turned its attention to a mass of insipid French painters who poured forth a stream of inane canvases."[1]

Hoeber, a champion of Tonalism and Impressionism, here refers to such painters as Bouguereau and Gérôme, whose major works commanded as much as $100,000 (or the equivalent of certainly well over a million in today's dollars) among connoisseurs in 1890. Speaking from a vantage point less than twenty years later, he was able to add gleefully that "today it is difficult to dispose of them at any price, there being simply no market for them."[2]

By 1950 major works of Bouguereau could be bought at fleamarkets and antique stores for, at most, a few hundred dollars. Bouguereau was one of the principal villains of the ideology of modernism. Today, in our "post-modern" mood, the maligned Frenchman's canvases fetch up to $300,000 at auction—still a long way from his lofty position on the art market mountaintop of his own day as the Jasper Johns of the 1890s.

During the 1910s and '20s American financiers industriously shopped around for ostentatious signs of family history, in an attempt to give fashionable cachet to themselves. Some actually went so far as to buy the titles of European nobles down on their luck, but many more took a shortcut by purchasing the family portraits that had hung in the patrician houses of England.

Dealers like the Duveen brothers made large fortunes selling these mock-emblems of family lineage. Astonishing price records were set in this field throughout the 1910s and '20s. Full-length portraits by such greats of eighteenth-century British painting as Reynolds, Lawrence, Romney, and Hoppner, sold for phenomenal amounts. In New York, on 29 April 1915, for instance, Reynolds's *Mrs. Otway and Child* sold for $30,000, and Lawrence's *Miss Sotheran* for $31,000, even though both works were part of a group of fifteen paintings that had been in a fire on the steamship *Mississippi* in November 1914 and were being "dumped" unceremoniously at auction by the Duveen brothers. A few days earlier a rather modest Raeburn had brought $11,000, an equally modest Romney had been knocked down for $10,300, and a smallish Hoppner had brought $9,300.

To put these prices into perspective, one might note that a large landscape by William Merritt Chase had sold just a few weeks earlier for $310, and a major Bierstadt, *Sunset on the Lake*, had brought $400, while a Tonalist work by Charles Warren Eaton, then a major favorite

among the art critics, had cost its new owner a respectable $65. Among European painters, a typical *Faun and Bacchante* by Bouguereau, well on his way down in the market, had brought $725, while *By the Sea*, a major work by Monet, well on his way up, had cost the firm of Durand-Ruel $1,800—a good indication of the lofty position the French Impressionists already occupied among collectors.

In 1921 Henry Huntington shelled out $728,000 for Gainsborough's *Blue Boy*, and a few years later he paid close to $450,000 to give the boy an appropriate companion in the form of Lawrence's *Pinkie*. Prices such as these, when properly adjusted for close to seventy years of inflation, compare quite nicely to most of the multimillion dollar deals being struck these days for Impressionist paintings.

With the onset of the depression in 1929, however, demand for British portraits disappeared almost overnight. Indeed, this market collapsed perhaps more precipitously than that for any other luxury commodity. Prices for these portraits, unlike those for most other vanity products, have never since approached their highs of seventy years ago. Even in today's overheated art market, one may obtain a first-rate, full-length, British portrait of the sort so sought after during the early twenties, for between $25,000 and $50,000. After adjustment for inflation, that is perhaps at best one-tenth of the price the same painting might have brought in 1915.

What happened to the market in British portraits was not just the result of the crash. These lavish icons to nobility represented an ideal self-image of gentility and historical identity to newly wealthy Americans of the early years of this century. But during the twenties and thirties cultural values gradually changed toward issues of social responsibility, and there was a revaluation of the moral significance of labor in the growth of American society. As a result of this new concern for the "common man," the stately portraits the newly rich had acquired to give themselves an instant noble ancestry gradually ceased to impress their guests. Finally, looking ridiculously out of place even to their owners, the portraits were moved to basements. When inheritors tried to sell them they found that it was once again "difficult to dispose of them at any price, there being simply no market for them."

II: AMERICAN IMPRESSIONISM AND THE NEW LEISURE CLASS

In this *Forum* article of 1908 Arthur Hoeber still felt compelled to defend "The Ten," even though they were already widely acknowledged as major figures in American art. Rather than concentrate on landscape most of the Ten specialized in painting interiors with figures, sunny "summer girls," and suburban scenes. At the time, such subject matter was still considered rather audacious. Hoeber readily admitted that the annual shows of the Ten in New York were widely commended for their excellence. "A sale, however, even at that exhibition is almost unknown, and the members have to make up the cost of the show out of their own pockets, and it is doubtful if, picture for picture, a better modern exhibition is held anywhere in the world than this of the Ten!"[3]

Hoeber's indignation rings with evidence of a cultural change already well under way among Americans. His is the voice of a well-to-do, upwardly mobile, middle class that was rapidly discovering a new cultural nationalism. This American upper bourgeoisie, made up of executives, powerful lawyers, real-estate moguls, and urban professionals placed a great deal of emphasis on a concerted exploration of the transcendent virtues of affluent leisure. They preferred to enjoy their blessings at home in lavish suburban quiet, rather than abroad in countries that were soon to be annoyingly at war with each other.

The paintings of the Ten spoke with new conviction to this patriotic leisure class, which was gaining a great deal of power, even while the industrial millionaires were still seeking a place among the members of an older, would-be aristocracy, well described in the novels of Edith Wharton and Henry James. This new, upward-moving class of professionals was bright, ambitious, affluent, modern. They saw themselves as in the forefront of a new society—which in gratitude would confer upon them the rewards of their worldly success. The Ten documented their days of leisure, and their paintings became nearly perfect visual records of the Americanization of *dolce far niente*. They responded to the temper of a time in which a wealthy "high bourgeoisie" felt compelled to support at least a public appearance of perpetual play in the luxurious garden

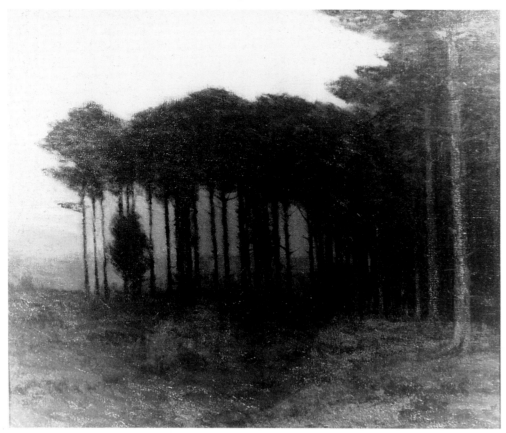

32. Charles Eaton. *The Strip of Pines*. 1908.

Until the ascendancy of the Ten this country's small but actually quite knowledgeable public of art lovers (as distinct from art acquirers) had been enchanted, and quite justly so, by the subtleties of Tonalism, a style that represents the culmination of an older, more religiously based, and more community-oriented social philosophy.

In the best examples of American Tonalism, broadly humanist concerns, related to a pre-industrial spirit of civic cooperation, are harmoniously integrated with intense emotions. Recollected in the contemplative tranquillity of the studio, not *en plein air*, these emotions led the Tonalists to the expression of a deep sense of tragedy. They mourned the loss of a world in which nature, as a majestic sentinel of an almighty, caring God, had cradled the human soul gently against the forces of chaos and darkness. Now, these painters intimated, that protection had gone, and humanity was much the poorer for that loss.

Artists such as Bruce Crane, Dwight Tryon, and William Keith specialized in painting chilly landscapes with muddy roads among bare trees in a waning light under heavy skies. Charles Warren Eaton, in painting after painting, saw the foreground of his world become an ever-darkening field of twilight fears, separated from the golden glow of a setting sun by rows of weathered pines. These trees, insistent on their own uprightness in face of the threat of night, turn their rigid, thin, vertical trunks into the bars of a prison of puritan severity separating the viewer from the warmth of a fading transcendence beyond (plate 32).

Charles Rollo Peters time and again places the viewer in the dead of night, banished from the protection of house, hearth, and family, looking wistfully toward the shadow of a faintly delineated haven, across a cold expanse of dangerous water, or a treacherous, almost indistinguishable path. From the home we long to reach cracks a bit of lamplight, held from us by closed shutters. Their closure suggests that we may not find ourselves entirely welcome, even if we succeed in reaching this dwelling unharmed.

In these paintings, light, as a reassuring promise of meaning in human existence, plays as much of a role as it does in Impressionism. But in

settings provided by country houses and resort hotels.

American-born, European-trained, sophisticated, and of middle-class background themselves, the painters who made up "The Ten Americans" (as Hoeber had been careful to stress) undertook to idealize the joys of living in the verdant gardens and country houses of the upper middle-class. Their stock-in-trade was idealized images of domestic bliss, of women in comfortable interiors caressed by warm light, or out-of-doors on breezy summer days, engulfed by sun and dressed in white, or in soft pastel colors, and almost always carrying parasols.

Landscapes without figures had to be suffused with the same transcendent light so that, even when brought indoors, these works might continue to remind their owners that they were in possession of a well-ordered world of conspicuous leisure. The future was bright: sunlight was the birthright of the upper bourgeoisie.

Tonalism, light is a symbol of the waning truth of religion, whereas in Impressionism light represents a fiction of bourgeois control. Tonalism is a very "American" counterpart to the psychological ambiguities of the European Symbolist painters. Where Impressionism casts us confidently into a world organized by human ambition, Tonalism speaks of fear and uncertainty more than of human control over the world at large.

Joseph Boston's *After the Rain* of about 1900 (plate 33) strikingly represents the essence of this American Tonalist sensibility. Painted almost entirely in shades of blue, it evokes the lonely figure of a woman trudging wearily home from market in the damp, fog-enshrouded half-light of an early winter evening. The moon struggles to break through a mass of ponderously dissipating clouds. Its icy light reflects in the fresh puddles of the muddy road, marking the many pitfalls that bring danger to a soul poised on the edge of a nature turned gloomy and brutish. The trees of the forest seem to lean toward the silent woman, and, molded into monstrous shapes by the hovering dark, they appear poised to assault this lonely figure with vile murmurings about the death of human faith. No wonder that she shuffles eagerly toward the few sparks of light that mark the houses of her village.

Paintings like this one that successfully integrate emotion and philosophy, style and inner fire, represent a sensibility closely analogous to that which echoes through "Dover Beach," Matthew Arnold's famous elegy to a world of humane interaction, with its fearful imagery of the onset of a new predatory world of industrial egotism:

The Sea of Faith
Was once, too, at the full, and round earth's
 shore
Lay like the folds of a bright girdle furled.
But now I only hear
Its melancholy, long, withdrawing roar,
Retreating, to the breath
Of the night wind, down the vast edges drear
And naked shingles of the world.

Ah, love, let us be true
To one another! for the world, which seems
So various, so beautiful, so new,
Hath really neither joy, nor love, nor light,
Nor certitude, nor peace, nor help for pain;
And we are here as on a darkling plain

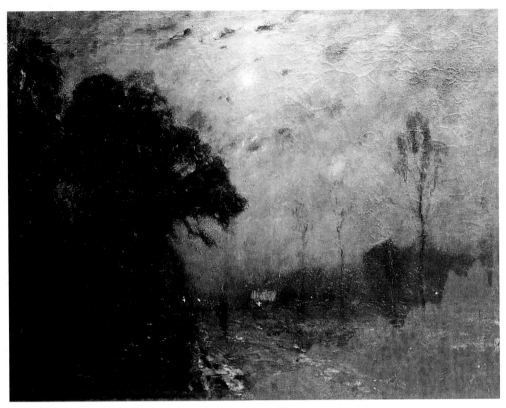

33. Joseph Boston. *After the Rain.* c. 1900.

Swept with confused alarms of struggle and
 fight,
Where ignorant armies clash by night.

In contrast, the modernist world was an arena of brash predatory ambition. Impressionism was one of its first full-fledged visual expressions. With its light-suffused, boldly distintegrating surfaces and its pastel women languorously anchored in the earth, it may seem far removed from the sense of loss that echoes through these documents of a dying, community-oriented humanism. But the harsh new world of Social Darwinism and imperialist expansion, with its "every man for himself" belligerence, was also built on a foundation of doubt and ambiguity.

Consequently, the humanist sensibility of Tonalism finds its most poignant expression in the work of those painters who effectively managed to integrate lessons learned from Impressionism with a more conservative worldview.

And in a similar conjunction of conflicting worldviews, the most unsettlingly successful works of Impressionism are those in which the glistening daylight of middle-class ambition was undermined by a lingering religious-humanist conservatism that succeeded in darkening a world of sunshine with "Tonalist" doubt: elements of a creative tension such as we find perhaps most frequently in the earlier works of Monet, or, among Californians, in such a relatively late convert to Impressionism as Granville Redmond.

IV: IMPRESSIONISM AND SOCIAL DARWINISM

Doubts about the harsh ambitions of the modern world found a progressively less sympathetic response among the self-important captains of the new industrial armies of production and commercial expansion. They wished to see themselves as in control of a material environment that basked gratefully in the light of their success. And they wanted to enjoy the same virtually absolute power at home as they felt they had the right to exert over their workers.

Hugely popular social interpretations of evolutionary theory had decreed that the Euro-American male was the most evolved specimen of intelligence to be found in the known universe and that woman was, at her best, the ornamental jewel in his crown. Her elegant, leisurely presence in his world was meant to demonstrate the advanced level of mastery he exerted over his domestic environment.

The publication of Darwin's *On the Origin of Species* in 1859 provided European and American males of the period with a justification for putting themselves at the apex of creative evolution. Darwin developed the theory of "natural selection" to explain the existence of what he saw as evolutionary inequality among various groups of living beings. This theme can even be found in the second part of the title of his book, which, for obvious reasons, is rarely cited anymore, even in reprints of the work itself: *Or the Preservation of Favored Races in the Struggle for Life*.

Simplified popularizations of Darwin's theories disseminated the notion that qualitative evolution took place whenever one of the powerful selected a proper mate. In the *Atlantic Monthly* of October 1866, Charles J. Sprague

published an article characteristic of this flood of popularizations, which for decades to come would find its way into the "upscale" periodicals of Europe and the United States. He was careful to emphasize the importance of the concept of natural *selection* to the development of a progressive inequality among humans: "Darwin endeavors to explain, in detail, how this differentiation takes place. The largest or strongest get the best food or the most attractive females, and then transmit their strength or their peculiarities to their progeny."[4]

A man choosing to display worldly power could therefore claim a place in the forefront of the evolutionary development of the "favored races" and demonstrate his right to that position of leadership by showing that he was capable of, among other things, "capturing" and maintaining (at least) one of "the most attractive females."

During the 1880s and '90s suggestions of this sort readily combined with the politically based Social Darwinism of such figures as Herbert Spencer (who was treated as a media star during his 1882 visit to the United States) and William Graham Sumner to create an atmosphere in which ideas related to the concept of "natural selection" invaded every aspect of daily life. By the turn of the century, evolutionary ambitions had come to rule the attitudes of the upper strata of European and American society.

Eugenicist theories became the order of the day. Evolutionary fitness was equated with "ideal proportion" and muscular power in males, while in women blonde hair, pale skin, and a conspicuous absence of muscle and bone was thought to be proof of advanced species development. The painters of the period, as well as those who commissioned their work, would have considered themselves extremely out of touch with "the truth of nature" if they had not demanded that evidences of evolutionary theory be manifest in the products of high art. The languorous, often blonde, "summer girls" of the Impressionists were, clearly, true specimens of evolved femininity—ideal companions to the "fittest" males.

Spencer and Sumner responded to the aggressive economic temper of their time by developing from the Darwinist rhetoric of "the fittest" a full justification of predatory individualism as a necessary factor of natural selection. This law required, to quote Sprague once more, that order must evolve "out of disorder, heterogeneous beauty out of homogeneous crudity, progressive

individuality of being and thought out of chaotic vapor."[5]

Spencer insisted that social evolution required an ever-expanding heterogeneity of forms in human society. This would lead to an ever-increasing inequality of intellectual capacity and, correspondingly, of economic privilege, social position, and civil rights, between those who were most evolved and those who had lingered on a lower level of development. He argued that an increasing disparity in the standard of living among the different classes within a country was a sure sign of its position in the forefront of evolutionary development among nations.

The upper bourgeoisie had little difficulty in recognizing themselves as the fittest—as the evolutionary elite of humanity. They adored and supported all manifestations of that progressive social heterogeneity that was supposed to signal their ascendancy, and they were, of course, especially careful to cultivate the principles of self-interest in the cause of natural selection. In the arts the cult of originality, the most sacred tenet of modernism, came to be seen as the clearest manifestation of this evolutionary ideology.

Where, in the past, artists had sought to perfect their craft by trying to emulate the classic masters of painting, to operate according to a concept of artistic homogeneity, one might say, it now became incumbent upon the progressively thinking artist to demonstrate that he was among the evolutionary elect by flaunting his particular brand of heterogeneous individualism: his originality as an artist.

Today it is customary to regard Impressionism as the first important manifestation of the modernist aesthetic. It is also the first art movement that clearly defined its task to be the depiction of reality as perceived by the individualized eye untrammelled by preconceptions and conventions of representation. Thus the Impressionist eye is the eye of the ego: the self as transcendent entity, as fittest observer, as rugged individualist. The visual space of Impressionism, moreover, defines itself as the realm of an ever-expanding, multifaceted heterogeneity, which breaks apart the "homogeneous crudity" of conventional ways of seeing. Impressionism, in other words, is, whether or not its originators consciously intended it to be such, an accurate transliteration of the ideology of evolutionary idealism into the realm of visual expression.

The much-emphasized, and much-admired, preoccupation of the Impressionists with depicting the multifarious manifestations of sunlight is the visual transliteration of a favorite metaphoric device of evolutionary idealism, which glorified the transcendent, ever-higher yearning intellect of the evolutionary elite as the realm of light, whereas darkness was the lair of the evil emissaries of degeneration.

A material world bathed in light was a world illuminated by the enlightening eye of the ego. It was a world controlled by the self and hence by the evolutionary motives of material self-interest. At least in metaphoric terms, it was a world owned by the observer, who, in the warm light of possession, found intimate reassurance for his position "on the very summit of the organic scale" in contemplating a world of civilized order. The Impressionist painter set out to remake the world in his own image—creating an individualized visual order out of primitive disorder, out of dark, "chaotic vapor," thus serving the cause of evolutionary progress.

The dualist imagination of the late nineteenth century discovered in the concept of natural selection an unceasing source of binary oppositions. The light of science battled the darkness of ignorance, the fittest warred against the forces of degeneration, the ordered, sun-drenched universe of heterogeneous bourgeois materialism must overcome the chaotic night of primitive nature. To the late-nineteenth-century captains of industry, as much as to this period's determinedly antibourgeois bourgeois intellectuals, that meant that the spiritual soul of man must also conquer and subdue the material essence of woman.

V: PARASOLS AND EVOLUTION

Darwinist doctrine succeeded in creating order out of disorder in the "war between the sexes" that seemed to the nineteenth-century male to be heating up. Some women were beginning to object to their roles as upper servants in the bourgeois household. By providing a scientific justification for the necessary evolutionary inferiority of women, Darwinism tried to drive these evil women back into domesticity.

Evolution, the argument went, manifested itself most strikingly in the growth of the human brain. The larger the brain, the more evolved the person who happened to be its proud possessor.

34. Claude Monet. *In the Field* (detail). 1876.

Evolution had also proved that it was the natural tendency of an organism to adapt itself in the most efficient manner possible to its proper function in the struggle for life. When in the course of evolution humanity had evolved from a bisexual, primitive, undifferentiated organism into separate male and female entities, a fateful separation of basic functions had taken place. The male had been given the task of creation, the female that of reproduction. Creation was an individual act, reproduction a mere physical mechanism.

If the evolutionary task of the male was the cultivation of the mind, the realm of woman was the fertilization of her body. She had been destined by fate to be no more than an extension of the arable soil of nature. Hence all women were Woman, a basically undifferentiated, essentially homogeneous mass of primitive reproductive matter that did not partake of the higher forms of evolutionary progress.

The Eurocentric, racist arrogance characteristic of virtually all late-nineteenth-century intellectuals had made them conclude that there was a "vast difference between the highest and the lowest species of the genus homo," to quote Sprague once again. Indeed, he added, "the Negro, the Malay, the Mongolian, are almost precisely what they were five thousand years ago. The Bushman, the Hottentot, the Patagonian, and the Digger Indian are today not much above the animals about them." The Euro-American white male, on the other hand, had proved himself to be at the center of the evolutionary impulse: "The Caucasian has gone on in a wonderful advancement, leaving the other races in the same state of development in which they were when the Caucasian was no farther advanced than they."[6]

This evolutionary stasis that was supposed to be so readily observable in the "inferior races" was the result of a form of constitutional "effeminacy." An inferior brain structure and a weakness for the pursuit of primitive erotic pleasures had kept the sensual male within the earthbound realm of static, undifferentiated femininity. In their most primitive forms as separate entities in nature, the human male and female had been virtually indistinguishable—which was not surprising, given their evolution from bisexual organisms.

Humanity's first evolutionary task had been to separate into truly male and female entities. The intellect was the realm of the male, the ani-

mal passions belonged to woman. If some men, even after thousands of years of evolutionary progress, seemed almost as primitive as the grossly sensual women with whom they consorted, there was even for this a clear explanation in the great scheme of natural selection.

It was a sacred evolutionary duty for the fittest, and hence most truly masculine men, to select as their mates the most "feminine" women. Evolution demanded from each creature, after all, the most perfect adaptation to function. It was man's evolutionary task to become as creative and productive as possible, to reach a state of pure, almost disembodied intelligence. Within this dualist equation it was woman's evolutionary responsibility to become as passive, as languidly and brainlessly reproductive as possible without actually melting back into the earth from which she had come.

In her perfectly passive state the truly feminine female never tempted the male but was content to be his silent companion. The many men who consorted with lewd temptresses thereby demonstrated their own incapacity to be among the evolutionary elect. What tempted them in women was the remnant of primitive, bestial femininity within themselves, causing them to yearn for that degenerate "fusion with the other," that dissolution of evolutionary differentiation into primitive homogeneity that was the mark of the female.

In contrast, women who deliberately set out to tempt the male were responding to the primordial remnants of aggressive masculinity within themselves. In essence, they refused to yield themselves to their evolutionary destiny by continuing to cultivate these bestial signs of primitive masculine individuation. The more aggressively they flaunted their sexuality in front of men, the more degenerate and primitive they showed themselves to be. The more easily a man gave in to their bestial temptations, the more effeminate, and hence degenerate, he showed himself to be.

Once we become aware of the prevalence of attitudes like these among the turn-of-the-century power elite and we remind ourselves that these ideas had assumed that aura of incontrovertible truth we like to give to our most cherished cultural platitudes, it should also become more readily apparent why certain clusters of iconographic detail—such as parasols and flowers, for instance—seem to recur in virtually every

Impressionist portrayal of women.

Take, for instance, that most expensive of all Impressionist paintings, Monet's *In the Field* of 1876 (plate 34). To most of us, this work might seem to be simply a pretty, well-composed image of a young woman comfortably ensconced in a field of flowers on a sunny summer afternoon. There would be ample justification to regard it as a true example of "art for art's sake." It is so harmlessly pleasant an image that we might even consider it rather dull, were it not for the skillful manner in which Monet makes the grass surge up around the young woman, until it becomes an almost tangible material presence to the viewer.

In discussing the painting, one might learnedly, and justifiably, discourse about the masterly brushstrokes, the subtleties of color, the abstract play of white against green. The late-twentieth-century art connoisseur is used to the discourse of abstraction. We tend to dismiss content as a rather vulgar, secondary concern, if we insist on it as a concern at all. Within the context of modernism, a painting is first of all a surface with paint on it, a planar composition whose textures, colors, and line are its sole, and sufficient, reason for being.

A century ago, when the concept of "art for art's sake" was still new, critics could be forgiven for believing such an idea to be an aesthetic revelation. Still, even those who championed the new way of seeing, having been trained to read any painting for its content first, would have taken notice of every painting's message, of its moral or philosophical implications. Even those artists and writers of the time most adamant in the pursuit of "pure art" easily succumbed to the temptation to embed symbolic meaning in their work.

The notion that the "content" of art is irrelevant to its function became a cultural commonplace only after World War II. Until well into our century most people expected to "read" paintings for their subject matter first. That, to the true modernist, so "naive" endeavor is what made—and still makes—many "unsophisticated" viewers object to the absence of "meaning" in abstract art.

During most of the nineteenth century, every work of art was expected to convey a message. Paintings that effectively expressed cultural commonplaces in a manner most could easily understand were deemed successful. Those whose message went against the grain were generally dismissed as failures. Every picture had a moral. An offensive picture had an offensive moral. Abstraction was deemed offensive precisely because its moral was that art had no moral.

In 1876, when Monet painted *In the Field*, many viewers would still have deemed the work offensive for flaunting the conventions of traditional representation in painting. That is not at all surprising, for Monet's work expressed the values of the new, rational, "scientific" intelligentsia, which, at this time, had not yet gained the cultural prominence it achieved by 1900. At the start of the new century, everybody who was anybody loved Monet and could be expected to discourse on the virtues of evolutionary theory. *In the Field* is evolutionary theory made tangible in an image.

In retrospect, this is apparent even in Monet's stylistic innovations. The academic painters were still in search of textural homogeneity (Bouguereau's "waxy," smooth, homogeneous surfaces, for instance, were to be a major source of disgust among modernists). In contrast, Monet's brushstrokes are emphatically "individualized": each is recognizably separate. Color, too, is more primary in Monet's work. Instead of "blending" colors in the fashion of the Old Masters, the Impressionist arranges primary colors side by side in a "heterogeneous" welter, to emphasize the infinite variegation of hues in the material world.

Sunlight, the light of order and control, symbolic of intellectual transcendence and progress, and hence of the Euro-American white male's evolutionary potential, suffuses Monet's tranquil scene of civilized leisure, and its presence clearly identifies the woman in his picture as a fully domesticated creature, properly guided by the cultural values of evolutionary ideology.

Plants were the most passive organisms in nature—true creatures of the earth, rooted in their origins. Flowers were the most beautifully evolved, most delicate products of the world of plants. Women, too, were quite properly creatures of the earth, fertile soil. Hence the truly evolved woman of the late nineteenth century was a flower among flowers—she blended with the world of plants to such an extent that it was hard to distinguish her from her flowery environment. Monet's lady of leisure wears a fluffy hat that seems like a flower itself, a larger version of the flowers that surround this woman in white, who, in consequence, blends in so perfectly with

35. Guy Rose. *The Moth.* c. 1892.

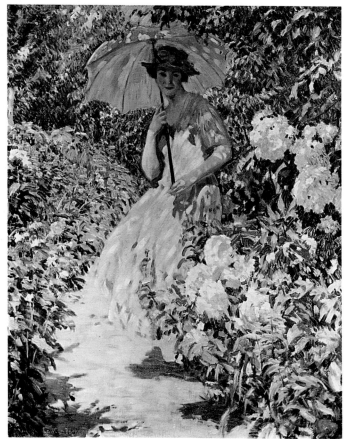

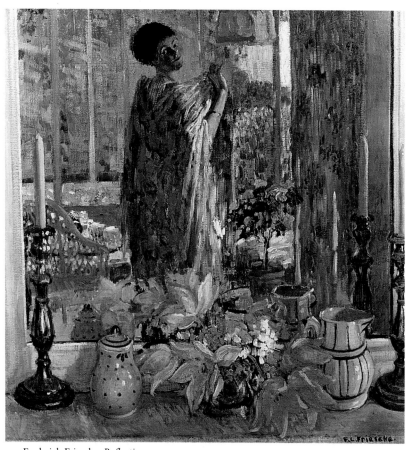

36. Lawton Parker. *Spring Blossoms.*

37. Frederick Frieseke. *Reflections.*

her environment that she seems to be growing out of the earth herself.

The fluffy flounces of her clothing, like her hat, become the petals to which her body is the stem. Over the entire scene, the bright light of the masculine sun spreads its benign, civilizing order. Peacefully reading a book (of instruction, one might assume), the woman warms herself in the sun, but she does not try to usurp any of the masculine creative functions. She knows her place: the light of the sun can be dangerous to the weak. She takes care not to attempt to gather in too much of the sun's energy: her rosy cheeks emphasize the whiteness of her skin. Only men can bask fully in the light of the sun.

To indicate her knowledge of all that, she keeps her parasol within easy reach: the parasol protects the whiteness of her skin, and the whiteness of her skin is the emblem of her fully evolved being as a reproductive machine in service to man's glorious intellectual future. This woman's

parasol, then, is the ultimate symbol of her full submission to her passive function in the world of evolution. It proclaims the modesty of her wishes in the sun-drenched world of creative masculinity. It announces her desire to exist only as a satellite to the masculine will.

The domestic world depicted by the paintings of the Impressionists fit beautifully into turn-of-the-century concepts concerning the proper roles of males and females in the evolutionary process. No wonder that the period's men of means soon came to regard it as a pleasant sign of their wives' compliance with the ideology of passive feminine domesticity if they let themselves be painted in nature, surrounded by flowers, modestly toting a parasol in the light of the masculine sun.

Since all women were "Woman," however, paintings of this sort did not have to be recognizable portraits of their wives. Indeed, the Impressionists were notably averse to portraiture

and instead concentrated on the depiction of generalized women in generalized settings. It therefore soon became quite acceptable to buy such a generalized picture of a "summer girl" and hang it in one's suburban home. Displayed in such a fashion the image became an appropriate iconographic sign of a wife's proper awareness of, and compliance with, the cultural ideology of the domesticated woman of leisure. Soon these paintings became effective passive indicators of one's membership in the elite vanguard of the evolutionary elect.

"The Ten Americans" came to be among the most enthusiastic purveyors of generalized portraits of the woman of leisure. Frank Benson became the illuminist of the woman in white in the bright light of organized summer fun. William Merritt Chase's women and children romped and picnicked in peaceful harmony with the natural world around them. Edmund Tarbell's wives stayed at home in well-appointed rooms bathed selectively by the light of the sun, and Robert Reid's outdoor girls grew like huge flowers from the soil of the gardens into which he had placed them. Childe Hassam's ladies of leisure took to staring morosely at flowers or tea services, symbolizing their existential status, and they did so with equal passivity in- or out-of-doors.

It is unnecessary to try to attribute a conscious ideological motive to every aspect of the work of these painters. Clearly they were not trying to make a precisely articulated statement about the separate functions of male and female in the evolutionary order of things every time they painted. But there is also no question that their work reinforced this dominant ideological platitude of their time. What would have been a self-explanatory element of narrative content to their contempories has, however, lost its specificity of statement for us. That is why it is important for us to rearticulate the messages embedded in the Impressionist portrayal of women.

VI: The Moth and the Mirror

Among California Impressionists the majestic primal force of nature was, in general, a more urgent theme than the proper domestication of woman. The still largely inviolate natural harmony of the California countryside spoke directly to the pantheistic mysticism of these painters. This does not necessarily mean that they stood significantly beyond the dominant gender

ideology of their time, but it does mean that their work often concerned itself with the celebration of values not immediately germane to that issue.

Still, the more "urbane" these painters' artistic education had been, the more they tended to echo the dominant gender ideology of their time. Guy Rose, for instance, consistently echoes the gender ideology of his European teachers and of his American colleagues of the second generation of Giverny painters, Frederick Frieseke, Richard Miller, and Lawton Parker.

Rose, as a matter of fact, contributed a blatantly "symbolic" painting about feminine foolishness to the Paris Salon of 1894.[7] Titled *The Moth* (plate 35), it shows a nude young woman with actual moth-wings, sprawled on the floor of a garret. Ebbing light, falling through the window, illumines the desperation in her pose. This woman, we are clearly meant to understand, is paying the price for her ambition. Like a moth, she flitted too close to the fire of masculine power and was burned. Rose depicted her as she lay, scorched by her sins, helplessly waiting for the inevitable end.

Rose liked this painting so well that he showed it again in 1896–97, at the 66th Annual Exhibition of American Art at the Pennsylvania Academy. Clearly, like his friends Frieseke, Miller, and Parker, he concurred with much of the casual, disdainful rhetoric concerning the constitutional debility and intellectual inferiority of women that swept through Europe and the United States during the 1890s. Women were flowers, they were brainless, decorative creatures—ideal subjects for a colorful, decorative art that was meant to be enjoyed "for its own sake."

A painting such as Rose's *Blue Kimono*, for instance, seems harmless enough, and it is certain to make us wish for lush gardens and summer afternoons (see plate 92). But the woman in the image, in her flowered gown, is a flower herself, wistful and evanescent, doomed to wilt all too soon: she already needs to steady herself by leaning against the branch of a tree, a bit as if she were a parasitic plant.

Similarly, in Lawton Parker's *Day Dreams* (or *Al Fresco Tea*; see plate 93) the two young women drinking tea are like flowers rising from the soil, no different from the foliage around them, while in his *Spring Blossoms* (plate 36) there is no longer any need to separate woman from the petals that surround her: woman is the

38. Childe Hassam. *Tanagra (The Builders, New York).* 1918.

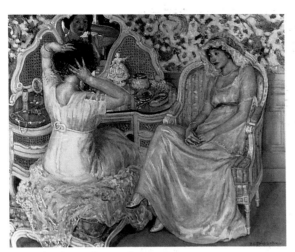

39. Frederick Frieseke. *Youth (La Toilette)*. c. 1912.

flower, her clothes are the petals, and her parasol is her crown.

Frederick Frieseke's *Reflections* (or *The Birdcage*; plate 37) brings the woman of leisure inside. In addition to being a flower, much like the flowers in the foreground of this painting, she is now also seen in her "civilized" habitat. Here, we are to assume, she lives as happily and as pleasantly as a parakeet in a birdcage: too "evolved" to be out on her own in nature, and hence too dependent and fragile to live her own life, she has found her proper realm in civilization, the sunlit veranda of a suburban home.

Paintings that juxtaposed women with domestic analogues to their existential fate were legion at the turn of the century. Given titles such as *The Goldfish Bowl*, *A Pot of Flowers*, *The Parakeets*, and so on, they would, like Frieseke's *Reflections*, draw sententious parallels between the passive, decorative, and captively domestic lives of these women and such other items in the inventory of a successful businessman's possessions as they were always shown contemplating in these paintings.

As Childe Hassam was pleased to demonstrate, even the classic terracotta figurines of standing women recovered from graves found near the Boeotian city of Tanagra, which had become elegant collectors' items at the time, took on a distinct ideological significance. Made from clay, the earth's primal matter, these figures were seen by turn-of-the-century connoisseurs as a symbol of woman as the passive breeding ground for evolutionary manhood. Since these little sculptures almost always stood upright in a rather phallic, columnar rectitude, they were also seen as priapic emblems of fertility.

To fin-de-siècle intellectuals these iconographic details were perfectly self-evident, and artists loved to show off their worldly knowledge by portraying contemporary women who carried such "Tanagras." Hassam, for instance, gave an oversized canvas of a woman holding up such a statue the title *Tanagra* (plate 38), clearly wishing to convey the intimate parallel he saw between the very generalized woman he had portrayed and the object she was contemplating.

Placed in an elegantly decorated interior, near a window with a view that reveals the scene's contemporary urban setting, the woman is surrounded by symbols of her eternal, unchanging, feminine destiny: a round table, signifying her circular, passive identity; fragile flowers in a circular floating bowl on the circular table, signifying the passive delicacy of the acculturated woman; a decorative screen behind her, continuing the theme of flowery fertility. The screen also emphasizes the domestic limits of the woman's realm. The flower bulbs in the windowsill provide the viewer with further suggestions of fertility. Then there is, of course, the woman herself, seen holding up the Tanagra figurine, the emblem of her destiny, while she looks at it in bland, expressionless resignation, thereby signifying her compliance with her existential fate.

Frieseke's *Reflections* contains, as we have seen, a similar overload of ideological directives concerning proper feminine self-conception. But in addition, this woman's "birdcage" is given a double meaning to complicate further the painting's message concerning the eternal essence of the feminine.

Paintings of women looking in mirrors were a staple of the turn-of-the-century art world. To us they may seem to be merely lush images of a quiet, well-ordered, elegant world of feminine leisure—something to idealize, to grow nostalgic over. But around 1900, these images were an integral part of the antifeminine campaign of the evolutionists.

In Frieseke's work we see both woman and birdcage only as they are reflected in a mirror. Hence we do not actually see the woman, we only see her reflection: we see her as she sees herself, the painter implies. At first that may seem to be a rather harmless suggestion. But, in fact, it is a suggestion rife with portentous implications. The painter has deftly framed the woman within a frame, and we do not see what we think we see.

The woman we see does not exist as a separate entity: she is a clever optical illusion, captured by the mirror in which we see her; the mirror itself is her "birdcage," the proper realm of her "domestication." She is, the implication is, a generic representative of the "unchanging, eternal, homogeneous feminine." Thus Frieseke's woman, while she is indeed "pretty as a picture," is actually a harshly ideological expression of the fin-de-siècle's most cherished platitudes concerning the feminine.

As earth, earth mother, vulval round; as the moon, lit only by the reflected light of the masculine sun, woman was a mere echo in the world of creativity, subject but not source: a reflection of the men around her. She was the arable soil of the material world, a chameleon taking on the

colors of her surroundings. She existed in and for what she mirrored, and in a civilized environment she mirrored the ordered prosperity of man. As Otto Weininger, a young Viennese student of Freud, wrote in his book *Sex and Character*, widely thought to be the last word on the subject when it was published in 1903: "Women are matter which can assume any shape." This was, he argued, because "mankind occurs as male or female, as something or as nothing. Woman has no share in ontological reality . . . she is non-logical. But all existence is moral and logical existence. So woman has no existence."[8]

Thus a woman's life had meaning only if she lived in the eyes of men. Knowing this, she tried to observe herself, whenever she could, through the eyes of the men around her. But, paradoxically, the moment she observed herself, she became aware of her existential insignificance. The boudoir, where she shaped her reflected existence was the realm of mirrors, of self-reflection. But a woman, seeing herself reflected in a mirror saw not a being, but nothingness.

Hence the puzzled listlessness, the tentative quality, the wistfulness, of so many of the mirror-gazing women in turn-of-the-century art. Frieseke's *Youth* (or *La Toilette*; plate 39) is a characteristic example of the genre, as is Richard Miller's *White Shawl* (plate 40). Indeed, Frieseke and Miller rarely painted a woman without giving her at least a hand-held mirror for the contemplation of the passive inanity of her being.

Guy Rose also demonstrated that he was perfectly aware of the philosophical implications of the mirror theme when he painted *Marion* (plate 41). The hand-held mirror so many painted women carried about wherever they went, was indeed emblematic of a multitude of symbolic reflections of their condition as women: circular, this mirror was a contained reflection of every-woman as chaos, the primal snake, the uroboros, biting its own tail. Looking into it a woman saw herself reflected as Woman, as the undifferentiated, homogeneous earth, as fertile clay to be shaped only by man's creative capacities. Thus she was a mere reflection, moonlight, an echo. Man was the light by which she could see herself: without the light of man, without the bright color schemes of the Impressionist painter, she could only see darkness, nothingness.

Rose, in *Marion*, even more than Frieseke in *Reflections*, plays an elaborate game of reflections: the woman gazes into her mirror and sees

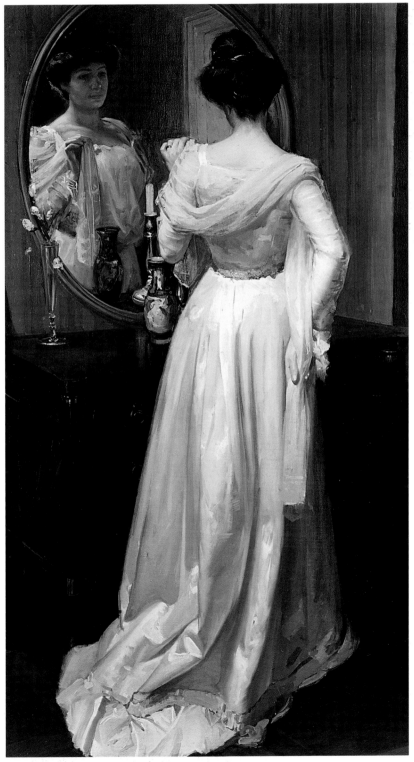

40. Richard Miller. *The White Shawl*. 1904.

41. Guy Rose. *Marion.*

her reflection. But she also sees her reflection in the oval mirror behind her, and we see her in that mirror, just as we see her seeing herself in that mirror and in the hand-held mirror we see reflected in the mirror that reflects her. One could go on, but Rose has made his point: this woman is Woman, encircled by mirrors, and she exists only in the reflections that surround her. She is the creation of man, in this case the creation of the painter who has caught and imprisoned her: she is the mirror in the painter's eye.

Alson Clark's *The Necklaces* (see plate 116) and *The Green Parasol* (see plate 121) are slightly more subtle versions of the same theme. The mirror in these paintings is a less specific comment on feminine nature than it is in the work of Rose. Here it serves as little more than an emblem of the homogeneous, self-duplicating realm of the feminine in general. As such these paintings do little more, in ideological terms, than reflect the cultural platitude of the period that mirrors "frame" the world of women.

VII: Water and Sun

There are very few turn-of-the-century images of men with mirrors. Only "feminine" men would find pleasure in such a derogatory association. Even such foppish men were more likely to be portrayed as Narcissus, looking at his reflection in the mirroring waters of a mountain pool. Water was the ultimate substance of symbolic femininity. An integral part of nature, it was capable of being poured into any mold: it could take any form. It also was a natural mirror, and, shimmering in the light of the sun, its essentially formless homogeneity emphasized the multifarious heterogeneity of the sun's rays.

No wonder, then, that those painters who were most closely attuned to the gender ideology of their time loved to show woman surrounded by mirrors of water, while she was illumined by the light of the sun—herself a mirror suspended in the mirror of nature, a speck of nothingness floating upon the homogeneity of primal being.

The possibilities for knowledgeable allusions to the tenets of evolutionary idealism were virtually inexhaustible within the context of this theme. For instance, in *On the River* of 1909 (plate 42), Rose once again used the structure of his composition to announce the philosophic content of his image. Woman, the flower, whose

flowery hat makes her head into a flower itself, here floats on the mirror of water emblematic of her universal nature, as it reflects the light of the sun shimmering around her. Sitting in an oval boat whose curve suggests the outline of a mirror, she might be no more than a reflection emerging from this mirror—a visual echo afloat on the water mirror of the eternal feminine.

Lawton Parker creates the same effect in his *Orange Parasol* (plate 43), and Frieseke, in his *Lady with Parasol* (plate 44), turns the entire surface of his canvas into a shimmering water mirror on which his lady floats in dire need of shading from an all-too-powerful sun. In this work American Impressionism achieved a true apotheosis of the theme of woman as flower: a decorative object, blandly floating on the surface of undifferentiated primal nature, a mere blossom dropped into a goldfish bowl.

With paintings such as these, we also find ourselves back in the realm of the parasol—clearly an item of standard issue to women of the early twentieth-century leisure class, and, indeed, one of the main defensive weapons wielded by these courageous members of man's auxiliary corps, bravely engaged in daily battle against the degenerative impulses within themselves.

VIII: A Prisonhouse of Color and Light

The sun was the symbol of each man's unique creative intellect, and water the sign of universal femininity. No wonder, then, that a well-tended, luxuriously blossoming flower garden, properly irrigated by the nutritive moisture of mother nature's essence and warmed by the sun's engendering rays, was—next to the water mirror—likely to be the chosen realm of the passive, domesticated, fertile, reproductive, universal female. But the sun can be too hot, too powerful, too strong, and a flower is fragile: it is modest in its demands for warmth, it cannot survive in the full light of the sun—it needs shade.

The turn-of-the-century woman's parasol thus became the ultimate sign of her domestication, of her willing compliance with the tenets of the ideology of evolutionary gender-separation. This process of domestication required her, in the words of August Strindberg, the famous Swedish novelist, playwright, and painter, to accept the progressive deterioration of her brain, in the ser-

vice of her reproductive function. Where the male's energies were focused on intellectual creation, woman's role as nature's reproductive machine made it imperative that she refrain from feeding her brain in order to feed her loins. This ongoing process of debilitation, Strindberg insisted, made it "appropriate to designate the normal physical and mental condition of the grown woman to be that of a 'sick child'."[9]

On the symbolic level, then, a woman's parasol was also her shield against over-exposure to the intellectual light of man, a light that, though it filled her with purpose, might also lead to her overexposure to matters of the brain of no concern to her, that could actually interfere with her evolutionary function as a gentle, properly passive incubator of the future generations of man. A woman's devoted use of a parasol therefore showed her to be compliant and passive. It was the ideal emblem of her femininity, since by using it to shield herself, she demonstrated to those around her that she had no wish to usurp those prerogatives of the intellect that evolution had reserved for men.

Once again, Frederick Frieseke brought his suave, would-be-European, ideological sophistication to bear on the subject. In his *Garden Parasol* (see plate 29), he brought together most of the usual themes of the lady of leisure, adding to them the motif of the parasol, here made to seem like a giant flower through which the light of the sun casts a properly diffused light over womanhood. The face of the woman who sits under this parasol is lit to a reddish glow, emblematic of the almost overly powerful warmth of the sun, but if any viewer were to be troubled over the dangerous effect this red light, even in its diffused condition, might have on this woman by firing her intellectual energies, Frieseke is quick to reassure him by emphasizing the dead embers that serve this woman for eyes. Clearly there is nothing "masculine," nothing active, to worry about in this woman's being.

When Alson Clark painted his *Reverie* (see plate 136), he probably did not have in mind any of the fashionable philosophical considerations that remain so close to the surface in virtually all of Frieseke's work. It is likely that Clark simply decided one day, when he saw his wife dozing comfortably out in the warm afternoon sun in the shade of her parasol, that the incident would make a lovely painting. But whether or not Clark consciously intended to paint a symbolic picture

in which his wife became the personification of Woman is not very important. The impulse that made him choose to depict his wife in this pose of passive indolence was a cultural impulse, in which the dominant aesthetic motives of his time (themselves heavily influenced by evolutionary idealism) and a set of common platitudes on the nature of the feminine joined forces to produce a perfect expression of the ideology of passive, reproductive femininity, of a creature "whose normal physical and mental condition" seemed to be indeed little more than that of a "sick child."

IX: The Parasol of Ideology and the Darkling Plain of Thought

Most of us, no matter in which historical period we live, respond to the ideological impulses of our time in the manner Alson Clark did when he came to paint *Reverie*. We don't scrutinize the motives that make us prefer certain images over others; we are usually content to assume that our aesthetic choices are based on sound judgment and common sense. But behind every choice lies a motive, a preference, an idea. When we choose to privilege certain images—certain themes—over others, we, in fact, privilege specific cultural values. All aesthetic choices are moral choices. To fail to recognize this is to choose to be carried along passively by ideological impulses whose precise significance we may not even understand.

The apotheosis of the white flower-woman with her parasol in today's art market thus becomes a disturbing sign of a retrenchment of attitudes concerning gender relationships among the members of our worldwide "power elite." After a decade in which many of the genuine advances made by women in the workplace have been accompanied by an "anti-feminist" rhetoric requiring women workers and executives to be successful and to be "proper housewives" as well, a nostalgia for "those wonderful days of leisure, when women were just content to be women," has made us hunt for reminders of those days to hang on our walls, much as our grandparents sought to buy up instant ancestors.

The art market is a complex mechanism, and expectations about an artist's historical solvency and consequent "investment potential" unfortunately are of far greater concern to most collectors than matters related to quality and moral content. Many of the same investors in the

42. Guy Rose. *On the River.* 1909.

43. Lawton Parker. *The Orange Parasol.*

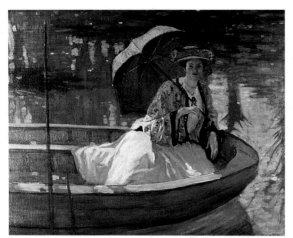

44. Frederick Frieseke. *Lady with Parasol (Green Umbrella)*. c. 1909.

art market who now vie for flouncy ladies with parasols might, indeed, be counted on to vie for portraits of Mary Wollstonecraft or Victoria Woodhull, if they thought these would, in the long run, bring them a good return on their money.

Unfortunately these investors do not need to buy portraits of early feminists, because these portraits have not been culturally validated in the same way the masculine ego, personified in such images as Picasso's early self-portrait, appropriately titled *I, Picasso*, has been validated. They are happy to "buy Picasso," to buy the myth of the great, individual, masculine genius, even though it costs them, at almost forty-eight million dollars, more for every square inch than they would need to spend on a dozen excellent, and complete, portraits of actual women from the same period. For those portraits there is currently no market: the likenesses of real women do not have the ideological value, the "gender validation," attached to an image of "innovative male genius."

Picasso's self-portrait is as much an ideological sign as it is a good painting. Nothing, in our society, even after decades of feminist struggle, is as valuable as our political myth of the rugged, masculine, individualist genius. Not even a flouncy woman with a flowered hat, the very personification of undifferentiated femininity, and painted by Monet in 1876. Ironically, even at nearly twenty-five million dollars, that painting, compared to *I, Picasso*, is worth almost exactly what the average woman worker of today earns for labor comparable to that of her male counterparts: a little more than fifty percent.

Are such analogues purely a matter of coincidence? Each of us will have to decide such matters to our own satisfaction. Perhaps a moment will come soon when the serious works of the American Tonalists will find as much support as the candy-colored confections of Frederick Frieseke. Certainly the imagery of the California painters of the early years of this century was not nearly as monolithically fixated on parasoled ladies as the art market might tempt us to think. In this exhibition there are several images of women that do not at all conform to our standard conception of the early twentieth-century woman.

Joseph Kleitsch, whose brilliance as a portraitist has until recently had to take second billing to his work as a landscape painter, was certainly not entirely removed from standard practice in the representation of women, as can be seen in his *Oriental Shop* (see plate 152). Still, Kleitsch had such a healthy respect for realism that he often painted superb, individualized portraits of women, such as his *Miss Ketchum* (plate 45), which is as lively and exhilarating a portrait of a woman as one could wish for.

Miss Ketchum, unlike so many of the generalized creatures in the work of Kleitsch's contemporaries, looks straight at us with determination and candor. There is no question about her self-possession and her independence. She signifies as much by placing her hand on her hip: an emblematic gesture we have come to associate with portraits of powerful, authoritative males. This portrait of a very individual woman subverts myriad myths. Indeed, only covert ideological resistance on our part could make us refuse to recognize it for the masterpiece of portraiture it is.

In a similar fashion, Kleitsch's *Problematicus* (see plate 149) has qualities we rarely find in the work of his male contemporaries. Here is a woman who is shown actually engaged in a process of thought. Whether or not she is herself the painter of the work on the easel before her is of much less importance than Kleitsch's candid portrayal of this unusual act of feminine rebellion against the standard imagery of "women's constitutional debility" so characteristic of early twentieth-century art.

These works, then, stand out for their realism, their accuracy of observation. This quality has much less to do with style than with content. Many of the fin-de-siècle painters who worked in a quasi-realistic style produced images quite as drenched in the ideology of evolutionary idealism as the work of the Impressionists. The Impressionist manner of rendering color and light may have served painters well in their attempts to turn individual women into emblems of "the eternal feminine," but the more apparently realistic modes of representation, especially the "symbolist" styles, were often even more blatantly antifeminine in content.

It is the individuality of the women Kleitsch portrays that makes these paintings stand out. Interestingly, though Kleitsch uses what he has learned from Impressionism to modulate light in these paintings, it would be something of a stretch to call them in fact Impressionist paintings.

We have, in general, taken the protestations

45. Joseph Kleitsch. *Miss Ketchum*. c. 1918.

46. Donna Schuster. *On the Veranda*. c. 1917.

of the Impressionists at face value, and we tend to credit them with having called our attention to the beauty of "material reality" instead of continuing to make us dwell on "idealized fictions," like those the academic painters tended to pursue. But paintings such as the portraits of Kleitsch, which do not at all fit into the orthodox canon of Impressionism, make us aware of the fact that Impressionism carried a double-edged sword. The vaunted "light" of the Impressionists, though it has, without doubt, brightened our perception of the natural world immeasurably, has also helped carry forward into our own time a very disturbing dualistic ideology about the relative values of "sun" and "shade," notions about "ideal" masculine and feminine roles that have played a significant part in restricting the talents of women in our society.

There were, certainly, quite a few women painters who chose to adopt the ideology of feminine passivity advocated by most of the male painters of the early years of this century. The works of Donna Schuster included in this exhibition make that all too clear. In Schuster's *On the Veranda* (plate 46), for instance, two women sit in static, perpetual suspension in a world of sun and shade. They would seem to have lost even the capacity to speak, for the painter shows them staring silently and listlessly in different directions, as if they were, in fact, unaware of each other's presence.

To be sure, not all of Schuster's depictions of women are this disturbing—her *Girl in a Hammock* (plate 47) is certainly more animated—but her work rarely approaches the remarkable portraits of active, creative, and thoughtful women produced by such painters of a slightly earlier generation as Ellen Day Hale (1855–1940), Marion Boyd Allen (1862–1941), or Margaret Foster Richardson (1881–ca. 1945). The brilliance of these artists has remained virtually unnoticed because they chose *not* to paint generalized images of women as the personification of passive femininity.

The antimoral, "rugged individualism" of the Social Darwinist ethos promoted the attitude that no one should be his brother's keeper, since anyone who could not fend for himself did not belong among those "fittest" who would lead mankind to a glorious evolutionary future. The equally antimoral "art-for-art's-sake" movement, which has since come to dominate the aes-

thetic theories of the twentieth century, was born into this nineteenth-century antihumanist environment. The avant-garde movements of our century have made the mistake of assuming that a wholesale rejection of conventional values represented progress—"evolution"—in art. But the avant-garde's strict "antimoral" attitude is no less expressive of a rigid ideological commitment than any number of moral sermons by a Tennyson or a Dickens. Baudelaire depended on Catholicism for his demons: opposites define the *limits* of a pendulum's motion.

Perhaps dualist oppositions are inevitable to establish the conditions for creative development. But those oppositions are, in themselves, simply the swings of a historical pendulum. Real qualitative change transcends dualities, by integrating the constructive values of opposing theories and by rejecting what is antihumane in any theory—and hence, in any work of art. We need to revalue works of art at least as much for the quality of their content as for their capacity to express our reigning orthodoxies concerning significant form.

Impressionism presents us with a seductively beautiful world of festive light and seemingly perpetual leisure. There is much in that world that promises harmony and joy, much that represents what is most creative and constructive in humanity. But to accept the Impressionists' worldview uncritically also means to accept their dualist fiction concerning human relationships. We would do well to remember that such ideas have helped precipitate the darkest moments of recent history. The seemingly so joyous café-dansants and the gorgeous, sun-drenched, suburban verandas of the Impressionists are also the brash visual music of acquisitive ambitions that drove a "civilized" world straight into two world wars.

The dark works of the American Tonalists, which, like the adagios of Mahler, found melancholy beauty in elegies for an ebbing tide of human concern, provided a sobering counterbalance to the reckless exuberance of our grandparents' evolutionary arrogance. But works with a contemplative content apparently still serve little purpose today. Instead, the Social Darwinist spirit is reflected more strongly than ever in our society, especially in its wholesale devaluation of human cooperation in favor of flashy displays of personal power—like those we see reflected in the foolish antics of the art market.

The ongoing reexamination and revaluation of the art of past generations, of which this exhibition is a splendid example, brings with it the hope that we may be able to integrate the positive values that speak through the art of those past generations with the values making up our world today. But that also means we need to know what negative qualities, what philosophical misjudgments, what counterforces to genuine human evolution are hidden in the messages embedded in that art.

Perhaps we may soon succeed in recapturing an adequate knowledge of all those modes of creative expression that, until recently, were generally dismissed as minor, or as hopelessly outdated by an art-historical establishment narrowly fixated on the myth of art for art's sake. If that were to happen, some of the genres of painting currently riding at such dizzying heights could well slip back to positions of relative obscurity. It has happened to a long succession of fads in the art markets of the past. It may signal a genuine change in our conception of gender relationships if it happens again.

BRAM DIJKSTRA

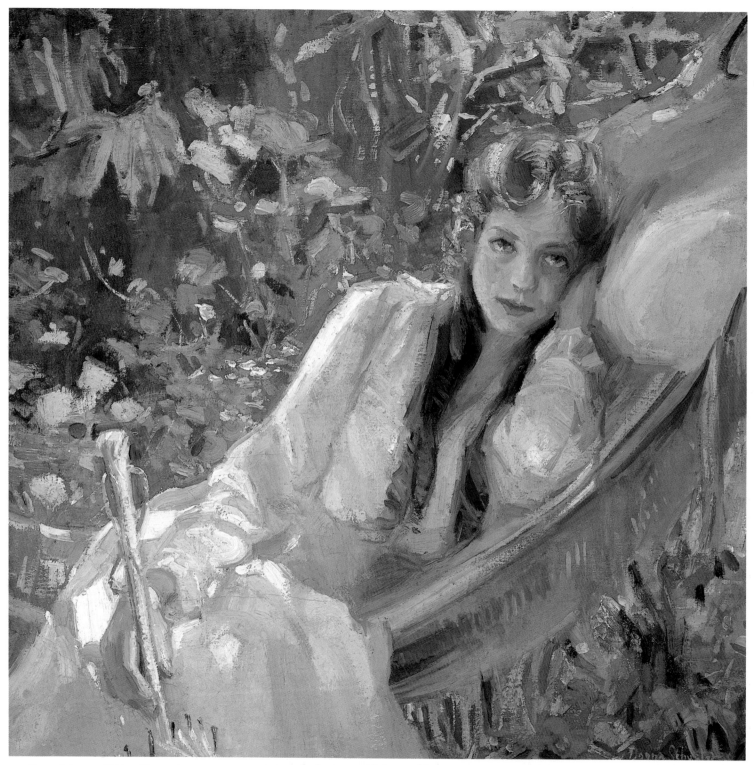

47. Donna Schuster. *Girl in a Hammock*. 1917.

IN
SEARCH
OF THE
SUN

Perhaps nowhere on earth has promotional literature had a greater effect on the growth of a region than in Southern California during the final decades of the nineteenth century. Not since the Gold Rush of 1849 did so many newcomers enter the burgeoning state. This time they were drawn to the heavily advertised southern region, as well as to its thriving northern counterpart, the more developed San Francisco. Variously described as the "Land of Sunshine," "American Italy," "Mediterranean of America," and "Land by the Sundown Sea," Southern California was connected with the East by rail for the first time in 1876. The region attracted an unprecedented number of immigrants in search of bright sunshine, azure skies, and golden poppies—all nestling amid the romance and tranquility of a Spanish mission heritage.

From the earliest days of United States history the West had held a special fascination for travelers, and journals of first sightings profoundly influenced the country's perception of the Pacific frontier. By 1840 the Mediterranean flavor of California was widely recognized. From the writings of Richard Henry Dana, John Charles Fremont, and the goldseekers, Easterners and even Europeans had heard about the wonders of California's climate and the attractions of San Francisco.[1] Northern California received a tremendous boost in 1869 as the first transcontinental railroad entered the state via Sacramento. Similarly, the most widespread news of Southern California's warm-temperate climate and unexcelled natural features accompanied completion of the Santa Fe railroad from Chicago to Los Angeles in 1885.[2]

While factory workers in eastern and midwestern industrial centers and farmers in surrounding rural areas suffered the rigors of harsh winters, California's land Boom of the Eighties sent scores of people westward to enjoy comfortable year-round living. Articles and books written by independent travelers, as well as by real estate and railroad promoters, compared Southern California to the Italian Riviera, the Greek isles, or Spain's sunny southern coast.[3] Their lavish descriptions conjured up images of an exhilarating topography annointed by an exotic Hispanic history. Newcomers to the state were not disappointed by its natural beauty even though they were often hardpressed to make a living.

One of the most popular early books on the region was Charles Nordhoff's *California for*

48. *Frank Felt as Father Salvedierra; Victor Jory as Alessandro.*

Health, Pleasure and Residence: A Book for Travellers and Settlers.[4] For Nordhoff, the whole of Southern California was "full of novelties and wonders to an intelligent person." There, a succession of vivid wildflowers replaced ornamental gardens, and "healthful open-air enjoyments" took the place of theaters and other public amusements. Invalids could easily find competent physicians, parents could place children in good schools, and life in general was "free and untrammeled." Excellent roads, cheap horses, fine mountain scenery, and constant, bright sunshine were everywhere. As a bonus, "Mission San Gabriel, twelve miles distant [from Los Angeles], among the foothills, had a better climate for consumptives than the city itself," and, in the verdant canyons forty miles east of San Diego, "consumptives rapidly improved and recovered."[5]

Before the boom of the 1880s, Northern California was the center of commerce, industry, population, and the arts. Southern California, in contrast, was primarily agricultural and frequently dismissed by San Franciscans as a collection of "Cow Counties." Even though the University of Southern California was founded in 1880 and other institutions of higher learning were starting to appear, the most heavily promoted attribute of the region continued to be its warm-temperate climate.[6] By the mid-1880s so much attention had been given to climate that an "interpretive science of climatology" became a popular pastime. Although later writers poked fun at the tourist preoccupation with weather, Southern California was protected from the harsh desert interior by rings of mountains.[7] Its unique climate was characterized by modest winter rains (averaging 13–15 inches) and summer drought. Westerly breezes from the Pacific were an added advantage and fog was seldom mentioned. Contemporary sources most often described the climate as "ideal, beautiful, glorious, majestic, incomparable, charming, romantic, enchanting, luxurious, marvelous, wondrous, unrivalled, colossal, and spectacular."[8]

Historian Douglas Gunn, writing in 1887, had no doubt that Southern California's "matchless climate" drew worldwide attention when tourists found a range of temperature "surpassing that of the most famous health-resorts of Europe, and carried the report of it home with them." As a result, the number of winter visitors increased, and these eventually became permanent residents. Since they "were chiefly men of capital, they began to look about them for occupation and investment. Thus, new fields of enterprise were sought out and developed, and a new order of things was gradually established. . . . Land was abundant and cheap, and, as the experimental stages of cultivation were passed, horticulture and agriculture displaced the grazing interest."[9]

In addition to climate, the heritage of the ranchos and missions was called upon to provide a backdrop for the newly romanticized era of California's history. Coincidentally, the boom of the 1880s not only witnessed the final dispossession of the rancho elite—the Spanish "dons"—but came at a time when former mission Indians were left with few lands of their own. Many Hispanic families, such as the Yorbas, Sepulvedas, and Verdugos, did not survive the lengthy litigation necessary to confirm their land claims, but their presence would ironically be honored in placenames throughout the region. Helen Hunt Jackson, whose goal was to publicize the sad state of the Indians, unwittingly created a nostalgic legend of "days gone by" when her ill-starred Indian hero Alessandro and his lovely Ramona became victims of the advancing tide of American immigration (plate 48).[10] Mrs. Jackson's friendship with Don Antonio Coronel of Los Angeles and the kindly fathers Francisco Sánchez and Antonio Ubach of Santa Barbara and San Diego helped mellow her strict Calvinist upbringing and gave her view of the missions a mystical warmth.

Among the most colorful and influential persons to promote both the real and imagined cultural traditions of Southern California's past during the late nineteenth century was Charles Fletcher Lummis. In 1885 Lummis walked the entire 3,000 miles from Cincinnati, Ohio, to Los Angeles. Upon his arrival, the twenty-five-year-old Lummis accepted a job as a reporter from Harrison Gray Otis, owner of the *Los Angeles Times* and sponsor of the 143-day trek. Originally a New Englander and Harvard student, Lummis had traveled to Los Angeles to regain his health. Instead, he worked himself into a paralytic stroke by age thirty. Forced to recover once again—this time in New Mexico—he became fascinated with Hispanic and Indian cultures. Returning to Los Angeles in 1893, Lummis published two works on the history of the Spanish Southwest that later became classics,[11] and, in

1895, he assumed editorship of a promotional magazine called *Land of Sunshine*. He incorporated multicultural themes, extolled the virtues of Southern California, and featured environmental issues of local and national concern.[12]

Lummis, who liked to be called Don Carlos and wear eccentric corduroy suits, built a home called El Alisal in the Arroyo Seco, a deep, wooded canyon north of Los Angeles, where he collected folklore and artifacts of Spanish culture.[13] With the proposal and promotion of a cultural museum for the city during the 1880s, he played an instrumental role in the founding of the Southwest Museum. By 31 December 1907 the museum was officially incorporated; after occupying two sites in Los Angeles, it was moved to its present home overlooking the Arroyo Seco on 3 August 1914. Lummis, who served as librarian for the City of Los Angeles from 1905 to 1911, also founded the Landmarks Club to help save and preserve the crumbling adobe buildings of California's Spanish missions and ranchos. A man of vigor, he was truly "the impresario of the Southern California tourist renaissance."[14]

Other authors, like New England-born Charles Dudley Warner, built upon the images created by earlier literature and promoted California's Mediterranean light and color. In 1891 Warner wrote in *Our Italy* that "now and then . . . some conjunction of shore and mountain, some golden color, some white light and sharply defined shadows, some refinement of lines, some poetic tints in violet and ashy ranges, some ultramarine in the sea, or delicate blue in the sky, will remind the traveller of more than one place of beauty in Southern Italy and Sicily."[15] Stephen Powers, who crossed the country on foot in 1868, could not resist the "secret power" of California's autumn landscapes. "There is that strange, desert glory, that wild and wizard something of transparency, of breath, of halo, which has for me an inexpressible fascination. California will be, like Greece, the home of genius, a land of light, of love, of song."[16]

Another popular writer who provided residents with poetic prose and helped attract newcomers to the region was art critic John Charles Van Dyke. In his book *The Desert* (1901), written from a vantage point in the foothills of the coast range, Van Dyke described Southern California in irresistible terms:

Between the ocean and the mountain you are standing upon lies the habitable portion of Southern California. . . . How fair it looks lying under the westering sun with the shadows drawing in the canyons, and the valleys glowing with the yellow light from fields of ripened barley! And what a contrast to the yellow of the grain are the dark green orchards of oranges and lemons scattered at regular intervals like the squares of a checker-board! And what pretty spots of light and color on the map are the orchards of prunes, apricots, peaches, pears, the patches of velvety alfalfa, the groves of eucalyptus and Monterey cypress, the long waving green lines of cottonwoods and willows that show where run the mountain-streams to the sea![17]

Van Dyke had come to Southern California for his health and to join his brother Theodore, who as a rancher was concerned about drought. John soon became aware of the effect of irrigation on the natural landscape. As he looked around he noticed that the terracotta of the granite could be seen through the chaparral of the hills and that even the valleys had "the glitter of the desert." He knew "intuitively that all this country was planned by Nature to be desert. Down to the water-edge of the Pacific she once carried the light, air, and life of the Mojave and the Colorado."[18] When it became known that water for irrigation was available from the Owens Valley northeast of Los Angeles and that water could be diverted through canals from the Colorado River, such descriptions attracted people of all professions to the region and made it possible for residents already there to expand their farming capabilities.

Even after the land boom had burst, new residents streamed into the areas between Los Angeles and San Diego for the same reasons that had led to the heavy migration of the 1880s. Midwestern wheat farmers, learning of irrigation projects and low interest rates, were drawn by opportunities to grow oranges, lemons, grapes, walnuts, avocados, and other exotic crops. Workingmen came to find a substitute for the dreary factory life of Chicago, Boston, and New York (plate 49). Others wanted to escape the coal mines of Pennsylvania and West Virginia. Still others fell under the spell of the continuous outpouring of travel and promotional literature. In 1906 San Francisco's devastating earthquake also sent many to the southern part of the state.[19]

An expanded Pacific Electric Railway introduced by Henry E. Huntington during the early

49. *Orange Grove, Southern California.* c. 1900–10.

50. *Pacific Electric Railway Pamphlet. 1895–1915.*

1900s eased transportation and communication for much of Southern California (plate 50). The slogan "Live in the Country and Work in the City" acted as a catalyst for increased land sales. It also brought into view for residents a wide variety of landscapes, from Pasadena's Sierra Madre to the Pacific Coast. Promoters in these new areas encouraged families to invite relatives back home to see California for themselves. Under Huntington's influence, the "Big Red Cars" connected forty-five incorporated cities within a thirty-five-mile radius and made Los Angeles the fastest-growing urban area in the United States.[20] Despite the railway's convenience, however, Southern California's middle class soon fell in love with Henry Ford's 1908 Model T. Once again, the area's mild and rain-free climate proved a determining factor in growth by allowing the use of automobiles year-round.[21]

The first American settlers in Laguna Beach arrived during the 1870s, when the canyon road from the interior was narrow and difficult and the coastal road from Dana Point or Newport Beach was a rough dirt trail (plate 51). Unlike other nearby areas of Orange County, Laguna was never professionally promoted by writers or developers. In 1889 Joseph Yoch opened the Hotel Laguna to accommodate tourists during the summer months, but because of its remote location and lack of amenities—especially drinking water—year-round residents numbered only ten at the turn of the century. Norman St. Clair, a painter, is often given credit for "discovering" Laguna Beach. He reached it by taking the train from Los Angeles and a stagecoach from El Toro through Laguna Canyon in 1900. St. Clair began to produce watercolor landscapes shortly after his arrival. His exhibitions throughout California attracted other artists to Laguna, and a tradition since unbroken took hold.[22]

Never part of a Spanish or Mexican land grant, the downtown and South Laguna areas remained government lands available for homesteading. The Timber-Culture Act of 1871 allowed families to stake out 160-acre claims and required them to plant ten acres of trees—in this case the Australian eucalyptus. These fast-growing trees formed windbreaks, furnished firewood, and prevented erosion of the barren hillsides. By 1910, however, they had become so dense that many had to be cut down to make room for the town. Nevertheless, these trees were so popular among artists working in the Laguna

Beach area that the term "Eucalyptus School" of painting was coined. In 1918 William Wendt, often called the dean of Southern California painters, built a studio home in Laguna Beach and soon attracted many followers to the seaside community. The natural beauty of Laguna's rocky, sunlit shore and grassy, tree-dotted back country did not disappoint them.[23]

By World War I, a number of artists were residing in Laguna Beach and making excursions throughout the back country on foot, on horseback, and in wagons. Inspired by the books they had read about California's Hispanic heritage, they traveled by horse and buggy to Dana Point and inland to the historic mission at San Juan Capistrano. Sculptors, craftsmen, and writers also found Laguna Beach a stimulating setting for their work. Edgar Payne, a prime mover in the formation of the Laguna Beach Art Association, promoted the exhibition and sale of the artists' work. The first art gallery, located in the old Town Hall shaded by a eucalyptus grove, opened on 27 July 1918 (plate 52).[24] Artist Henri de Kruif wrote in 1919 that the gallery had been so well attended—by 15,000 visitors—that plans had already been made for one (today the Laguna Art Museum) that would "command a comprehensive view of Laguna's gold-fringed coast line, and look across a sea of emerald and sapphire to the tinted peaks of Catalina." For de Kruif, Laguna Beach was "one place in southern California where harmony and cooperation existed among artists" and some 300 belonged to the Laguna Beach Art Association.[25] In later years the term "Eucalyptus School" took on a negative connotation when many amateurs attempted to imitate the style initiated by professional artists.

San Diego, after two land booms in the 1880s, began to attract a steady, although slower, stream of immigrants. Two key figures—sugar magnate John D. Spreckels, who purchased the *San Diego Union* in 1890, and E. W. Scripps, a Detroit newspaperman who took over the *San Diego Sun* just a year later—helped promote the town at the turn of the century. Spreckels purchased the financially failing, but still magnificent, Queen Anne style Hotel del Coronado and linked it by trolley and ferry boat to downtown San Diego, Mission Cliff Gardens, and other points of interest. Caught up in the nostalgic revival of the city's Spanish heritage, Spreckels restored the spacious but run-down adobe house of José Estudillo, built on the plaza at Old Town in

1829. He connected it to his trolley line and gave it fame as "Ramona's Marriage Place." Spreckels and Scripps, although newspaper rivals, joined with sporting goods manufacturer Albert G. Spalding and civic leaders George Marston and Charles Kelly to purchase and save the site of the ruined Spanish presidio overlooking Mission Valley. In 1908 Spreckels and Scripps also served with Spalding on the county road commission to encourage development of San Diego's agricultural back country.[26]

Even though San Diego was often referred to as a "sleepy village," it continued to grow steadily after 1900. The well-respected theosophist Katherine Tingley had proposed in 1896 the founding of a school for the study of antiquity at Point Loma after the aged General John Fremont in New York confirmed San Diego as a place where she could build "a white city in a golden land by the sundown sea." She established her Theosophical Society headquarters and community of scholars on the 132-acre Point Loma site during the early 1900s. Madame Tingley invited English artists Reginald W. Machell and Charles J. Ryan, members of the society, to become instructors at her Raja Yoga school.[27] When artist Maurice Braun, a practicing theosophist, arrived in 1909, she advised him to follow his profession independently and gave Braun his own studio in the Isis Theater building, formerly the Fisher Opera House, on B Street.[28] In 1910 Braun founded the San Diego Academy of Art in the same building, which was once owned by the Theosophical Society.

San Diego's Chamber of Commerce during this period actively promoted the city's scenic features in an effort to attract tourists and new residents. The chamber supported plans to beautify San Diego's major city park, renamed Balboa Park, and broke ground for the Panama-California Exposition there on 19 July 1911. The official program boasted that the "fourth epoch of California" would begin "with the rebuilding of San Diego" and close "with the completion of the Panama Canal and the San Diego & Arizona Railway, thus concentrating the traffic of a continent and the commerce of a great ocean in the harbor of San Diego."[29] The Santa Fe Railroad tore down its picturesque but inadequate Victorian railroad depot and built a Mission Revival structure with a characteristic Moorish-style dome.

San Diegans were optimistic about their future role in world commerce, and the 1915 Exposition in Balboa Park attracted nationwide attention (plate 53). The magnificent approach via the Cabrillo Canyon Bridge presented such a panoramic view that, years later, visitors would still be impressed by architect Bertram Goodhue's evocation of Spain with its Mediterranean and Moorish counterparts. Many of the temporary Spanish colonial buildings were retained, and along with the romantic heritage of the missions, they contributed to the development of a regional architecture in Southern California. The exposition was so popular that it was continued for another year and renamed the Panama-California International Exposition for 1916.[30] At its close, the Friends of Art took some of the exhibits on loan and exchange, including works by Robert Henri, to a temporary gallery in the Museum of Man and encouraged the building of a permanent structure. On 28 February 1926, the Fine Arts Gallery, today's San Diego Museum of Art, was opened to the public. Designed in the Plateresque style of the Spanish Renaissance by William Templeton Johnson, it contained twelve exhibition areas with some 12,000 feet of floor space.[31]

Despite the fact that San Diego had the only good deep-water port south of San Francisco, the city failed to keep economic pace with Los Angeles. Blocked by mountains to the east and Mexico to the south, it never became the terminus for a transcontinental railroad and therefore grew much more slowly. Los Angeles, in contrast, moved ahead rapidly because it had created a deep-water port at San Pedro, imported fresh water from the Owens Valley, developed a system of interurban transportation, promoted its desirability for settlement through advertising, and created an aura of romance through its talented writers. From 1890 until 1920, the Los Angeles Chamber of Commerce played a principal role in the process. It sponsored exhibitions and fairs throughout the county that featured oranges, grapes, and vegetables and promoted the image of California as an earthly paradise—the land of plenty—the new Eden.[32]

Among the writers who rivaled Charles Lummis in providing the region with an imaginary past and praising the beauty of its scenery was an English-born professor of literature, George Wharton James. Although similar in background and interests, Lummis and James were quite different in temperament and seldom

51. *The Old Coast Road (Arch Beach Road), Laguna Beach.* c. 1905.

53. *California Building Art Gallery, Panama-California Exposition, 1915, Balboa Park, San Diego.*

rose above their on-going feud.[33] James, who lectured widely on California literature, became involved in the Arts and Crafts movement and edited a single edition of *The Arroyo Craftsman* in 1909.[34] A tireless promoter of Southern California, he described the enchanting first glimpses experienced on arriving by train:

> For here are orange groves in full bloom. . . . Snow-clad peaks greet the uplifted eye in every direction, yet the atmosphere is warm and summery. Everything is richly green and profusely flowered; the orchards are charming and redolent of blossom—pear, peach, apricot, almond, prune, fig, nectarine, loquat, guava, lemon, olive, pomegranate. . . . Miles of vineyards stretch their vivid green in the searching sunlight, and thousands of acres of alfalfa account for the immense herds of cattle that graze in fenced fields, and the gigantic stacks of hay that abound. His train dashes through large and prosperous-looking towns . . . and he finds a marvellous city, grown from a Mexican pueblo of early California times . . . to a cosmopolitan city of over half a million.[35]

California, "a great land for the artist," provided a never-before-dreamed-of abundance of color: "Surf, waves, billows, oceans of colour; torrents, rivers, streams, rivulets, cataracts, cascades, sprinklings, drops of colour . . . colours simple and complex, harmonizing and clashing, separate and combined, loud and soft, timid and bold, exuberant and quiet; colours of dignity and colours of frivolity, of pride and humility,—but all of life, rich, full . . . free, abundant, and glorious."[36]

A new group of immigrants came to Southern California just before World War I—Europeans who came to escape the growing unrest on the Continent and Americans to profit from developments in the aircraft, oil, and movie industries. The founding of two major art schools in Los Angeles just after the war contributed to the advancement of art on the West Coast. *Los Angeles Times* owner Harrison Gray Otis donated his residence to Los Angeles County to be used as an art school. Opened in 1918 as the Otis Art Institute, it became affiliated with the Los Angeles County Museum of History, Science, and Art. Donna Schuster taught at the Institute during the 1920s and exhibited with several artists' groups. The Chouinard School of Art, founded in 1921 by Nelbert Chouinard, accommodated the overflow from the Otis school.[37] In the post-

World War I era, art dealers in Los Angeles expanded their holdings and began to feature local artists in addition to European and East Coast paintings. Cannell and Chaffin, interior decorators, and the Stendahl Galleries, which opened in the Ambassador Hotel in 1921, both contributed to the success of plein-air painters. Earl Stendahl also opened branch galleries in Pasadena and San Diego.[38]

Between 1920 and 1930 an unprecedented 1,900,000 people migrated to California and of these 1,368,000 settled in Southern California. Freed from the constraints of World War I and given the added mobility of the automobile, they came in numbers that far surpassed the population boom of the Gold Rush years or the land boom of the 1880s.[39] The continued efforts of the All-Year-Club of Southern California (founded in 1921 by Harry Chandler, son-in-law of Harrison Gray Otis) to promote real estate development, and the campaign of the Automobile Club of Southern California to portray the area as a year-round mecca for sun-worshippers and connoisseurs of beautiful scenery kept the growth of Los Angeles steady. One pamphlet, promoting California's sun as a marketable commodity, boasted that "the sunshine of Southern California is so beneficial, due to the violet rays therein, that scientists are endeavoring to reproduce it artificially."[40] Finally, the fast-growing Hollywood motion picture industry "acted as an irresistible lodestone" drawing to Los Angeles "artists of the crayon, brush and other allied crafts," along with persons hoping to participate in any aspect of the glamorous movie business.[41]

Another area that attracted newcomers was the city of Pasadena, described as "the new translation of paradise regained" with "every natural advantage within the gift of a beneficent Providence."[42] Long interested in cultural programs and the arts, the city had sponsored the Tournament of Roses since 1 January 1890, and offered a variety of outdoor activities for residents and visitors alike. Home of the Stickney Memorial Art School since 1912, Pasadena boasted a growing colony of artists during the 1920s, many of whom lived in the Arroyo Seco area (plate 54). The canyon, now the site of the Pasadena freeway, was originally a natural, tree-lined area cut by a quiet stream. Franz Bischoff, Alson Clark, and others had studio homes in the parklike setting, along with a number of craftsmen. Both Clark and Guy Rose taught at the Stickney Art

School, and Clark succeeded Rose as the school's director in 1921.[43]

The Southern California plein-air painters were professionally trained artists who came from various parts of Europe and the United States to take advantage of the area's fresh, light-filled, colorful environment. They doubtless were attracted by the same forces that appealed to most newcomers: travel literature—especially the descriptions of breathtaking land- and sea-scapes; a climate that made outdoor painting possible during almost all seasons; the romantic heritage of the rancho and mission days, which provided unique painting subjects; and the encouragement of fellow artists, who had painted regional scenes on the coast and along "El Camino Real" from San Diego to the Arroyo Seco. Escaping eastern or midwestern winters, they continued their artistic development in a new and stimulating atmosphere, reaching their heyday during the late 1920s.[44] The paintings they created, and the artists they trained and inspired, give testimony to their remarkable talents and pay tribute to the beauty and brilliance that was Southern California during an earlier, more tranquil time.

IRIS H. W. ENGSTRAND

52. *Laguna Beach Art Association, First Art Gallery, Old Town Hall, Laguna Beach.* 1918.

54. *Stickney Memorial Art Institute.*

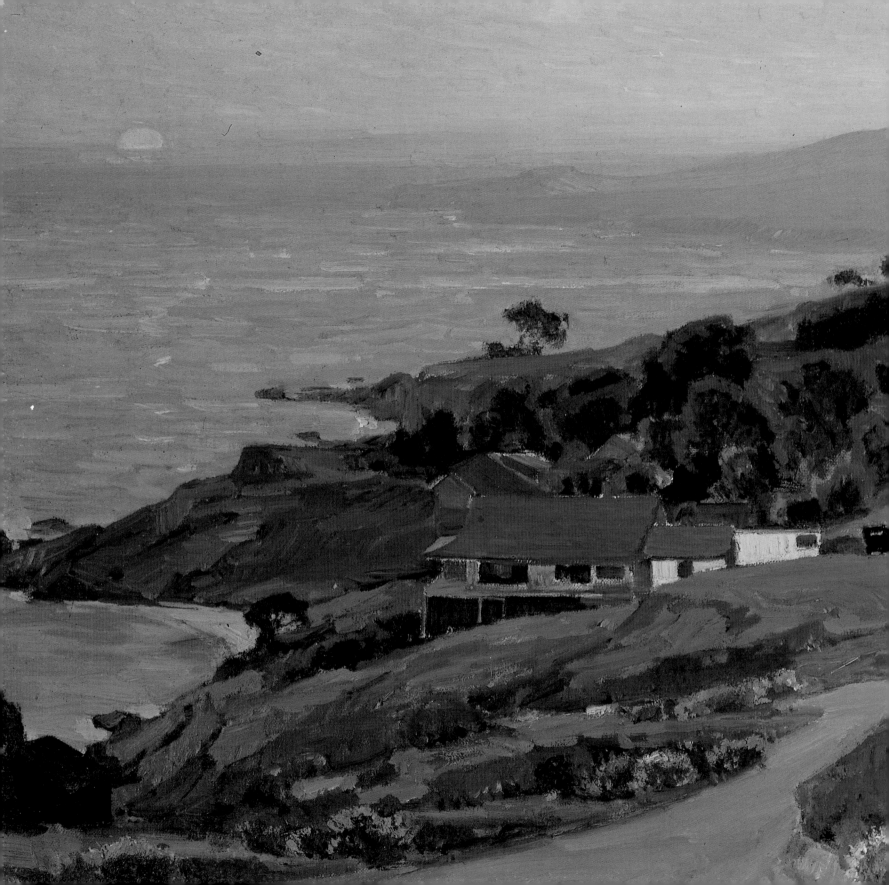

THE SPLENDID, SILENT SUN

Reflections on the Light and Color of Southern California

F irst among the legendary excesses of Southern California is a sheer excess of light. When sunlight is not softened by clouds or fog, or dimmed by dawn or twilight, or when it is not absorbed in the vast green mantle of grasses that so briefly covers our landscape from late winter through early spring, the land seems to hunker down in all its naked aridity, drained of juice and harsh of contour, waiting impatiently in a blaze of light as if embottled in a giant frosted incandescent bulb.

Certainly, for a painter at his canvas, a white-hot base informs the candied pastel light of Southern California, very like the white screen on which technicolor images made of filmic dyes are projected, or like the whiteness of this page beneath the dyes of printer's inks. And certainly an incandescent, sunscald yellow fumes this underlying white, as if to scorch what otherwise might seem too clean and characterless, too virgin and vacant. Thus, to a Southern California painter at his canvas, the prime coating on the sized linen called the "ground"—once a prime coat of warm lead white but by the late thirties a cooler titanium white—doubtless grounds the canvas doubly, both technically and expressively. For this fundamental white in Southern California seems an expression of the end as much as the beginning, as if all landscape painting, true to the unique light and color of the region, would evolve from white to rainbow splendor and back again toward the underlying white from which all hues of light have come.

*Give me the splendid, silent sun
with all his beams full-dazzling . . .*
WALT WHITMAN

Carey McWilliams, author of perhaps the most perceptive and informed nonfiction book published until recently on Southern California, wrote in 1946:

> The color of the land is in the light, and the light is somehow artificial and controlled. Things are not killed by the sunlight as in a desert; they merely dry up. A desert light brings out the sharpness of points, angles, and forms. But this is not a desert light nor is it tropical for it has neutral tones. *It is Southern California light and it has no counterpart in the world.* (Italics added.)[1]

Charles Loring Brace, a tourist of 1869, described a Southern California wherein "heaven was as brass, and the earth as iron."[2] But most tourists, far less certain in what light the region should be cast and far more susceptible to their own passions and fantasies, have over the years described it more romantically as a land of elsewhere: "A Mediterranean land without the

55. George Hurrell. *William and Julia Wendt at Home in Highland Park, Los Angeles.* 1939.

marshes and malaria"; "the American Italy"; "The New Palestine"; "The New Greece"; " a geographical Pleiades"; "Eden"; "Shangri-la"; and, lately, "La La Land." Perhaps the most authentic description of all remains the earliest: some etymologists insist that the origin of the word California is not from the old Spanish romance of Calafia, but from "a Catalan word meaning 'hot oven,' a story that is not good for the tourist trade."[3]

Yet, for most visitors to this land in which even the trees and plants came from elsewhere, a pastiche of irreconcilable descriptions is oddly accurate. Easterners have long portrayed Southern California as an elusive and indeterminate no-man's-land. One tourist from Cincinnati wrote:

> There seems to exist in this country a something which cheats the senses. Whether it be in the air, the sunshine, in the ocean breeze. . . . There is a variety in the evenness of the weather, and a strange evenness in this variety, which throws an unreality around life. . . . All alike walk and work in a dream. For something beguiles, deludes, plays falsely with the senses. . . . In Cincinnati I would have sensed the going by of nine honest, substantial hours; but here I do not.[4]

California has always been an island of sense and sensibility (if not always precisely the geographic island of history or legend[5]), a place entire unto itself, apart from seasons, days, and hours. To some, it seemed a cultural cutoff and a spiritual dead-end. "I have heard that everyone deteriorated in Southern California," wrote Julia M. Stone in one of her tourist books; and Charles Dudley Warner observed in "Our Italy" (relating Southern California to an Italianate softening of the asperities of everyday life) that the region "does produce a certain placidity that might be taken for laziness."[6] Here on the far-out fringe of the country, California was what Kevin Starr aptly designated "a geography of expectation"—not of fact—in which, as Starr put it, "the dream outran the reality."[7]

If the dream prevailed, it was because tourists and artists, migrants and settlers, were compelled to discover the region afresh; and most described or illustrated their expectation, not their reality. They described what they brought with them in the only terms they knew, using their own idiomatic dubbing, with mythic images and cul-

tural subtitles, which "they learned elsewhere and have not the imagination to transcend."[8]

Fernand Lundgren, an Eastern-trained artist, once wrote, "I had to unlearn most of what I had understood as light and color and especially atmosphere, or lack of it."[9] J. Bond Francisco bemoaned "the mocking brilliance of the sky" and pointed out how he had discovered, late in life, that "light was the thing in Southern California; that the light actually changes the texture and shape of the hills."[10] Carey McWilliams complained that "early Southern California painters such as Elmer Wachtel, William Wendt, and Guy Rose (the only native son of the lot) . . . saw the land dimly and imperfectly. One can examine hundreds of these early Southern California landscapes of sunlight flickering through eucalyptus groves, of the flush that swiftly passes over the mountains before the sun falls into the sea, and recognize nothing except the strenuous, largely futile, forced effort that went into the attempt to picture a scene not yet familiar."[11] *Los Angeles Times* art critic Antony Anderson wrote in 1917:

> As a matter of fact, the "man from the East," the stranger within our gates of gold, finds himself so bewildered and overwhelmed, so absolutely unable, for many months, to "see" in our brilliant light, that his eager records [i.e., the artist's paintings], in that space of time, are valueless as works of art, though he may be a painter of parts in his own hometown. These sad new canvases of his miss our mountains and traduce our sunsets; they are like bits of still life painted in a studio whose light is all from the north.[12]

The sad, cool light from the north, or from the east, is not the light of lotus land. Our light is always southern and western, glowingly solar, Arcadian and Utopian, flushed with milk and honey: a light more appropriate to Eden. Thus, the iconography of Eden came to reflect our everyday self-image, a reason why an iconography of irony conveys the Southern California image for so many living elsewhere. And if our iconography was that of Eden, then our ethos—our outlook and visual stance—was in the temperament of a *gaze*. (*Webster's Third* defines the "gaze" as "the long, slow view" and the *Oxford English Dictionary* as a view in which one might "gaze the world away.") Painting the gaze, postcards from paradise, the early Southern California landscape artist pictured for the nation the Southern California Dream. "The Land of Heart's Desire"—perhaps the most familiar phrase of early boosterism and the title of what may be William Wendt's most familiar painting—captured for the nation the sunny idyll at the end of the continental road.

But whether the myth of Southern California is represented by the iconography of Eden or by the iconography of irony, it is best written or drawn in the dry, elusive dust of chalk, whose brilliant whiteness is the essential unifying element of a mature vision of Southern California light and color. It is a whiteness not of sunshine alone but also of fog and mist and rain, an "evenness in variety" that sometimes makes our weather patterns difficult to tell apart. (What is fog or mist or rain is especially moot: as this is written, one local weather report contends that .01-inch precipitation is "morning fog," while another reports .01-inch precipitation as "dripping mist," and still another calls .01-inch precipitation "drizzling rain."[13]) Nevertheless, the everyday, rain-or-shine reality of a dry and chalky incandescent glare underlies the authentic vision of Southern California light and color, and only rarely is it otherwise.

Far more often than not, our vision of light and color is perceived through eyes bleached by the calcimined skies of our infamous "inversion-layer"—a condition noted as early as 1542 by Juan Cabrillo as he watched the smoke of Indian fires rise and hang in layers over San Pedro. Today, beneath a noxious atmospheric shroud of smog, the objects we see rarely contrast in chroma (brightness), tend to blend in hue (color), and least of all diverge in value (tone). Shadows are lightened; highlights are dulled; forms are not diffused but outlined and flattened. Once blanched by atmospheric haze and now by atmospheric acids, color stands in Southern California not so much revealed by light as besieged by it.

Not long ago, even the oranges of Southern California were described in terms of light. "Around us were trees laden with little golden lamps of orange," wrote Alfred Noyes.[14] And nothing in the pictorial traditions of our early painting gives more light to the landscape than the eucalyptus tree, that other ubiquitous symbol of Southern California. Silhouetted and nearly hueless, it droops against the atmospheric scrim of the sky as if its only role were to oppose the

Omit the clouds . . . and the landscape would be one glare of light without variety.

HENRY DAVID THOREAU

scene and reveal by contrast the high-key value (tone) of local light. Most often it stands anonymous in languid darkness against the sharp light of landscape like a portal into space, framing California's otherwise relatively monotonous brightness; or it becomes a foil for space in what was once called a "barrier composition." In spite of Merle Armitage's famously derogatory phrase "the Eucalyptus School of painting," the eucalyptus is rarely seen in California paintings simply for itself. "Quite fittingly," wrote Genevieve Taggard, "there has never been a poem written about a eucalyptus tree. There could not be, until this special tree has gone into the experience of many people."[15] Ironically, with rare exceptions (like Marion Kavanagh Wachtel), neither did the eucalyptus enter much into the experience of the "Eucalyptus School" of painters.

Nature, and Nature's Laws lay hid in night.
God said, Let Newton Be! and all was light.
ALEXANDER POPE

In 1666 Isaac Newton dismantled the age-old deity of sunlight when he shattered white sunlight through his prisms into spectrums of rainbow colors. It was one of the most significant discoveries of the century: sunlight, the essential unitary agent illuminating the earth, was suddenly a collection of colors. Newton called his discovery the "oddest if not the most considerable detection which hath hitherto been made in the operations of nature."[16]

Until then, sunlight had been the central element in divine creation, inviolate and pure, a supernal power set against primeval darkness. Often enough, the enchantment of color was thought to be little more than a hedonistic temptation, a seductive allurement leading to sybaritic opulence and hence to one or more of the seven deadly sins (one sin was assigned to each of the seven spectral colors, including black).[17]

Until the publication of Newton's *Opticks*, color was thought to be the property of black. In generalized terms, black represented mineral earth, fertilized land, and the initial, germinal stage of all things, including colors. White was male, ethereal and supernatural; black was bedrock, home of the dark earth-mother. For many people today, black still seems deeply subterranean and primal. Things germinate in darkness and terminate in darkness: in the darkness of the womb and the blackness of the earth.

Thus until the seventeenth century pure sunlight seemed to manifest as well as to symbolize divine illumination and sublimity, radiating supernaturally from on high to enlighten a shadowy world. Although color was used to attract the faithful, color was nevertheless commonly associated with the earthly charms of the physical senses, with the terrestrial beauty of mere things, and with the ultimate darkness of worldly materiality.

Even today, a lingering cultural memory of light's long-forgotten meanings still haunts the dreams of philosophers and theologians, and the light of day reflects the flame of ancient visions still residing behind the eyes of artists and poets: "God's first creature" (Francis Bacon); "offspring of Heav'n firstborn" (Milton); "the first of painters" (Emerson); "the white radiance of Eternity" (Shelley). More to us than science and art, light is life itself.

With Newton's Laws, the immaterial was reduced to the material, and God's pure light was seriously compromised because it was composed of colors. Worst of all, the hand of man could now recompose colored light back to white light again. It was a "Dark Night of the Soul" for many (Saint John of the Cross was canonized the year Newton died), and many of the wisest objected to Newton's revelations—artists and poets as well as philosophers and theologians.

But no one objected to Newton's *Opticks* more than Johann Wolfgang von Goethe, the great German poet, whose imaginative, romantic mind would always resist the reductive rationalism of the rigidly classical. For Goethe, Newton's *Opticks* was spirit-negating *unnature*[18] in the soulless embrace of a self-rationalizing but unreasonable science. The first three hundred pages of Goethe's magisterial three-volume *Theory of Colors* (*Zur Farbenlehre*, 1810) is a criticism of Newton's hard, Cartesian line between matter and spirit. Goethe wrote: "If the eye were not akin to the sun, how could we ever see the sun? If God's spirit did not live within us, how could the divine inspire us?"

For Goethe, the realm of light and the realm of the spirit were the same. His theory emerged from an appreciation of Pythagoras who, in the sixth century B.C., explained vision as the meeting of visual rays, one emitted by the seen object, the other by the eye. Goethe wrote: "From indifferent, subsidiary animal features, light produces an organ of its own essence; and so the eye forms itself from light for light, in order that the inner light can meet the outer."[19] This rather romantic and seemingly retrogressive suggestion that light was a field of reciprocal energies long made

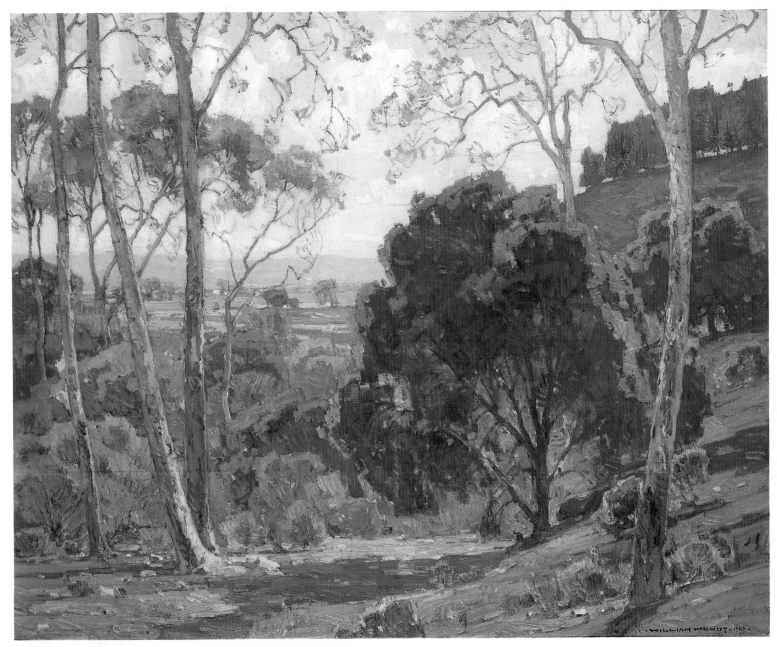

56. William Wendt. *Days of Sunshine*. 1925.

Goethe's theory unacceptable to scientists and, conversely, appealing to artists.[20] Not until relativity theory and quantum mechanics redefined the role of mind in the structure of reality could an "inner light" seem more than religious metaphor or artistic license; and although Goethe's vision was that of an artist and poet, his theory has been revived with honor, for he predicted some of the most recent concepts in physical science.

A founder of the new physics and one of the greatest theoretical physicists of our time, Werner Heisenberg was impressed by Goethe's intuition and by the way in which the visual impressions of his sensitive mind combined to form a more complete order of reality. Heisenberg stated that insight is not gained by siding with Newton or Goethe, since artists and scientists have profited from the views of both. Rather, their theories are "different layers" of the same reality, but Heisenberg greatly honored Goethe's "inner light" as a way of retaining "the living touch with nature." For Heisenberg, there was no alternative to accepting *both* aspects of visual experience: we all fluctuate—sometimes wildly and sometimes delicately—between an "inner" and "outer" vision of the world. And if we seem conditioned toward a biased vision, then our opposite pole remains more potent precisely *because* it is repressed and hidden.[21]

Indeed, the mind of the observer has become a central part of recent physical theory and an essential component in any scientific equation. Heisenberg stressed that the laws of nature no longer deal with elementary particles but with *knowledge* of these particles—that is, with the contents of our own minds.[22] The spiral of our expanding vision has not only returned us to ourselves but also to our past.

The earliest known records of observations on light occurred almost simultaneously in the East and West about the time of Gautama Buddha, in the fifth or sixth centuries B.C. In China, the philosophers who followed Mo Ti studied the mysteries of sunlight by means of gems and mirrors. But it was Pythagoras and his followers in southern Italy who first speculated on sunlight's aesthetic and spiritual meanings and its purifying and life-giving benefits.

Yet the sun was not always considered the source of light. Pre-Aristotelian atomism, as developed and systematized by Democritus in the fourth century B.C., proposed that light consists of tiny particles beamed from objects toward the eye. A century later Euclid—in the *Optics* and the *Catoptrica*—completely reversed the beam's direction, proposing precisely the opposite theory, that the eye sends out visual particles and that we "cast our eyes" on objects, shining forth upon them like a lamp.

In the East, the Hindu philosopher Kanada had proposed the particle theory of light (pointing to "motes in a sunbeam") as early as 500 B.C., but it was not until two millennia later with the strict empiricism of Newton's Laws that the particle theory—or "corpuscular" theory, as Newton called it—was widely accepted. This long-standing particle theory of light is worth extra consideration here, because it may well have served as a rationale for influential light-and-color theorists such as Michel-Eugène Chevreul. The systems of these theorists led to the particulate nature of color-mixtures in the light and atmosphere of the Impressionists, the Pointillists or Divisionists, and others working in related painting styles.

Newton's research into the nature of light, carried out with a prism in 1666 when he was still a student at Cambridge University, eventually convinced artists and scientists that white light contains all the colors of the rainbow. Artists were especially hard to convince, since their pigments seemed to prove that combined or mixed colors become black, not white. Artists' palettes supported the earlier belief that white light was purified or free of color and that colors were related to darkness. But pigments and light mix colors differently, and Newton's *Opticks* was powerfully convincing because it was strictly empirical. Newton reported a wide variety of experiments with illustrations, mathematical analyses, and deductions from general laws. It was evidence that changed the meaning and content of sunlight forever.

At about the same time, in 1665, the Jesuit Francesco Grimaldi published a fascinating study of shadows, showing that shadows have fringes of color and that there is no sharp boundary between light and shade. His study helped to shake the rigid distinction between light and dark, between objects and their shadows, and between the color properties of black and white. Thus he, too, anticipated painterly styles that came much later. This obscure genius also made astonishing studies of the colors formed in light

reflected from thin films, such as insect wings, studies that are worth further research by art historians and artists.

But Grimaldi's exotic studies anticipated even more, for his effects are now known to be the consequence of the wavelike character of light. The wave theory of light was first put forward by Newton's contemporary Christiaan Huygens in Holland but was quickly rejected by most seventeenth-century scientists and philosophers. The idea that light rays were analogous to waves in water simply could not be accommodated to the idea that light was propagated by indiscernible particles moving in a straight trajectory. But in 1801 Thomas Young (said to be "the last man who knew everything") presented to the Royal Society of London a lecture entitled "The Theory of Light and Colors" in which he demonstrated the validity of the wave theory by showing that light was made up of a train of crests and troughs very like ripples in water.

Orbiting the spiral history of light back to preconscious significance was James Clerk Maxwell's theory of electromagnetism. Published in 1862, Maxwell's mathematical analysis proposed that the velocity of electromagnetic radiation and the velocity of light were equal, thus broadening the spectrum beyond what we can see to include what we can feel. Light has the power to enter our bodies as easily as it enters our eyes. Invisible parts of this broader spectrum of light manifest themselves directly on other parts of ourselves. Light is more than visual: ultraviolet light is invisible but causes sunburn; infrared light is invisible but produces heat. In today's world, the increasing threat of cancer-causing sunlight—plus the probable reduction of our oxygen and food supply as a result of decreasing photosynthesis caused by depletion of the ozone layer—brings a newly ominous dimension to the spectrum of light. Once again, light begins to take on mythic proportions, and, as in ages past, it seems to determine not just visibility but also destiny.

In this prodigal, Eliade-like, mythic return, light is now *both* particles *and* waves, *both* matter *and* ether, *both* visible *and* invisible, composed of incredible numbers of indescribably miniscule particles with zero mass, particles that recede from you no matter how fast you chase after them, particles that ripple and wave and dance in a gravitational field. Under these new conditions, which recapitulate old percepts and concepts, the painter's vision of light and color takes on momentous significance.

Ours is a planet of chlorophyll. And together green chlorophyll and sunlight are responsible through photosynthesis for all life on earth. The agile brain of warm-blooded birds and mammals demands the high oxygen consumption produced by a green world as well as food in the concentrated forms of fruits and vegetables, nuts and grains. Hence, the rise of flowering plants provided the concentrated energy that changed the nature of our planet toward advanced forms of life. Our very life breath originates in green; and all the other living colors on earth arose in the concentrated energy and tantalizing nectars and pollens of angiosperms: the flowering plants. Charles Darwin called them "an abominable mystery," because they appeared so suddenly and spread so fast. Flowers and their colors began to bloom as the great reptiles disappeared and, wondrously, flowers and emerging humans appeared simultaneously.

William Wendt understood the power of color. It was Goethe, Wendt's compatriot, who over a hundred years earlier had insisted that in *green* the eye finds the soul's "deepest and most real" satisfaction.[23] For Wendt, the "deepest and most real" satisfaction was not to be found in softer seasons or gentler evenings—not in the lilac mist of June or the bronzed rose of August—but in the clear, uncompromised green of midwinter. Only then was Wendt's deeply Bavarian, northern soul content (plate 55).[24] Wendt gloried in the coldest, wettest Southern California winters: "It has been blowing like hell here for nearly three days," he wrote excitedly to his dealer Earl Stendahl from Trabuco Canyon near El Toro in midwinter of 1923, "and my hands are numb with cold."[25]

No Southern California painter has been more closely identified with a single color. *Green* virtually became Wendt's trademark. He knew that February was by far the most inviting month in which to hike through chaparral-covered Southern California hills—the month when fresh grasses carpet the hills and valleys where deer, antelope, and elk once grazed and grizzly bears browsed. (Wendt was painting here in the Santa Ana mountains and canyons as early as 1908, precisely where and when the last grizzly in Cal-

I am struck in California by the deep and almost religious affection which people have for nature, and by the sensitiveness they show to its influences; not merely poetically, but also athletically, because they like to live as nature lives. It is a relief from business and the genteel tradition.

GEORGE SANTAYANA

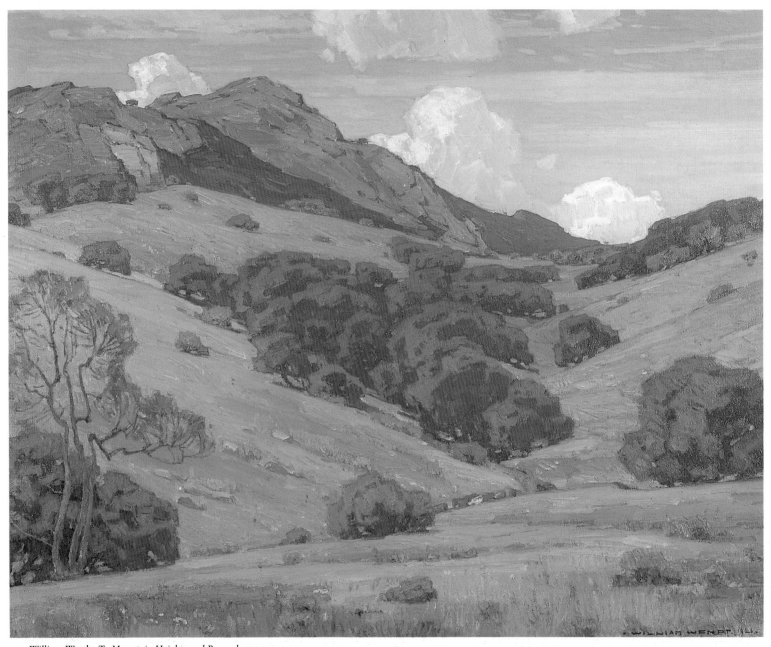

57. William Wendt. *To Mountain Heights and Beyond.* 1920.

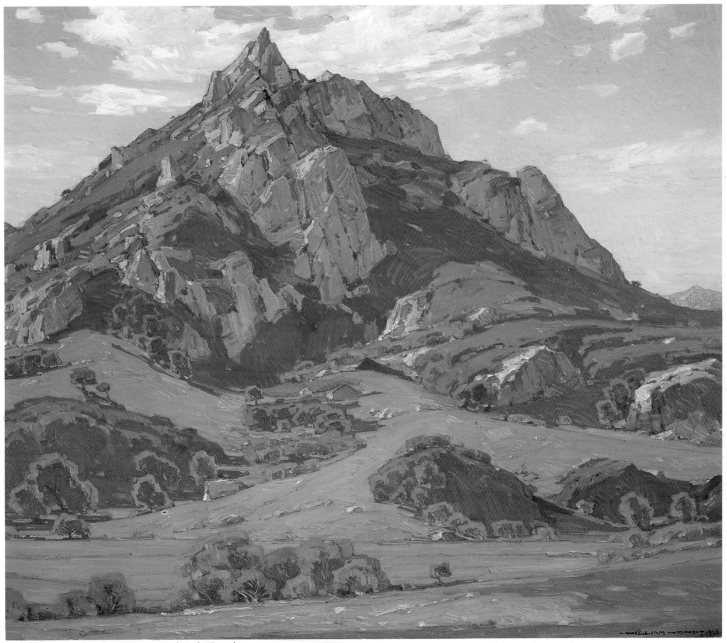

58. William Wendt. *Where Nature's God Hath Wrought.* 1925.

59. George Hurrell. *William Wendt with "Where Nature's God Hath Wrought" on Easel.* 1925.

ifornia was shot.)[26] Midwinter and early spring were Wendt's favorite months for painting. Diminishing rainfall and hotter, drier summers now make this emerald season even more precious because it is so brief; but California mission animals once grazed for half a year on those wetter grasslands, spreading seeds of European annuals such as velvetgrass, vernalgrass, and tall fescue through native fields of bromus, lolium, avena, aira, and briza. Giant wildrye and small-flowered melica, ripgut brome and foxtail fescue, wall barley and red cheat are the most prevalent grasses now. These raw, awesome greens are in all their virescence in February—the coldest, wettest, and often enough the most beautiful time of the Southern California year.

In Southern California, the clear winter days offer a startling, laser-like sharpness that can penetrate the eye, cutting away the haze and smog of the rest of the year. Highlights are silvery white and shadows an uncharacteristic ultramarine—so deep as to sometimes turn purple and even red. On such days the light seems icy, yet the air is warm, and a crystalline ambience bathes body and mind. Everything shines as if cleansed; forms are crisp, clean-edged and profoundly present. At the age of thirty-three, Wendt described the invigorating Southern California winter and spring of 1898 in a letter to his friend William Griffith:

> The earth is young again. The peace, the harmony which pervades all, gives a Sabbath-like air to the day, to the environment. One feels that he is on holy ground, in Nature's temple.
>
> The warm green of the grass, sprinkled with flowers of many hues, is a carpet whereon we walk with noiseless tread.
>
> The perfume of the flowers and of the bay tree are wafted on high, like incense. The birds sing sweet songs of praise to their Creator. In the tops of the trees, the soughing of the wind is like the hushed prayers of the multitude in some vast cathedral. Here the heart of man becomes impressionable. Here, away from conflicting creeds and sects, away from the soul-destroying hurly-burly of life, it feels that the world is beautiful; that man is his brother; that God is good.[27]

For Wendt, the days of this brief winter-into-spring were a religious experience, and his paintings of such days have become the classic images of the Southern California Eden. In contrast to the rosy epiphanies of Maurice Braun, Wendt's firm greens present a physical, up-front urgency. *Mantle of Spring* is a classic icon of the green Southland Eden.[28]

But February is also the first month when Southland hills are awash in brilliant patches of black mustard—*Brassica nigra*, a cool, high-key, yellow-flowering plant that spills sharp and spicy over the raw green hills. Wendt took advantage of this cooler, fresher yellow as often as he did of green—a yellow far different from the hot bronzed gold of dried summer grasses, for which the Southern California hills are more famous. In *Days of Sunshine* of 1925 (plate 56) Wendt illustrates the beginning of the Southern California winter. Here the white-barked sycamore trees have shed their leaves, and the leaves of black-barked native walnut trees have turned a deep fragile gold. The first rains of winter have just begun to sprout the tender grasses of winter's green—the green that Wendt would depict again and again in hundreds of paintings, such as *The First Green of Spring*, *Verdant Hills*, *In Garb of Green*, *The Green Earth*, and *Green and Gold*.

Wendt also responded to spring giving way to summer, as in his *To Mountain Heights and Beyond* of 1920 (plate 57). Yet it is typical of him that what is transitional in nature is rendered as if monumentally permanent; and Wendt's interfolding, overlapping slopes of green and gold are as solidly mortared as bricks in a wall.

Examining *To Mountain Heights and Beyond* is like scaling a wall. In the manner and style of most mature Wendt paintings, it is workmanlike and solidly constructed, with even the hills and trees laid up like masons' blocks. The clouds are rocklike, defying gravity, and they repeat the hills and trees in patterned pictorial slabs like a fortress facade. Yet there is anatomy as much as architecture in Wendt's painting style. His hills—"rock-ribbed, and ancient as the sun" (William Cullen Bryant)—march in crisscrossed, sweeping brigades, with a hearty muscularity.

To Mountain Heights and Beyond is "masculine" as well as muscular (as critics used to say), and its structure is as athletic as it is architectonic. And it is even more humanized by Wendt's inner, Wagnerian *Sturm und Drang*, a contained romanticism—a literary romanticism, one would guess from his titles—walled-in by his determined structural control. But nothing illustrates Wendt's leanings toward monumental grandeur more than his painting of the largest volcanic cone among the fifty-million-year-old

"Nine Sisters," located between San Luis Obispo and Morro Bay. *Where Nature's God Hath Wrought* (plates 58 and 59) is a portrait of the 1,559-foot Bishop Peak, with a monumentality to match Wendt's structure and his passion.

And Wendt's passion was far stronger for matter than for light. Light for Wendt was a shadowless beacon of color. Directness in his illumination, like directness in his life, was Wendt's manner in everything—and both could be blunt. Note, for example, his *There is No Solitude Even in Nature* of 1916 (plate 60), depicting a hunched and craggy, withering midday in Laguna Canyon near El Toro, with Old Saddleback Mountain peaking remotely in the distance. Or note his even more stark Laguna Beach *The Silent Summer Sea* of 1915 (plate 61). The shadowless directness of high noon seems to belie Wendt's darkly brooding melancholia, with which he was often seriously troubled.[29]

Nevertheless, Wendt's subjects were generally not the majestic Sierra but humble hills and simple valleys, for he usually wished to avoid the too-obviously "scenic." No human figures exist in his scenes, yet not only are his landscapes muscular, they are visceral. What is majestic and human in a Wendt is not the depicted subject so much as it is the monumental structure and the almost corporeal anatomy of the landscape. Hills and valleys are formed like flesh, trees are like bones, and branches are like arteries and nerves.

This duality is not unusual for the period. It recalls the standard academic style of the twenties and thirties—especially George Bridgman's anatomy books (*Constructive Anatomy* and *The Human Machine*) in which the human form was taught as a pile of perspectival blocks.[30] Similarly, Wendt's blocks are massed like flesh and blood. In many Wendts, a close viewing shows an internal plasma nearly hidden in the interstices between forms. These are like venous secretions and are in fact blood-red undersketches, the linear remnants of an imprimatura painted in deep alizarin and red-violet. These red edges give a visceral juice to Wendt's blocklike forms, and they set off against his greens with a complementarity that brightens them. Wendt used this same alizarin to gray his greens as well as to heighten an edge and flick a form to life—to put "a kick in it," as he would say.[31] Sometimes he overlaid the thin red stroke, retouching and reinforcing it, pulling it up out of the substratum to surface against the green mass, as if to emphasize it in a final expressive adjustment.

But whether flesh or fortress, physicality and materiality were the substantial vehicles Wendt needed to express the elusive ephemera of light and color. Moreover, he needed his body's response to the landscape in the mark of the hand and brush—what we call "gesture"—to embody the fleeting scene. Wendt transposed his passing sensations into units and masses of strokes, building slashes and jabs of pigment into architectural anatomies of shape and mass, volume and color. His gesture and touch are parts of the constructive process, the seismographic record of the artist's body-mind.

In *Evolution and Its Relation to Religious Thought*, Joseph Le Conte, then Professor of Natural History at the University of California at Berkeley, wrote in 1888 of the importance of the ("lower") physical in relation to the ("higher") divine:

> True virtue consists, not in the extirpation of the lower, but in its subjection to the higher. The stronger the lower is, the better, *if only* it be held in subjection. For the higher is nourished and strengthened by its connection with the more robust lower, and the lower is purified, refined, and glorified by its connection with the divine higher, and by this mutual action the whole plane of being is elevated.[32]

Kevin Starr, emphasizing the widespread regional significance of Le Conte's thought (to which Wendt doubtless had access), writes that Californians were always suspicious of ungrounded transcendence, and that physicality seeking a return to the spirit, without pseudotranscendence, without repudiation of physicality's best gifts—was at the inner nexus of Californian aspiration."[33]

Only rarely have Southern Californians looked backward to the East and to Europe. Having arrived at lands-end and facing west still, no wonder we find the Pacific sunsets so compelling. Sunsets punctuate the worldly round, making the end of the day a momentary end of the world. Yet Pacific sunsets emphasize the wide horizon hopefully and offer a periodic scope and promise to our abiding westward outlook over the largest ocean in the world. We also respond, more fundamentally if more primitively, in ritual. The sun at the visible circumference of the world—at that taut, thin line between light and darkness—has

If we are blinded by darkness,
we are also blinded by light.
When too much light falls on everything,
a special terror results.

ANNIE DILLARD

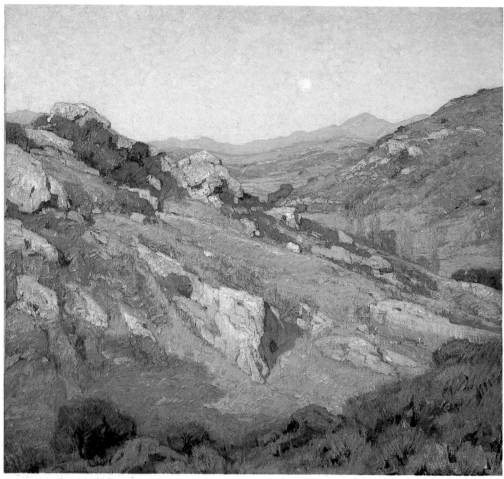

60. William Wendt. *There is No Solitude Even in Nature.* 1916.

always inflamed man's inner need for ceremony and rite. The coastal middens of native California Indians may have constituted sacred grounds of twilight worship as much as tribe-gathering and food-gathering kitchens.[34]

Contemporary sunset rituals in Southern California are no less exotic. The world slips into another, more primal dimension at twilight, and all along the coast people emerge as if under a Circean spell from towering beach condos, grand ocean mansions, and squat seaside cottages, stilled together in a luminous, liquid light like figures in an ancient frieze. And somewhere offshore, surfers on their boards also grow still in quiet contemplation and homage while the sun sets. Not until the last flick and slither of the sun's dragon tail sinks beneath the sea do today's natives retreat into the night and the former limits of their lives.

The Southern California sunset is often a fire-breathing riot of writhing, flaring color. Some of us prefer the softer, deeper, more subtle and exquisite afterglow. Across a teal-blue evening, the sun can splash and streak the predusk sky more boldly than most painters dare. At other times the sunset spectrum turns from cheerfulness or exultation toward melancholy, and the teal-blue sky grows sad and cerulean. As the sunset symbolizes closure it also releases daylight's roles and expectations, symbolizing a more elemental, aboriginal, and inward experience of light-becoming-color as it turns into darkness. Strong light is not for everyone, even when strong color is. The great spectacles of nature can be too much for art, and too-florid sunsets can mock human sentiments by their excess of drama. And perhaps in his *Old Coast Road* of 1916 (plate 62), William Wendt preferred to subdue the light, painting his sunset in the flat, shadowless light of his favored midday. Here the wall-like weight of Wendt is heavy armor, and the light of the sunset seems blunted if not quite subdued.

Accordingly, the nocturne may afford a more discreet and workable subject than the sunset. Maurice Braun's nocturne *Moonrise over San Diego Bay* of 1915 (plate 63) is a convincingly honed and quietly resonant tone poem, largely because Braun mutes his response to light in a sustained, methodical way. His touch is as cool and meditatively repetitive as an incantation, and his firm shapes float in a steady, almost still luminosity that few sunset paintings could achieve. Compare Braun's *Moonrise* with Childe

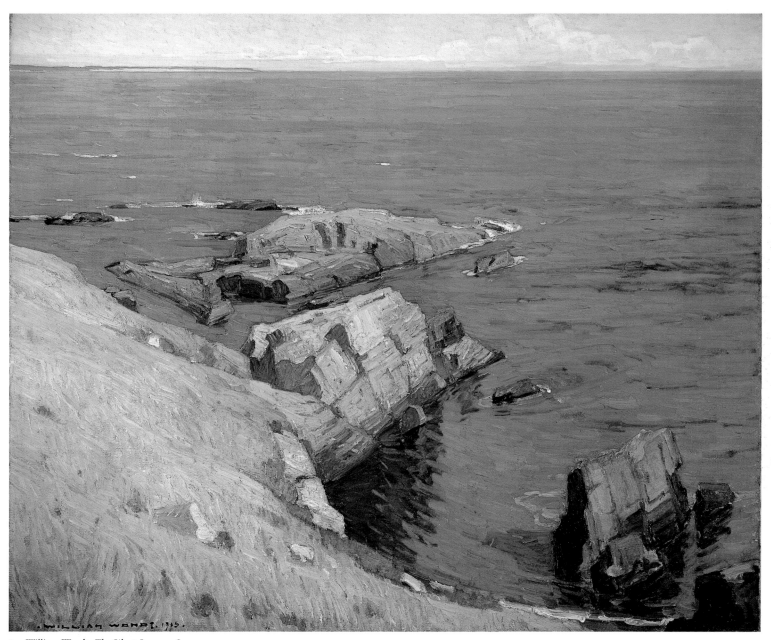

61. William Wendt. *The Silent Summer Sea.* 1915.

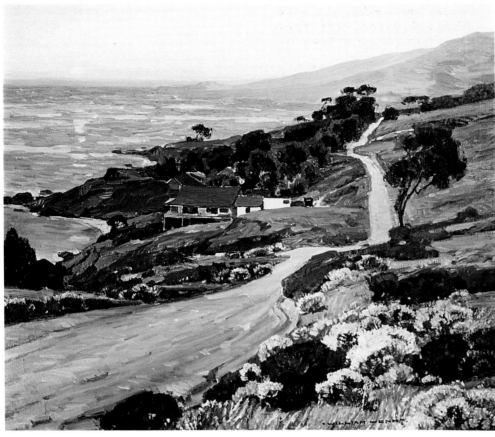

62. William Wendt. *Old Coast Road*. 1916.

Hassam's *Moonlight—Isle of Shoals* of 1892.[35] Hassam was an artist whose work was known and admired by Braun,[36] and each of these moonlight paintings stalks the quality and color of night by virtue of an almost hallucinatory simplicity of floating, suspended shapes.

Most curiously, however, Braun's nocturne is even closer to Granville Redmond's undated *Silver and Gold* (plate 64). Both paintings are as tactile as they are visual, like woven nets to catch the light; and both achieve light by chroma (brightness) as much as by value (tone). A calm, undistracted, meditative focus unifies the picture plane as much as it unifies the shapes; and attention to the relationship of shapes—with intimate flickers set against vast masses—lends a wistful, poignant vitality to the calm of the whole. Warm-against-cool hues (colors) are even more carefully controlled than values (tones), and they play against each other far more subtly than dark-against-light. Redmond's misty afternoon scene overlooking poppy fields along the Marin coast may as well be a nocturne, for his sunlight reflects upon the sea like a watery, ghostly moon. Redmond's sun is in fact less visible than Braun's moon, and Braun's nighttime reflection of the moon is even brighter than Redmond's daytime sun. Both are lunar in "mood," and both might be called "dreamscapes"—however much their fields of light picture what we call "reality." They depict not the brilliant spectacle but the subdued hush of light.

But etherized nocturnes are not the only alternatives to the whiteness of daylight or the bright colors of sunset. Sometimes amber sunlight angles through late afternoon, and early evening takes on an opalescent, golden rose, mellowing hills and valleys even more beguilingly than sunsets or nocturnes. Southern California landscape painters have long been tempted by the sensuality of this presunset hour. Perhaps because it is between extremes: the midday whiteness is tempered by the angle of the afternoon sun, diffused through a thicker atmospheric mass, and the sunset is not yet in full display. In the hour before sunset a fleshy warmth soon turns to alpenglow on mountains from Topatopa to the Tecate Divide, and this slant of light is irresistible to most Southern California landscape painters.

Examples abound, but two of the more classic are Maurice Braun's *El Cajon Mountain (El Capitan Mountain)* of about 1917 (plate 65), and

William Wendt's *Big Tujunga* of 1930 (plate 66). A slant of sunlight informs these mountains with rose and gold respectively, while shades of lilac and cyan contrast not in value (tone) or chroma (brightness) but in hue (color). *Color*—almost more than light—seems to be what these sensuous landscapes are all about. The slant of sunlight casts more color than shadow—an old Impressionist ploy that was often taken to extremes by Southern California painters. This is partly because our atmospheric haze erases shadows, but probably more important, because there are no shadows in Eden.

Goethe understood color as artists understand color, never letting the white source of colored light interrupt his contemplation of color's effect on the human soul. Nor did he attempt to use rules, however scientific and rational they seemed, to explain feelings or to translate luminous sensations into quantitative constructs. Fundamental to his thesis is the observation that colors are produced by the interaction of light and darkness. Sunlight darkened by clouds produces colors that emerge as the visible sunset. He called this the "archphenomenon" (*Urphänomen*); the smoke rising from a chimney or the iridescence of certain translucent materials, such as isinglass, are examples. Goethe's examples are always in accord with experience, and this is the central idea in his theory of color—as well as the reason it appeals so much to artists.

To eighteenth-century painters and poets, light itself was "sublime." But for them it was most meaningfully articulated and expressively beautiful when it was refracted into color. A century before Impressionism, painters and poets discovered new meanings in the individual colors of the prism, thereby discovering new content in the colors of the landscape—in sunrise and sunset, and in the parading succession of atmospheric colors throughout the day. During the British literary flowering of the eighteenth century, there entered into art—and especially into poetry—a "symbolism of the spectrum," suggested by many but put forth most sensually by the melancholy Scot James Thomson in his Spencerian poem "To the Memory of Newton." Beginning with a "whitening undistinguished blaze" of light, he broke light down into its "gorgeous train / Of parent colors":

First the flaming red
Sprung vividly forth; the tawny orange next;

And next delicious yellow; by whose side
Fell the kind beams of all-refreshing green.
Then the pure blue, that swells autumnal
 skies,
Ethereal played; and then, of sadder hue,
Emerged the deepest indigo, as when
The heavy-skirted evening droops with frost;
While the last gleamings of refracted light
Died in the fainting violet away.[37]

Like the eighteenth-century painters and poets, Southern California painters were often enchanted with "delicious yellow," spellbound by "the kind beams of all-refreshing green," entranced by "pure blue" skies saddening into "deepest indigo" and "fainting violet." The newly vivid sense of color, especially in the late afternoon and early evening light of Southern California, had an emotionally symbolic potential, and the expressive coloristic "moods" of slanted sunlight were at least as compelling as the Impressionist theory of color depicting light and atmosphere. Like nothing else in nature, the slant of sunlight from late afternoon through sunset to afterglow reminds the painter of the emotional and symbolic power of *hue*. In Southern California, the intense whiteness of the day may contribute a prismatic brilliance to the sunset. But to our painters, as it was to Goethe, color was not a property of light alone: it was also a reflection of the human soul. Color was expression, not just representation; and the colors of feelings were as important as the colors of light.

Caught historically as well as geographically between color as symbol of an inward "mood" and color as imitation of an outward image, Southern California artists have fluctuated, and sometimes floundered, between Expressionist impulse and Impressionist style. With his sensuous, indulgent brush, Franz Bischoff reveled in the voluptuous qualities of color. His fulsome style in *Summer—A California Woodland* (see plate 173) is an example of light-as-color. Here color is like a thick, rich sauce that can almost be tasted. Bischoff's chrysanthemums and roses may as well be sunsets, and they are perfect excuses to luxuriate in color. Compare his tunnelling *Summer* with Wendt's equally late afternoon (rare for him) light-as-color *Sycamores Entangled* of 1923 (plate 67). Wendt's blocklike slabs of certainty depict no welcoming tunnel into sunlight. His is, instead, a "barrier composition"—a gridlike, confrontational obstruction of skeletal trees that arise from blood-red ground and stand

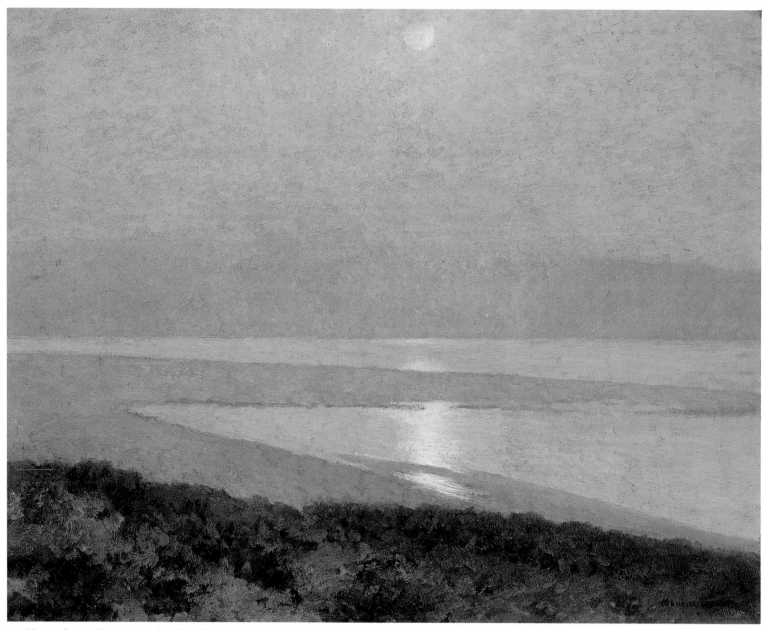

63. Maurice Braun. *Moonrise over San Diego Bay.* 1915.

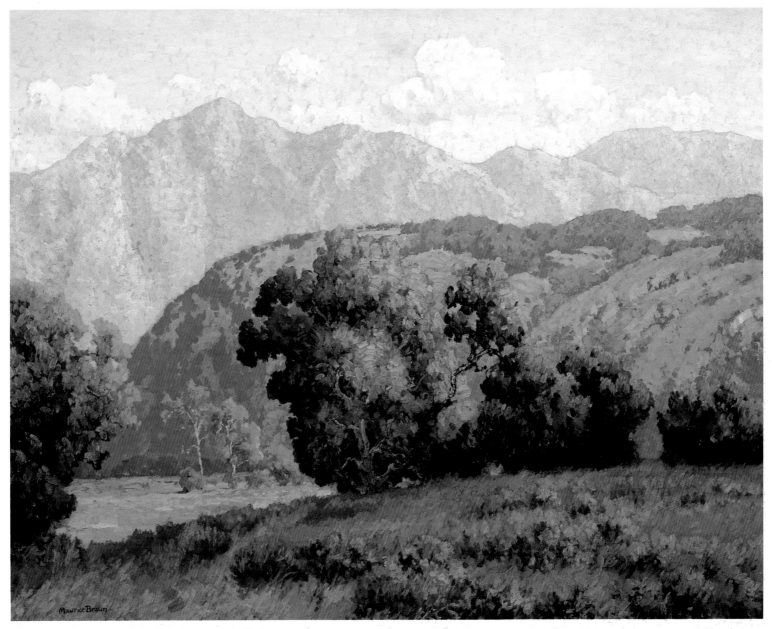

65. Maurice Braun. *El Cajon Mountain [El Capitan Mountain]*. c. 1917.

64. Granville Redmond. *Silver and Gold*.

66. William Wendt. *The Big Tujunga*. 1930.

against the blue-black of almost dangerous hills. And look again at Edgar Payne, the most skilled Southern California draughtsman of his generation, carving out his shapes and colors as if from stone—drawing his color instead of painting it.

While William Wendt laid claim to light-as-color by blocking and gridding it in, Edgar Payne seized light-as-color by drawing it into the triangular shapes of sails and mountains. Payne's scenes of sailing boats—such as his early, ethereal *Adriatic Cargo Boat* (plates 68 and 69) or his later, more relaxed but less subtle and brighter, *Breton Tuna Boats, Concarneau, France* of about 1924 (plates 70 and 71)—are not about boats alone but also about the color reflected broadside from hoisted, untrimmed sails. A massive sheet of sail captures and contains light-as-color, an antenna to claim the hue and a flag to signal the "mood."

Payne's mountain peaks are surprisingly like sails, and they usually perform the same function. Lateen-rigged sails rising from the bay in Payne's *Breton Tuna Boats* are not unlike the lapped peaks rising from a High Sierra lake in his *Fifth Lake* (plate 72). The white sails of *Adriatic Cargo Boats* synesthetically echo the peaks above Tamarack Lake in *Rugged Slopes and Tamarack* of about 1919 (plate 73).[38] The dense, leaden darkness of boat hulls in one painting and the stands of lodgepole pines in the other respectively oppose the sloped, light-filled sails and the mountain peaks. And surely Payne's *Matterhorn from Zermatt* of about 1923–24 (plates 74 and 75) points its great white triangle skyward against the blue precisely like a Newport Harbor sloop's Marconi-rigged sail.

It might be of some psychological interest to explore Payne's triangle as symbol and to uncover meanings beyond color and light. The triangle can be a Freudian symbol of male aspiration, or a Jungian symbol of the urge to escape. The triangle as Neptune's trident may signify the sea (boats), as it was once the alchemical symbol for air (mountains). Upended and superimposed on itself, the triangle becomes a Solomon's seal or a six-pointed star, symbol of the soul.

But the finality of fading evening light, as it is represented in Edgar Payne's high-horizoned *Restless Sea* (plate 76) serves as symbol enough. The massive blue-black and red-black foreground headlands rise up to cover three-fourths of the canvas in all their dark, wet, whalelike bulk; and the spout at the peak is a snowy splash of wave that may as well be a sharp Sierra summit or a sail. *The Restless Sea* is a rare sunset afterglow, and few painters have captured it as well. But gazing into Payne's afterglow is like gazing into a crystal ball. The dream of Eden disappears in an ominous Promethean fire, and the dark flame of human "progress" melds with nature's solar blaze to strike a terrible new light.

Just what is the light of day? What is the primal luminous substance of the daily experience of Southern California? Confined by our air-conditioned, prophylactic lives, can we even *see* the light of day?

In Southern California's "lion country," converging a quarter mile below Lookout Ridge, are Carbon Canyon and Carbon Creek on the east and the oak woodlands of Lions Canyon on the west, with Soquel and Sonome Ridges rolling down toward the urban flatlands and the sea on the south. Here, the curious whistle of the mountain lion can still be heard, although housing development rages like wildfire at the lower slopes. Here, one can still survey an undozed, oak-shagged, and chaparral-encrusted countryside most typical of an earlier time, and one can still watch the mule deer in the meadows at twilight and the redtail hawks and golden eagles riding the thermals at midday.

On Lookout Ridge one lives by the light. One sets one's daily chores by the light, one's pleasures and periods of rest. Now at the summer solstice, these grizzled hills—remnants of the northern range of the peninsular Santa Anas, worn and rounded by a hundred million years' erosion—have mellowed to an amber-gold, composed mostly of red cheat and ripgut brome lately highlighted with the blond delicacy of wild oats. Olive shadows, blanched by smoggy haze, have faded to a wan blue-lavender gray. In the still and windless late morning, shadows are short and value (tonal) contrasts radically diminish. At these times—and for much of the year—the Southern California landscape flattens and withdraws, subdued and diluted as if to vaporize and vanish in the noonday sun.

An image that magically conjures this 1990 view from Lookout Ridge is *California Valley Farm* (plate 77) painted about 1920 by Maurice Braun. With uncanny, numinous prescience, Braun's picture summons and recounts this landscape, and the living image reflects the vision and touch and sensibility of Maurice Braun. That

Intone the light.
WALT WHITMAN

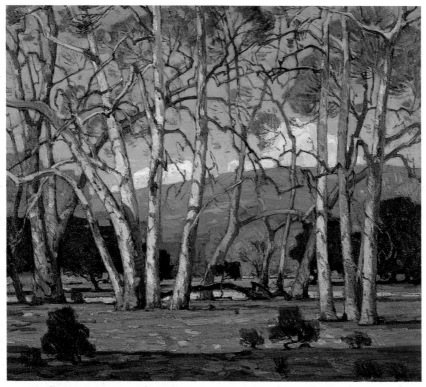

67. William Wendt. *Sycamore Entangled*. 1923.

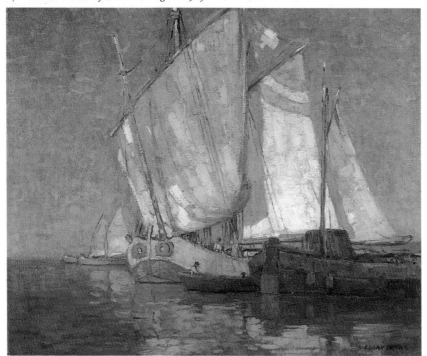

68. Edgar Payne. *Adriatic Cargo Boats*. 1923.

Braun's image of Southern California can still mirror reality some seventy years later is miracle enough, considering the region's growth rate; but that it can fundamentally duplicate today's panoramic valley view from Lookout Ridge is almost a mirage. Neither Braun's valley nor this one is a delusive apparition. Rather, the two seem a kind of co-creation. Capillary and centripetal, Braun's image draws forth from memory's geocentric marrow what T. S. Eliot called "the still point of the turning world."

Indeed, Braun's *California Valley Farm* has all the contrasts and contradictions of a dreamscape—a Shangri-la with shades of Maxfield Parrish—part invention and part representation, a play of illusion and reality that characterizes Braun's creative method. His best paintings stand their ground upon a rather classical mode of pictorial structure. One need only view his solidly composed, Cézannesque *Southern California Landscape* of about 1920 (plate 78). Here, nobility without arrogance, tautness without tightness, belie easy composition. *Los Angeles Times* critic Antony Anderson wrote of Braun in 1917: "The cut and dried composition, the conventional scheme, is generally cast to the four winds by our artist, who therefore offers us arrangements that would be disquieting if they were not so absolutely 'right'."[39] A certain aright stability underpins the lyricism of the man and his work, although a loosening tenderness, even a fragility, emerged increasingly in Braun's later years. Disquieting compositions are not always obvious in Braun's work, but commonly a gridlike picture plane, of verticals and horizontals (trees and horizons) activated by diagonals (mountains and hills), contributes a tangible architectural firmness to a composition that supports an otherwise intangible realm of light and space. See, for instance, the determined structure and coloristic grit of his *Southern California Hills* of 1915 (plate 79). Like *Southern California Landscape*, a gridlike structural rhythm contains the dreams of a lyrical—even musical—sensibility. Dreaming up reality is surely by now a California prerogative, and Braun's motifs (or "motives," as he called them)[40] were composed very like Bach's themes, with endless variations and circlings.

Witness Braun's majestic, Bach-like *San Diego Bay* of 1910 (plate 80). Painted from sketches made near a spot on Point Loma (plate 81), where he would build his home some fifteen years later, the canvas is composed in white light

with a musicality that is both simple and complex. A bold field of billowy, horizontal, overlapping cumulus clouds echoes and re-echoes a horizon that is delicately punctuated along a thin line of city and shore. Horizontality—a recurring symbol of Braun's characteristic tranquility—is reaffirmed in the foreground bluffs and shrubs, and the slight tableland tilt repeats the subtler angles of distant city, clouds, and mountains. A sweeping grandeur of image and structure accommodates nature's fulsome whiteness, and a refined painterly rationale of warm-against-cool hues and large-against-small shapes lends variety to a repetitively strict, frontal, compositional structure. Typical of Braun's more ambitious work, *San Diego Bay* is a composition that lets the imagination soar while, at the same time, its firm, gridlike flatness affirms the picture plane. It is a field of light that not only recalls Bach but also predicts American field painting of half a century later.

Another variation on exactly the same theme under an opposite quality of light—and an even more certain harbinger of sixties field painting—is Braun's meditative *Moonrise*. A tone poem of color, shape, and texture, this equally refined view looks in exactly the same eastern direction toward the same horizon as *San Diego Bay*. These day and night variations on a scene are especially significant as indicators of Braun's personal sense of position and place. Each painting is confident and grounded, formally focused and emotionally steady, close to a centered stillness, which surely confirms Braun's passion and commitment toward this extreme corner of the country and his emotional focal point at this exact spot on earth. It is a site looking east, from which he had only recently arrived, in 1909, and which he would periodically revisit. Both paintings anticipate the view from what was to become his front room and studio (plates 82 and 83). More important, both paintings foreshadow the fields of light inaugurated in America by Barnett Newman and developed in the floating, cloudlike planes of Mark Rothko.

But Braun's is a gentler, more intimate sensibility, and his structure and scale conform more to comforts of the home than to temples and towers of church and industry. His "mood" (as he called it) is lighter, and his shapes and masses are arranged not like sermons and speeches or emotional outcries but like bouquets. Such works would be overwhelmed on most modern museum

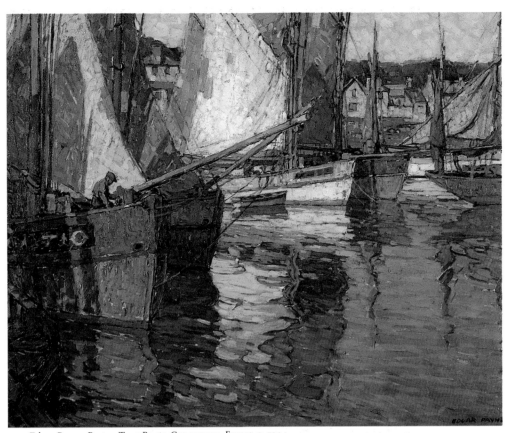

70. Edgar Payne. *Breton Tuna Boats, Concarneau, France.* c. 1924.

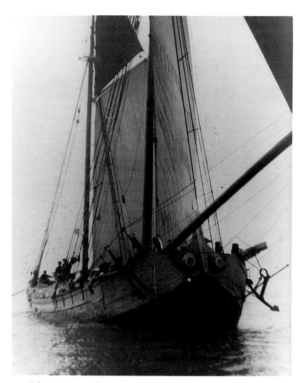

69. Edgar Payne. *Adriatic Cargo Boats*. 1923.

71. Edgar Payne. *Breton Tuna Boats, Concarneau, France*. c. 1924.

walls, as they would be lost in the murk and scale of downtown loft studios; and never do they reflect a smoky or leaden urban light, much less an urban structural and architectural ambience, as the field painting of later decades often does. Such sunny works as *San Diego Hills* of about 1920 (plate 84) can seem too bright to be real, a far-fetched gold and lavender dream trumped up for the tourist trade. Indeed, *San Diego Hills is* a dream, but it is a daydream that accurately expresses the unique light and color of Southern California's environmental reality. Braun's work seeks not the power of strategic theory or the proclamation of image and identity but instead to record a space in which to take flight. It seeks a light outside the studio in the familiar shapes of nature and the openness of horizons—horizons in which pictorial scale does not compete with nature as highway billboards do. Braun's scale is human scale, appropriate to memory and keepsake—like a talismanic charm, or magic spectacles, or a wishing cap. Perhaps his is not even a style as such, but simply an offering in celebration of the countryside he loved.

Nevertheless, as an icon of an era the synthesizing vision of Braun's *California Valley Farm* roots his somewhat otherworldly world in an ongoing genre. The Southern California Dream remains as yet largely unawakened to the increasingly harsh and threatening contemporary environmental reality.

In the yet unawakened Southern California Dream, the day is still filled with a soft, cottony light. It seems a much whiter light than the Italianate or Franco-Mediterranean light to which it is commonly compared. Our sky looks broader, heavier, denser than other skies—somehow more present than in Italy, higher than in France, broader than most anywhere else. Our atmosphere feels thicker than in Northern California where the sky is less milky and the shadows less filmy. The light-dispersing moisture droplets of the Southern California atmospheric haze permeate the few shadows with the same white they give to highlights. Haze or smog is far less dense in Northern California, making shadows deeper and contrasts sharper. Here the shadows are as frosted as a eucalyptus leaf and as planar as animated multiplane Disney cartoons.[41]

Seen elsewhere, Southern California paintings that too indiscreetly reveal this dreamy whiteness can seem pale and bloodless, vague and weak—implying everything from inner vacancy to emasculation (consistent with everything else in Southern California, Eastern critics were once persuaded).[42] Light here erases as much as it delineates, and outshines as much as it illuminates. A fierce, aggressive light, it can devour, metabolize, and absorb its own subject. To the Southern California painter at his canvas, light does not always exist to reveal form; sometimes form exists to reveal light.

Braun's fundamental simplicity of disposition, combined with a curiosity of mind and a workman's steady will, seems to have relaxed his angle of vision, so to speak; and his meanings, like his margins, are unfixed, apparently innocent, and open to many, even contradictory, interpretations.

Nevertheless, there is more to Braun than sweetness and light. When the eye of the beholder is backed by an active mind, Braun's pictorial diversity and internal contradiction are accessible. Even at a glance, Braun's *California Valley Farm* reveals strong, almost unsustainable contrasts. On the one hand, the painting is so laced with haze that it threatens to aerate into tangy afterbreaths and flowery aromas. Braun has painted his landscape in thin air. But, on the other hand, with unlimited soaring, the eye can become exhausted and even disoriented. Seeking rest from an endlessly open vista, the eye returns to the more tangible threshold and surface of the picture plane, grateful to perch securely on a foreground bastion of sedimentary Pliocene rock piled with wild red buckwheat, black sage, and impenetrable chaparral. Nothing in Braun's entire oeuvre is more densely rendered than this flat, impacted foreground. It stands abruptly against the picture plane like the apron on a theater stage, or like a draped still-life curtain, in stark and heavy-handed contrast to the delicate touch that renders the play of light and space in the scene beyond.

The thrust of Braun's spirit is, of course, into deep spatiality: beyond the darkly weighted platform of the foreground lies a platinum morning. But then, much less obviously, another quite different scenario may well unfold. At this more active level of interpretation, the glow of the land can begin to glower, the sleepy farm turn sullen, and the oaks grow brazen with a brassy, sulfurous yellow, which next to dusky lavender sours all the sweetness for miles around. What has begun as airy and open can become in the mind's

To the dull mind nature is leaden.
To the illuminated mind the whole world burns and sparkles with light.
RALPH WALDO EMERSON

72. Edgar Payne. *Fifth Lake.*

74. Edgar Payne. *The Matterhorn from Zermatt.* c. 1923–24.

eye both thick and closed. An experience of painting can resemble not a snapshot but a movie, and, indeed, the Southern California landscape has inspired much of the visual tradition of the Hollywood cinema. These films are intensely visual—not literary, not just stories to be read. They are visually engulfing works of art based on sequences of light that both immerse and transform us.

Braun's openness and apparent simplicity include a temperamental lenience toward the viewer, an allowance entirely respectful of the viewer's subjectivity. Hence, his work can emancipate the active observer, providing the option of an experience that expands beyond the two-dimensional. Braun's openness is not vagueness. It is a clemency that allows and encourages a wholeness of experience—even including formal and expressive oppositions—and Braun himself wrote of painting's ability to prompt several "moods."[43]

California Valley Farm is already a classic icon of the Southern California idyll, but it hangs in different frames of reference with equal aplomb. Even if we over-interpret the painting, no interpreters more wrongly misuse this work than those who limit its meaning to nostalgia and sentimentality. Not just a token of lost innocence, nor merely an embarrassing memoir in the aftermath of "progress," in its simplicity and openness it is all of these at once.

Braun was no showman, and his purposes and beliefs were not worn on his sleeve. His aesthetic simplicity and guileless craft concealed a lifelong philosophical quest for an inclusive worldview that went far beyond the local and regional. He did not stand existentially alone vis-à-vis the world; he had no tormenting inner demon, no need to create himself and the world anew but only to rediscover and constantly reaffirm what, honorably and pictorially, represented to others the nature that he loved. For Braun was an amateur naturalist, and the sciences of nature were a lifelong preoccupation. Paralleling his concentration on light and color is his genuine understanding of local flora, which are usually specifically identifiable in his work by genus and species. Antony Anderson wrote in 1914: "Braun has never been conquered by facts, but he has used them as aids and allies. His canvases have a decided lyric quality, but it is the lyricism of Wordsworth, not of Shelley; it mounts like the lark, but it is not lost in the blue. His pic-

75. *Edgar Payne in the Swiss Alps.* 1923.

76. Edgar Payne. *The Restless Sea.* 1917.

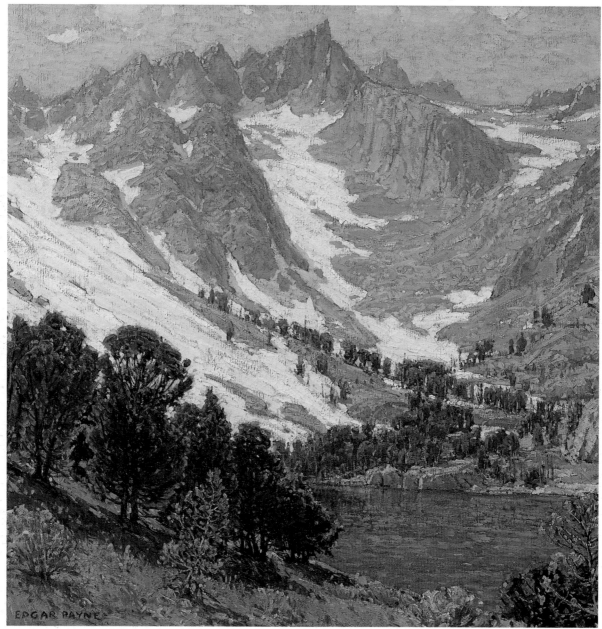

73. Edgar Payne. *Rugged Slopes and Tamarack.* c. 1919.

77. Maurice Braun. *California Valley Farm.* c. 1920.

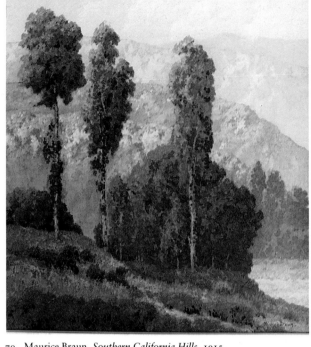

78. Maurice Braun. *Southern California Landscape*. c. 1920.

79. Maurice Braun. *Southern California Hills*. 1915.

tures are always built on actuality, however poetic they may be."[44]

And again, in 1918, Anderson wrote of Braun as "a man who is in love with nature even more than he is in love with art."[45]

The universe is wider than our views of it.
HENRY DAVID THOREAU

In a life of unusual grace for an artist, and with an honest craftsman's consistency, Braun recorded the "actuality" as much as he expressed the "mood" of the Southern California land and light. But beyond his passions for natural history and the artist's craft, beyond his science and his art, what most suggests the complexity and richness of mind that underlies Braun's increasingly serene simplicity is his lifelong involvement in theosophy and its esoteric principles.

The first of these principles is the belief in ancient knowledge: knowledge that surpasses the self-serving and divisive conventions of modern man; knowledge that emphasizes the karmic unity of many worlds, both seen and unseen. Formidably multifarious and labyrinthian, theosophical thought encompasses elements of belief from the classical Greek to Tibetan Buddhism and from East Indian Hinduism to Western Christianity. The "masters," or "adepts," of theosophical tradition include Pythagoras, Plotinus, Buddha, and Christ. The originator of this vast theosophical synthesis, however, was the notably earthy and fiercely creative Madame Helena Petrovna Blavatsky, who, with Colonel Henry Steel Olcott, gathered the first handful of followers in New York City in 1875.

When Blavatsky died in 1891, a struggle over succession between Colonel Olcott and William Quan Judge resulted in an American society with Judge as president. The Theosophical Society flourished in America until Judge died in 1896, whereupon Katherine Tingley formed the new American society on 132 acres at Point Loma in San Diego, California, in 1897. Changing its name to The Universal Brotherhood and Theosophical Society, the domed "white city" of Point Loma flourished for over forty years as the major center of theosophical study in America.

This later, more artistically inclined, manifestation of theosophy under Mrs. Tingley at Point Loma drew Maurice Braun to California in 1909. Mrs. Tingley insisted on his relative independence from the center and provided him with

a studio and living space in the downtown Isis Theater building, then owned by the society. Three years later, in 1912, Braun established the San Diego Fine Arts Academy in the same building. In the years that followed, Braun became a student of Sanskrit, and he read theosophical publications regularly throughout his life, sometimes writing or illustrating for *The Theosophical Path* magazine. During the last decade of his life he became a member of the society's Directors' Cabinet, and in 1937 he headed the art department of Point Loma's Theosophical University, which had been chartered in 1919.[46]

The Theosophical Path was a cross-cultural synthesis of creative and romantic vigor and broad philosophical belief. Classical arts and arcane thought were fundamental to the broad view of theosophy, and they provided a background of rich complexity without which Braun's serene simplicity might not have developed. Above all, theosophy at its highest level seeks a certain "emptiness" of self, of egoic attitudes and even of beliefs, certainly of artistic angst. To a theosophist, a universalizing, unifying emptiness lies behind all human vision and material form. Without detailing the complexities of realizing "emptiness" here,[47] it is necessary to point out that Braun's painting tended to distill the material world toward an emptiness for which his melting, evaporating fields of light and fading, dissolving space stood as metaphor. Braun also had special help and support toward his understanding of the play of form and emptiness from truly exceptional friends, among whom were Oxford's great Tibetan Buddhist scholar, W. Y. Evans-Wentz, who lived next door; and the world-renowned Swedish scholar of Chinese aesthetics and art Osvald Siren, who was a frequent visitor on his trips to and from China. (Braun's last works especially show the influence of Siren's studies of Tang and Sung aesthetics.)

Theosophy's three "fundamental" concepts, God, Law, and Being, lie securely behind the theosophical concept of light. *God* is what it is to *Be*, without beginning or end, in eternal space and endless light; *Law* is the nondualistic, nonseparate, unified field of all life; and *Being* is karma, periodicity, cause and effect, darkness versus light. *Fo-hat*, the light and energy of both God and human consciousness, is represented in theosophy by the Hindu god Isvara. Both transcendent and immanent, external and internal, Isvara as light is author of the universe and material cause of the world. Braun, as a theosophist, sought the light of the sun as a representation of the universal light of the human spirit and the brotherhood of life, and his painting constituted for the theosophist a form of *Gayatri* (also called *Savitri*): a sacred homage or prayer addressed to the sun.[48]

But light is also connected in theosophy to Eros, where light is the male within the female womb of space. Male, the generative principle; female, the passive principle: hence space the mother, light the father. A passage in Blavatsky's major theosophical tract, *The Secret Doctrine*, quoted from her earlier, originative tract of theosophy, *Isis Unveiled*, reveals Braun's theosophical belief in the importance and meaning of light, and illustrates its doctrinal complexity:

> Light is the first begotten, and the first emanation of the Supreme, and Light is Life, says the Evangelist and the Kabalist. Both are electricity—the life principle, the *anima mundi*, pervading the universe, the electric vivifier of all things. Light is the great Protean magician . . . its multifarious, omnipotent waves give birth to every form as well as to every living being.
>
> From its swelling, electric bosom, spring *matter* and *spirit*. . . . It was the ray of this *First* mother, one in three, that "God," according to Plato, "lighted a fire which we now call the sun," and which is *not* the cause of either light or heat, but merely the focus, or, as we might say, the lens, by which the rays of the primordial light become materialized, are concentrated upon our Solar System, and produce all the correlations of forces.[49]

In its quality and intensity, the white radiance of Southern California light bears heavily on early art in this region and, even more certainly, on late Southern California art. Our art has never been especially noted for its structural or formal invention, only occasionally for its chic flamboyance and its beachboy sense of style. Instead— from Guy Rose to David Hockney—the unique quality and intensity of Southern California light and color best define this art, and it cannot be overemphasized that many of the region's late abstractionists are no less under the spell of Southern California light than were the early landscapists. If Braun and his colleagues are our root artists, whose light-filled works can signify an era, then surely they are the generic, if not the ge-

Nature is a mutable cloud
which is always and never the same.
RALPH WALDO EMERSON

80. Maurice Braun. *San Diego Bay*. 1910.

netic parents, however yet unrecognized, of the Southern California Light and Space artists of our own time.[50]

Light and color are notoriously ephemeral and personal. Psychologically variable and physically fugitive, such phenomena cannot be firmly perceived or verbally grasped, much less clearly and exactly communicated. Nevertheless, Southern California has a genre of its own that reflects the special radiance of our light. Such a bare proposal—that the Southern California Light and Space artists near the end of this century are rooted in the work of the plein-air artists near the beginning of this century—takes getting used to. One wishes that some of our root artists were more fortifying growth factors than they are; and some contemporary artists resist perceived relationships as much as they do critical and historical categories, just as this writer does. But is it not likely that the light of contemporary Southern California artists such as Robert Irwin, James Turrell, Larry Bell, Maria Nordman, and Doug Wheeler has its *precedence* (not influence) in the light of early artists such as Alson Clark, Maurice Braun, and Guy Rose? Surely the pale atmospheric delicacy of Maurice Braun's best landscape painting possesses a perceptual and aesthetic relationship to the work of Robert Irwin, a major contemporary Southern California artist whose abstract paintings and installations are equally pale, atmospheric, and delicate. Irwin's studies of light perception are philosophically based meditative expressions, as are Braun's; and Irwin's work has been profoundly significant and widely influential here, not only because of his theoretical teaching and writing but because his installations so keenly organize and focus the essential quality of the Southern California visual experience. Form in the service of light, even to the point of formlessness—whether it is the elegantly bold simplicity of Irwin or the guileless, gentle simplicity of Braun—constitutes a regional preoccupation with all the ongoing continuity of a tradition. From the white light of our plein-air painters early in the century to our "white paper" watercolorists of mid-century to the Light and Space installations late in the century, Southern California artists have been preoccupied with a light so uniquely their own and so pervasive and consuming as to signify not a motif but a milieu, a sense of place, and a spiritual setting. Beginning with the underlying whiteness of oil-on-canvas grounds or water-

81. *Maurice Braun Painting on a San Diego Beach.*
 1918.

84. Maurice Braun. *San Diego Hills.* c. 1920.

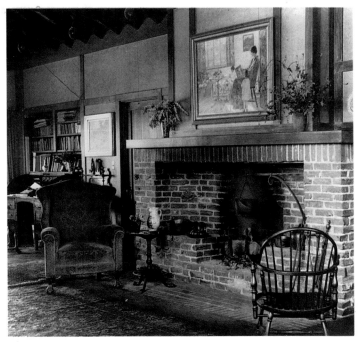

82. *The Braun Studio Living Room Hearth, Point Loma, California.* 1934. 83. *Maurice Braun Painting in his Studio Living Room, Point Loma, California.* 1940.

color paper surfaces and ending with the over-lying whiteness of the light illuminating object and space, Southern California artists past and present have lived and worked in a light perhaps unique in all the world. From the dry, white morning light of Maurice Braun's *California Valley Farm* to the dry white scrims and discs of Robert Irwin or the incandescent whites of James Turrell's projections is only a step between conventions. For all these artists the palette is light itself, and for them light is not simply a visual phenomenon but an engulfing experience. The meditative fields of light in which each artist finds his personal expression are clearly in confluence as they merge in the mainstream of the Southern California Dream.

Today in Southern California, profit defines progress and bottom lines are leveling the landscape. Within hardly more than a century—since the first plein-air landscape painter arrived in Southern California—we have virtually overrun and spoiled the landscape and badly compromised our dream. Old-timers say that Southern California is dead, and that it began to die at almost the same time our landscape painters died—about 1945, just after World War II, when

epidemic disillusion infected culture and the arts, and when the "new man" of the West, with his hard eye and Marlboro-ad stance, crowded out the dreamer.

In this incredibly crucial new decade one hopes the work of Southern California artists will somehow reclaim the dream—as new vegetation reclaims the hills after a wildfire. However romantic or naive it seemed to others elsewhere, and even sometimes to ourselves, that dream was nothing less than a paean of praise for the health, beauty, and harmony of Californians and their environment. Even if compromised, the Southern California Dream remains a meaningful vision and a precious reality.

JOACHIM SMITH
Lookout Ridge
Carbon Canyon, California
Summer Solstice 1989

Here [in California] if anywhere else in America I seem to hear the coming footsteps of the muses.
WILLIAM BUTLER YEATS

THE
COSMOPOLITAN
GUY
ROSE

Guy Rose was one of the most notable landscape painters in Southern California during the first decades of this century. Best known today for his views of the California coast, Rose actually led a quite varied, cosmopolitan career, painting in the United States and France and participating in significant turn-of-the-century art movements.[1] The son of Leon J. Rose, a successful rancher, horse breeder, and winemaker, Guy was born in 1867 on the family ranch in the San Gabriel Valley. His rural childhood gave no hint of his future life. During his formative years as an artist, from 1886 to 1904, he studied art in San Francisco and Paris, worked as an illustrator and teacher in the New York area, and exhibited publicly. Rose's mature work falls into two periods: his Giverny years, from 1904 to 1912; and his American years. After his return to the United States in 1912, he lived on the East Coast, for almost two years. Settling in California in 1914, he worked there until the early 1920s when ill health forced him to abandon painting. Rose rarely dated paintings created during these years.[2]

When Rose arrived in Paris in 1888 he was already well trained. He had attended the San Francisco Art Association's School of Design for at least two years, 1886 and 1887, studying there with Virgil Williams and Emil Carlsen and winning student awards in oil painting.[3] Both Williams and Carlsen were foreign-trained landscape painters; Carlsen also was known for his still lifes. Rose's fruit and flower still lifes from these years, such as the one of plums painted in shades of purple, reveal Carlsen's influence and show how quickly the young Rose developed the basic skills of an artist.[4] In Paris, Rose entered the Académie Julian, perhaps the most popular French art school of the late nineteenth century. He registered in 1888 and again in 1889, studying with noted French painters Jean-Joseph Benjamin-Constant, Jean-Paul Laurens, Jules-Joseph Lefebvre, and Henri Doucet.[5] While Laurens was one of the most popular teachers among American students in the 1890s, all four Frenchmen were well-established artists who taught the fundamentals of academic art: sound draftsmanship, traditional composition, and the importance of figure painting.

Rose's progress continued to be swift and his paintings were soon selected for exhibition in the annual Paris Salon.[6] Three peasant scenes, con-

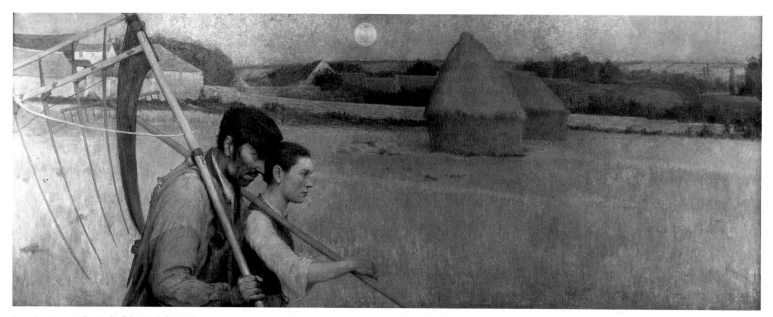

85. Guy Rose. *The End of the Day*. c. 1890–91.

tributed to the Salons of 1890 and 1891, are late examples of a strong tradition of peasant imagery that had been popular since mid-century as a result of the art of François Millet, Jules Breton, and Jules Bastien-Lepage. *The Housewife*, a woman in a peasant kitchen, shares its theme with the small *Madame Pichaud*, a dark painting in rich purples and grays.[7] Both *The End of the Day* of 1890–91 (plate 85) and *Potato Gatherers* of 1891 were set outdoors.[8] While the bent figures in *Potato Gatherers* recall the peasant laborers in Millet's *The Gleaners*,[9] Rose's peasant paintings owe a far greater debt to Bastien-Lepage, an artist heroized by English, American, and French artists by the time of his death in 1884. Indeed, his famed *Joan of Arc* of 1879 (plate 86) was acquired by the Metropolitan Museum of Art in New York. His peasant paintings of the late 1870s and early 1880s offered academically trained artists like Rose a means of combining their figure studies with outdoor settings. Rose's two paintings of peasant field-workers share with Bastien-Lepage's interpretation the dignified character of the peasants, naturalistic figure types, placement of the figures in a landscape with a high horizon thereby visually flattening the image, and an overall soft, grayish tonality.

The End of the Day is a strong painting for an artist barely out of his student years. It dem-

onstrates both skilled draftsmanship and a daring sense of design, and it ranks as Rose's most progressive painting of his pre-Impressionist years. The painting suggests that the artist did not follow one aesthetic narrowly but was open to a number of currents, both conservative and progressive.

The End of the Day is painted on an attenuated horizontal canvas, a shape that Rose rarely used later. This format had long been associated with landscape, particularly topographic views, but its adoption by figure painters coincides with the resurgence of mural painting in the 1880s. The large size and muted palette of soft pinks and grays, similar to those of the most famous muralist of the era, Pierre Puvis de Chavannes, suggest that Rose's choice of color and format may have been influenced by mural painting.

Cropping the figures of the main protagonists at the waist as well as their placement to the extreme left of the composition may owe a debt to the more avant-garde work by Edgar Degas and Toulouse-Lautrec or to their source, Japanese *ukiyoe* prints. Equally plausible is the influence of the American artist Theodore Robinson, who used a narrow, horizontal format, large-scale figure cropped at the bust, and outdoor setting in his 1885 watercolor *Girl in a Red Dress*.[10]

Rose seems to have begun *The End of the*

Day in Crécy-en-Ponthieu in 1890 and completed it the following year in Paris.[11] But the Norman village of Giverny on the Epte River was his inspiration. In summer 1890, Rose was there along with Theodore Robinson, one of the first Americans to discover the village.[12] Robinson may have been the link between Rose and Giverny.[13]

Rose's choice of theme for *The End of the Day* was no doubt encouraged by the grainstack paintings that Claude Monet, Giverny's most celebrated resident, was creating at that time.[14] Monet had been painting this subject since the mid-1880s, and in May 1891 when Rose's *End of the Day* was on view at the Salon, he exhibited his grainstack series at Durand-Ruel in Paris. In his pure landscapes Monet celebrated the nation's agricultural fecundity without reference to its industrialization,[15] while Rose, a recently trained figure painter, no doubt still felt that serious painting required figures and a narrative element.

An elegy to peasant life, *The End of the Day* may also signify the end of the traditional peasant lifestyle that was threatened with extinction by increasing modernization and industrialization. By juxtaposing the standard symbol of death—a man carrying a scythe—with the figure of a young woman carrying a rake, Rose may allude to the young people who were abandoning the countryside for the city in search of jobs.

Many of Robinson's French paintings were outdoor scenes composed around a large peasant figure, and these may have been the model for Rose's painting. Compositionally as well as thematically *The End of the Day* relates to two specific pictures that Robinson painted of Giverny the year Rose began his painting. In *Scene at Giverny*[16] Robinson used an extended horizontal format for a view of buildings and a field of haystacks similar to those in the landscape background of Rose's painting. In another oil, a small study executed in Paris but based on his Giverny experience (plate 87), Robinson added the figure of a peasant, on the left, in strict profile looking directly at a haystack, on the right. Rose's decision to cast his scene in a cool, crepuscular light also may have been encouraged by the palette Robinson often favored, although uncommonly rainy weather in Giverny during summer 1890 may have contributed equally to Rose's choice.

Even though *The End of the Day* is not Impressionist, it previews Rose's later French Impressionist paintings, and the role of Giverny

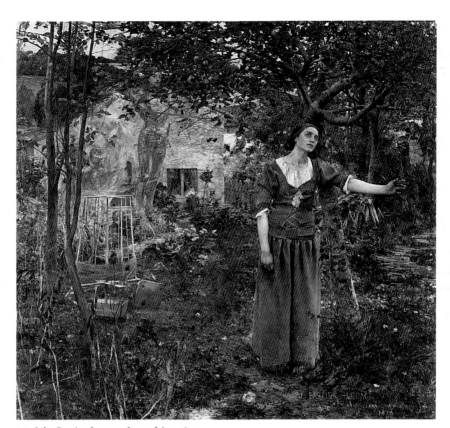

86. Jules Bastien-Lepage. *Joan of Arc.* 1879.

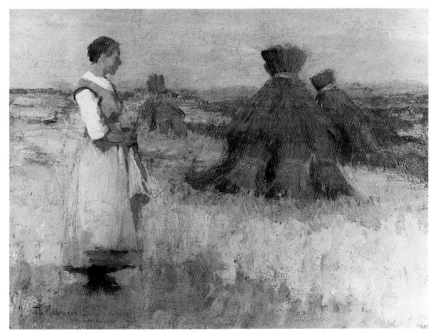

87. Theodore Robinson. *Study.* 1890.

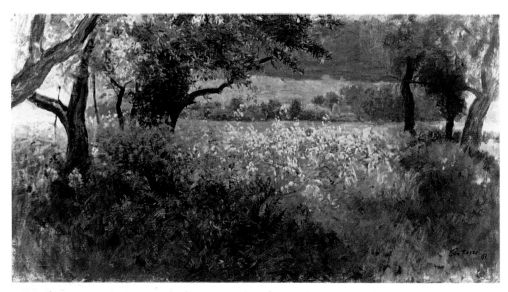

88. Guy Rose. *July Afternoon*. 1897.

89. Arthur Wesley Dow. "Landscape exercise."

as its inspiration should not be minimized. The painting also reveals the artist's preference for delicate effects of natural lighting and compositions arranged around strong horizontals and verticals.[17]

Rose had to abandon painting because of the ill effect of lead poisoning, which he first experienced in Greece in summer 1894. After recuperating in Venice, where he worked on illustrations for *Harper's*, Rose returned to the United States in February 1895. After taking his new bride, Ethel, for a short visit to meet his family in Southern California, Guy and his wife settled in New York, where they lived for most of the next four years. Ethel Boardman came from Providence, Rhode Island, and it seems that the two probably met in Paris where Ethel, like Guy, had gone to study art and where they married shortly before returning to the United States.[18] In New York Ethel and Guy began careers as illustrators and Ethel eventually became highly esteemed in the specialized field of fashion illustration. Rose also taught portraiture and drawing from antique casts at Pratt Institute in Brooklyn, from spring 1896 through the 1898–99 term.[19]

Although primarily involved in illustration and teaching during these years, Rose did not give up painting altogether. One of his few dated landscapes, *July Afternoon*, of 1897 (plate 88), demonstrates that Rose painted pure landscapes before his residence at Giverny. In bright yellows and greens Rose suggested petals, leaves, grass, and ferns with a varied brushwork of dots, larger dabs of paint, and short and long strokes. Although still not truly Impressionist—the tree trunks are too solidly rendered—Rose fully conveyed the sense of summer sunlight, air, and breeze, even using a thin, pure-white ground as did the French Impressionists to intensify the brilliance of the scene. Rose probably painted *July Afternoon* outdoors in upstate New York. During summer 1896, he had conducted an outdoor sketching class at Fallsburgh, New York, and the following year he summered in Sullivan County, New York.[20]

At Pratt Institute, Rose may well have become a friend of Arthur Wesley Dow, who had recently begun to teach life and design classes there. Both artists had studied at the Académie Julian in Paris and both painted landscapes in the French provinces (Dow in Brittany) at about the same time. During the 1890s, Dow formulated the principles of design and composition that

made him famous and were eventually published as *Composition* (1899). With a strong knowledge of French Post-Impressionism and Japanese art, he analyzed landscape as abstract two-dimensional design, arranged according to the organization and repetition of lines and the delicate balance of simplified dark and light shapes. Such a structuring of composition no doubt appealed to Rose, and this is demonstrated by the similarity between the arrangement of trees in his *July Afternoon* and one of Dow's compositional diagrams (plate 89).[21]

In 1899, Rose and his wife returned to Paris, where they both continued to do illustrations for *Harper's Bazaar* and other American magazines. Five years later they settled in Giverny, staying first at the Hôtel Baudy, the center of the artist colony, where most newcomers resided. They then remodeled an old stone peasant cottage, part of the *Sente des grosses Eaux* property, adding a studio. The cottage was situated at the western end of one of the two major thoroughfares in Giverny (plate 90).[22] Not far away, on the opposite side of the small village, were Monet's residence and gardens. Rose described his earlier, initial visit to Giverny:

> When I first saw the French countryside at Giverny, it seemed queer and strange, and above all so wonderfully beautiful, that the first impression still lasts.
>
> The village is on the road from Paris to Rouen, in the lovely Seine valley, between the hills that rise on either side. A long winding road is bordered with plastered houses, whose lichen-covered, red-tiled roofs gleam opalescent red and green in sunlight or look like faded mauve in the shadow. High walls surround picturesque gardens; and long hillsides . . . slope down to low flat meadows through which runs the river Epte, bordered with stunted willows. Trees are loaded with fragrant bloom, and poppies and violets are everywhere.
>
> Here the beautiful days come and go,—each changing season, each hour, more full of fascination than the last.[23]

By 1904 the once quiet village had been invaded by hordes of American artists.[24] Rose became a member of this colony, enjoying not only its artistic atmosphere but its recreational diversions. An avid sportsman, he was reputedly the best shot in Giverny hunting parties. He joined Frederick Frieseke for fishing, and may have also played billiards, badminton, and tennis with Alson Clark, who was another skilled sportsman (plate 91).[25] The country air as well as various athletic activities restored Rose's health and allowed him to paint again.

The invasion of Giverny by so many artists disturbed Monet, who had originally moved there in 1883 because the village offered him quiet and inexpensive accommodations not far from Paris and because it was the perfect natural setting for his plein-air studies. Although he had welcomed the first Americans, later he found it necessary to protect his privacy by refusing to see visitors. Published accounts and reviews on Rose vary concerning the nature of his association with Monet. Rose may have met him during an early visit to Giverny with Robinson, who was one of the few Americans privileged to be on close terms with the French master. Or, he may have met the French artist much later through another American artist, Lila Cabot Perry, who was Monet's good friend and neighbor.

Rose need not have been an intimate of Monet to have felt his influence. By 1904, Monet's art could be studied through his numerous paintings exhibited at the Paris and New York galleries of Durand-Ruel and illustrated in published accounts of his art. Rose certainly experienced Impressionism second-hand through the work of other American artists already painting in an Impressionist mode. During his eight years in Giverny, Rose developed a style that incorporated elements from the work of both first- and second-generation Impressionists.

In Giverny, Rose met Alson Clark and Richard Miller, both of whom later lived in Southern California; and Rose made friends with Midwestern artists Frederick Frieseke, Lawton Parker, and Louis Ritman. In 1910, Frieseke, Miller, Parker, and Rose exhibited in New York as "The Giverny Group." Frieseke, Miller, and Ritman are best known for their figure paintings, set outdoors and indoors, and Parker had come to Giverny in 1904 for the express purpose of painting the model in open sunlight. Although Rose later preferred landscape to figure painting, during his Giverny years he painted a number of figurative works, often sharing models, such as Sadie Frieseke, with the others.

The figure paintings of the second-generation American Impressionists presented an idealized conception of woman. In the late 1860s and '70s, the French Impressionists created gar-

90. Alson Clark, *Giverny*. 1910.

91. Alson Clark. *Tennis Court, Hôtel Baudy, Giverny, France* (left to right: Frederick Frieseke, Guy Rose, and others). 1910.

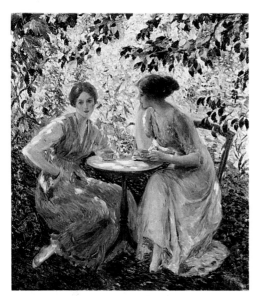

93. Lawton Parker. *Day Dreams* (or *Alfresco Tea*). 1914.

denscapes in response to the gardening craze and popularity of public pleasure gardens and parks among the middle class.[26] Paintings by Monet, and later, in the mid-1880s, by John Singer Sargent, encouraged the development of the floral theme among late-nineteenth-century American artists.[27] By the time Frieseke, Rose, and the other Giverny residents painted women in gardens the imagery had an added social context. While the equation of women with flowers had a long tradition, the Impressionist woman of leisure in a garden came to symbolize the Victorian wife and mother who was beautiful, pure, and above all passive. The private, walled garden represented the safe sphere of upper middle-class domesticity at a time when the family's very existence was threatened by industrialization and the suffrage movement.[28] Just as Rose's *End of the Day* was an idealization of a dying peasant lifestyle, his Giverny figure paintings were a reactionary response to the threat to traditional middle-class values.

Like his Giverny colleagues, Rose often dressed his female models in casual, at-home costumes with a timeless quality, like the oriental kimono and pleated silk tea gown the woman wears in *The Blue Kimono* of about 1909 (plate 92). Rose set his models in gardens less often than his colleagues, but when he did he created richly colored scenes. In *The Blue Kimono* he took advantage of the intensity of natural sunlight to use highly saturated shades of blue, rose, yellow, and green. Typical of many of the academically trained American Impressionists, Rose never lost his sense of the figure, despite the brightness and glare of the sunlight and his vigorous handling.[29] By contrast, Frieseke, in paintings such as *Lady in the Garden*, of about 1912, and Parker, in *Day Dreams* (or *Alfresco Tea*) of 1914 (plate 93),[30] tended to use a more broken brushstroke and flickering patterns of sunlight and shadows that often made it difficult to distinguish figures from their surroundings. Rose differed too from the Giverny Group in his disinterest in the study of the nude.[31]

Boating was another popular theme. Monet and Edouard Manet set the precedent with the boating scenes they began to paint in Argenteuil during the mid-1870s. Two decades later Mary Cassatt and Robinson took up the theme, as did Frieseke, Parker, and others still later. Frieseke's *Two Ladies in a Boat*, of about 1905,[32] is in the tradition of Monet and Robinson, with the

viewer presumably on the bank looking out toward the boat passing by on the river. Rose's *On the River* (see plate 42) follows the more daring composition of Manet's *Boating at Argenteuil* of 1874.[33] In both paintings the boat is cropped at the lower edge of the canvas so that the viewer looks down into it almost as if he were a passenger.

Rose was closest to Frieseke and others of the Giverny Group in his quiet scenes of women seated in comfortable interiors. In Rose's *Early Morning*, strong sunlight flows into the room and forms a backdrop to the figure.[34] Equally important was his fascination with pattern. By combining into one scene a variety of different patterns—decorated garments, drapery, upholstered furniture, and wallpaper—Rose aligned himself with the decorative direction that characterized twentieth-century Impressionism and the Post-Impressionist scenes of Pierre Bonnard and Edouard Vuillard. Rose continued this approach later in his American scenes, with costume and setting often the only indicators of place and date. Examples of this are *The Difficult Reply* (plate 94), probably a Pasadena scene from about 1918, *The Model* (plate 95), with the style of the woman's dress, umbrella, and hat suggesting a postwar date, as do the woman's hairdo and attire in *Marguerite*, exhibited in 1919 (plate 96).

Rose devoted more of his time to landscape painting than to the figure, often selecting locales that were popular with Monet. *The Blue House, Winter*[35] is the picturesque walled property on rue du Chêne that Monet had originally purchased for its vegetable garden and later gave to his stepdaughter and her husband, American artist Theodore Butler.[36] In addition to scenes of the gardens and rustic buildings of Giverny, the Epte River, nearby Vernon, and the valley of the Seine, Rose traveled further afield in Normandy, to Honfleur on the Atlantic coast, and as far south as Antibes.

A comparison of two paintings reveals the scope of interpretation Rose demonstrated in his French Impressionist scenes. In *Fig Trees, Antibes, France* (plate 97), one of his most colorful French landscapes, the brilliant Mediterranean sun on the dried grass of late winter casts the scene in strong golden-orange hues. *The Valley of the Seine* (plate 98) is in a softer, more pastoral mood, and its palette of sweet pastel greens and purples is more characteristic of Rose's French paintings.

Typically Impressionist was Rose's interest in the varied and changing aspects of nature, often indicated in titles that refer to the season, time of day, and weather conditions. *Morning Mists* and *Early Spring, Giverny* are typical.[37] Sometimes he painted two similar views at different times of day or under opposing seasonal effects. In one afternoon he painted two versions of *Low Tide at Honfleur* an hour apart, with the earlier one gold in tone and the later one after the sun had set behind the hills, all in a dusty rose.[38] *The Blue House, Winter* is in light blues, greens, and lavenders to suggest the cold, while the now-lost spring version probably had a warmer palette.[39]

At Giverny, Rose was more intrigued by the light effects of a delicate haze or the nuances of early morning and twilight than by brilliant sunlight. Consequently many of his French scenes, such as *Late Afternoon, Giverny* (plate 99), are characterized by soft, almost wispy brushwork, delicate coloration, and a limited tonal range. In *November* (plate 100), he achieved a quiet mood by limiting the color and value of his palette to delicate greens. In *November Mists*[40] Rose used the same size canvas but turned it on its side to create a vertical and even hazier variation of *November*. The existence of two versions is quite logical, especially since they relate closely to the Mornings on the Seine series Monet painted in 1897.

In paintings such as *The Seine at Giverny, Morning Mists*, 1897 (plate 101), Monet explored the ways in which mist and haze could blur the distinctions between solid objects and their surroundings as well as obscure details and unify the scene. Rose's November paintings not only share the subtle light and atmospheric conditions of the Morning on the Seine paintings but also a similar composition and the view of a river. In *November* Rose simplified the bushes, boat, river, and reflections on the water into a few large shapes and omitted a glimpse of the distant sky that would have given a sense of depth. The trees and river bank are even less defined in *November Mists*. Following Monet's example, Rose investigated the decorative potential of abstract lines and shapes. His November paintings are also close in mood and palette to turn-of-the-century American Tonalist landscape paintings and similar in the light effects he himself used in his early Salon paintings. Rose differed from Monet and the Tonalists in adding a narrative element: two

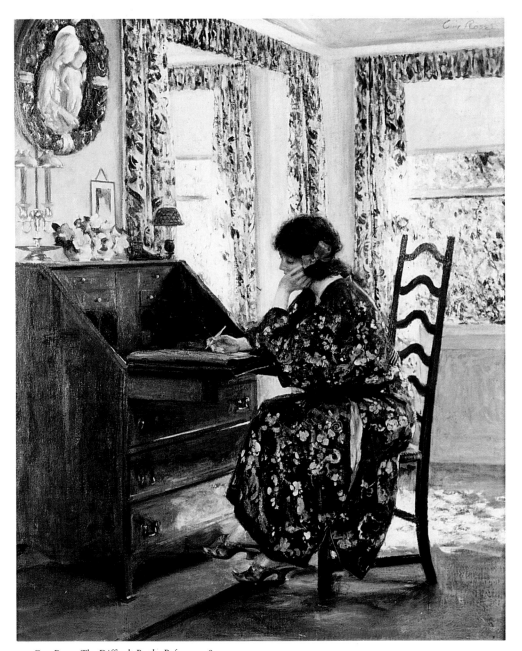

94. Guy Rose. *The Difficult Reply.* Before 1918.

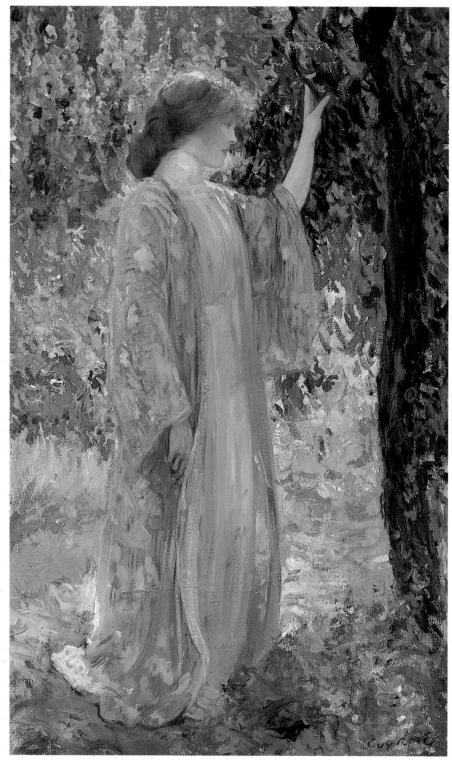

92. Guy Rose. *The Blue Kimono*. c. 1909.

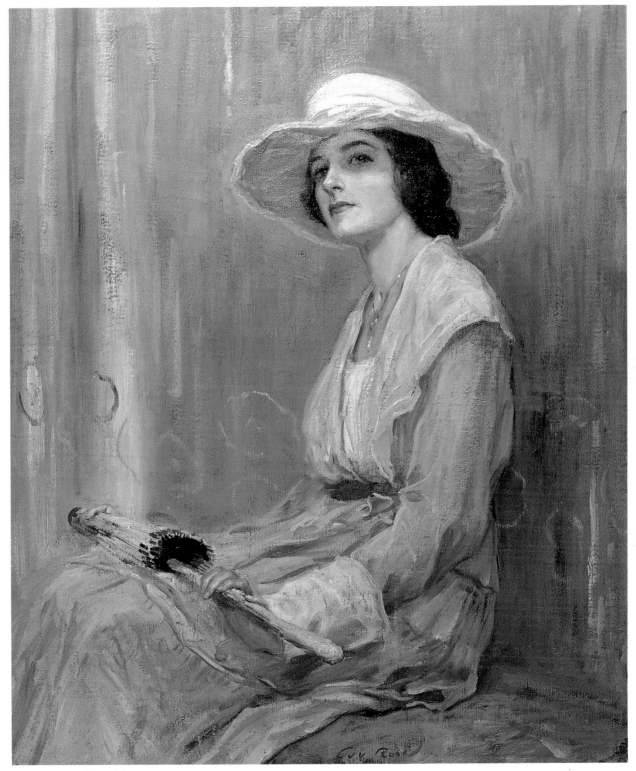

95. Guy Rose. *The Model.*

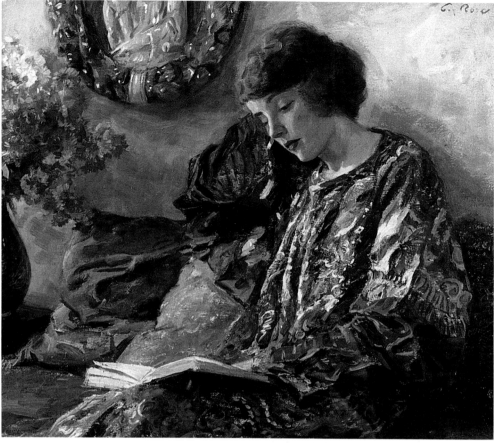

96. Guy Rose. *Marguerite.*

boats in the corner lead the viewer into the scene.

A row of trees silhouetted against the sky became a favorite motif for Rose at this time. *Bowling on the Riviera* (plate 102) and *Tamarisk Trees, Southern France* no doubt were done during the same visit.[41] There is no narrative distraction in *Low Tide, Honfleur* or in *Morning Mists*. The composition, delicate atmospheric effect, and arrangement of trees against the light sky in these two paintings reveal Rose's debt to Monet's *Poplars* series of 1891. Rose continued to use the "row of trees" and "silhouetted tree" motifs in his California landscapes, such as *Moonlight, Carmel*, of about 1918 (plate 103). He found the gnarled limbs and fantastic shapes of the California cypress and the delicately rippled limbs of the eucalyptus as decorative in effect as the French poplars, tamarisks, and fig trees.

After Rose returned permanently to the United States in 1912, he settled for a time in New York and led an outdoor sketching class at Narragansett Pier in Rhode Island during the summers of 1913 and 1914. Resettled in Southern California by the close of 1914, Rose painted some of his most celebrated images in his native state. Living in Pasadena, he quickly became an important member of local art circles. From November 1915 to the end of 1922, he was on the board of trustees of the new Los Angeles Museum of History, Science, and Art and served as its art director in 1917. In 1918 he assumed the directorship of the Stickney Memorial School of Fine Arts in Pasadena. Both Guy and his wife taught at the school and served as caretakers for the charming English house that housed its classrooms and studios.[42]

Soon after his arrival in Pasadena, in February 1915, Rose was given an exhibition at Steckels in Los Angeles. He had numerous other solo exhibitions in Los Angeles, Hollywood, and Pasadena at commercial dealers, including the gallery of J. F. Kanst and Stendahl Galleries, and for organizations, such as the Friday Morning Club. He was also accorded three solo exhibitions at the Los Angeles Museum, in 1916, 1918, and 1919.[43] His work was so successful that by spring 1917 Rose could boast to the New York dealer William Macbeth that he had sold more pictures than anyone else in the area.[44]

Rose perhaps hoped that an art colony like the one in Giverny could be established in the Los Angeles area.[45] For that reason he must have been pleased when his Giverny colleague Richard

97. Guy Rose. *Fig Trees, Antibes, France.*

98. Guy Rose. *The Valley of the Seine.* 1907.

99. Guy Rose. *Late Afternoon, Giverny.* c. 1907–9.

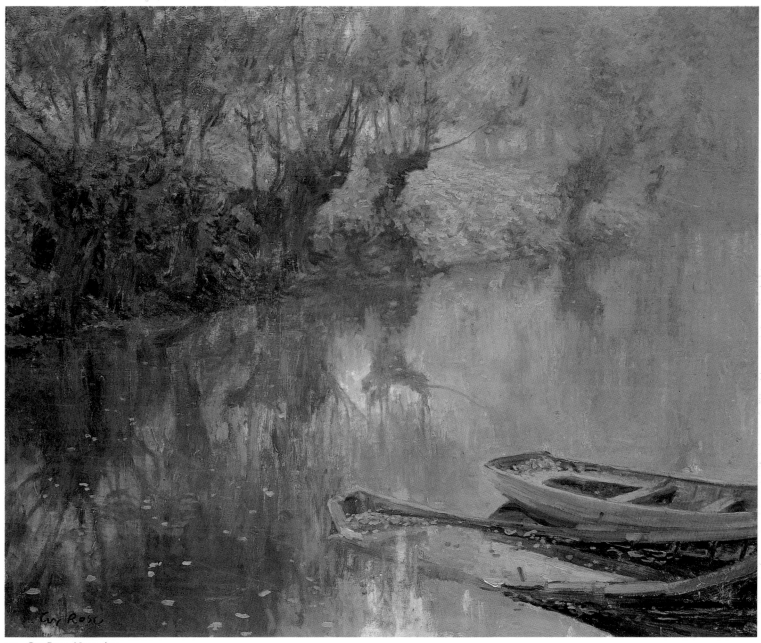

100. Guy Rose. *November.*

101. Claude Monet. *The Seine at Giverny, Morning Mists.* 1897.

Miller came to Pasadena in 1916 to teach at Stickney. Rose's art had more in common with Miller's type of Impressionism than with that of other landscape artists active in the area. Indeed, when Macbeth warned Rose not to send him "any of that damned brown California stuff" to sell in New York, Rose replied that that would not be a problem, since "California does not look that way to me."[46]

During the first three years after his return to California Rose painted mainly in the southern part of the state. Coastal views of La Jolla and Laguna predominate, and these reveal the degree to which he was wooed by the Southern California light. The critic Antony Anderson immediately noted the transformation in the paintings Rose exhibited in 1916 at the Los Angeles Museum.

> He is a stronger painter today, you will admit—and a more American one, certainly a more western one.
>
> His recent pictures from La Jolla and Laguna Beach will tell you exactly what I mean. . . . Charming as are the pictures from Giverny and Toulon, they have not the grasp on the solidities that we find in those from Laguna and La Jolla. They are not so translucently poetic. Perhaps the painter has always needed the sunlight of his boyhood.[47]

The Southern California images do vary, however. Some views share with the Giverny landscapes both a delicate mist and similar composition. More often a clear, pale, yellow light, comparable to the atmosphere of Rose's Antibes paintings, warms the Southern California landscapes, such as *Indian Tobacco Trees, La Jolla* (plate 104). The cloud-filled, airy, blue sky in *Laguna Trees*[48] slightly bleaches and softens the trees into gray-green shades, while the brilliance of the sun sometimes clarifies and intensifies the hues, as in *Incoming Tide*, about 1915 (plate 105), a view of the cove near Arch Beach in Laguna.

In his California landscapes Rose continued to refer to the time of day and to weather conditions, but less often than he had in his French landscapes. One critic explained that the paintings themselves were "less subtle and more detailed" than the French scenes.[49] Rose might have felt that explanatory titles were unnecessary.

Despite his active painting schedule in Southern California, Rose is more often identi-

fied with Carmel.[50] When he first painted in the Monterey Peninsula is not documented, but after that visit he may have returned often. It seems unlikely that he made the first trip as early as 1914, even though the activity there of two of America's most famous artists, Childe Hassam and William Merritt Chase, was recorded by the national press. Hassam was in San Francisco that spring to participate in preparations for the Panama-Pacific International Exposition of 1915, while Chase decided to hold his summer school at Carmel in 1914. Somewhat surprisingly, Rose seems not to have painted there until summer 1918, because there were no Carmel scenes in his one-man exhibitions until his show in May 1919 at the Los Angeles Museum.[51]

The artist Channel Pickering Townsley may have encouraged Rose to visit Carmel. Director of Chase's summer school at Shinnecock, New York, for twelve summers, Townsley came to California to organize the 1914 class at Carmel. When the school closed in late September, he decided to remain in California.[52] Settling in Los Angeles, Townsley became director of the Stickney Memorial School of Fine Arts in Pasadena; he was also instructor at the Carmel-by-the-Sea school in 1915–16, when the Carmel class was officially the summer school of Stickney Memorial.[53] The coincidence of Rose's visit to Carmel in 1918 with his appointment as director of Stickney Memorial suggests a similar relationship, but there is no evidence that Rose held classes at Carmel.

Carmel and the other areas on the coast of the Monterey Peninsula—the towns of Monterey and Pacific Grove—would have appealed to Rose, for they offered some of the most beautiful scenery in the United States. And, by the time Rose visited, several art colonies were already in full force. A mission and the natural scenery had attracted artists in the late nineteenth century, but the area only prospered after the San Francisco earthquake of 1906 forced many local artists to move the remnants of their studios to the peninsula. These artists were able to attract the attention of East Coast collectors through the gallery opened by the Del Monte resort hotel in 1907. Just as Monet in his travels gravitated at first to sites noted in contemporary guidebooks, Rose may have been swayed in his choice of subjects by the popularity of tourist sites.[54]

Rose expected Carmel to inspire a different type of coastal view than had Laguna and La

Jolla.[55] Scenes such as *Carmel Hills* (formerly *Carmel Beach*) (plate 106) and *Carmel Dunes* (plate 107) convey the solitude of nature on a grand scale through their empty, open spaces and cool, floating mists, and they are unlike anything Rose had conceived previously. The entire region fascinated him, from the dramatic, windswept, coastal cliffs to the solitary sand dunes and the quiet interior valley and groves. In these paintings, the distinctive cypress, pine, and scrub oak of the region appear frequently. Rose cast his scenes in the gray mist and fog of the area as well as in the clear sunlight, at midday, in the afternoon with long shadows, at twilight, and under moonlight (see plate 103, *Moonlight, Carmel*), as if he wished to examine the Northern California terrain under all possible atmospheric conditions.

Rose made a large number of paintings of the coastal area, especially of Point Lobos, the cliffs and rock formation along the coast at the south end of Carmel Bay and just below the town of Carmel (see plate 108, *Carmel Coast*). On several occasions he painted a view and then moved a few steps away to paint almost the identical scene; examples of this are *Mist Over Point Lobos* and *Point Lobos, Carmel (Rocks and Sea, Point Lobos)* (plate 109).[56] The similarity between *Out to Sea* and *Point Lobos Headland* has been explained as the first painting serving as the sketch for the more finished work.[57] Indeed, in both the Northern and Southern California views Rose varied his handling from loose brushwork to a more controlled, albeit vigorous brushstroke and even a thick impasto. In some cases, but definitely not all, his painting location determined the handling. The looser, less precisely defined images were usually created quickly, out-of-doors, while in the studio again he devoted more thought and control to his painting. Since few of the coastal scenes have identical counterparts, however, the artist probably did not make a practice of doing preparatory sketches for specific studio pictures.

Whether Rose painted the Carmel views as a systematic study of the area is not known. The coastal scenes seem to be close variations on a few themes: the rocks at the water's edge, a panoramic view of the cliffs and specific rock formations, the sandy path toward the ocean, and the flat, open dunes. While the Carmel paintings are not the same size, they are usually almost square in shape and with few exceptions measure 24 by 29 or 21 by 24 inches. Rose preferred certain compositional treatments and often used a traditional format with a foreground cliff as a foothold for the viewer, whose attention is directed out toward the neighboring headlands, coves, and open sea. Often the distant shore, seen as a thin band of land, becomes the horizon. Almost always, the sweep of the sky fills a third if not half of the scene. Less frequently, Rose presented a more daring composition, eliminating the foreground foothold, as he did in *Point Lobos, Carmel.*

During Rose's student years in France and his later residence in Giverny, Monet was working in terms of serial painting. In Monet's series, a preconceived idea restricted a group of paintings to a single motif or related motifs painted in the same format.[58] Rose probably never thought of his Carmel images as a discrete group, nor were they ever exhibited as a group or referred to as a series. Rather, his Carmel paintings relate more to the sequence of paintings Monet created at Argenteuil during the 1870s. The Argenteuil scenes arose from Monet's day-to-day painting in an area he was exploring over the course of time. Although he chose several motifs, seen under contrasting light and weather conditions, one motif—the bridge at Argenteuil—took on greater significance and eventually determined the composition of Monet's paintings. Rose's Carmel paintings arose from a similar experience, and the rocky shore of the Northern California coast, like the Argenteuil bridge, also may have assumed greater significance as he continued to explore the area. Indeed, Point Lobos became an icon of Rose's experience of the peninsula.

The coastal views of Carmel rank among Rose's most powerful paintings. In the sunlight scenes, the light is less diffuse, sharper than in the warm Southern California atmosphere. Rose heightened the intensity of his hues—deep ultramarine blues and greens often dominate—and painted with a fully loaded brush and bold, forceful strokes. Surely he knew the views of the rocky cliffs of Etretat, Fécamp, and Belle-Isle that Monet painted in the 1880s, and while their invigorated brushwork and strong coloration found no echo in Rose's French work, they were surely an important source for his paintings of the Carmel coast. Rose's *Point Lobos, Carmel* and other views of Point Lobos are often close to Monet's interpretation of a similar rock formation. Rose

102. Guy Rose. *Bowling on the Riviera.*

103. Guy Rose. *Moonlight, Carmel.* c. 1918.

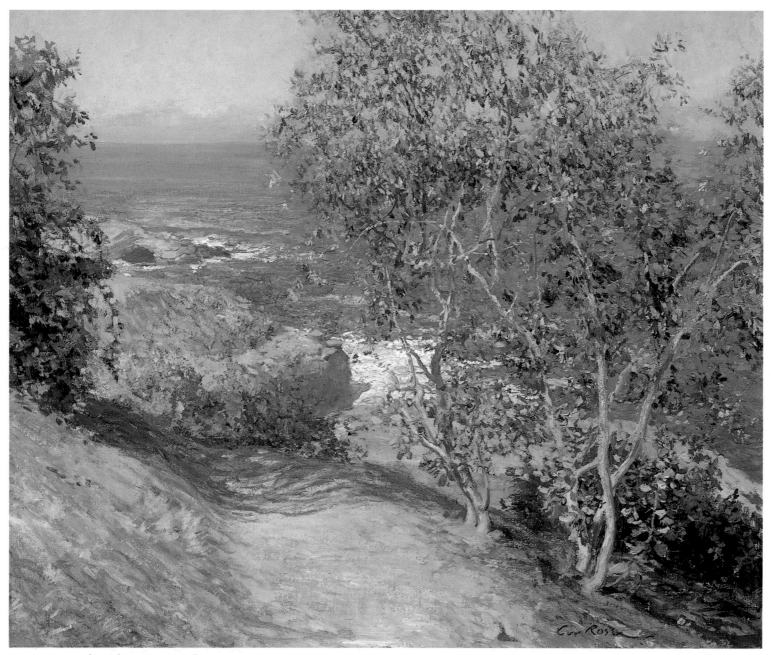

104. Guy Rose. *Indian Tobacco Trees, La Jolla.*

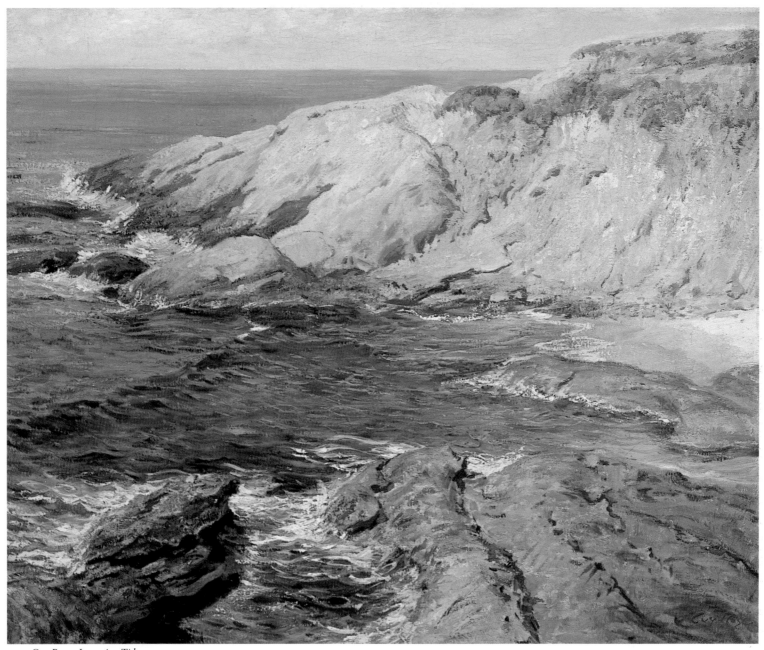

105. Guy Rose. *Incoming Tide*. c. 1915.

106. Guy Rose. *Carmel Hills* (formerly *Carmel Beach*).

107. Guy Rose. *Carmel Dunes.*

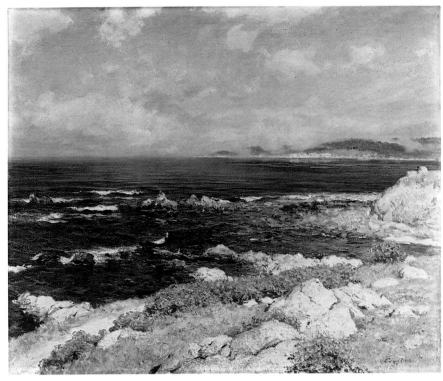

108. Guy Rose. *Carmel Coast.*

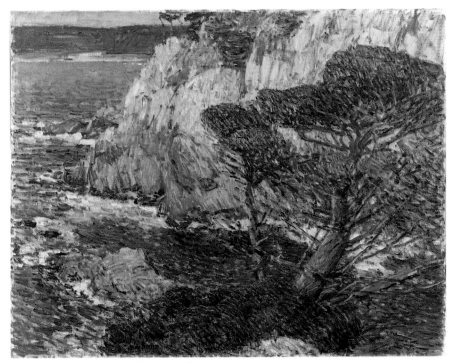

110. Childe Hassam. *Point Lobos, Carmel.* 1914.

even borrowed the unusually sharp downward perspective that results in a high horizon, as Monet did in *Les Pyramides at Port-Coton, Belle-Isle,* 1886.[59]

Rose's coastal views, like Monet's works from the 1880s, have a tendency to present nature, both sea and land, at its most elemental. In this respect Rose came close to the seascapes of Armin Hansen, an artist identified with the northern coast of California. Rose's Carmel paintings are reminiscent of Childe Hassam's Maine seascapes as well, and there is an even stronger similarity between Rose's *Rocks and Sea, Point Lobos,* and *Point Lobos Trees*[60] and Hassam's *Point Lobos, Carmel,* 1914 (plate 110), in brushwork, perspective, and composition.

In his Carmel paintings Rose pushed the limit of his art. He chose not to go further and create more modern, Post-Impressionist landscapes, as did the contemporary San Francisco artists of the Society of Six. By the time of Rose's death in 1925, Impressionism had ceased to be a vital, progressive art movement. Yet the aesthetic had served Rose well, enabling him to evolve a strong, personal, landscape art and one that fit well the fresh and unspoiled character of his native state of California.

ILENE SUSAN FORT

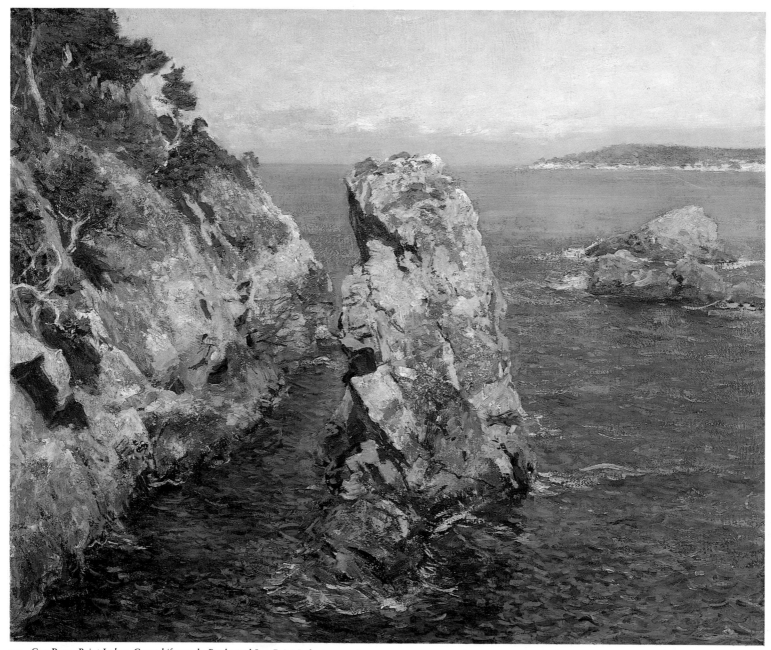

109. Guy Rose. *Point Lobos, Carmel* (formerly *Rocks and Sea, Point Lobos*). c. 1918.

ALSON CLARK *An American at Home and Abroad*

Alson Clark's most potent artistic mentors were William Merritt Chase, who gave him a spirited introduction to the tradition of plein-air painting, and James McNeill Whistler, whose distinctive style and persona attracted many young artists to his short-lived Paris atelier. Clark worked in America and abroad for most of two decades before settling in Southern California in 1920. In France he gradually absorbed the basic tenets of French Impressionism, and for the rest of his career he worked in a modified Impressionist style. But, like many American painters of his time, he never abandoned the penchant for descriptive realism.

Clark was born in Chicago, on 25 March 1876, the second son of Sarah Skinner and Alson Ellis Clark.[1] A prosperous commission merchant on the Chicago commodities market after the Civil War, by the turn of the century Alson Ellis Clark was owner of the Wadsworth-Howland Paint Company. Summers were spent at the family's second residence on Comfort Island, near Alexandria Bay, New York. To encourage the artistic bent their son showed in grade school, the Clarks enrolled Alson in Saturday classes at the Art Institute of Chicago, in 1887, when he was eleven years old.[2] In 1889 the family began a two-year grand tour of Europe, where, during a stay in Germany, Alson received private lessons in watercolor to supplement studies at the German school he was attending.

After their return to America, Clark finished grammar school and began his high school education at the Chicago English High and Manual Training School. Along with algebra, zoology, and German, his extraordinary manual skills and his respect for materials were developed; and at about this time his lifelong interest in photography began. After graduation, he studied at the Art Institute of Chicago from November 1895 through March 1896. Despite two honorable mentions, Clark was bored by the exercise of drawing from antique casts, the tedium of three-dimensional modeling, and the prohibition against using color. Angry and frustrated, he dropped out of the Art Institute. A few months later, he left for New York.

In New York, Clark found renewed stimulation in the school newly formed by William Merritt Chase. Among his classmates were Marshall Fry, Eugene Ullman, and Lawton Parker, who was also an assistant at the school (plate 111). Chase had been one of the most popular instructors at the Art Students League, and he not

111. *The William Merritt Chase School, Class Photo, New York City.* 1897. (Left to right, top row: second figure, Alson Clark.)

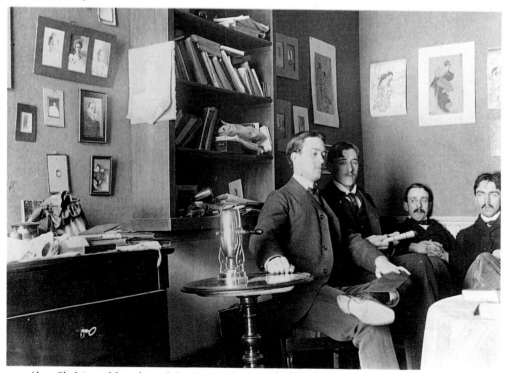

112. *Alson Clark (seated far right) with friends, Paris Studio.* c. 1901.

only reinforced Clark's innate traits but also cultivated in him the faculty of quickness in capturing a subject. Chase's painting, too, was a model for aspiring young artists, who looked closely at the pictures that dominated the shows of the Society of American Artists—works by Sargent, Whistler, and Chase.

Chase's advice to his students tended to be positive, spirited, and specific, filled with technical as well as liberating suggestions: be impulsive, keep your interest at white heat; don't imitate, don't copy, don't fall into habits; draw with color. Experiment, but at the same time use the best materials: "Fine technique is like the giving forth of a perfume."[3] Among Chase's recommendations were the use of a moth-eaten brush, a finder (black on one side, white on the other),[4] a thread through the canvas at the vanishing point to help establish lines of perspective, a varnish formula—two-thirds mastic varnish, one-third refined linseed oil—applied sparingly with a cloth. Finally, he admonished, "Don't argue, PAINT!" By the end of Clark's first year in New York, in November 1897, Chase observed that his student's work was much improved over the previous year.[5]

Clark studied with Chase both in New York City and at Shinnecock, on the east coast of Long Island, from fall 1896 until 1898. At Shinnecock, Chase taught a summer class from 1891 to 1902, where serious outdoor sketching and painting or still-life studies (indoors on rainy days) alternated with more active summer pleasures—going to town on "wheels," golf on a neighbor's lot, swimming, kite-flying, banjo-playing, and Monday evening dances at Chase's studio. Clark and several other students rented an old ranch in summer 1898, with "a corn crib, barn, two chicken houses and a big house and grounds. 20 chickens."[6] Securing their subsistence one Sunday evening in July, the group excitedly captured eight chickens in the trees and, clipping their wings, managed to contain them in a coop Clark had built that morning. But the more serious events of the season were the Monday morning critiques by Chase of student work from the previous week, and on two occasions that summer he kept for himself a sketch by Alson Clark.

Chase instilled in his students the need for European study to enhance and complete their training as artists. In January 1898, Clark mused about his artistic future: "I can't think of defeat in art. . . . I hate to leave the folks to go abroad

but suppose it is my duty to myself."[7] Lawton Parker and Eugene Ullman were already in Paris, and by mid-November Clark and two of his Chase School classmates, Melvin Nichols and J. Coggeshall Wilson, reached London. At the British Museum, they looked at Michelangelo, Raphael, Titian, and Rubens, and at the National Gallery, Clark especially admired portraits by Velázquez and Hals. And after locating John Singer Sargent's place on Tite Street, they made an unsuccessful attempt to see the painter himself. By 23 November the group reached Paris, where "all looked gloomy and dirty and forlorn." They went directly to Lawton Parker's and from there Parker and Eugene Ullman escorted them to the Hôtel Minèrve. The next morning they looked in on the crowded Académie Julian, "which disgusted me," Clark wrote.[8] Two days later they found an apartment at 17 rue du Dragon; and on 28 November Clark and his companions enrolled in the Académie Carmen, the newly opened Paris atelier of Whistler and Frederick MacMonnies, named for its manager, Carmen Rossi, who had modeled for Whistler since she was a child.[9]

Clark's first impression of the school at No. 6 passage Stanislaus was negative. "We got bum places and as a whole the school is rotten"; then he added, "I drew and had rather good luck." On 30 November, Whistler gave a talk to the students but no individual critiques. "He makes a noise like he is grooming a horse when he paints."[10] But, on New Year's Day 1899, the attitude changed. That morning a group of students went to the school and then on "to Whistler's studio where we had a treat seeing his pictures and work. He gave us cigarettes and champagne and was very amiable."[11] Admiration for the master's work grew as well. On 3 January, Clark went "to Luxembourg and had a good look at the fine Whistler [*Arrangement in Grey and Black No. 1: the Artist's Mother*, 1872, purchased by the French government in 1891, is now in the Louvre, Paris] and all the other good works. One likes the Whistler more and more the more one sees it."

By spring 1899, the Académie Carmen had begun to falter. Most of the students in the men's life class had left—including Alson Clark—unwilling to accept the deliberate, slow progress Whistler required. Yet Whistler's students had not only been exposed to the accumulated wisdom of his last years but also to the evidence in his work of direct contact as well as sympathy with the French Impressionists.

On 9 April 1899, Clark learned that his first submission to the Paris Salon had been rejected. A week later, he left with J. Coggeshall Wilson on a ten-day trip to Belgium and Holland, where the work of Hals and Rubens again caught Clark's eye. Returning via Cologne, he found the cathedral a beautifully proportioned building but the stained glass "fierce." Holland interested the travelers most, and they talked of returning for the summer. Soon after, Wilson did return, with Eugene Ullman; but Clark went on alone for a week in May to Tours, Nantes, and Basse-Indre, trying to decide if he should return to Chicago after a Paris doctor had urged him to undergo an appendectomy. On 1 June, Clark sailed for home. He returned to Paris in mid-November with new vigor and confidence after successful surgery.

From late fall 1899 until mid-May 1900, Clark worked with renewed concentration and enthusiasm. Often he drew and painted from models who came to his studio: Pauline; a young Italian named Louise; Miss Whitticomb, a model he shared with Will Howe Foote. Sometimes his subject was a fellow-artist posed by a window, and there was a rare pastel self-portrait. At other times he depicted the studio interior, or a still life of oysters or fish. At times he sketched Paris landscapes—the Seine or a wreck at the Pont-Neuf. After five months at Comfort Island, Clark returned to Paris again, in November 1900. He and Wilson intermittently attended classes at the Académie Delacluse; and in December Clark briefly joined the class of Alfonse Mucha, the Czech designer prominent in the Art Nouveau movement (plate 112).

From 1899 to 1909, the influence of Whistler can be clearly seen in Clark's paintings, in both their formal structure and in his attempt at a careful tonal mood, suggestive of Whistler's "arrangements." The teacher's interest in Japanese prints is evident in Clark's spatial organization and his use of a deeply angled point of view, and in several paintings Japanese prints or ceramics are part of the setting. Clark's *Violinist*, his first acceptance by the Paris Salon, in 1901, is a Whistlerian portrait set against a sparse background and presented in somber, harmonizing tones.[12] The painting was hung *à la ligne*! In spring 1901, Clark traveled in Normandy with artist friends, and his *Sunset, Normandie*, of that

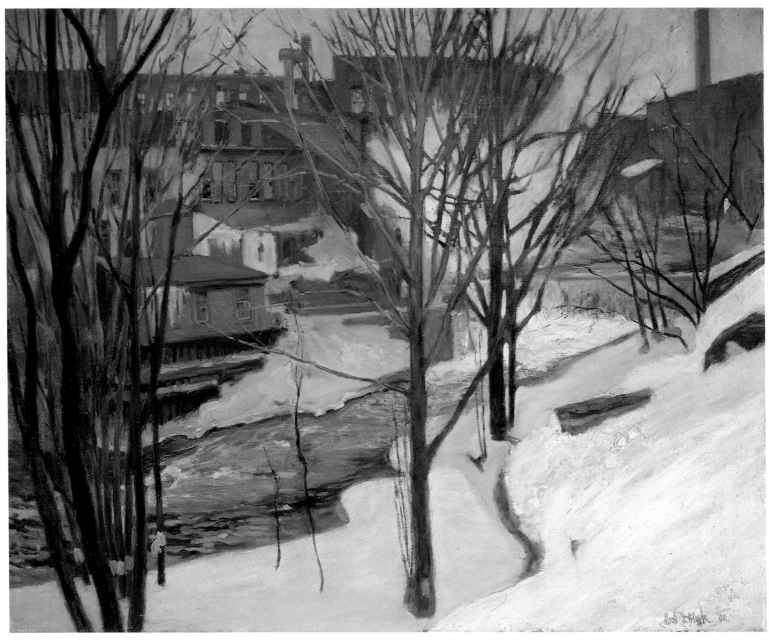

113. Alson Clark. *The Black Race*. 1902.

year, could easily be termed a Whistlerian "arrangement" of soft, tonal, pastel colors.[13] The mellow variations in tone, from the lavender blues and mauves of the distant mist-veiled hills to the pink horizon and the gradually deepening greens and aquas of the sky, are all held in delicate harmony by the pervasive, underlying, soft red that warms the entire painting.

Later in 1901, Clark returned again to America, and early in 1902 he set up a studio in a converted stable in Watertown, New York, not far from his family's summer house on Comfort Island. That winter he painted often along the Black River, and *The Black Race* (plate 113) is a somber winter scene of the sluice, or race, on the river near Watertown (plate 114). While this painting evokes some of Whistler's tonalities and suggests very little of Chase's influence, its theme and style are in many ways associated with Robert Henri. Its provocative subject—urban despoilage—has a parallel in the works of the "Ash Can School," which frequently focused on the downtrodden, and on the seamier elements of city life. *The Black Race* was Clark's first critical success with an American painting, and it was exhibited widely, in New York, Chicago, Cincinnati, and Philadelphia.

At Watertown, Clark soon built a darkroom in his studio to print the photographs he made as naturally as he drew and painted. In the spring he planned his first one-man show, an installation of his French paintings in his studio, opening it on 10 March 1902 to an attentive but unaccustomed Watertown audience of about forty people. One canvas sold, *The Sun in the Luxembourg Gardens*, to Mrs. Jack Taylor.[14] Energetically working alongside him to realize this show was Atta Medora McMullin, whom he had met the previous December and who became his wife the following October. In November, Clark returned to Paris with his bride, and the couple soon settled into a sunny balcony apartment at 6 rue Victor Considerant, near the Place Denfert-Rochereau. Paris soon became home for the Clarks, and they began to spend at least part of each year in Europe and the rest in America until the outbreak of World War I.

Whistler's influence is again much in evidence in *From Our Window* (plate 115), of 1903, a view of Paris from the Clark apartment. An oblique perspective moves the viewer into the distance via a left-to-right zigzag, a compositional device Clark used often. On a stagelike foreground arena, a group of masonry workers cuts stone blocks; well beyond, lies the cemetery of Montparnasse; and in the far distance, apartment houses line the Seine. Dominating the picture is a distant overcast sky, with an ethereal space of veiled sunlight in the foreground. On first reaction this painting seems to be an arrangement in greens and grays. It is rather a synthesis of Clark's training, expressed in a unique and personal style, both in the handling of light and in the complex picture space.

In spring 1904 the Clarks left Paris to tour Italy, arriving in Genoa on 7 April. En route to Naples they made brief stops in Pisa and Rome. In Naples, Clark began to paint, depicting streets and fields with buildings massed in sunlight and a view of Vesuvius from the hotel window. On 14 April, Medora wrote in her diary, "Am in love with this foolish city where every coachman yells at you and every one sticks you for a sou." Turning north again, they explored Roman museums and monuments for five crowded days and then moved on to Florence. There, between visits to the cathedral and the museums, Clark painted the Ponte Vecchio, a view looking out over the city, the Church of San Miniato, and the Porta Vecchia. In Venice a chance encounter with Lawton Parker led them to an altarpiece by Palma Vecchio. Clark soon painted Saint Mark's at night, a view under a bridge with the green doors of a building reflected in the canal, and another looking through an arched colonnade. Again he sketched observed details, such as a single door or a picture frame. At each stop, visits to cultural monuments alternated with trips to see pictures, as the Clarks energetically absorbed the vitality of Italy.

Soon after the Clarks arrived in Paris their apartment became a gathering place for friends and colleagues, including Eugene Ullman, Lawton Parker, Frederick Frieseke—who painted Medora against the light of the balcony—Will Howe Foote, and many others. Most of their friends were Americans, many were Czechs, some English, Scottish, Russian, Australian, Spanish, and a few French. At first the apartment was also the studio, and Medora continued to be Clark's primary model.

In winter 1905 Medora Clark posed for *The Necklaces (Les Colliers)* (plate 116), one of a series of paintings that explores the motif of a woman turned away from the viewer and reflected in a mirror, a device that has often been

114. Alson Clark. *The Black Race, Watertown, New York*. 1902.

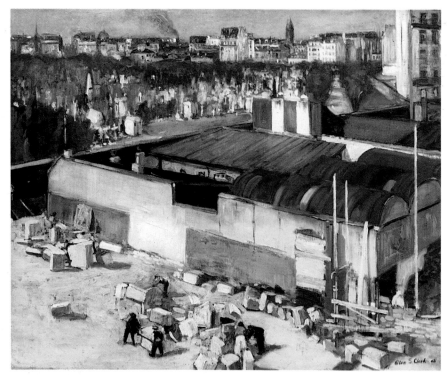

115. Alson Clark. *From Our Window, Paris.* 1903.

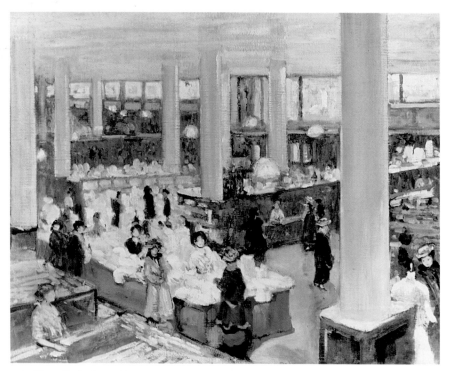

118. Alson Clark. *Carson Pirie Scott Department Store.* 1905.

used by Western artists since the 1860s (see plate 117). A similar pose was adopted by Clark's colleague, Richard Miller, in *The White Shawl* (see plate 40). Standing before the white marble mantelpiece in their apartment, about to decide which necklace to wear on her fashionable bare shoulders, Medora is dressed and coiffed precisely à la mode. The S-curve of the firmly corseted body, the white evening gown with ruffled bodice and train, and the "Gibson Girl" coiffure coincide perfectly with the 1905 date of this painting. Another picture of the same year exemplifies Clark's abiding interest in a different kind of subject, the architectural landmark. That fall in Chicago, he painted several exterior and interior views of Carson Pirie Scott and Company, the downtown department store designed by Louis Sullivan. This interior view of the store (plate 118) was developed from one of Clark's smaller sketches of the building.[15]

In January 1906 amid a fierce blizzard the Art Institute of Chicago opened Alson Clark's first one-man show in a museum with a gala formal party. Fifty-seven paintings were exhibited, primarily works from Brittany, and the show was enthusiastically received by the critics. Later that month, Clark returned to painting Chicago winter scenes and Medora posed for Lawton Parker on several occasions. One February morning, when the studio became too dark for Parker to paint from his model, he joined Clark to sketch near the State Street bridge. Clark's best-known painting of this time is *The Coffee House* (plate 119), begun in late January and painted from a bridge-tender's house on the Chicago River. That October, this view of the State Street bridge in the winter fog and smoke gained him the Art Institute's annual Martin B. Cahn Prize for the best painting by a Chicago artist. In many ways *The Coffee House* is similar in feeling to *The Black Race* of 1902, an urban winter scene in somber tonalities. A Chicago newspaper reviewer found it "realistic . . . in the 20th century spirit," no doubt comparing it to the work of Robert Henri and the Ash Can School (see plate 120).[16]

For Alson Clark's portraiture, Whistler's influence was profound. *The Green Parasol* (formerly *The Green Umbrella*, plate 121), painted in Clark's Watertown studio in April 1906, may represent the amalgam of Whistlerian thought in Clark. Medora is posed casually, turned away from the viewer, her face reflected in a conveniently placed mirror. The long swaying curve of

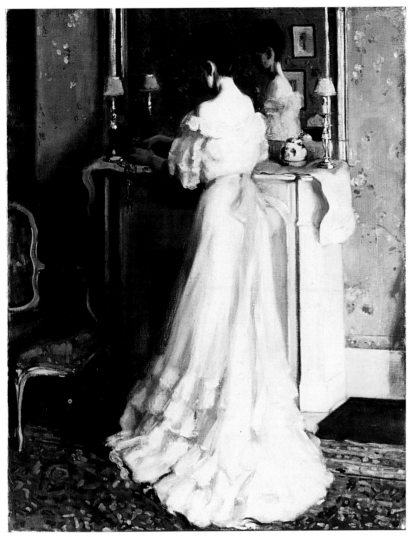

116. Alson Clark. *The Necklaces (Les Colliers)*. 1905.

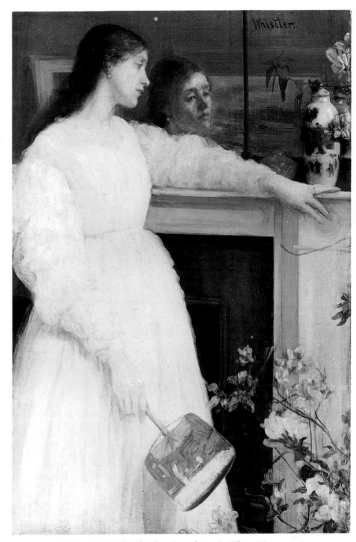

117. James Abbott McNeill Whistler. *Symphony in White, No. 2: The Little White Girl*. 1864.

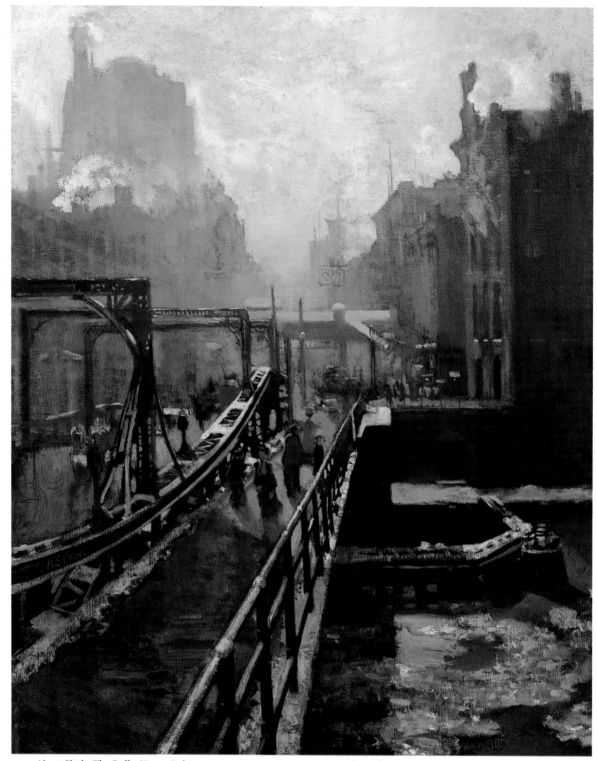

119. Alson Clark. *The Coffee House*. Before 1906.

her dress counterpoints the vertical and horizontal lines of the dresser and mirror, while the influence of Japanese art is evident in the carpet pattern, the wallpaper, and the blue-and-white porcelain jar. Clark delighted too in the nostalgia inherent in costumes and accessories from earlier times, salvaged from the attic trunks of family friends. As he developed *The Green Parasol*, he photographed Medora in a dress from the late 1860s (plate 122). The enormous skirt of the dress hangs in loose folds at the back, for "large hoops are doomed, no one wears them in Paris now," *Godey's Ladies' Book* reported in January 1867. Also typical of the late 1860s are the sleeves and the watered silk or "moire" fabric; but the lace collar and "jabot" are later, probably from the 1870s or '80s; and the parasol is of a style popular in the 1840s. Although Medora wears a "Eugenie" hat of the 1860s, the fullness of her hair betrays the "Gibson Girl" look of the 1900s. Yet, despite this pastiche of modes and motifs, Clark harmonizes the overall mood of the picture poetically, in carefully chosen tones, giving it a feeling of gentle melancholy.

In November 1906 the Clarks postponed a long-planned trip to Japan to prolong a Quebec visit, which at first had been only their starting point for the Far East. Again the winter landscape fascinated Clark. Even in the deadly cold of the Canadian winter he insisted on painting outdoors, often of necessity on snowshoes. When the paint froze on his palette, he had a small, coal-heated enclosure devised to keep them pliable. For a fortnight during their stay, Medora awaited Clark in the tiny village of Saint Pacome while he traveled to a remote logging camp in the Laurentian Mountains. Despite the forty-degree-below-zero weather, he succeeded in returning with several studies of the loggers at work.

In summer 1907 the Clarks returned to Paris, and in a newly purchased tri-car—a three-wheeled vehicular novelty with a passenger seat in front—they traveled in the French château country. There Clark produced a body of work significantly brighter than the earlier Normandy and Brittany scenes. In these new pictures the walls of the châteaus are bathed in warm sunlight and the colors are bold and strong, as his work begins to reassert the heritage of William Merritt Chase. Clark's final conversion as a painter of sunlight came in 1909, on an extended trip through Spain with Medora and one of his old Chase School classmates, F. Luis Mora, who pro-

posed the trip. Clark's Spanish paintings, and the sketchbooks he was constantly filling, are a remarkable achievement. There are scenes from Málaga, Casarabonela, a remote mountain village; Seville, where they spent Holy Week; Granada; and Madrid; and from short side trips to Toledo and to Segovia, where they met one afternoon with Ignacio Zuloaga. The piercing Spanish light is evident throughout these works; the colors are bold and strong; and the mood is spontaneous and light. Except for his Italian visit, Clark had not worked in Southern Europe, and the contrast between these paintings and those of Northern climates is dramatic.

One of the outstanding pictures from their stay in Madrid is the *Plaza of the Puerta del Sol, Madrid*, painted on a bright afternoon after a passing rainshower (plate 123). In Madrid, Clark found the strong, almost overwhelming power of the sun. Conceived from a second-story vantage point looking across the plaza to a broad avenue in the distance, the composition is very reminiscent of Parisian street scenes by Pissarro. Perspective lines unite at the center of the painting, with a secondary focus leading from left to right. People mill about, some entering and some leaving the scene, and the cropped streetcar in the foreground reinforces the passing moment. These formal elements and the brilliant prismatic color are clearly linked to the French Impressionists and not to Whistler. A delightful watercolor notation of the plaza from one of Clark's sketchbooks has all the animation of his first intent (plate 124).

Yet Whistler's power and presence are not forgotten in Madrid. One very interesting and charming little sketch, *Plaza del Sol at Night* (plate 125), of the plaza from the same vantage point, is very Whistlerian. But the eerie glow of the huge gaslights entirely changes the character of the scene. In the background, dimly lit buildings blend softly into the darkness, and the deep spaces evident in the daylight painting are now merely imprecise shapes that serve only as backdrops for the glowing foreground shapes. *Plaza del Sol at Night* is truly a Whistlerian nocturne in every sense of the term (plate 126). While Spain had led Clark to paint bright, sunny, color-filled views, this small, intimate night scene was evoked by his strong and abiding admiration for Whistler. In March 1910, Clark showed thirty-eight of the Spanish paintings at the O'Brien Gallery in Chicago. Not only was the show a critical

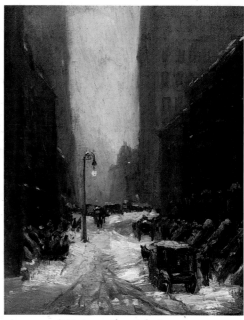

120. Robert Henri. *Snow in New York*. 1902.

122. Alson Clark. *Medora in Clark's Watertown, N.Y., Studio.* 1906.

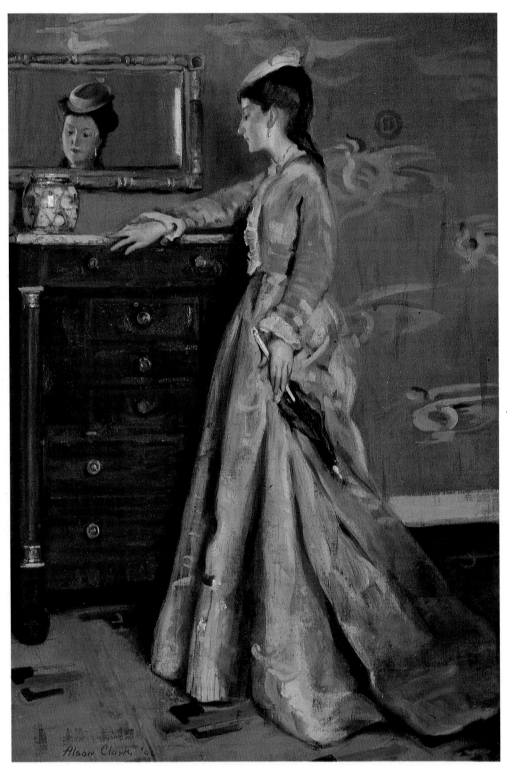

121. Alson Clark. *The Green Parasol* (formerly *The Green Umbrella*). 1906.

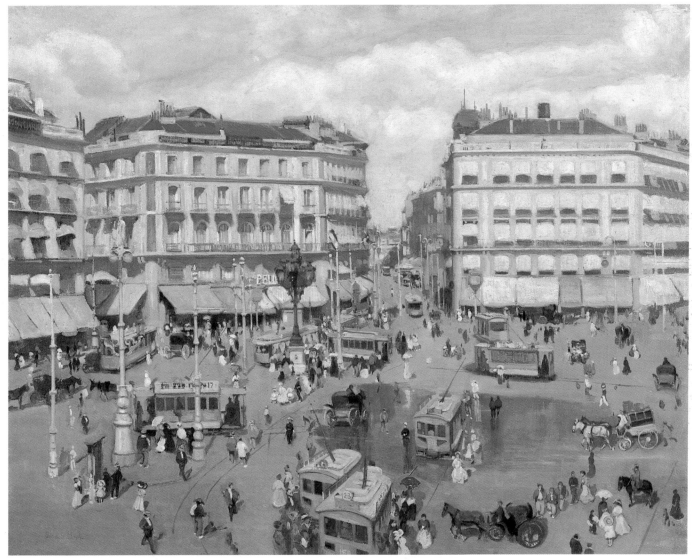

123. Alson Clark. *Plaza of the Puerta del Sol, Madrid*. 1909.

124. Alson Clark. *Plaza of the Puerta del Sol, Madrid*. 1909.

125. Alson Clark. *Plaza del Sol at Night.* 1909.

126. James Abbott McNeill Whistler. *Nocturne in Black and Gold, the Falling Rocket.* c. 1875.

127. Alson Clark. *Medora Clark* [left], *Sadie and Frederick Frieseke, Giverny.* 1910.

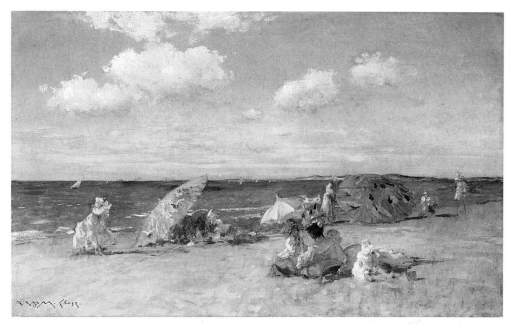

128. William Merritt Chase. *At the Seashore.*

success but all of the work was sold. When the art critic Harriet Monroe wrote about the Spanish paintings for the *Chicago Tribune*, on 5 March 1910, she asked Clark why he did not paint at home, or in "our vividly colored southwest." He responded that "'it costs so much more to live in America . . . studios are expensive, also travel and hotels out west, where I often have longed to go. In Paris studios are cheap, and there are crowds of artists from everywhere whom one can make friends with; and besides competition and comment are so keen that a man is kept up to his best work, which would be difficult in a lonely desert in Arizona.'"

In spring 1910 the Clarks returned to France, and they spent that summer and fall in Normandy. From fall 1910 until about 1917, Clark worked in a style that closely resembled French Impressionism. Traveling with the Clarks in Normandy in 1910 were the Eugene Ullmans and their children, and the group settled in the coastal village of Urville. Clark's visit to Giverny during October and November seems to have been at the suggestion of Lawton Parker who was living there at the time, as were their friends Frederick Frieseke and Guy Rose (see plate 127). These artists formed part of "The Giverny Group," a name they adopted when they exhibited together at the Madison Art Gallery in New

130. Eugène Boudin. *The Beach at Bénerville, Marée Basse.* 1892.

129. Alson Clark. *On the Beach, Urville, Normandie.* 1910.

York in 1910. An album, which Medora began in 1904 of drawings dedicated to her by the Clarks' artist friends, contains several souvenirs of this visit: a vibrant sketch in watercolor with oil impasto by Frederick Frieseke of his wife, Sadie, relaxing under a parasol in a flower-covered bower; a watercolor of a woman with a parasol, seated at a tea table in a garden, by Lawton Parker; and a pen-and-ink drawing of a Giverny resident by Ethel Rose. Although there is no evidence that Clark ever met Claude Monet, who rarely associated with American artists any longer, Clark's style at this time certainly reflects Monet's influence in the adoption of a broken brushstroke, bold use of a brilliant color range, and marked reliance on purple for vibrant shade effects.

This new turn to a more authentic Impressionism seems to have brought Clark back to his formative years with William Merritt Chase (plate 128). *On the Beach, Urville, Normandie* (plate 129), painted in 1910 at Urville, fully reflects Chase's style and inspiration, which in turn owes a debt to Eugène Boudin's beach scenes (see plate 130). Starting with the wealth of bravura detail in the foreground tidal line, Clark takes the viewer's eye across a massive, curving sweep of beach to the horizon and then back again to the shore where several people are wading in the warm summer sea and the Ullman children play in the sand (plate 131). While the composition is very similar to that of *From Our Window*, of 1903, the mood is completely different. Here the subject is the warm, naturally bright light of the summer shore. The dazzling vibrance of *On the Beach* is achieved by broad sweeps of the brush accented by a profusion of small, sparkling patches of bold color. The source of Clark's inspiration is clearly in Chase's work at Shinnecock. In *Thousand Islands, New York* (plate 132) of 1911, Clark continued to personalize this style, and the following year his work became even more vibrant and intense.

In the next few years the peripatetic Clarks continued to spend much of their time in France, visiting Dalmatia and England in 1912 and Panama in 1913. Panama was one of Clark's more difficult undertakings. The physical and logistical obstacles of this trip were formidable—including a round trip from Panama to Paris midway in the work to replenish painting materials and return in time to paint the activity leading up to the blowing up of the dike separating the two Amer-

132. Alson Clark. *Thousand Islands, New York.* 1911.

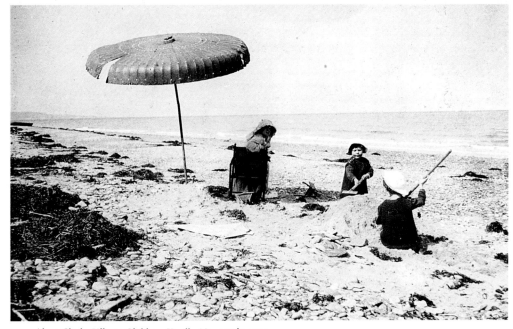

131. Alson Clark. *Ullman Children, Urville, Normandy.* 1910.

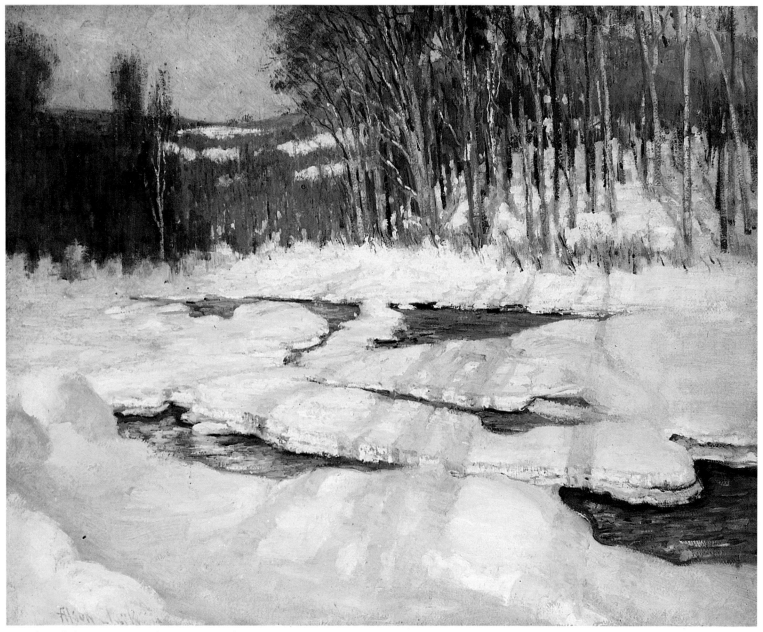

133. Alson Clark. *Frozen River, Jackson, New Hampshire.* 1916.

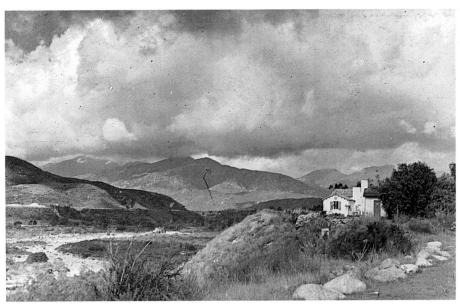

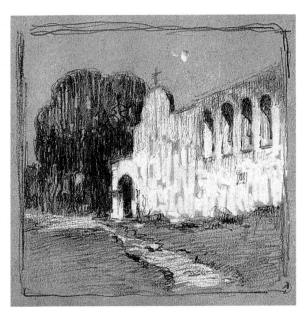

135. Alson Clark. *Alson Clark's House and Studio at 1149 Wotkyns Drive, Pasadena.* c. 1920.

134. Alson Clark. *Moonlight, San Juan Capistrano Mission.* 7 April 1919.

ican continents! Nonetheless, Clark produced a significant number of pictures of great scope and originality. In addition to many small panels, he painted a number of large outdoor canvases of the activity along the canal construction site as well as some scenes of Panama City, with the brilliance and immediacy that characterize his style during this period. In 1915 he showed eighteen of the Panama paintings at the Panama-Pacific International Exposition in San Francisco. Although he received a Bronze Medal, some of the critics were less kind. Their attitude was exemplified by Eugen Neuhaus, who labeled the works "shallow . . . devoid of any quality. They are illustrations, that is all."[17] Clark showed the eighteen Panama pictures again at the Art Institute of Chicago in 1916; he then removed them from their stretchers, rolled them up, and never exhibited them again.[18]

When France mobilized for World War I in August 1914, the Clarks had just returned to Rochefort-en-terre from a summer of painting and touring in Brittany. They were able to reach Paris a few weeks later; there, given the uncertainties of wartime, they decided to roll up Clark's Panama paintings and carry them as part of their limited baggage allowance on a ship that sailed from Le Havre. After their return to America they began to divide their time between Chi-

cago and the Saint Lawrence area, with occasional working trips to other parts of the country. During fall and winter 1915–16, invigorated as always by the snow and cold, Clark painted a series of brilliant, impressionistic snow scenes. Among them was *Frozen River, Jackson, New Hampshire* (plate 133) of 1916, a work in which he captured the effect of shimmering light reflected by wide expanses of snow. Clark shared this predilection for snow scenes with a number of other American painters working in New England at the time, including Willard Metcalf, Edward Redfield, and Gardner Symons. When America entered World War I in April 1917, Clark immediately enlisted in the Navy and was commissioned an ensign. That fall he was sent to France. After his skills as a photographer were discovered, he was assigned to a naval aerial photography unit. He spent much of the next year in the forward compartment of an F2A flying boat over battle areas and military concentrations, leaning out over the fuselage to photograph the required targets.

Clark visited California for the first time in February 1919, to help cure an ear ailment contracted in the dampness of London toward the end of his military service. En route to the West he confided to Medora that he never wanted to paint again. But the environment and the His-

137. Alson Clark. *Medora on the Terrace*. August 1920.

panic history of Southern California soon captivated him, and during this visit Alson Clark began the second half of his long and productive artistic career. At the end of February, Clark wrote in his diary, "Splendid month. Feeling like painting again. Ear nearly normal."[19] By this time he had already made several pictures of the San Gabriel and San Fernando missions, and a visit to San Juan Capistrano on 1 March convinced him to spend more time there. Among the many paintings and studies he made that spring of the facades, arches, and doorways of the Capistrano mission are several seen by moonlight. A small drawing in his sketchbook of this period is almost identical in composition, value scheme, and mood (plate 134) to the haunting "nocturne" *Moonlight, San Juan Capistrano Mission*.[20]

On 1 January 1920 the Clarks became permanent residents of Pasadena, where they immediately readied a house and studio "perched on the edge of the Arroyo Seco, the banks dropping down . . . almost perpendicularly to the bed of the Arroyo far below, the wide expanse of floor filled with wild growth and boulders, eucalyptus and sycamore trees. We could look up the wide ravine for miles, with the mountains on all sides." Enchanted with this undisturbed beauty, Clark began to work at once. Soon the small house was moved on the lot and enlarged, with a separate studio added (plate 135).[21] An unforeseen benefit of Clark's move was his renewed acquaintance with Guy Rose. California-born, Rose had returned in 1914, and in 1918 he became director of Pasadena's Stickney Memorial School of Art (see plate 54), a small school that offered elementary classes in art. In January 1921, Clark accepted an invitation from Rose to teach painting and decoration. By the end of the year, when failing health forced Rose's retirement, Clark became the school's director.

The first of Clark's Pasadena paintings were in a modified version of the bold French Impressionist style he had adopted after 1910. The rich, choppy brushwork that so dominated his French and Panamanian scenes was still used with virtuosity but now large parts of the central composition were achieved with solid areas of impasto, often applied with boldly textured brushstrokes. In *Reverie* (formerly *Medora on the Terrace* plate 136), painted in the Clarks' backyard on a warm summer afternoon in 1920, Medora reclines in softly filtered shade, as occasional patches of hazy sunlight touch her filmy

dress and illuminate her parasol (see plate 137). The effect of different light intensities reflecting off the textures of the dress fabrics is masterful. Although the dress is pink and white, very little white pigment is used, and then only for the brightest of highlights. The rest is painted in varying tones of cream, off-white, and mauve. The same careful observation of light and texture is evident in the treatment of the patio tiles. Color is carefully controlled, again, but little is in the terra cotta of the tiles themselves, while the strong grid pattern of the paving gives an illusion of recession. By contrast, the background is a lively profusion of dissolved color, diffused in an almost abstract pattern yet fully in the Impressionist mode. Another painting of the same year is composed and executed with all the spontaneity of a sketch. In *Reflections* (plate 138), a partly clothed young woman sits in repose, softly defined by the light from a curtained window seen only as a reflection in the mirror behind her. The color is delicate and opalescent, but here, in contrast to *Reverie*, the space is blurred and foreground and background seem almost inseparable. Both color choices and motif recall the figure painting of Richard Miller and Frederick Frieseke.

Soon after settling in Pasadena, Clark began to explore the rich variety of California landscape. To maximize the freedom to paint outdoors year round, he equipped a Dodge truck for working trips to the High Sierra (plate 139). On 12 July 1921 the Clarks became parents of a son, an event Clark recorded in his diary as "the most wonderful day of my life." Four days later he printed the first photographs of the baby and many more photographs and drawings followed. That November, at the newly opened Stendahl Galleries, Clark had his first one-man show in California. In his review of the exhibition for the *Los Angeles Times*, on 15 December 1921, Antony Anderson commented at length on Clark's training and the scope of his work, adding that "Alson Clark loves California. He paints our landscape with the same clear vision, the same sure hand that we note in all his other pictures. . . . Nor must we forget his cleverly wrought and refined brief studies of women, often only partly draped, in which textures of skin and costume are delicately differentiated in delicate schemes of color subtly subdued with grays."

In 1922, Clark painted a large canvas of su-

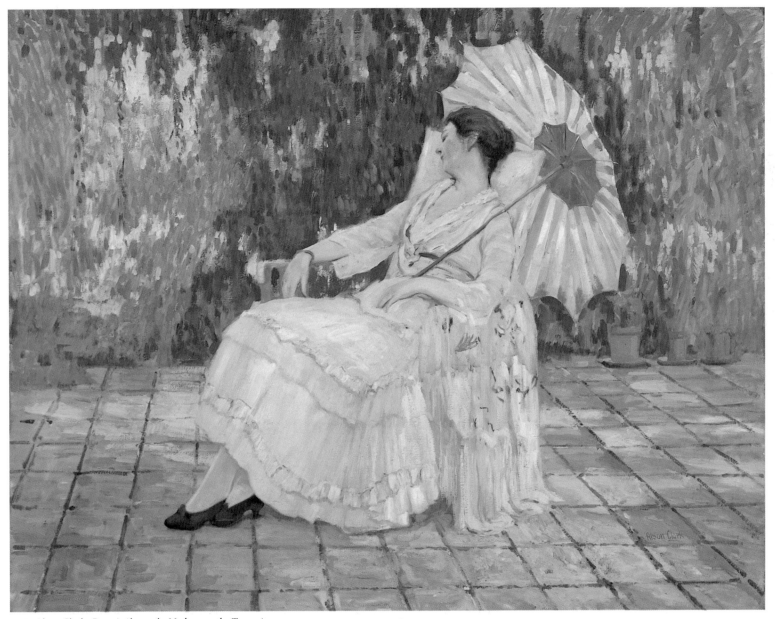

136. Alson Clark. *Reverie* (formerly *Medora on the Terrace*). 1920.

139. *Alson Clark Painting at Lone Pine near Owens Valley in the High Sierra.* c. 1921.

perb light and color titled *The Fruit Pickers* (plate 140). During the workers' noon break on a hot and bright summer day, with the sun overhead casting purple shadows under the trees, the wagons and horses contrast starkly with the glare on the dusty ground. The light on the wagon details is minutely recorded, and the realistic treatment of the horses shows a remarkable control of color and modeling. Two small sketches of trees from this period show Clark's careful observation of massed foliage as well (plate 141). The rest of the work is painted in a typically Impressionist manner, and this technique along with the use of a dark brown ground gives the painting its rich brilliance and luminosity. Clark often used an umber primer on his canvases—or at times a dark-colored underpainting—to increase the contrast between sun and shade.

From the same year and similar in style to *The Fruit Pickers* is *California Picnic* (plate 142), which was exhibited in a group show at the Stendahl Galleries in Pasadena's Maryland Hotel the following year. A reviewer for the *Los Angeles Times* of 5 June 1923 wrote: "Another fine Clark is 'California Picnic,' a magnificent sky full of clouds in motion above a group that have just stepped from their flivvers and are making bright bits of color on the sunny landscape—our friends from Iowa, perhaps." By chance, *California Pic-*

nic is painted on the verso of a work from 1910, titled *Chicago in Winter* (plate 143).

Clark made the first of four trips to Mexico in 1922, an exploratory visit that attracted him to its dazzling light and architectural richness. "It is magnificent painting ground," he wrote Medora, "even more Spanish than Spain."[22] This visit yielded several small paintings, many sketchbook studies, hundreds of photographs, and some motion pictures. On a second, extended trip, in 1923, he painted a group of large canvases of the smaller towns near Mexico City that brought him enthusiastic critical acclaim in San Diego, Chicago, and New York. One of these paintings, *After the Shower, Cuernavaca*, was awarded the Grand Prize that November in the Annual Exhibition of California Artists at the Southwest Museum in Los Angeles.[23] A third trip, in 1925, to Cuernavaca and Mexico City again yielded a number of large canvases. On his last visit to Mexico, in 1931, Clark worked for most of two months in Taxco. That November a gala reception and excellent reviews greeted the exhibition of his latest Mexican paintings at the O'Brien Galleries in Chicago.

In the early 1920s, Clark's fascination with the Colorado Desert led him to camp there often and, in 1925, to construct a small studio with basic amenities for short stays. This two-level shel-

141. Alson Clark. *Two Sketches of Trees.* 29 April 1920.

ter on a Palm Springs hillside became the focus of painting trips every Thanksgiving, Christmas, and Easter until World War II. Clark excelled at painting the bright, intensely hot light of the nearby desert, and in his later years he did many desert landscapes that were far superior to the routine "Desert Verbena" landscapes of the period. But the breezy, sunny, coastal environment stimulated his best work of this period. The beach scenes of Normandy offered precedents for pictures like *The Weekend Mission Beach*, painted just south of La Jolla, in summer 1924, one of a series of spectacular pictures showing a strong influence of William Merritt Chase.[24] The composition is markedly divided into land and sky, and a distant row of tents and people separates the two main elements. No lines or planes lead the eye to a central subject. The foreground is very Chase-like, a mass of colorful brushstrokes. Only because the tents recede to the right do we feel any sense of depth. Clark parallels the depth of field created by the tents by aligning the clouds on the same perspective lines. The result is a commanding sky of great vastness and power that reduces figures and tents to minor players in a dramatic scene. Indeed, this painting is as much a skyscape as anything else. Clark continued to paint the sea and the sky of the La Jolla area, and *La Jolla Cove* (plate 144) of 1928 focuses from

above on the intense blue sea of the jutting coastline.[25]

Clark's exposure to the distinctive light of Southern California is clearly evident in his painting. He depicts both its all-pervasive strength, with its feeling of heat, and its alternately hazy quality. This haziness creates a profound sense of depth along with subtle color changes. Clark's penchant for purple shadows and his use of contrasting colors became much more pronounced in California. His desert paintings, particularly, capture the hot, almost blinding glare reflected from the ground and at times from the misty atmosphere itself. Although Clark worked primarily in oil, on canvas or panel, as well as continuously in several media in his sketchbooks, he was also a muralist, a lithographer, and a decorative artist. His first mural commission, *The Pied Piper of Hamelin*, came in 1902 from Chicago's Mancel Talcott High School, a school named in honor of his greatuncle, a founder of the First National Bank of Chicago. More than two decades later, in 1925, Clark was invited to decorate the newly constructed Pasadena Playhouse. He not only planned the interior decoration but also designed and painted the huge asbestos main curtain with a dynamic image of a sixteenth-century Spanish galleon under full sail. Soon Henry McCarthy

143. Alson Clark. *Chicago in Winter.* 1910.

138. Alson Clark. *Reflections*. 1920.

commissioned him to do a set of monumental murals on California history for the foyer of the Carthay Circle Theater. The success of these decorative projects led to so many commissions for both public and residential decor that for about ten years Clark's painting was severely curtailed.

A larger studio was required for the mural projects, and in it Clark installed a darkroom and a lithographic press. His interest in lithography had been aroused in 1908, after William Fox, director of the John Herron Art Institute, had arranged special sessions for him, during an extended museum tour of Clark's French château paintings. Returning to Paris after the tour, Clark acquired a lithography press and went on to learn color etching as well, under the informal tutelage of his friend and neighbor François Simon, the Czech color etcher, with whom he traveled to Prague a few years later. In 1936 the International Printmakers' Society invited Clark to produce its Annual Patron's Print, and in 1937 he was given a one-man show of lithographs at the Fine Arts Gallery in San Diego. As the Southern California watercolor movement gained momentum, in the 1930s, he began to work seriously in this medium as well.

With America's entrance into World War II and the restriction on civilian travel, Clark put painting aside as he had during World War I. In Pasadena for the duration of the war, he joined a group of artists and craftsmen in a workshop for the fabrication of parts necessary to the war effort. At the close of hostilities, his life returned briefly to its prewar pattern, with the execution of new mural commissions in 1946. But later that year he had a serious heart attack, foreshadowed in 1934 when shortness of breath forced him to abandon a campsite in the High Sierra. Now, between episodes of ill health, Clark managed to do an occasional figure study, sharing a model in the studio of a friend. In 1949 he suffered a stroke, and a week later he died, on 22 March, three days before his seventy-third birthday.

Alson Clark considered himself above all a landscape painter, yet his landscapes from the start embrace architecture and sometimes deftly interactive figures. Often a building detail interested him most—a distinctive doorway, a window, an arcade—frequently because of the changes in color or texture caused by sunlight or shadow. Nor did the temporal or climatic moods of these landscapes elude him—a ruined château facade, moonlight dematerializing the adobe

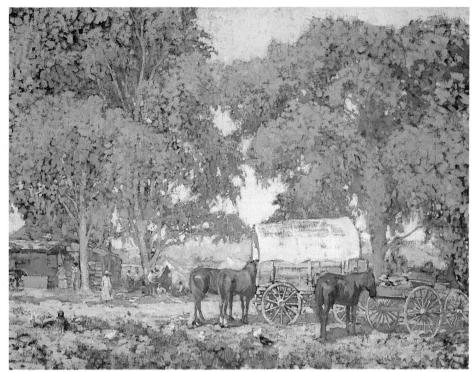

140. Alson Clark. *The Fruit Pickers*. 1922.

142. Alson Clark. *California Picnic*. c. 1922.

144. Alson Clark. *La Jolla Cove.* 1928.

walls of a Spanish mission, or amber mist blurring the Sierras. Throughout his career, however, the female figure preoccupied him too, and he usually placed his models in domestic settings, consistently avoiding eye contact between subject and viewer. Heirs to the Tonalist tradition, Clark's women avert their eyes and turn their heads away.

Clark epitomized the professional artist, thorough in his craft and exacting in his achievement. A painter of views and moods, he had no patience with "abstraction," preferring instead the inexhaustible faces of nature. He was fully aware of the pressure to exhibit and of the idiosyncrasies of collectors, just as he was amenable to satisfying the decorative preferences of his patrons. Pictures were to be lived with. From the panorama to the discrete form, Clark's eye consistently interpreted his motifs in terms of "the glowing surface of life and nature. In short, it is high comedy, not tragedy . . . high comedy which escapes prose and is never dull."[26]

JEAN STERN

JOSEPH KLEITSCH

A Kaleidoscope of Color

J oseph Kleitsch," wrote art critic Sonia Wolfson, in 1931, "is the most perverse person I've ever met. Artistically and personally. He's the despair of the art dealer, the bane of the reviewer. He can't be labelled, classified, pigeon-holed or otherwise definitely and securely rubber-stamped, which is to his credit, but a source of pathetic bewilderment to his followers." Wolfson continues: "Kleitsch's artistic appetite . . . happen[s] to be remarkably discriminating, active, vastly and diversely absorbing! . . . Because of his perversity, which spells diversity, he gives infinite joy."[1]

European-born, Kleitsch became a consummate artistic explorer, constantly in search of new means of expression. His restless talents and his perennial dissatisfaction were fed by an adventurous, bombastic, and charismatic personality. Kleitsch's roots and family environment undoubtedly contributed to the complex individual he became. His distant ancestors from Alsace-Lorraine migrated to Hungary during the Hapsburg reign of Charles III (1711–1740), who offered largesse to German settlers during the eighteenth century.[2] The era of reconstruction, from 1711 to 1848, provided the foundation for the resettlement of Hungary and an opportunity for migrants to repair the "destroyed Bulwark of Christendom" that Hungary had become.

The Germanizing of Hungary brought about a nationalistic reaction that blossomed into the Magyar cultural renaissance and economic and political reform. Most of the German minority in post-World War I Hungary sprang from the eighteenth-century colonizers, among whom were Kleitsch's ancestors. Joseph Kleitsch was born on 6 June 1882 at Nemet Szent Mihaly, a village in the Banat region of Hungary (present-day southwestern Romania),[3] approximately twenty to twenty-five kilometers from Temesvar, a large cosmopolitan city on the Bega River.[4]

An extraordinary insight into the early accounts of Kleitsch's life was provided by Theresa Kleitsch Haynel, a half-sister of the artist.[5] Joseph Kleitsch's mother died when he was three-and-a-half years old and his father remarried about a year later. His new mother recognized his artistic talent and fostered his interest in painting by supplying him with materials at an early age. Kleitsch's musical bent may have been fostered early, too, perhaps at high mass in the Roman Catholic church of Saint Josephine on Scudier Plaza in Temesvar.[6] A mixed choir accompanied by a small church orchestra sang the masses of Mozart, Beethoven, and Schubert.[7] And the vi-

145. William C. Baker. *Joseph and Emma Kleitsch in Mexico.* 1907.

brant, jewel-like color that appears much later in Kleitsch's painting might have been imprinted on his memory during these sumptuous services as the flickering light of acolytes' candles reflected in the richly embroidered liturgical garments. At the age of thirteen or fourteen, Joseph apprenticed to a sign painter known as Lanjarovics. Within eighteen months Kleitsch was released from his contract with the comment that he had learned all that he could and should move on.

No longer an apprentice, Kleitsch began to work as a free-lance artist, applying his natural talents to portraiture. So successful was he at oil portraits that he soon opened an atelier and engaged an agent. His earnings allowed him to travel, and he made a trip to Munich to study.[8] Upon his return home, he continued to prosper and engaged an additional agent. Kleitsch came to be known as "the little Munckacsy," a reference to Mihaly Munckacsy, who was then Hungary's most celebrated artist.

The only extant portraits from this early period are those of his cousins Karoline and Johann Kleitsch, which he made in Hungary in 1899 and 1901.[9] These charcoal drawings are straightforward, bust-length portraits against neutral backgrounds, and they seem to have been based on photographs.[10] Although the artist, like the photographer, has applied a compositional formula, Kleitsch was able to interpret the salient physical traits of his models at this early stage in his career. This later set him apart from many of his colleagues who chose not to portray the unflattering characteristics of their sitters, artists such as John Singer Sargent. This idealization of the sitter was even more prevalent among European portrait painters.

Before departing for America, Kleitsch probably went to Munich, where he would have seen a profusion of paintings by European masters. Several articles have noted his ardent admiration for Titian and the Dutch masters. The multiple influences that affected his art led to a certain eclecticism that is evident throughout his career.

On advice, Kleitsch called on the local bishop for support in expanding his career. According to Theresa, the church responded that Kleitsch's talent was recognized, but that the religious pictures they were waiting for had not been forthcoming.[11] Angered by this, Kleitsch threatened to leave for America. Somewhat later, when the church offered to support his career, he

refused. Soon after, in 1901 or 1902, Kleitsch left Hungary without a passport and crossed the border into Germany, prompted in part by the likelihood of military conscription.

From Germany, Kleitsch emigrated to the United States in late 1901 or early 1902, where he settled in Cincinnati, Ohio.[12] In 1902 he married Emma Multner, who is recorded in local business directories as a teacher, later as a confectionery store owner, and, at the time they married, as a physician.[13] Emma Multner was twenty-five years older than Kleitsch, and the marriage may have been arranged to secure his passage to America.[14] After the marriage, Emma Multner appeared in the Cincinnati city directory as a physician in 1902 and 1903, but neither she nor Joseph is listed in 1904.

Several paintings from Kleitsch's formative years reveal that he had expanded his repertory to include landscape, still life, and genre painting. About 1904–5 he painted a group of landscapes as illustrations for Union Pacific Railroad ads. Two landscapes with wooded copse and trees, in an apparently northern climate, seem to have been painted out-of-doors.[15] Rather stiff in execution and within the Barbizon mode, they nonetheless show some experimentation. Neither work, however, foreshadows Kleitsch's vibrant landscapes of Laguna painted in the 1920s.

In 1906 and 1907 Kleitsch is listed as a resident-artist in the Denver city directory. In Denver, he did a bust portrait of L. D. Reithmann, a prominent businessman. For a time the artist continued to use the formula he adopted in portraying his Hungarian cousins, but the model here is fleshier, rounder, and less mannequinlike. The competently handled fleshtones contrast with the muted tones of the man's apparel and the neutral background. At about the same time, Kleitsch painted the portrait of another successful Colorado businessman, George J. Kindel, who later became a United States Representative from Colorado (1913–15).[16] During 1907 Kleitsch moved to Hutchinson, Kansas, where he exhibited his work and also gave instruction in art to groups and individuals. After a short stay in Hutchinson, Kleitsch moved again—this time to Mexico City, where he lived during 1907, 1908, and 1909. He was joined there by his wife, Emma, and their Denver artist-friend William C. Baker, who also had worked for the Union Pacific (plate 145). In 1908 Kleitsch captured Baker's forceful, animated personality in a portrait that

was similar in manner to those of Kindel and Reithmann.

Five oil paintings and drawings have surfaced from this Mexican stay, all of them reasonably well painted: two portraits, including one of Baker, signed and dated *Mexico, 1908*; a still life in the Peale family tradition; a religious scene, probably based on an engraving; and a genre scene in the cast of J. G. Brown. The drawing of Baker is signed and dated *Mexico, 1907*. Kleitsch's first visit to Mexico is also documented by a letter, dated 1909, to Baker in Mexico City from a Mr. Hausmann of Hutchinson, Kansas, inquiring about Mr. and Mrs. Kleitsch.[17] While it seems that Kleitsch painted extensively during the time in Mexico City, only the Baker collection validates the work of this first visit.

In the Chicago census of 1910, Joseph Kleitsch is listed as a resident-artist.[18] Since his residence in Mexico from 1907 to 1909 has been confirmed, the artist and his wife must have moved to Chicago in late 1909. Kleitsch's reason for moving to Chicago is not documented, but we can assume that the city's importance as an art center and its ethnic population offered the artist an attractive environment. There is also evidence that during this period Kleitsch met Charles Schwab, the steel magnate from Pittsburgh, and that the artist returned to Mexico in 1911 under Schwab's patronage.[19]

In 1912 Kleitsch attained a prominent status in Mexico, as a result of commissioned portraits of President Francisco Madero (1911–13) and his wife.[20] This commission and a gold medal award from the Mexico Art Associates led to further portrait commissions from other prominent Mexicans (plate 146). Kleitsch returned to the United States from Vera Cruz on 22 March 1912 aboard the steamer *Monterey*.[21] A letter to his friend William Baker indicates serious concern about the unsettled political situation: "I am still alive with the shooting we have here; but now it's all well, but I don't know how long it will last."[22] In the aftermath of Madero's murder on 23 February 1913, several collectors of Kleitsch's work were among the Mexicans who fled to Spain. When Kleitsch traveled to Spain in 1926, he visited these collectors, one of whom owned fifteen of his paintings.[23]

When Kleitsch returned to Chicago in 1912, a renaissance in the arts was well underway. Yet many still perceived Chicago as a commercial city that exploited the immigrant and the poor.

Upton Sinclair's *The Jungle* (1906) was one of a number of publications that treated the theme of the urban immigrant, particularly the rural immigrant, who was ill-equipped to survive in the city because of his "stubborn individualism." Although Chicago's cultural activity had not yet penetrated the larger community, when Sinclair's *The Jungle* appeared, the Art Institute of Chicago already had been in existence for forty years. (The institute received its present name in 1882, after beginning in 1866 as the Academy of Fine Arts.) By 1900 Chicago was the most important art center between New York and San Francisco; by 1913 its annual exhibitions for Chicago artists, held from 1896 to 1912, were extended to include artists from Chicago and vicinity. Foreign artists were the biggest attraction at these exhibitions. "Traditional works . . . formed an important part of the public's art education. . . . They were 'tastemakers' because of the inexperience of their viewers, the social prestige of their owners, the apparently monolithic taste of art officials, dealers, and critics. A traditional flavor was thereby imparted to the city's art scene which was almost totally undisturbed until the 1920's."[24]

To attract the very best in American art, a society called Friends of American Art was formed in 1910. Initiated by Chicago artist Ralph Clarkson, who was most energetic in its development, the group's efforts enabled the Art Institute to spend $30,000 annually for the purchase of American art. James William Pattison, in his 1912 review of the institute's prestigious Annual Exhibition of American Art, commented on the selection process for the annuals.[25] American artists in the United States and in Paris—artists of "superior abilities"—were invited by the Art Institute to exhibit in these shows, and a jury of painters and sculptors from the Chicago area and other parts of the country made selections from the other works submitted. In Pattison's opinion, the jury system and the awarding of prizes focused attention on the "neglected knowledge of art."

The popularity of portraiture in Chicago must have influenced Kleitsch's decision to concentrate on this genre. Surely, he was aware of Chicago artist Louis Betts, who had returned from Europe and quickly gained recognition as a portraitist. As Kleitsch considered the direction of his career, he enrolled as a "special student" in the Saturday School of the Art Institute of Chi-

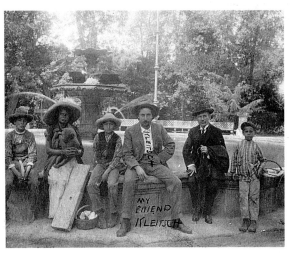

146. *Joseph Kleitsch in Mexico City.* c. 1912.

cago, attending classes there from 4 May through 16 June 1912. He was not compelled to follow the prescribed program for full-time students because of his advanced accomplishments. Professional artists at the school during this period attended figure painting and portraiture classes in order to work from live models and often devoted time to copying paintings in the Art Institute's galleries.[26]

Information on Kleitsch is scanty for 1912 and 1913, but a letter from his half-sister, Theresa, gives some additional background: "In 1912 . . . Agnes [Kleitsch's sister] and I came to America and . . . Joe came to Philadelphia to visit us . . . [Emma and Joe] came to Chicago to live, where he had his art studio on Michigan Boulevard in 1913. His wife died of sleeping sickness [10 August 1913], she was buried in Cincinnati in the family grave."[27] No records exist of Kleitsch's artistic activities in 1913; his works were first exhibited in Chicago in 1914. His wife's illness and death probably occupied him during those months. On 22 July 1914 Kleitsch married Edna Grigelus (Gregaitis on her death certificate and shortened to Gregg during her lifetime). Edna was born in Grand Rapids, Michigan, on 16 January 1890. A son, Eugene, was born to the couple in Chicago on 21 May 1915.[28]

Kleitsch is listed in the Chicago city directory from 1912 through 1917, and no city directories were published for 1918 and 1919.[29] Nor was Kleitsch in the telephone directories for those years.[30] His residency, however, is validated by the exhibitions in which he participated. From the Palette and Chisel Club logbooks at the Newberry Library, exhibition records at the Art Institute of Chicago, Chicago city directories, a profile of Kleitsch and his work in the *Fine Arts Journal* (1919), and various exhibition reviews, Kleitsch's artistic endeavors can be traced from 1914 through 1919.

Soon after arriving in Chicago, Kleitsch joined the Palette and Chisel Club, which was formed in 1895 and incorporated in 1897.[31] At first, the club leased space in the Athenaeum Building, where its members met weekly, worked from a live model, and then dined and drank inexpensively. Nonetheless, the club had the serious intention of expanding Chicago's artistic climate. In January 1906 an article in the Chicago *Examiner* called the club "the oldest and strongest practical art organization in the West." Precisely when Kleitsch joined the Palette and Chisel

Club is not certain. The logbooks of 1914, however, indicate that he exhibited in the club's 19th Annual Exhibition, and that he participated vigorously in the club's "Hi-Jinks" each year as a musician and an actor. The club's newspaper, *The Cow Bell* of 1914, offers an insight into Kleitsch the "Flamboyant Hungarian":

Vodvil Show: The Kleitsch-Taylor-Carlsen trio proved a scream, the harmony was delicious in the extreme and reminded us of a "death rattle" we heard a guy do once who had gotten all mussed up in a railroad wreck.

Cabaret on the Border: The club band covered itself with glory, and deserves a bundle of credit for a night's labor. With only one rehearsal before the show this flock of talented disturbers crawled out into the big pen and dragged forth from their various instruments a bunch of harmony that was immense. The band was under the leadership of Kleitsch, and is now being secretly observed by the state sanity commission.

The club held several "fantastical" parties each year, and Kleitsch apparently entered fully into the spirit of these occasions (plate 147). He undoubtedly utilized the Palette and Chisel Club as a springboard into the mainstream of the local art world. Through the club he met artists, exhibitors, and the supporters of the arts. In 1915 he and Edgar Payne were listed among the exhibitors as "the strong painters of several seasons." (Their careers would interface again in California.) That same year, Kleitsch was awarded the A. H. Ullrich art medal for two portraits in the Palette and Chisel annual, an award "for the most creditable work by a member and not a prize on an individual picture." The remarkable range and scope of his talent is reflected in an unidentified newspaper article of May 1915: "Cubism Has Advanced Beyond Cubes," "'Chemistry' by . . . Kleitsch, is a wild conception of atoms, molecules and gases gyrating in prismatic form. It is scientific to the last degree in the realm of abstraction."[32]

From 1914 through 1919, Kleitsch exhibited regularly in the annuals of both the Art Institute of Chicago and the Palette and Chisel Club. In 1916, for instance, he showed a self-portrait in a Palette and Chisel Club exhibition at the Chicago Public Library, and the following year he exhibited the same portrait in the Art Institute's 29th Annual Exhibition of Watercolors, Pastels, and Miniatures by American Artists.[33] In 1917 he

showed three oils, *Natsi*, *Von M.*, and *In My Studio* (plate 148),[34] in the 21st Annual Exhibition of Artists of Chicago and Vicinity at the Art Institute. *Problematicus* (plate 149), a figure in an interior of "mellow luminosity," hung in the Art Institute's 22nd Annual Exhibition of Artists of Chicago and Vicinity in 1918.

As Kleitsch continued to hone his skills as a portraitist, he began to use backlighting to illuminate his interior scenes. His exposure to Vermeer and the "little Dutch masters" is evident in the artist's work during these transitional years in Chicago. His interior series are certainly autobiographical. These paintings are done under familiar, controlled conditions: the artist's studio, his paintings, his wife, and his moods. Like Vermeer, Kleitsch places his figures before a window and allows the light to illuminate parts of the figure and the objects in the room. Like the Dutch master, Kleitsch, too, "recognized the important psychological functions of light and how its intensity and distribution affect the mood of a figure or setting."[35] Kleitsch also recognized the important role that color, texture, and decorative patterning played in his attempts to evoke a mood through setting and character. The soft light and somewhat subdued tonal qualities are characteristic of his work during this period, and they reflect the gray, wintry months in Chicago.

Kleitsch's new awareness of the subtle play of light and shadow in an interior space manifests itself in such paintings as *In My Studio* of 1917 and *Problematicus* of 1918, part of a series of interior scenes he did in his Chicago studio.[36] The first picture is a self-portrait of the artist and his wife Edna, thoughtfully studying the picture (perhaps of themselves) on the easel. Newspaper accounts stated that the painting has "little color" and that it is primarily "an arrangement of gray and yellow" of subdued tonal qualities and "mellow luminosity."[37] Elizabeth Bingham, in *Saturday Night* on 9 June 1923, called *In My Studio* one of the artist's "masterpieces," adding that "the dominant interest lies in the sense of intimacy within the darkened room, but the passage above the two heads, the window shade, the light both within and without, is really the chief point of contact."

Problematicus depicts the artist's wife lost in contemplation of a picture on the easel, most likely of herself. The painting creates the same mood as *In My Studio*, with backlighting that flows through the amber-colored shade to cast

147. *Joseph Kleitsch and Other "Band Members," December 1914.*

148. Joseph Kleitsch. *In My Studio.* 1917.

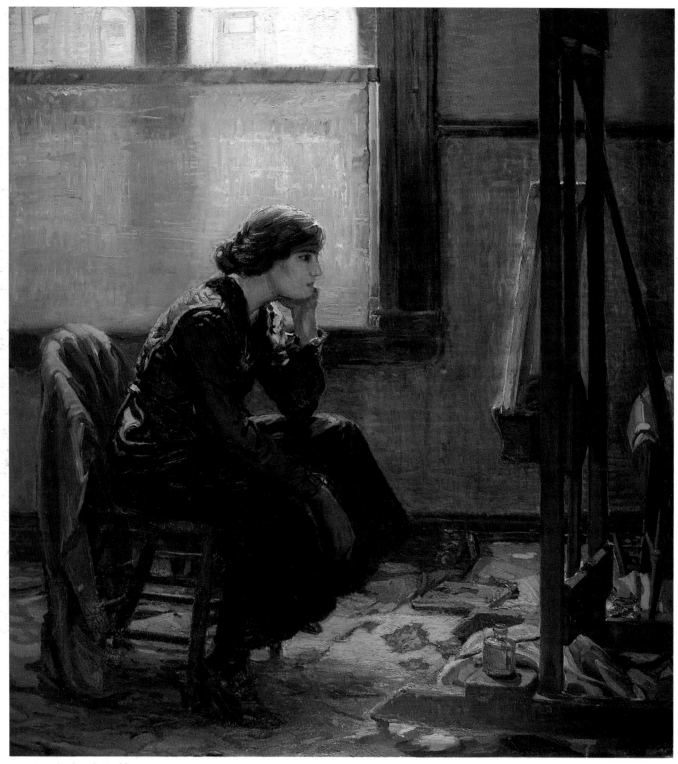

149. Joseph Kleitsch. *Problematicus.* 1918.

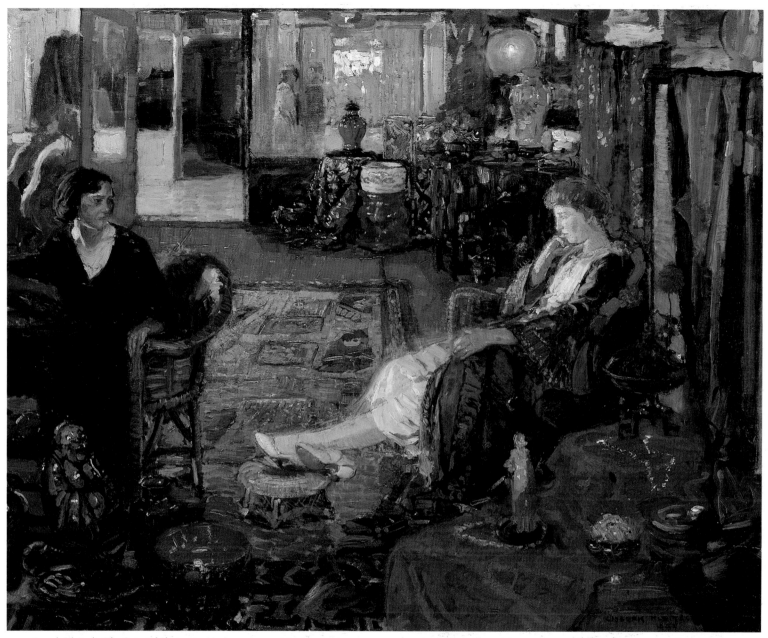

152. Joseph Kleitsch. *The Oriental Shop*. 1922.

150. Joseph Kleitsch. *The Attic Philosopher*. c. 1918.

highlights on her hair and body. The close tonal arrangements of golds and gray blues give it an elusive, poetic quality. Perhaps influenced by Matisse, the artist adds colorful decorative patterning in the rug and the vest, and a profusion of colorful decoration became Kleitsch's hallmark later in his California pictures. Although chiefly a tonal picture, some impressionistic brushwork is evident in the gray blue wall and in the buildings seen through the window. Some stylistic irresolution is evident as well, in the lack of consistency in both the use of planar and rounded forms and in perspective. In addition, Kleitsch's gestural brushwork is used arbitrarily in the figure, not necessarily to model forms or as highlights.

Kleitsch continued to paint half- and full-length portraits of himself and his wife in different attitudes and dress. In addition to commissioned portraits, like the well-received *John C. Nichols*,[38] he also painted friends. In *The Attic Philosopher* of about 1918 (plate 150), a reviewer noted: "We have a masterpiece in portraiture. The whole character of the blond dilettante, a young Swedish friend of the artist in Chicago, is here—the dreamer, the musician, the philosopher, the sensualist, and the idealist. Kleitsch saw so much that his friend was reluctant to continue the poses, hence the picture was three months in the painting."[39] Kleitsch captured the Nordic appearance of his friend in a subtle characterization. The full lips and liquid blue eyes emphasize the sensuality of this young man, whose Bohemian lifestyle was probably that of his artist friends. Intimacy with the model is also reflected in the strand of hair curled over the forehead, the cigar, and the jaunty neckpiece. Vigorous, sweeping brushstrokes replicate the sitter's animated personality and suggest the work of a popular portraitist of the day, Wayman Adams, whose "gifted, brilliant, and colorful characterizations" also were achieved with the daring sweep of his brush (plate 151).[40]

In *Miss Ketchum* of about 1918 (see plate 45), Kleitsch portrayed a young, attractive, independent woman, a successful New York designer who visited the Kleitsches in Chicago. The directness of her personality is revealed in her striking pose and her deep-set brown eyes.[41] The mood of the painting emerges in the facial expression, particularly the eyes, the expressive hands, the shapely figure, and indeed in the costume. "Hats will be worn" was the order of the

day in 1918, but in the case of *Miss Ketchum*, it was not worn, it was held. The small red tam, or modified beret, held in her right hand indicates a certain break with the establishment; she is not wearing her hat but still maintains decorum, convincing the viewer that the hat is there in case of emergency, when it might have to be put on quickly. Her attire suggests a spirited walk through the woods for exercise. As a liberated woman, she is not wearing a corset, but she looks comfortably chic nonetheless. The stylish placement of the red sash, with its soft bow just in front of her right hip, was arranged by the artist. Her less-than-perfect hairstyle indicates that fashion is not everything to her, in character with the independence of her personality.[42] Miss Ketchum's attitude is clearly that of a woman of the 1980s.

Kleitsch's portrayal of individual expression and his freedom of thought and action are especially discernible in his uncommissioned portraits, such as *The Attic Philosopher* and *Miss Ketchum*. His best portraits, however, seem to be of people he knew and with whose mannerisms and personalities he was familiar.

By 1919 Kleitsch had reached the high point of his career. He was recognized by his peers and by critics as an outstanding portraitist. His art was widely seen in local exhibitions, and he had received special recognition and awards. In the June 1919 *Fine Arts Journal*, the critic James William Pattison wrote a most complimentary article on Kleitsch, comparing his talents to such notable artists as the Spaniard Sorolla, Rembrandt, and other painters of the Dutch School.[43] In the same article, Pattison refers to an invention by the artist of a fictitious French name and a boyhood in Alsace, where a German priest who baptized him changed his Gallic name to a Teutonic one. Since the author's research conflicts with this story, a plausible explanation is needed.[44] During and after World War I, a strong bias against people with Teutonic names developed, and as a consequence, many citizens of German ancestry changed their names. The author believes that Kleitsch's fiction was a result of the public antagonism toward Germans.

Singling out Joaquín Sorolla as one of "the best portrait painters . . . ever mindful of the rich beauty of the softened light of a fine interior," Pattison added that "one who can master this lighting has gone far in portraiture and for this reason the work of Joseph Kleitsch may be said

to be representative of the best element of the younger portrait painters of today. This artist is indeed essentially a portrait painter." Pattison continued: "Kleitsch is a substantial painter, engrossed in the character of his subject as expressed in his person and gifted with an innate faculty for good *arrangements of mellow light and rich shade*."[45]

With Kleitsch's career as a portraitist well assured, it is surprising to find that he decided to leave for California. His move there on 3 January 1920 is documented by information in his petition for naturalization dated 30 January 1924. Why *did* the artist pull up stakes and move "[only to] bury himself in a village on the continent's terminal point?"[46] Several factors probably influenced him. His friend and successful colleague, Edgar Payne, had established studios in both Chicago and Laguna Beach, and Laguna was rapidly becoming a haven for artists. The climate beckoned, too. There would be no more harsh winters with long periods of indoor confinement. Kleitsch's unique talent and achievements as a portrait painter would be immediately acknowledged because of his successes in Chicago and Mexico. Moreover, there were few portraitists of Kleitsch's stature and reputation in Southern California. Indeed, he had already been commissioned to paint a portrait of S. W. Straus, a prominent financier, who was later instrumental in financing the Ambassador Hotel in Los Angeles.[47]

With his strong receptivity to color and light, Kleitsch was enchanted and finally compromised by California. He had established residence in Laguna at the Edwards's cottage, near the Laguna Hotel. From Laguna the artist could capture the rhythms of the sea as well as the mountains and the varied landscapes of the coastal region. This new environment provided the stimulation and unfettered freedom of living that began to transform his paintings.

From the *Santa Ana Daily Register* of 1920,[48] Kleitsch's activities during his first year in California can be chronicled. Ostensibly, he came to California to do the portrait of S. W. Straus, who was vacationing at the fashionable Hotel Huntington in Pasadena. That March, Kleitsch spent about ten days there painting the Straus portrait. During the first half of 1920, he also painted portraits of other patrons in Pasadena, Laguna, and Santa Ana: Miss June Harding of Laguna, Mildred Whitsen and Elizabeth Scott of

151. Wayman Adams. *Portrait of William Preston Harrison*. 1924.

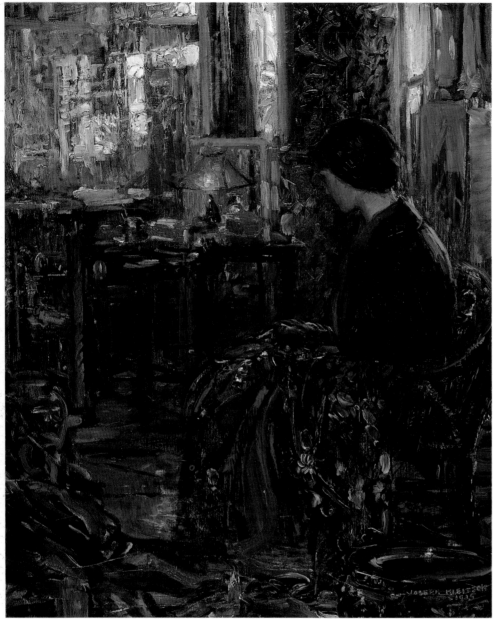

153. Joseph Kleitsch. *The Oriental Shop* (or *Jade Shop*). 1925.

Santa Ana, a larger-than-life-size portrait of Mrs. Paul E. Hurst (Hedda Nova, a Russian movie star), and a portrait of S. W. Straus's daughter.[49] The portrait of Mrs. Hurst was exhibited at a reception honoring Joseph and Edna Kleitsch at the Laguna Beach Art Gallery in May. The Kleitsches and Hursts became close friends, perhaps because of the European backgrounds of Kleitsch and Mrs. Hurst.

In June 1920 the Kleitsch family left for New Orleans, where the artist had decided to do a group of paintings of Creole life for exhibition in the fall. The uniqueness of the New Orleans population, climate, food, and historical sites proved bountiful stimulation. Returning to Laguna later in the year, they settled there permanently.

The years 1921 through 1925 were productive and happy for Kleitsch. He explored Southern California and motored to the San Francisco Bay area. His restless nature, perceptive eye, and an appetite for color were fulfilled by the countless opportunities to paint and record. On 16 March 1922, Kleitsch signed an exclusive contract for Southern California with Stendahl Galleries, insuring timely exhibitions and giving him ample and favorable exposure from the media.[50] Opened on 1 January 1921, the gallery was located in the new Ambassador Hotel, which soon became the social center of Southern California.

As early as *Miss Ketchum*, of about 1918 (see plate 45), color and decorative pattern began to emerge as an essential part of Kleitsch's compositions. These elements emerge even more clearly in the California pictures where he seems to return to the spirit of Hungarian painting. In 1916 Hungarian painting was described by Christian Brinton in his critical review of the Panama-Pacific International Exposition in San Francisco: "The art of Hungary is before all else a typically rhapsodic expression. You feel in it a marked degree of rhythm and a rich, vibrant harmony rarely if ever encountered elsewhere. . . . In each [painting] you meet the same deep-rooted race spirit, the same love of vivid chromatic effect, the same fervid lyric passion."[51] Four other paintings—*The Oriental Shop, Creek—Laguna Canyon, Morning, Laguna,* and *Highlights*—illustrate well the depth of Kleitsch's understanding of and sensitivity to color.

The Oriental Shop, of 1922 (plate 152), dazzles the eye with a galaxy of color and a profusion of objects and multicolored decorations. Displaying the entire color spectrum, the painting has the

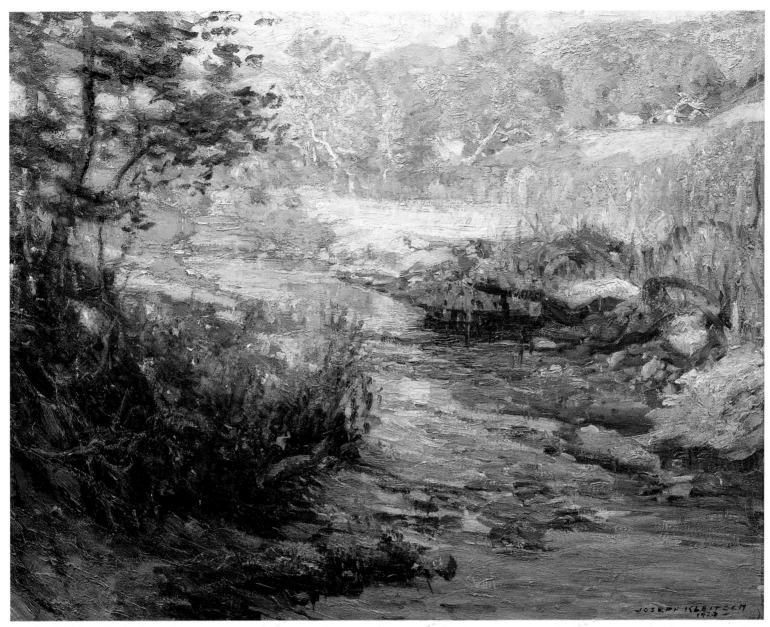

154. Joseph Kleitsch. *Creek—Laguna Canyon.* 1923.

155. John Singer Sargent. *Alpine Pool.*

opulence of movie palaces of the teens and twenties. Although a writer for the *Los Angeles Times* complained, on 20 April 1924, that the picture lacked "coherence," he praised the artist for a "virtuosity that . . . [made one] gasp" and singled out the woman [Edna] on the viewer's left as "a little masterpiece of itself." Kleitsch's virtuosic brush moves freely in swirling arabesques, and his dark, vibrant colors, applied dark on dark in the same intensity and in a wet technique, suggest the subtle shapes and forms of his objects. And, against a white ground, the colors become richer and more contrasted.[52]

Kleitsch sculpted the hands and faces of his subjects on the canvas with a variety of colors to produce delicate or swarthy fleshtones that are glowing and opalescent, just as the rich colors of their hair reflect the light of lamps and mirrors but at the same time blend in a chromatic crescendo. The brushstrokes of the clothing create soft, natural folds and crosses of many colors that look like scintillating light skipping off fabric as light dances on water. The artist often employs a tilted perspective to draw the eye back to the impressionistic, light-filled windows revealing the figures passing by, reminiscent of the Tiffany windows of the 1920s.

In *The Oriental Shop* of 1922, the model for the fair-complexioned redhead reclining in a wicker chair was Florence Marsh, wife of the manager of G. T. Marsh and Company, an Oriental shop in the Ambassador Hotel, where Kleitsch set this painting. Marsh's father, G. T. Marsh, founded the House of Marsh's in San Francisco in 1876 and was among the first to introduce Oriental art to the West Coast.[53]

In a smaller version of *The Oriental Shop* (or *Jade Shop*) of 1925 (plate 153), Kleitsch portrayed a single figure, who is almost incidental to the multicolored decoration and patterning. Less distinctive and more abstract than the 1922 painting, it seems to reflect a change of mood by the artist.

Comments by the press on Kleitsch's exhibitions from 1922 through 1925 detail his career path of those years. In June 1922 his first one-man show of thirty-eight paintings was held at the Stendahl Galleries in the Ambassador Hotel, where Kleitsch had opened a studio during the year. From a review by Vandyke Brown in *Life and Art* (Laguna Beach), on 28 July 1922, it is clear that the artist began to receive some notoriety:

One of Laguna's leading citizens is Joseph Kleitsch, that uncompromising belligerent with the broad brush. And most of the thirty-eight canvases are pictures of Laguna Beach, at that. The portraits and figures are very few, yet even these are almost all lovely ladies from Laguna. Our friend Joseph has not found it necessary to go far afield for subjects. . . . Kleitsch is certainly a painter. Of an equal certainty he is an artist. What exuberant vitality and what gorgeous schemes of color we find in these canvases! And what poetry, too, in many of them. You never dreamt, till you looked at these pictures, that Laguna offers to the artist a diversity in composition and subject hard to beat anywhere else.

Kleitsch also entered two paintings in the third exhibition, Painters and Sculptors of Southern California, at the Los Angeles Museum of History, Science, and Art in Exposition Park from 21 April to 28 May 1922. *Portrait* of a young woman with a red shawl was described by a reviewer as a "vigorous piece of painting" and "brilliantly alive in color."[54]

"Joseph Kleitsch's Brilliant Exhibit" is the headline of Antony Anderson's column, "Of Art and Artists," in the *Los Angeles Times* of 3 June 1923. Critics were surprised by the magnitude of this show at the Stendahl Galleries, which included seventy-one paintings by Kleitsch. Anderson was eloquent: "Kleitsch is an artist with a temperament and with not a little of the divine fire. I am not saying that . . . Kleitsch is 'driven,' but I do believe that he often works inspirationally—or at all events at a white heat of creative esthetic energy—call the moment what you will—and that he occasionally gives us pictures that are truly masterly." Anderson singled out *In My Studio* (see plate 148), *Problematicus* (see plate 149), and *The Attic Philosopher* (see plate 150), saying that "these few are the masterly ones—I may even venture to term them masterpieces—that merge emotion and technique with absolute completeness, that show a perfect adjustment of means to ends, and that have the elusive, the poignantly thrilling and touching beauty that we find in all works of art of a high excellence—in music, poetry, sculpture, and painting."

During this productive period, Kleitsch also found time to start an artists' club. In early July 1923 he and F. Grayson Sayre decided to found the Painters and Sculptors Club in Los Angeles.

At the club's first meeting, Joseph W. Cotton was elected president; Kleitsch, vice-president; and Sayre, secretary-treasurer. The *Los Angeles Times* of 15 July 1923 stated that "the objective was to form a democratic working club for men only which shall provide a studio with models where members may draw or paint in any medium they wish, without interference or instruction. . . . The atmosphere will be one of absolute freedom." The club was patterned after the Palette and Chisel Club of Chicago in which Kleitsch had been active and the Salmagundi Club of New York. Provision was made for associate as well as artist members, allowing businessmen to mingle with artists in theatricals, minstrel shows, and mixers, an arrangement that had been extremely successful in both New York and Chicago.

An article in *California Southland* of July 1924, titled "The Laguna Art Colony," described Kleitsch "as a sun-browned young man whose virility invades his canvases" and his wife as "a woman with a personality as vibrant as a Sorolla, and an excellent intermediary between the world and her restless painter-husband."[55] The writer noted that the "artistic influx to Laguna began with Gardner Symons . . . who was eminent among eastern painters. Today there is a 'colony' whose proportions are sufficiently extensive to give the Village its tone. Babbitry has done slight damage as yet—though something of a building boom has developed—the fishermen, town-folk and creative intruders dwelling piously in peace."

A few months before, on 2 March 1924, the *Los Angeles Times* covered an exhibition of thirty paintings by Kleitsch at the Biltmore Salon in Los Angeles, among them studies of Capistrano and Carmel. "The Carmel pictures are not many, for Kleitsch found color and climate up there a trifle cold for his temperament. Yet how subtly and convincingly he has conveyed the difference between the North and the South in this exhibition." That August the *Los Angeles Times* reported on one of the portrait commissions Kleitsch continued to receive during this period—a painting of Dr. Morgenstiern, an eminent Russian graphologist and psychoanalyst.[56]

On 1 February 1925 Antony Anderson exuberantly reviewed the exhibition of forty paintings by Kleitsch at the Stendahl-Hatfield Galleries: "Ah those still-lives! You will pounce upon four or five in the gallery that are simply overwhelming in their virtuosity. If Frans Hals were

156. Joseph Kleitsch. *Garden Fence.* c. 1923.

157. Joseph Kleitsch. *Morning, Laguna* (formerly *California*). 1924.

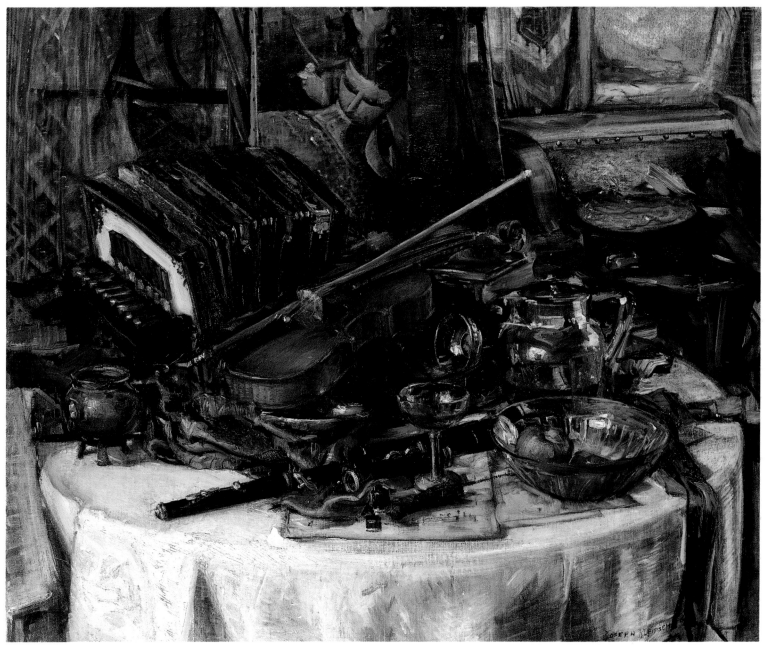

158. Joseph Kleitsch. *Highlights.* c. 1925.

159. *Edward Vysekal, Earl Stendahl and Joseph Kleitsch, Paris. 1926.*

160. Joseph Kleitsch. *Lunch Hour. 1926.*

alive today—Kleitsch reminds us of the Jolly Dutchman more than once—he would toss up his cap and shout, 'I greet you brother, for you sure can tickle the canvas and make it laugh for joy.'" Specific recognition was given to Kleitsch at the 120th Annual Exhibition of the Pennsylvania Academy of the Fine Arts, where *In My Studio* (see plate 148) was exhibited from 8 February to 29 March 1925. The painting was also shown at the Art Institute of Chicago, the Des Moines Art Association, and the Philadelphia Art Week Association.[57]

Not unlike the American master John Singer Sargent, who late in his career indulged his "insatiable curiosity and appetite" for painting landscapes, Kleitsch, during his California years, developed a passion for producing scenes of Old Laguna and the back country. In his *Creek—Laguna Canyon* of 1923 (plate 154) there is the same "evocation of form through light, the vibrancy of colour, and the force of brushstrokes themselves" that are evident in Sargent's *Alpine Pool* (plate 155). Kleitsch's focus on the reflective surface of the water is contrasted with the foreground shadows, while the background is illuminated by California's radiant white light.

Kleitsch painted a prodigious number of scenes of Old Laguna. In the morning, noon, and evening light, he captured its distinctive shoreline, its opalescent sea, its distant hills (plate 156), and the original structures that lined its dusty mud roads.[58] He also painted Laguna's ever-present eucalyptus trees in sun and shadow, blown by Pacific breezes, or with their golden leaves hanging in the heat of a summer noon. He conveyed "the richness of massed leaves without losing the characteristic droop of the gum tree's vertical foliage."[59] Framed by eucalyptus trees, *Morning, Laguna* (or *California*) of 1924 (plate 157) gives a sense of Old Laguna—a small beach community with an art colony, where residents were compelled "to wade through mud, to plow through dust, to import water, to cook with kerosene, to pant up steep hills."[60] With his vigorous brush loaded with myriad rich colors and by manipulating light, Kleitsch has effectively captured the mood with his highly accomplished technical skills.

The most astounding of Kleitsch's still lifes, painted about 1925, recently surfaced after thirty-five years in a private collection. *Highlights* (plate 158) is exuberantly baroque in its color and dazzling light. This autobiographical still life is probably one of the most freely painted works by Kleitsch. It abounds with vigorous gestural brushstrokes, rapidly applied to sculpt both form and decorative patterning. With unctuous pigments, applied with brush, brush point, palette knife, and thumb, the artist achieves one of his most personal statements. Amid the profusion of objects piled and strewn on the table are Kleitsch's violin, flute, and accordion (the last, he played sitting alongside the road in front of his Laguna house on Saturday nights), and sheets of music.[61] Painted canvases are propped against the wall, one a landscape and the other a Matisse-like subject, and there is of course his palette and paint. Remnants of the gathering, wine and fruit, complement an evening of music among intimate friends. *Highlights* may have been among the still lifes that Anderson commented on in the *Los Angeles Times* of 1 February 1925 as "simply overwhelming in their virtuosity." Compared with the simple trompe l'oeil still lifes of his transitional years, Kleitsch produced a resounding crescendo!

During the twenties, portraiture continued to be Kleitsch's principal source of income. The *Lifeguard*, a portrait of artist William Griffith's son, Nelson, shows the way in which Southern California light had brightened his palette. Many commissioned works, such as *Ruth*, *Mrs. Ben Frank*, and *A Portrait of a Woman*, reveal the effect of Hollywood glamor on the artist's style.[62] The model's attitude becomes highly mannered, and the surrounding objects are still lifes in themselves. We see less of the individual expression that set Kleitsch apart from his colleagues earlier in his career. Portraits of old men, however, such as *El Peon* of 1923, painted in Capistrano, or the *Spanish Officer*, painted in Seville, Spain, in 1926, remain consistent in treatment.[63] Their most characteristic feature is the forceful, somewhat rough technique. The wrinkled, weather-beaten faces and large expressive hands recall the art of the Dutch master Josef Israels, whose work Kleitsch studied when it was exhibited at Moulton and Ricketts Galleries in Chicago, in 1914.[64]

By late summer 1925, Kleitsch had been a resident of Laguna for five and one-half years. Although he truly loved the village, he was growing restless and seriously contemplated a change. He was now forty-three years old, and although he had gained recognition and acceptance from his peers, he did not enjoy the national fame of many of his contemporaries, such as Maurice Braun,

Alson Clark, Guy Rose, and William Wendt. Still regarded a Chicago and a California painter, he had not been elected a national academician ("N.A."). Nor had he been out of the country for thirteen years, and he felt the need for travel and further European study. Undoubtedly he counseled with Stendahl as he made plans for the trip.

Kleitsch and his family began their trip in November 1925, stopping first in Chicago where he was feted by colleagues and given a fine reception by patrons, collectors, and old friends.[65] From Chicago the Kleitsches went to Grand Rapids, Michigan, Edna's birthplace. There, they stayed at the Rowe Hotel in order to project an image of success to the local population. It is not certain that they next accepted an invitation to visit Edward B. Good, a major patron and collector of Kleitsch's work, in Lancaster, Ohio. In New York, they decided that Edna would remain in the States with their son, whose schooling was a primary consideration.[66]

Kleitsch sailed for Europe on the *President Roosevelt* on 6 February 1926, proceeding to Paris, where an important commission awaited him.[67] He soon continued on to Madrid, where he spent many hours in the Prado studying the masters, visited several exhibitions, and did some painting. His next stop was Asturias, where he was commissioned to paint the portraits of a Spanish family he had known in Mexico. Major patrons of Kleitsch, by this time they had acquired fifteen paintings from his second stay in Mexico.

In early spring 1926 Kleitsch spent several months in Seville. He gained permission to paint in the gardens of the Alcázar, and he witnessed the gorgeous pageantry of the procession of the Nazarenes throughout Holy Week. Kleitsch painted extensively in Seville and again studied the masters and visited galleries. The southern Spanish city was a stimulating experience for him and he relished the traditions, customs, and landscape as well as the Sevillians themselves.

Stendahl arrived in Europe in about mid-July 1926, and he traveled with Kleitsch until mid-October (plate 159). In Munich, Rome, Florence, Vienna, Budapest, and in Romania and England, when they were not visiting exhibitions and galleries, or enjoying fine food and wine, Kleitsch painted incessantly with orgiastic outbursts of energy.[68]

In November 1926, Stendahl wrote Kleitsch: "I have written a letter to Mr. Good

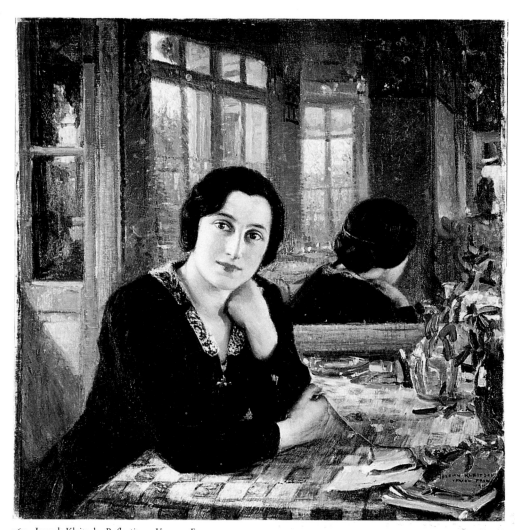

161. Joseph Kleitsch. *Reflections, Vernon, France.* 1927.

telling him what we talked about, asking him to see to it that your wife and boy were sent over so they could take care of you." And Stendahl added: "All I can say Joe is to finish up enough stuff for a big exhibition. I don't care what you do or how much, just plant yourself and paint." Kleitsch spent considerable time in Paris where he studied the paintings at the Louvre and at the many galleries on the Left Bank. "He liked the 'ideas' of the French in art, but he was equally taken with the 'finish' of the English. He considers some of the still-life painting of the modernists remarkable work, and he even did some himself with much satisfaction." The artist revelled in the Parisian environment and painted extensively, attracted above all by the subject matter along the quays and under the bridges of the Seine.[69]

His longest stops were at Seville and Vernon, near Giverny (plate 160), where he found the settings and material that best suited him. Surprisingly, "he did not care for Rome—its grandeurs, ancient and modern, jumbled together, confused and disquieted him."

A poignant description of Kleitsch's trip was written by the critic J. C. Bulliet: "I opine that . . . Kleitsch's happiest days were spent in the green valleys of Giverney's [sic] springtime, and in the brilliant streets of Seville—two absolutely divergent sketching grounds, but each perfect of its kind. . . . Highly sensitive, alertly experimental, . . . Kleitsch painted at Vernon and Giverney [sic] some beautiful things that may make us think of Constable." The writer wondered "how Kleitsch could . . . escape from the subtle and gentle spirit of Monet on the great Frenchman's own pleasaunce?" Kleitsch's European paintings clearly show that Monet's influence was minimal.

Correspondence in June 1927 between Stendahl and Edna Kleitsch may have been prompted by rumors of Kleitsch's philandering in Europe. The letters also may have been provoked by the number of attractive women whose portraits Kleitsch painted. Edna wrote to Stendahl: "Joe is coming back a big refined dignified Kleitsch you just watch and I am absolutely out of it all—I can say I will disown him if he is not—I don't think there is a person who has better habits than Joe. I can trust him anywhere." Stendahl responded to Edna: "Joe is a very fine boy and on my trip through Europe with him I find that he is much better than the average man. I can see no reason why he should stay over in Europe any longer as

there is much work to be done here."

Kleitsch had expected Stendahl to return to Europe in 1927, to arrange an exhibition in Paris, and was extremely disappointed when Stendahl cancelled his trip at the last moment. A letter to Stendahl indicates the artist's displeasure at the lack of sales during the past year: "I don't have to sell any pictures. Have a place in the East and one in Laguna, if you please. I can stay in Chicago, paint portraits for a living and buy my own pictures. You have not sold enough pictures of mine since I am here [, and] there must be about fifty of them there with you. Looking over my list, some of them [are] as good as you have seen." Kleitsch then asked Stendahl to sell $5,000 worth of paintings and send the money to his benefactor and patron, E. B. Good, who had loaned money to Kleitsch as an advance against his future sales at the Stendahl gallery. Stendahl's reply was cryptic: "Out of the question is the business of 5000 dollars, business not so brisk now—European trip called off."

In November 1927 Kleitsch returned from Europe to Chicago where he rented a large studio in the Athenaeum Building to prepare for his homecoming show in Los Angeles. The May 1928 exhibition at the Stendahl Galleries received broad coverage in the local press. The "Art and Artists" section of the Los Angeles Times of 6 May 1928 carried the headline "Brilliant Painter offers European Subjects." On 13 May the Times critic remarked, "Joseph Kleitsch has successfully slowed down his pace, taken more time for thoughtful design and refinement of color and paint application. . . . This is a first reflection on his 'Homecoming' exhibition at the Stendahl Galleries." And an article by Fred Hogue in the Los Angeles Times on 25 June 1928, titled "A Hungarian Artist," reads in part:

As I look at the canvases of Joseph Kleitsch I forget the painter. As a colorist he is not clever; he is great. If the mantle of Titian has fallen upon a modern artist, it is draped about the shoulders of this Hungarian painter. When I look at his creations I think of Titian; there is an association that I feel, but cannot express. Curiously enough, Titian is the artist that Kleitsch most admires.

Joseph Kleitsch is an artist. In his breast smolder the fires of Vesuvius. When they burst forth into a flame, he transfers them to canvases and a masterpiece is born.

While a rejuvenated Joseph Kleitsch did return after two years in Europe, it would seem that the press too enjoyed some rejuvenation.

There is little information on Kleitsch between the time of his return from Europe until the Stendahl exhibition in May 1928, and he did not exhibit with Stendahl again until April 1931. On 30 June 1929, a *Los Angeles Times* article noted that Stendahl and Kleitsch would summer in Spain, sailing for Cadiz 16 July on the liner *Magallanes*. Their intention was to visit the International Art Exhibition at the expositions in Barcelona and Seville. This report was corroborated in the monthly *California Arts and Architecture* of August 1929, which mentioned that Kleitsch was painting and sketching in Spain that summer.

The paintings produced during and just after Kleitsch's European trip of 1926–27 indicate a loss of artistic focus. This was a time of experimentation in technique, form, and subject matter. The work of these years, such as *Reflections* (plate 161), *Lunch Hour* (see plate 160), *Resting* (*Reposé*),[70] and others, lacks the vibrance of his earlier paintings, as a result of his attempt to reinterpret in his own personal idiom the works of the old masters, the Impressionists and Post-Impressionists, and the Paris School. Several interior scenes seem to have been inspired by works of Manet, Monet, Velázquez, and others. Among Kleitsch's subjects at this time are young and old women engaged in sewing,[71] women in cafes in front of reflective mirrors and windows (plates 161 and 162), parklike landscapes outside of Paris and in the Seine Valley, beggars under a bridge, and still lifes of fruit. This is the most eclectic period in the artist's development, and it signals a major change in the direction of his art. Two late paintings of bathers, *Sunday, Laguna Beach (Main Beach)* (plate 163) and *Ocean Front—Main Beach, (Laguna)*,[72] seem to forecast a freer, more consistent and expressive, and more modern approach. The almost haunting figures are abbreviated and summarily treated, while swirling brushwork animates the sky and gives a sense of foreboding.

We do know that Kleitsch continued to paint in Laguna during 1928, 1929, and 1930, from the dates of paintings such as *Sunday, Laguna Beach (Main Beach)* of 1929 and *Ocean Front—Main Beach (Laguna)* of about 1929–30. In fall 1930 he exhibited two paintings at the Laguna Beach Art Gallery as a member of the Laguna Beach Art Association. *Miss Ketchum* attracted the attention of a reviewer, who commented that he felt "a deep reverence for the painter and subject."[73] Kleitsch's last exhibition before his untimely death in November 1931 was at the Community Club in Laguna that August and September. From the *South Coast News* of 4 September 1931, a subdued critique of the exhibition by Antony Anderson, former critic of the *Los Angeles Times*, revealed a certain disappointment: "Many of Kleitsch's best pictures have been sold and the artist was unable to borrow them. However, the pictures shown are good, quite representative of Kleitsch's talent. Kleitsch still remains a painter of portraits chiefly, and it is in those that his best and most individual work as an artist is to be found. . . . It is in those that he shows us what he can really do with his paint."[74]

With fortunes lost in the crash of October 1929, most collectors were rendered inactive. Kleitsch and Stendahl experienced severe difficulties in collecting debts on paintings that had been sold previously. Stendahl wrote Kleitsch on 21 March 1931: "Winston hard hit and is pitiful in spite of that he gave me a check for $100. He will also give up the painting if Mr. Good will buy it for $2000—if he wants it. Winston is in love with the picture still and would have paid for it long ago if he had the money. He is trying to sell an interest in his business but I don't think he will be able to sell anything right now." In addition, a rift apparently had developed between Kleitsch and Stendahl, noted in a letter written to Stendahl on 29 September 1931 by D. M. Leaman, probably an attorney acting on the artist's behalf: "Impossible to be at the opening of Stendahl's new gallery—wishes him success—business keeps him in Laguna. He desires to have all pictures and frames collected and left for him to pick up. At that time he will leave some new pictures if you care to have them. Kleitsch would like an itemized list of all sales to date and a statement."

The financial pressures of the time and the limited sales from his European years, coupled with the driven personality of Kleitsch himself, led to a fatal heart attack on 16 November 1931.[75] A memorial exhibition of thirty paintings was held in June 1933 at Exposition Park by the Los Angeles Museum, then directed by William Alanson Bryan. In a review in the *Los Angeles Times*, on 18 June 1933, Arthur Millier wrote,

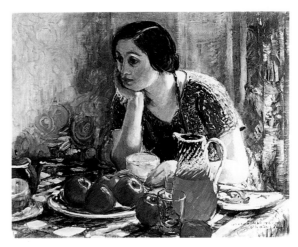

162. Joseph Kleitsch. *Madonna and the Apples, Paris, France.* 1927.

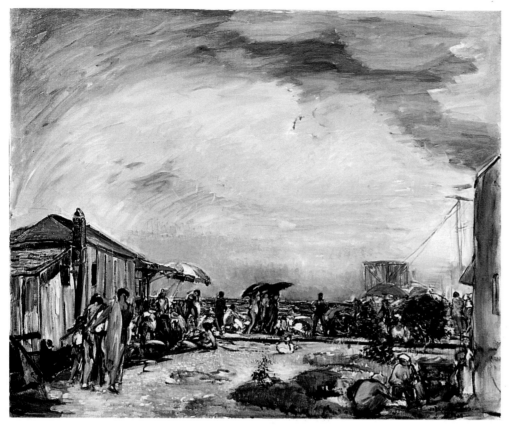

163. Joseph Kleitsch. *Sunday, Laguna Beach (Main Beach)*. 1929.

"Kleitsch would have nothing to do with rules. One of the most sumptuous pictures in the show, a still life called *Highlights* (see plate 158) was, he told me, painted after hearing a disciple of Cézanne in a Paris cafe inveigh against high lights as a form of visual superficiality which should never be reported by an artist."

The International Art Exhibit of twenty-seven paintings by Kleitsch was arranged, with Edna Kleitsch as exhibitor, at the Tower Auditorium of the Drake Hotel in Chicago from 10 to 24 February 1934. Edna continued to live in Laguna, where she taught drawing and ceramics, until her death on 4 August 1950 at the age of sixty. Joseph was buried at the Angels' Abbey in Compton, while Edna was buried at the Holy Sepulcher Cemetery in Orange, California. In 1953 a number of Kleitsch's most important works were sold at auction to settle the estate of Edna Kleitsch.[76]

Restless in the pursuit of both his art and his life, Kleitsch's goals and ambitions shifted frequently, and he never fully exploited the strengths of his talents. His portraits and indoor scenes were masterful, as were his California landscapes of the early to mid-1920s, which animatedly convey the brilliance of the region's light and color. Indeed, Kleitsch discovered the full radiance of color in California. Another strength was his gestural brushstrokes—the most consistent aspect of his painting—although the wealth of borrowed ideas in his work give his pictures a quality of irresolution. Today, multiplicity characterizes the pluralistic Post-Modernists, who also deny the authority of resolution.[77]

PATRICIA TRENTON

FRANZ BISCHOFF

From Ceramist to Painter

What motivates a man "who drops a teacup and grabs a canvas the size of a barn door [?] . . . he has stepped from the zone of the zephyr into the vortex of the tornado. He is living, as artist and man, to the top of his bent. Once Bischoff gave you roses—pink ones—on a platter, now he offers you purple mountains on a canvas." Franz Bischoff, the man described by critic Antony Anderson in the *Los Angeles Times* on 9 November 1924, was born on 9 January 1864 in Stein Schönau, a small town in northern Bohemia that belonged to the Austrian Empire but is now part of Czechoslovakia.[1] Situated in the heart of a region renowned for its glassmaking, Stein Schönau is only about thirty miles southeast of Dresden, long famous for the manufacture and decoration of porcelain.

At the age of twelve, Bischoff began a three-year apprenticeship at a craft school in Stein Schönau. Commenting on this experience later, he said, "Talents are not considered at all. When I first began I had to do firing, carry wood, and all that." At eighteen, Bischoff went to Vienna to study applied design, watercolor painting, and ceramics.[2]

Three years later Bischoff sailed for the United States, reaching New York in August 1885.[3] His first job, in New York City, was that of a decorator in a china factory, and he continued to find employment consistent with the quality of his training in china and art glass. From New York Bischoff moved to Pittsburgh, where he applied for United States citizenship on 20 December 1887.[4] The following year he moved to Fostoria, Ohio, where his employer relocated, and he was listed in the 1889–90 city directory in Fostoria as a worker in art glass. In Fostoria Bischoff met Bertha Greenwald, who also had emigrated from Europe in 1885. They filed for a marriage license on 28 December 1889, and were married on 24 May 1890.[5]

Bischoff made his first trip to Detroit in 1888, sparked by an interest in learning more about china painting. There, Mrs. Mary L. Wagner, an artist and a socially prominent Detroit patron of the arts, invited him to join her ceramics studio.[6] Their business association was brief, for by 1891 he was operating Franz A. Bischoff's Art Studio at 84 Madison Avenue, where he also taught china decorating and watercolor painting.[7] He prospered as a result of orders for his

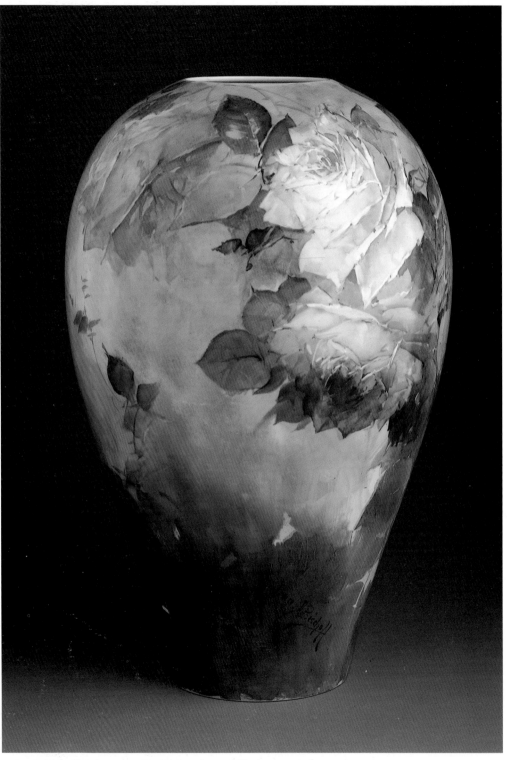

164. Franz Bischoff. *Vase Painted with Roses.* (Front and back views.) Before 1910.

chinaware and large enrollments in his ceramics and watercolor classes. Bischoff became a member of the Detroit Society of Artists, and in 1890 he exhibited two watercolors, *Peonies* and *Lilies*, at the First Annual Exhibition of Michigan Artists at the Detroit Museum of Art.[8]

By 1893 Bischoff had become an established member of the Detroit art community. He served as vice-president and president of the Detroit Keramic Club, and in an interview in the *Detroit Journal* 17 May 1893 he was called "one of the most talented and successful ceramic artists in the country." He also gained notoriety as an inventor and manufacturer of special colors for ceramic decoration and was best known for a color called "Ashes of Roses."[9] Various gold colors of his invention were sold to wholesale houses throughout the country, according to the *Detroit Journal* reporter.

Family sources state that Bischoff was both an exhibitor and a recipient of awards at the 1893 World's Columbian Exposition in Chicago.[10] Before the fair opened, the *Detroit Journal*, on 17 May 1893, had described in some detail Bischoff's plan for a major exhibition of his work in Chicago, across the street from the Columbian Exposition, but with no mention of his direct involvement in the fair.[11] In December that year Bischoff showed a group of his tiles in the New York City studio-gallery of Luetta E. Braumuller, editor of the earlier *China Decorator*.[12]

In spring 1894 Bischoff temporarily closed his studio and discontinued classes until fall.[13] His business prospered as a result of the exposure of his work in Chicago and New York, and the numerous orders he received left him with little or no free time for teaching. Bischoff's work consisted of brilliantly painted florals applied on blank porcelain forms imported from Limoges and Sèvres. Bischoff personally glazed and fired his pieces in his studio, turning out prodigious quantities of uniformly flawless pieces. His work included vases of all sizes and shapes (plate 164), plates (plate 165), platters, serving dishes, decorative plaques, and painted tiles. Many of the pieces were accented with intricate gold leaf and open-work patterns, and his painted designs included birds, fish, and scenic landscapes. His favorite subjects, however, were flowers, and he was among a small and select group of artists, including Fantin-Latour in France (plate 166) and Abbott Fuller Graves in America, whose names had become synonymous with flower painting.

Bischoff was noted above all for his paintings of roses, a renown that earned him the title "The King of Rose Painters."[14]

During the next few years, Bischoff continued to work and teach in Detroit, and he gave classes in Ohio, New York City, and Newton, Massachusetts. In spring 1895 he moved his family to Dearborn, Michigan, where he opened a studio and a pottery (plate 167), although he continued to teach in Detroit. Bischoff's industrious habits not only brought him success as a ceramist but also enabled him to own a house free of debt in Dearborn and employ a full-time servant. By this time the Bischoffs had two children. The first, Frances Matilda, was born on 15 February 1891 and the second, Oscar Franz, on 7 January 1895.[15]

In winter 1899 Mary L. Wagner, Bischoff's former business associate and longtime acquaintance, left for Paris to represent American ceramic art at the Universal Exposition of 1900.[16] It seems that some of Bischoff's work was among the group she selected for the exposition. A comprehensive display of his ceramic art reportedly was shown at the Louisiana Purchase Exposition in Saint Louis in 1904, which suggests that his reputation as a ceramic painter had grown.

In spring 1900 Bischoff visited Los Angeles and was favorably impressed by the climate, scenery, and the rapidly growing art colony in Southern California. He purchased a lot in South Pasadena in April 1905. Less than a year later the family left Dearborn, stopping briefly in San Francisco and then proceeding to Los Angeles, fortunately just before the disastrous San Francisco earthquake of 18 April 1906.[17]

Los Angeles in 1906 had a small but thriving art colony, which included Benjamin C. Brown, painter and printmaker; J. Bond Francisco, who was also concertmaster of the Los Angeles Symphony Orchestra; William Lees Judson, painter and craftsman; Paul de Longpre, known as "Le Roi des Fleurs" for his delicate watercolors of flowers; Hanson D. Puthuff, part-time artist and full-time commercial painter; Elmer Wachtel, a painter and also a noted violinist; Marion Kavanagh Wachtel, painter; and painter William Wendt, who had visited Southern California several times before settling there. Bischoff's arrival was noticed by the *Graphic* (Los Angeles), on 1 December 1906. He immediately established a studio in the Blanchard Studio Building on Hill Street in downtown Los Angeles, a location

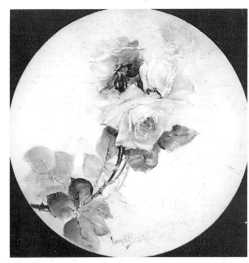

165. Franz Bischoff. *Plate Painted with Three Roses.* Before 1910.

166. Henri Fantin-Latour. *Roses.*

167. *Franz Bischoff in His Laboratory, Dearborn, Michigan.* c. 1900–5.

168. *Interior of Franz Bischoff's Studio Gallery, South Pasadena.* c. 1928.

shared by many Southern California artists. He soon planned a permanent house and studio on the lot he had purchased in Lincoln Park on the Arroyo Seco in South Pasadena and was quickly accepted into the social circle of the artists and intellectuals living along the arroyo.[18]

Bischoff's arrival in Los Angeles coincides with the start of his career as a landscape painter. Until this time his subjects were almost exclusively flowers, particularly the rose, which he carried over to his canvases with a baroque exuberance. Like the decorative floral painter George Cochran Lambdin (1830–1896), Bischoff's attachment to the rose theme was deeply passionate. Although he continued to paint flowers, Bischoff seriously began to paint landscapes as well, gradually curtailing his china painting. A primary factor in Bischoff's sudden shift to landscape painting must have been the climatic and physical attraction of the Southern California region. His association with resident artists, many of them landscape painters, undoubtedly was another powerful stimulus. Perhaps, too, he became dissatisfied with the conventional aspects of china painting. And lastly, this change of direction came when he was in his early forties, a time when many individuals make career changes.[19]

In February 1908 Bischoff moved into his new house and studio at 320 Pasadena Avenue, in South Pasadena, and opened it to the public.[20] The imposing architecture, in an eclectic blend of Italian Renaissance, Gothic, and California Mission styles, attests to his financial success. The gallery-studio was built of solid concrete, a necessary precaution for firing ceramics. The gallery space was 36 by 40 feet, and lighted by half-circle skylights set deeply in arched recesses on either side and at times by an immense fireplace. Glass display cases held examples of Bischoff's ceramics and the walls throughout were covered with landscape and flower paintings (plate 168).

Up a short flight of steps from the gallery was the studio itself, with a large picture window looking out on a panorama of the arroyo and mountains. In the basement were Bischoff's second room for decorating ceramics, and beyond, a laboratory for preparing mineral colors and a splendid kiln for firing.[21] The gardens surrounding the house and studio contained a large, colorful display of flowering shrubs, to which Bischoff devoted much time and care. These gardens certainly offered him constant inspiration.

Early in 1908 Bischoff held an exhibition of

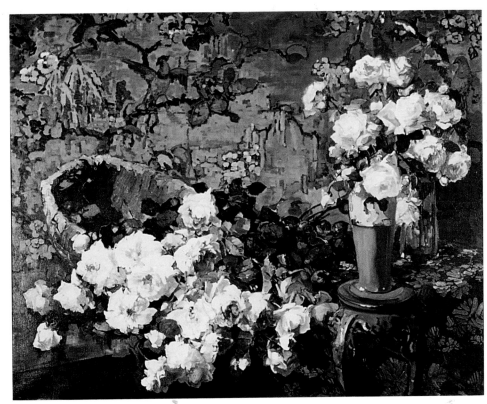

170. Franz Bischoff. *Roses.* c. 1912.

169. Franz Bischoff. *Canna Lilies.*

recent works in his spacious gallery. Among the many interesting pictures were small landscape sketches of his immediate surroundings on the picturesque Arroyo Seco, painted on panels of about 13 by 19 inches. They were lauded by a *Los Angeles Times* critic, on 23 February 1908, for their broad and honest approach, their quickness, and their truth to nature. "California's grey days, as well as her sunshine, have appealed to Mr. Bischoff. Therefore, these sincere studies are the records of many moods. In color they are very beautiful, and their great decorative charm is doubtless due to their author's early training in the principles of design as used in China painting."

Summer 1908 found Bischoff in Seattle teaching china decorating. That fall he sketched in the foothills behind Pasadena, and from January to April 1909 he exhibited his landscape and flower studies in his gallery-studio.[22] Bischoff's flower studies demonstrate his spontaneous brush, economy of means, and direct approach toward his subject. They are usually painted *alla prima* on unprepared boards 19 by 26 inches, or on half-panels of 13 by 19 inches. An example is *Canna Lilies* (plate 169). There is no sign of preparatory drawing, and the brush is used boldly in a lively, painterly manner. The shapes of flowers and leaves are only suggested, with little attention to detail, yet from a distance the effect is that of a closely observed, faithfully rendered painting.

In January 1911 Bischoff participated in the First Annual Exhibition of the California Art Club, submitting several studies of flowers and landscapes.[23] He exhibited again with the California Art Club in November, showing a group of landscapes, a painting titled *The Path to the Church*, and one rose study. A *Los Angeles Times* critic, on 26 November 1911, lamented that there was only one painting of roses but praised it highly for its superb color and impeccable drawing.

In March 1912 Bischoff hosted a show in his studio that included many large and important canvases of floral and landscape subjects. Among the group was an impressive still life titled *Roses* (plate 170), a large painting of masses of cut roses

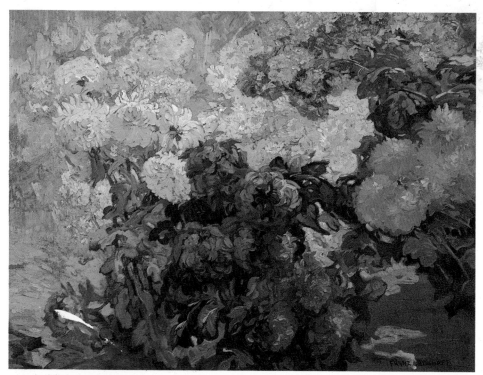

171. Franz Bischoff. *Peonies*.

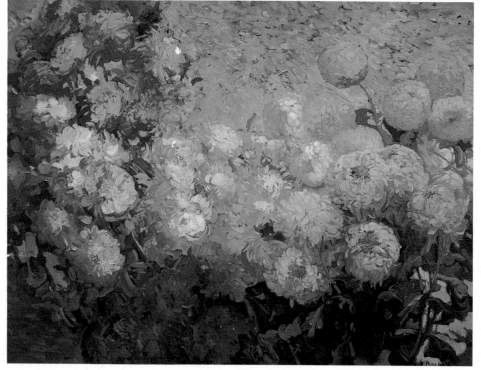

172. Franz Bischoff. *Mums*.

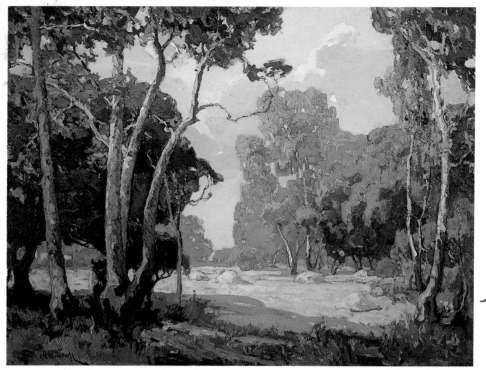

173. Franz Bischoff. *Summer—A California Woodland*.

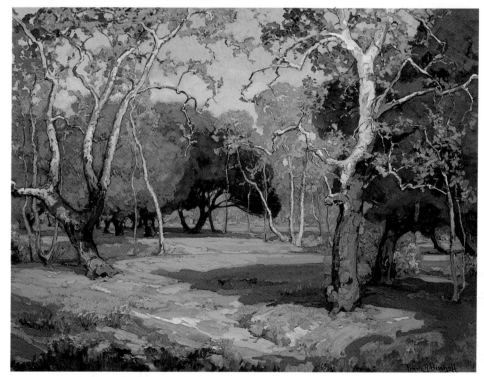

174. Franz Bischoff. *Amidst the Cool and Silence*.

175. Franz Bischoff. *The Bridge, Arroyo Seco.* 1915.

with the feel of dark wet soil, cool swaying breezes, and warm blue sky filtering through myriad blooms. In both paintings color varies from the dark greens and browns of the stems and leaves to a brilliant mixture of exploding pinks, yellows, golds, and soft blues in the central parts of the pictures. The technically elegant paint texture also varies from an almost precise rendition of individual petals to a whirling pattern of strokes, applied throughout with rapid facility.

In addition to flower and landscape paintings, Bischoff showed for the first time a group of landscapes painted at the port of Los Angeles in San Pedro. These show that his virtuosity of color and handling also extended to large, fully developed landscapes. Yet, at this time Bischoff had not greatly extended his range of subject matter: "I never have to go very far away from home for my inspiration to paint."[25] Nonetheless, his paintings of this period show his success with a new genre of California landscapes. By 1912 he could persuasively claim to be one of the leading plein-air painters in Southern California.

On 27 September 1912 Bischoff and his daughter, Frances, left on an eight-month tour of Europe, where they visited Naples, Capri, Pompeii, Venice, Florence, Rome, Munich, and Paris.[26] The day of their departure the *South Pasadena Record* reported that Bischoff intended to study the old masters, while his daughter would study music and voice culture. In France, the artist copied several of Degas's paintings of ballet dancers and made a small copy of van Gogh's *The Sower*, all presently unlocated.[27] This European visit was Bischoff's first since he left Europe in 1885 and his first direct exposure as a mature artist to many Impressionist and Post-Impressionist paintings. As a result, his work for a short time employed the bolder and more harmonious colors seen in his San Pedro group, painted immediately after his return to the United States in 1913. Later in his career the bold colors reappear, and they are used most fully in the last few years of his life.

Fisher Fleet, San Pedro and *Mending Nets*, exhibited in the Fourth Annual Exhibition of the California Art Club in October 1913, are from the series of port subjects that Bischoff began before his trip to Europe. Fishermen engaged in the daily routine were conceived in bold color and large, complex compositions, developed from small preliminary sketches in watercolor and oil.

spilling out from a basket next to two arrangements of roses, one in a green and yellow, Austrian Art Nouveau vase and the other in a beautiful crystal vase.[24] The whole composition is set off by a colorful Oriental tapestry and a rich blue table covering. The treatment of the pink, yellow, and lavender roses is completely natural, with every petal exquisitely rendered in delicate textures and tones. Illumination entering from the upper left highlights the delicately tinted roses and picks up the richness of the two vases and carved hardwood tables. The light on the tapestry is soft and subdued, and provides a provocative, mysterious background.

In the California Art Club exhibition of 1911 there was a group of flower paintings made *in situ. The Rosebushes* and *Chrysanthemums* were garden pictures. Two other works in the show, *Peonies* (plate 171) and *Mums* (plate 172), are an interesting blend of still life and garden modes. At first glance they seem to be still-life paintings of flowers, but it soon becomes apparent that the subjects are painted from earth level,

In the Post-Impressionist mode, these works move beyond mere visual representation toward an exploration of color as the central element in the picture. By contrast, *Roses* and *White Rosebush*, submitted for the premier exhibition of the Los Angeles County Museum of History, Science, and Art in November 1913, were precisely what the public had come to expect from Bischoff (see plate 182).

From 1914 to 1920 Bischoff did an extended series of paintings on seasonal changes in the Arroyo Seco. Both small panel sketches and large final works in this series bear titles such as *Spring*; *Spring Poem*; *A Summer's Parting*; *Sycamores Fall Foliage*; *Autumn Moods*;[28] and *Summer—A California Woodland* (plate 173). In *Summer*, a fully developed landscape, Bischoff captures a small, golden hayfield framed by sycamores at the peak of a hot, muggy day. Deep gray clouds foretell an impending thunderstorm. The success of this picture springs from Bischoff's masterly use of color. By orchestrating a series of hot yellows and oranges with deep shades of cool greens and soft blues, he achieved the sensation of a hot, languid summer day.

By contrast, *Amidst the Cool and the Silence* (plate 174) indulges in the softness and freshness of a mild spring afternoon. The zigzag pattern of light, punctuated by long, deep shadows, invites the viewer to step onto the dewy green grasses and wander into a tall grove of leafing sycamore trees. No muggy atmosphere alters the sparkling light that pervades the picture. Bright greens, yellows, and pinks give the painting its vivacity and overall rich color scheme.

To a large degree Bischoff's facility in handling color can be attributed to his expertise in ceramic decoration. In ceramic painting, transparent colors are applied in successive layers and the finished product achieved by gauging the effect of a base color on the colors yet to be applied. Essentially, this is the same as the traditional glazing technique of oil painting, in which layers of color mixed with varnish are superimposed to produce a deep, glowing color that seems to come from within the painting. An examination of Bischoff's oil paintings, however, shows that he did not use glazes but instead relied on a predetermined undercolor, which "warms through" to give the final color a distinctive glow. This was done by applying the final color quickly and somewhat thinly on dried paint and not allowing the colors to mix on the canvas.

176. Franz Bischoff. *Cambria—A Peaceful California Village.* 1927.

During this active period of work, Bischoff constantly exhibited locally and at his gallery-studio. In October 1914 he had a major exhibition of twenty-seven paintings at the Friday Morning Club in Los Angeles. Praised for his use of bright color and artful rendering of dazzling light and colorful shadows, he was credited too with the facility to present the gloomier side of Southern California's climate and soft light, in "tonal pictures where one dominant color is selected around which all the harmonies are to be played as a theme, the one basic color being now subtly suggested, now openly revealed, but everywhere felt."[29]

Concurrent with the Friday Morning Club show in 1914, Bischoff submitted *The Gate to the Mountain* and *Roses* to the Fifth Annual Exhibition of the California Art Club. The following year these two paintings received a Bronze Medal at the Panama-California Exposition in San Diego. When the fair continued into 1916 as the Panama-California International Exposition and Bischoff allowed the paintings to remain on ex-

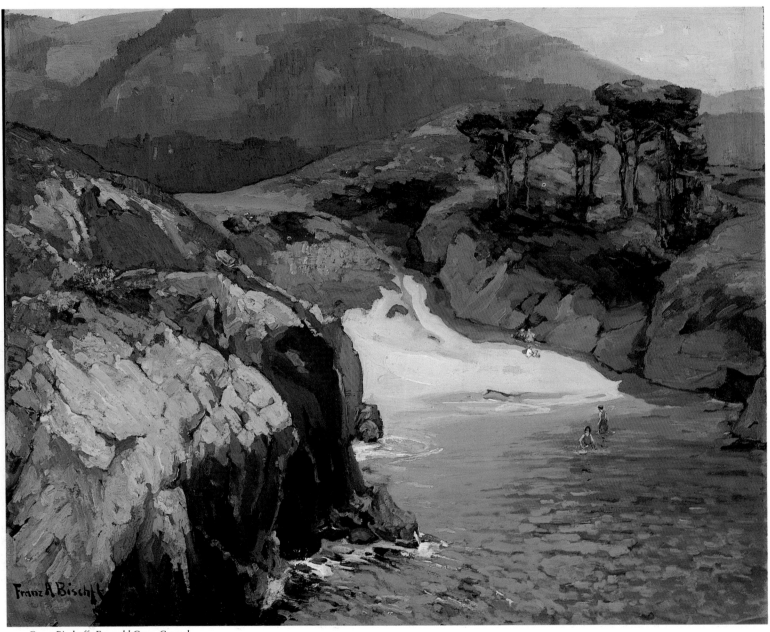

177. Franz Bischoff. *Emerald Cove, Carmel.*

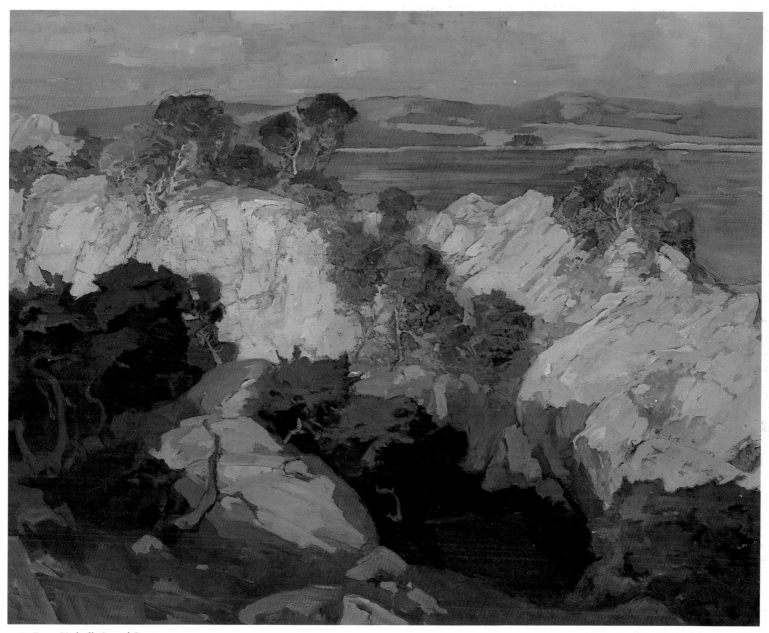

178. Franz Bischoff. *Carmel Coast.*

hibition, he was awarded a Silver Medal.[30]

In late 1915 Bischoff sent a group of paintings to the exhibition for Michigan artists sponsored by the Scarab Club at the Detroit Museum of Art.[31] Among them was *The Bridge*, of 1915 (plate 175), a view of the Arroyo Seco outside his studio window, which he exhibited again in 1916 (or possibly showed a second version) at the First Annual Exhibition of Contemporary American Painters at the Los Angeles Museum of History, Science, and Art. In the Summer Exhibition of Paintings at the museum in 1916, he submitted *Cloud Shadows*,[32] another view of the Arroyo Seco, first shown in his 1912 studio exhibition. In October he exhibited *Mountains Beyond Eagle Rock Canyon* at the California Art Club.

Throughout the remainder of the decade, Bischoff continued to show both flower still lifes and landscapes inspired by his immediate environs. In the California Art Club's Spring Exhibition of 1917, however, he exhibited a landscape unusual for his oeuvre called *Bathers in a Mountain Stream*, a group of nude figures in a secluded stream. In fall 1917 he exhibited two still lifes, *Chrysanthemums* and *Roses on a Tea Table*, at the club's annual exhibition. An untitled still-life painting with a theme similar to *Roses on a Tea Table* demonstrates a more painterly style that uses bolder colors and vigorous brushwork. The tilted perspective of the table, with its tea service, bowl of fruit, and hallmark bouquet of roses, indicates Bischoff's awareness of modern trends. The composition here shows a radical change for the artist, and it contains passages that border on the abstract.[33] On 27 July 1918, Bischoff was one of twenty-five artists who participated in the initial exhibition of the newly formed Laguna Beach Art Association.[34]

In 1920 Bischoff made the first of several extended painting trips into the Sierra Nevada mountains. Undoubtedly, the two Sierra paintings by Edgar Payne in the California Art Club fall exhibition of 1919 prompted Bischoff's trip.[35] The refreshing scenery with its majestic vistas that could be seen from accessible locations, such as Bishop Creek and Big Pine Canyon, seems to have completely occupied Bischoff's attention, because he did not exhibit in 1920. Two of his Sierra works, *Mount Alice* and *Black Lake and Glacier*, were shown in the California Art Club annual fall exhibition in 1921. *Mount Alice* (*Mount Alice at Sunset*)[36] is a depiction of the granite monolith, in tones of red and pink with occasional highlights of lime green against a mustard-colored sky. The provocative color scheme is singularly convincing. Critic Antony Anderson, in the *Los Angeles Times* on 16 October 1921, complimented the artist on the technical advances in this painting: "Beauty has never been absent from his work, but here he has caught it and given it decisive expression, it is no longer tantalizing and fugitive."

In May 1922 Stendahl Galleries in Los Angeles showed sixteen of Bischoff's paintings, including flower studies, the Sierra pictures, and recent works painted at Laguna Beach. Reviewing the show in the *Los Angeles Times* on 28 May 1922, Antony Anderson both praised and damned Bischoff's color: "[The artist's] landscape is not always the landscape that you or I see, it is far lovelier, it has melting harmonies that no one but Mr. Bischoff sees. . . . His chief fault is a certain lack of solidity in forms, a tendency to utilize color for its own sake and to disregard the fact that objects in nature must have the quality of those objects when translated into paint."

During the mid-1920s Bischoff painted along the central and northern California coast. In May 1924 he was invited to participate in the first exhibition of the Painters of the West, at the Biltmore Salon, in the Los Angeles Biltmore Hotel. That November he had a smaller show of twelve paintings at the same location: *A Villa on the Monterey Coast* and *Windswept Twisted Cypress* suggest that the artist had developed a fondness for popular scenic haunts. At the California Art Club that fall he showed *Cliff-Born Trees, Monterey Coast* and shared the Mrs. Henry E. Huntington Prize with Alson S. Clark.[37]

From 1924 to 1927 Bischoff painted a group of canvases in the village of Cambria, the central-California coastal community, works that are remarkably luminous and harmonious in color. In *Cambria—A Peaceful California Village* of 1927 (plate 176), Bischoff chose to portray his scene in the soft, hazy sunlight of early afternoon. Lively yellows and pinks contrast with deep purples and lavenders, and the earth tones of the soil play against the cool deep greens of the vegetation and complement the bright houses. Bischoff breaks his colors into a multitude of others, rarely using a single, solid color alone. And there is always an undercolor that gives the final color a warmth and brilliance typical of the artist's mature works.

In the Cambria pictures, Bischoff explored

the traditional American theme of the relationship between man and nature. For the artist, Cambria epitomized bucolic America. It represented the nobility of the rural village with its attendant cleanliness, spirituality, and above all, peacefulness. The theme of rural quietude runs through the small but noteworthy group of Cambria paintings, and many of these canvases are drawn with a softened line, which results in a fuller, rounder form, reminiscent of children's storybook illustrations. The larger works may well have been painted in the studio but still exhibit a gentle, nostalgic light very much in keeping with the stylized line and form. By contrast, the small Cambria panels are impressionistically and spontaneously handled, indicating that they were painted *in situ*.

While he worked in Cambria, Bischoff was accompanied by a younger artist, J. Christopher Smith (1891–1943), who had been a student of Robert Henri. A comparison of Smith and Bischoff's Cambria pictures shows the younger artist's work to be stronger in form and composition and more striking in color.[38] Bischoff's paintings, however, are more elegant and subtle in color and technique, and Smith probably gained some technical advantages from working alongside the mature artist. It is even more likely that Smith's use of color was a strong stimulus for Bischoff's movement toward the use of bolder colors.

The Monterey area with its rocks, sea, trees, and fog was another stimulus for Bischoff's strong color sensibility. A number of his works show the inland and coastal landscape under conditions of light and atmosphere, each with its own particular colors and tones. *Emerald Cove, Carmel* (plate 177) has much in common with the Cambria group. The sense of light and atmosphere and the vivid, crisp colors are almost identical. Figures are rarely included in Bischoff's oeuvre, and when they are they are usually incidental to the landscape. Bathers add interest in *Emerald Cove*, but their function seems only to accentuate the breadth of the cove with its adjoining beach.

In *Emerald Cove* as well as his other Carmel-Monterey works, Bischoff concentrates on the rich and vibrant light of the coast with its distinctive softening effect, especially at the time when the morning fog has lifted and the sun is veiled in a cool haze. *Carmel Coast* (plate 178), a large painting of the rocky cliffs above the ocean, also was captured at this time of day. The light warms the rocks with a soft iridescent glow, an effect that is aided by the careful choice of an undercolor. In the unfinished parts of the left foreground are vivid colors of salmon, yellow, and green, and their subtle presence gives the rocks and cliffs their unique appearance.

The craggy cypress trees of the Northern California coast also inspired Bischoff's sense of design. In *Monterey Trees* (plate 179) he fills the canvas with a complex network of undulating lines, and coupled with his use of color this gives the work a richly decorated appearance that resembles a Persian carpet or a stained-glass window. Set in the soft, overcast, morning light, it is painted in muted tones and subtle color harmonies. The restrained contrast between light and shade gives the picture its uniform, nondirectional quality of light.

Bischoff's paintings of Northern California, although occasionally striking in color and provocative in line, are firmly rooted in the Impressionist tradition. They are works that deal primarily with representing the visual effects of light. Moreover, they retain several qualities characteristic of American Impressionism: a well-developed sense of depth and space, a retention of solid form, and a reverential approach to nature as subject matter. The charm of the Carmel-Monterey area for an Impressionist painter was the distinctive mood created by the different climatic conditions, and many of Bischoff's titles testify to this: *Mist Veiled Days, Monterey*; *Morning Mist, Monterey Coast*; *Gold Rimmed Rocks and Sea, Near Highlands*; *Beneath a Sky of Mazarin, Point Lobos*,[39] and others. Although bold in their color harmonies and contrasts, these works have a common aim—a clear and convincing representation of the optical effect of natural light.

Bischoff continued to enter his Carmel-Monterey group of paintings in local shows from 1925 through 1928. Early in 1926 he began to paint in the desert near Palm Springs. That June he exhibited a group of his desert pictures at the Ainslie Galleries, in the large Barker Brothers Store in Los Angeles, and sent other desert paintings to San Diego for the First Exhibition of Artists of Southern California.[40]

In 1928 Bischoff contributed to an exhibition of California artists at the Pasadena Art Institute with *The Dairy*.[41] He showed again at the Ainslie Galleries, this time a diverse group of paintings of the Sierra, Monterey, and Palm

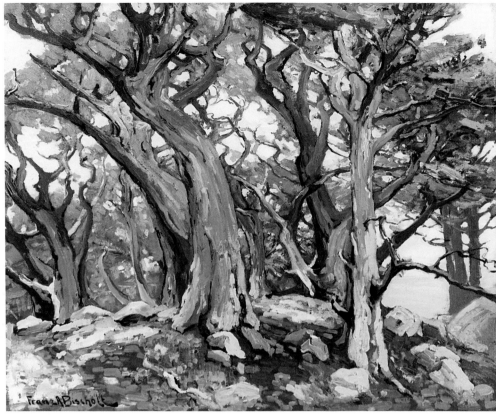

179. Franz Bischoff. *Monterey Trees*.

Springs. This diversity of subjects and the re-showing of older work suggest that in these later years Bischoff was painting less.

In summer 1928 Bischoff took the last of his painting trips. Accompanied again by J. Christopher Smith, he painted the Zion National Park in southwestern Utah. Here he was impressed most by the pageant of vivid colors seen in the towering sandstone cliffs. In depicting them he departed from their natural colors, choosing instead extremely strong hues. The audacious colors of the Utah pictures, so far beyond Impressionism, point to Expressionism and Fauvism. Smith's paintings of the same subjects show an even greater departure from the natural colors of the sandstone cliffs, relying more on color for dramatic tension and emotion. When Bischoff showed two of the Zion Canyon paintings at the Kanst Gallery in Los Angeles that October the reviewer mentioned the artist's subject matter without commenting on the color scheme, diverting his praise instead to the artist's earlier works in the show.[42]

Bischoff's exploration of painting areas beyond California was cut short only a few years after it had begun, when he died of heart failure, on 5 February 1929, at his home in South Pasadena. His artistic career had been energetic and practical in orientation. A successful business-man and a prolific artist he produced a vast number of ceramics and paintings. From the very first of his many exhibitions his handling of color gave him a special identity, and today Bischoff's color continues to enthrall us.

JEAN STERN

PATRONS AND CRITICS IN SOUTHERN CALIFORNIA
1900–1930

In 1929 Arthur Millier, art critic for the *Los Angeles Times* from 1926 to 1958, reviewed the growth of art in Los Angeles during the first three decades of the twentieth century. With great insight he noted that "the future historian will probably trace the homogeneity of the Southern California landscape school, which can at times seem rather tame and obvious, to the fact that [artists], once they had discovered the new country, settled down to acquaint themselves with it more intimately than had the earlier painters, choosing small, rather than grand, subjects and seeking for truth of appearance."[1] Millier declared that this period in California art "concerned itself principally with studying the land rather than with creating an art by composing elements of California life, beliefs and experience."[2] In 1915 critic Alma May Cook concluded that California's isolation from the art centers (probably meaning New York, Chicago, and Paris) was "a blessing in disguise." It afforded the California artist an opportunity to be more self-reliant and individual because he was shielded from all the latest styles and able to pursue his art in relative peace.[3]

Although art activity in California, and especially in Los Angeles, was provincial in contrast to that of major art centers, such as New York and Chicago, Los Angeles nevertheless strove to emulate the sophistication of those centers. Despite the inroads being made by modernist art, Impressionism in its American form dominated the mainstream of art in the United States from about 1890 through 1930. In California, too, much of the work produced between 1900 and 1930 was based on Impressionist theory and technique. Promoted by local dealers and lauded by local writers and critics, this style quite naturally developed a local patronage.

Los Angeles at the turn of the century was exactly the kind of setting to which Cook referred. It was hardly a cosmopolitan city,[4] although during the 1880s and 1890s, an influx of cultured Midwesterners and Easterners of means (from both the middle and upper classes) had relocated in the milder climate of Southern California.[5] These people became the patrons of artists who began to arrive in increasing numbers after 1900.

At the end of the nineteenth century, the preeminent dealer in the works of local artists as

180. *Interior of Kanst Art Gallery at 826 South Hill Street, Los Angeles, with John Kanst.* c. 1917–23.

181. *Interior of Kanst Art Gallery, Hollywoodland, Opening Day, April 1924.*

well as those by Americans from the East and European artists was John F. Kanst (1863–1933). Kanst first came to Los Angeles in 1895, and by 1911 he had earned a reputation as a premier collector as well as an expert on American art. He operated his gallery at several locations in Los Angeles until 1924 (plate 180), when he opened a custom-designed gallery-residence in the Hollywood Hills (plate 181).

Most of the city's public art activities and exhibitions took place in the Blanchard Music and Art Building at 233 South Broadway, opened by Frederick W. Blanchard in 1899. The building provided both studio and exhibition space for artists and musicians. In 1906 Blanchard organized an art committee that became the Municipal Arts Commission of Los Angeles in 1911.

Women played pivotal roles in the development of cultural activities in Los Angeles. In 1888 a group of women founded the Ruskin Art Club. Its members met in the Blanchard Building and devoted themselves to the study of art history and appreciation. One of its leaders was Henrietta Housh, wife of Harvey Housh, the principal of Los Angeles High School. Encouraging regular art exhibitions, she later established the Fine Arts League, "to found and maintain after the highest standards and for the public good, an institution of Fine Arts, including music and poetry."[6] As a result of the League's efforts, an art gallery was added in 1910 to the plans for the proposed Museum of History and Science in Los Angeles.

Women's social clubs, like the Ruskin Art Club, soon became one of the most important avenues by which the local artists could become known. Among these clubs, the most notable were the Friday Morning Club and the Ebell Club. The Friday Morning Club, established in 1890, held its first exhibition of paintings in 1903. By 1911, an Art Committee was formed to promote public interest in art. The club took special pride in the work of California artists, extending an invitation to the California Art Club, founded in 1909, to hold regular exhibitions in the club's auditorium. Activities of the Friday Morning Club included the sponsorship of exhibitions, lectures, and special programs from other parts of the country.

The Ebell Club held regular exhibitions for artists throughout the teens and twenties. In 1929 it established an art salon and an art patrons' committee. Fred Hogue, chief editorial writer for the *Los Angeles Times*, wrote in 1930 that "art appreciation in Los Angeles . . . received a powerful stimulus through the activities of . . . the Ebell Club."[7] The club's bulletin published articles on art and artists that generally reflected the prevailing conservative viewpoint.

In 1913, the year of the revolutionary Armory Show in New York, the Los Angeles Museum of History, Science, and Art in Exposition Park was completed. The opening of the museum's art galleries was lauded both for the opportunities it would offer local artists and for the possibility of beginning a collection of national and international art (plates 182 and 183).[8] It was immediately embroiled in controversy, however, when the California Art Club was refused permission to take part in its opening exhibition without submitting individual works to the scrutiny of a museum jury. Although the museum immediately dropped the jury requirements and invited club members to lend work for exhibition as individuals, many of them refused to participate. Instead, they held their own exhibition at the Blanchard Building. Among the local painters who participated in the museum's opening exhibition were Maurice Braun, Franz Bischoff, Jean Mannheim, John Gamble, and Elmer and Marion Wachtel.[9]

The museum's opening exhibition consisted of several small groups of loans: twenty-seven old-master works and numerous foreign works from various periods (including, for example, a Corot landscape, a Daubigny sunset, and a Bouguereau peasant girl) loaned by local collectors; sixty paintings by California artists; and twenty-six paintings by New York artists. The New York paintings were selected by artist Gardner Symons and included the work of leading Eastern painters of the time. The Los Angeles show took place about nine months after the Armory Show, but, significantly, each of the twenty-six paintings by New York artists represented mainstream American art of that time. Among the painters whose work was shown in Los Angeles were Frank W. Benson, Childe Hassam, Daniel Garber, Frederick Frieseke, Willard Metcalf, Richard Miller, Paul Dougherty, Cecilia Beaux, and William Ritschel. No work that might be deemed controversial or "modernist" was included.[10] The impressionistic style of these works was also seen in the sixty works by California artists. By the next year, the California Art Club had mended the rift with museum officials, and its members began to

show works at the museum annually. In addition, the museum began to schedule one-artist exhibitions regularly for local painters and sculptors.[11]

Until 1918, however, Los Angeles lacked an art benefactor and a major collection. That year William Preston Harrison (1869–1940) moved to Los Angeles from Chicago. Harrison's aim as a collector was to acquire works by artists of national stature, and he made an initial gift to the museum of twenty-eight paintings, most of them works by contemporary American artists, including Frederick Frieseke, William Merritt Chase, Frank W. Benson, Robert Henri, and George Bellows.[12] In recognition of his major contribution, Harrison was made Honorary Curator of Art at the museum in 1921.

Although beginning in 1922 Harrison annually provided prize money for local exhibitions by California artists, he rarely patronized their work. An exception was his purchase of a painting by William Wendt in 1922, which Harrison gave to the museum.[13] Harrison's lack of interest in patronizing local artists was typical of the region. Porter Garnett, writing in the *San Francisco Call*, commented in 1919 that California collectors preferred the work of artists from Europe or the Eastern United States out of "fear of appearing provincial" and from a lack of "trust" in their own artists.[14] William Wendt was one of the few California artists who had achieved national status, largely through participation in exhibitions at the Art Institute of Chicago. Thus he was a reasonably secure choice for Harrison's collection.

A catalogue of the summer exhibition at Kanst Galleries in 1921 reflects California's collecting trends. Included were works by E. Irving Couse, Emil Carlsen, Bruce Crane, Paul Dougherty, Childe Hassam, William Keith, Edmund Osthaus, and Edward Pothast, among others, all of them well-known Eastern painters. Kanst, however, also encouraged the collecting of local painters. He held monthly and bi-monthly one-man shows for local artists (he exhibited works by Hanson Puthuff as early as 1908) and published small catalogues of their work. As a lecturer at the various social clubs, Kanst was very influential in gaining public support for these artists.[15]

In 1921 Earl Stendahl established the Stendahl Galleries in the Ambassador Hotel. Over the next ten years he promoted the works of local painters and at times published lengthy monographs on their work, often in collaboration with Fred Hogue (plate 184).[16] Although admittedly not an art critic, Hogue wrote several articles on local painters for the *Los Angeles Times*, which helped to promote their work.[17] By this time there was a solid base of patronage for local artists whose work was essentially in a style rooted in French Impressionism.

The acceptance of Impressionism by Los Angeles patrons was reinforced in 1916 when artist Richard Miller visited, staying for nearly a year in Pasadena, where he gave criticisms to young artists at the Stickney Memorial School of Art (see plate 54). During his visit he also painted several portraits of society women in the garden of Dr. and Mrs. Adelbert Fenyes. Eva Scott Fenyes (1846–1930), herself an artist, was an important patron as well, and she made her garden-studio available to many artist friends, including Benjamin Brown and John Hubbard Rich. The Miller visit was reported in the *Los Angeles Times* and then recalled several years later by Mabel Urmy Seares in her illustrated publication *California Southland*.[18]

Los Angeles patrons were generally unreceptive to the directions espoused by the more radical contemporary painters working in Europe. In December 1925, *The California Art Club Bulletin* published a letter from Los Angeles architect Joseph Weston, then traveling in Europe. Weston commented on "the trend of so-called Modern Art" and referred to it as "the freakish dabbling of an untrained mind. . . . Rootless sprouts who are either incapable of drawing, or are too lazy."[19] Artist Benjamin Brown, in an article in the *Los Angeles Times* in 1929, emphatically stated his position on modernist movements:

> I am interested in the play of light and shade on objects of nature, and my pictures, though realistic, are carefully composed and balanced in areas, like the concealed decorative effect of nature rather than the formalistic artificial balance. I have no sympathy with the modernistic theory of so-called organization, self-expression and crass ugliness.
>
> My antagonism to 'modernism' is because I believe that it is a transient fad and will pass away as did extreme expressionism, impressionism, Whistlerism, pointillism, art moderne, and so forth.[20]

The attitudes of Weston and Brown reflected a majority opinion. Most art patrons across the country strongly opposed avant-garde modern

182. *First Art Exhibition in the Museum of History, Science, and Art, Opening Day, 6 November 1913.*

183. *First Art Exhibition in the Museum of History, Science, and Art, Opening Day, 6 November 1913 (detail).*

art, especially Cubism and Futurism.[21]

One of the most prominent collectors in the Los Angeles area during the 1920s was Josephine P. Everett (1866–1937), widow of Henry A. Everett of Cleveland. As a winter resident of Pasadena, Mrs. Everett amassed a large collection of contemporary American art, which included a number of the California Impressionist painters, among them Guy Rose, Edgar Payne, Hanson Puthuff, Gardner Symons, and William Wendt. In 1927 Everett began a regular program of giving works of art to the San Diego Museum of Art. This process continued until her death, when her estate was divided among the San Diego Museum, the Pasadena Art Museum, and the Cleveland Museum of Art.[22]

The conservative environment must be taken into consideration when analyzing the critical writing on art in Los Angeles between 1900 and 1930. Not until the late 1920s did any critical writing address modernist concerns. Since the attraction of Southern California for many artists was its climate and topography, writing from that era repeatedly refers to the beauty of the California landscape and the unique quality of the light. Several contributing writers to *Art in California*, published a year after the 1915 Panama-Pacific International Exposition, wrote extensively about the lure and the charm of California. Noted architect Willis Polk stated: "Here where nature displays herself in her most artistic mood, there is a life and virility that the painter feels each time he puts his brush to the canvas."[23] Antony Anderson, of the *Los Angeles Times*, referred to the "seductions of landscape,"[24] while Michael Williams, of the *San Francisco Examiner*, cast an even stronger romantic note when he described "the land of the great out of doors, a region where art may touch the life-giving bosom of Mother Earth once more, and be fructified anew."[25] Such glowing reports naturally attracted landscape painters, and Arthur Millier remarked that those figure and portrait painters who settled in the area would soon be lured into painting the landscape.[26]

In California, as elsewhere, artists were still dealing with Impressionist ideas about the interpretation and depiction of light. Christian Brinton remarked that the radical movements of the times—Cubism, Futurism, and Orphism—which were represented at the Armory Show, had been excluded from the American section at the PPIE, an indication of the strong resistance that modernism was encountering in the United States.[27] Ranking the Impressionist discoveries as second in importance to the discovery of perspective, Brinton considered Frederick Frieseke the most important American artist at the PPIE.[28] "Mr. Frieseke proved the official as well as popular success of the exhibition . . . , his canvases are . . . captivating in their sheer, bright-toned beauty, their luminous iridescence, whether of boudoir or sun-flecked river bank."[29]

Impressionism continued to leave its mark on California in the years following the PPIE. In the north J. Nilsen Laurvik, director of the Palace of Fine Arts in San Francisco, reviewed the San Francisco Art Association's 1918 annual exhibition and found that it revealed the "new point of view in art crystallized by the influence of the Panama-Pacific International Exposition."[30] Laurvik noted that all the works were imbued with a "modern sense of light and color," works representing Impressionism, Realism, Post-Impressionism, and Cubism.[31]

In the south, Antony Anderson echoed Brinton's opinion when he stated in 1916 that Impressionism was the only method permitted in the painting of the landscape. To Anderson, an artist himself who had studied at the Art Students League in New York and at the Art Institute of Chicago, the ideas of the Cubists and the Futurists were only fleeting, whereas Monet's ideas, once considered radical too, were still alive, thus proving their merit. Anderson felt that the future of painting would be "a direct offshoot of impressionism."[32] The following year Mabel Urmy Seares wrote about Southern California's landscape school and the challenge of painting the brilliant sunshine. In agreement with Anderson, she noted that "not until the advent of broken color, brilliant contrasts and direct painting from nature in its modern high key has . . . the southern part of the State found true interpretation."[33]

This emphasis on the depiction of color and light is central to much of the critical writing in Southern California from about 1910 until 1930. Antony Anderson made his support of Impressionist methods clear in his review of the 1917 Spring Exhibition of the California Art Club. "The showroom is like a flash of summer, full of sunlight and full of color. The landscapists have been out of doors in full force for many months past, and the glory of their sports is not to be dimmed by four walls and a skylight. The figure painters—and they are numerous—are equally

bold in light."[34] Interest in color and light is a recurring theme in Anderson's reviews, most of which were encouraging but with little critical analysis. He recognized, however, those artists who were successful in employing what he saw as a modernist direction.[35] About Clarence Hinkle, whose works show a decided Cubist influence, Anderson wrote that "his experiments in technique are interesting. Wonderful effects of air and color are attained in the parallel bars of pure color that he employs in the pictures. . . . The canvases are crisp, sparkling, brilliant . . . the diffusion of light is so subtle."[36] For Anderson, Joseph Kleitsch was one of the area's foremost painters. "Kleitsch paints the facts of light, color and form with a superb and easy gesture."[37] Maurice Braun painted landscapes "full of brilliant light, and all done with his usual free swing of the palette knife."[38] Guy Rose he considered the premier Impressionist painter, since Rose had lived for many years at Giverny, where he came under the influence of Monet. Rose, Anderson wrote, had "a preference for the lovely and often dreamlike aspects of diffused light."[39]

The emphasis on light and color in critical discussion of California art and artists was not confined to local publications. Rose V. S. Berry of San Francisco, writing for the *American Magazine of Art* in 1924, discussed extensively the California landscape where "color is riotous" and the "rarified atmosphere . . . sharpens every line into a thread, obliterates distance, and throws the entire landscape into a detailed area defying the artist who looks for indefinite masses to treat with great breadth."[40] Her evaluations of Jean Mannheim, Alson Clark, William Wendt, Guy Rose, Hanson Puthuff, Jack Wilkinson Smith, and Benjamin Brown focused on their ability to interpret light and color. Like Anderson, she made a point of comparing works of the California artists, especially Rose, with the work of Monet.

More definitive criticism and analysis came from Arthur Millier who replaced Antony Anderson as art critic for the *Los Angeles Times* in 1926. More receptive to modernist ideas than Anderson and writing at a time when Impressionism as a style was waning, Millier was a much more objective critic. In November 1927 he described the annual exhibitions of the California Art Club as "middle of the road," representing "the main stream [*sic*] of local art production."[41] Making a careful analysis of the

184. *Interior View: William Wendt Exhibition, Stendahl Art Galleries, Los Angeles.* April 1939.

works, based on form, color, and design, he commended those artists whom he felt had used these elements to the best of their abilities. In his review of the Eighteenth Annual Exhibition of the California Art Club, Millier found much to be praised in Charles Reiffel's *Summer Design* (winner of the Evelyn Dalzell Hatfield Medal) and in Franz Bischoff's *Cambria* (see plate 176). "But, glancing around the room, the rule seems to be the beautiful, the charming, or the pretty picture. That is often the artist's aim, and that is what the public expects from him. But where are the penetrating comments on our life and people? Where is that sudden sting of keenly felt beauty such as grips one when walking on Broadway or scaling a California mountain?"[42]

Millier continued his analysis in August 1927, with a comparison of the cultural differences between San Francisco and Los Angeles, observing that Los Angeles lacked a cultural center and that most of its artists were from agrarian areas.[43] As a result, Los Angeles art was "rural and naturalistic" whereas San Francisco art was "urban and asthetic [*sic*]."[44] Los Angeles artists "concern themselves little with abstract theories of art, giving their whole time to the interpretation of nature."[45] Millier was most insightful

when he stated that "it is fashionable today to talk about the 'fundamentals of art,' but no two people describe the same fundamentals. Wherever artists are sincerely working and thinking, art will be produced. To arrive at a sympathetic appreciation of their work it can hardly be amiss to consider their aims and the background against which they create."[46] Perceptively, in this statement Millier aligned himself with art historians of today who are reevaluating French Impressionism by looking at it within the context of its time rather than solely on the basis of its technical theories.

Millier also contributed to *Argus*, the first, but unfortunately short-lived, California journal of art criticism, published in San Francisco from April 1927 to April 1929. The publication had broad distribution throughout the state, and it reported on local, national, and international events. The goal of its editor, Jehanne Bietry Salinger, was to support and encourage the younger, more audacious artists, whose methods were being met with resistance by the general public.[47] Millier leveled his severest criticism of this resistance in the February 1928 issue of *Argus* when he stated that Los Angeles art patrons limit their appreciation to "a diluted form of impressionism, unable to take the step that will reveal the un-material 'form' of Cezanne, the passion of Van Gogh's line and color and the carefully related color harmonies of Matisse, principally because it has never been confronted with these."[48] Clearly, Millier felt that it was time to move on from Impressionism. That same year, Merle Armitage wrote a satirical article in the *West Coaster*, accusing nine-tenths of the artists on the West Coast of grinding out repetitive calendar illustrations. Calling their "harmless art" the "eucalyptus school" of painting,[49] Armitage coined a phrase that came to be applied to all the Impressionist artists, including the serious, professional, and highly respected painters who had arrived in California during the first decade of the twentieth century.[50]

Also indicative of the changing times, the California Art Club in 1926 published a defense in its November *Bulletin*, in response to negative criticism of the work of its members. The statement read in part: "Some say that we are docile; some say that we are conservative; some say something else again, but we are going ahead, we are painting and modeling in the way we are sure is right and some day the wise ones will find it out."[51]

The following year Aline Barnsdall donated her house, designed by Frank Lloyd Wright, and the park surrounding it to the city of Los Angeles for use as a cultural center. The home was given to the California Art Club as its new galleries and headquarters under a fifteen-year lease. Barnsdall, herself a collector of modern American and European art, recognized that artists needed more than just wealthy patrons and that, in fact, the healthiest art was free of patronage.[52]

Armitage's article, however, and Millier's observations reflect the changes that were occurring in the arts in Southern California as well as elsewhere in the late 1920s. Modernism in its various forms was beginning to have an impact. Impressionist technique, with its emphasis on color and light, was put aside as artists turned to subjects that could be better interpreted in more modern terms.

JANET BLAKE DOMINIK

NOTES

MᶜMANUS, *A Focus on Light*

1. William H. Gerdts, *American Impressionism* (New York: Abbeville Press, 1984), 306.
2. New York: John Lane Company, 1916, 15.
3. *Los Angeles Times*, 22 May 1927, 2:4.

GERDTS, *To Light the Landscape*

This essay is dedicated to my good friend and colleague Dr. Barbara Novak, one of the first to "see the light."

1. Barbara Novak, *Nature and Culture: American Landscape Painting 1825–1875* (New York and Toronto: Oxford University Press, 1980), 41–42.
2. Asher B. Durand, "Letters on Landscape Painting, No. VI," *The Crayon* 1 (4 April 1855): 210.
3. Thomas Cole, "Lecture on American Scenery," *Northern Light* 1 (May 1841): 26.
4. Reynolda House, Winston Salem, North Carolina; Cleveland Museum of Art.
5. New Britain Museum of American Art; The Brooklyn Museum of Art.
6. Barbara Novak, "On Defining Luminism," in National Gallery of Art, *American Light: The Luminist Movement 1850–1875, Paintings Drawings Photographs* (New York: Harper & Row, 1980), 25.
7. Ibid.
8. Metropolitan Museum of Art, *A Memorial Catalogue of the Paintings of Sanford Robinson Gifford, N. A.*, essay by John F. Weir, New York City, 1881, 9.
9. Clarence Cook, "National Academy of Design—The Thirty-Ninth Exhibition, II," *New-York Daily Tribune*, 30 April 1864, 3; James Jackson Jarves, *The Art-Idea* (New York: Hurd and Houghton, 1864), 193.
10. The Metropolitan Museum of Art.
11. George P. Lathrop, "Art," *Atlantic Monthly* 31 (January 1873): 115.
12. H. Barbara Weinberg, *The American Pupils of Jean-Léon Gérôme* (Fort Worth: Amon Carter Museum, 1984). Weinberg does not, however, delve into the impact of Gérôme's teaching upon painters of landscape.
13. See Gerald M. Ackerman, *The Life and Work of Jean-Léon Gérôme with a Catalogue Raisonné* (London: Sotheby's Publications, 1986), although the author does not deal specifically with Gérôme's concern with landscape.
14. Musée des Beaux-Arts, Nantes.
15. Philadelphia Museum of Art.
16. City Museum and Art Gallery, Birmingham.
17. Gallery of Modern Art in the Palazzo Pitti, Florence.
18. Galleria d'Arte Moderna, Venice.
19. "R. T.," "Sunshine," *Fine Arts Quarterly Review*, n.s. 2 (June 1867): 363.
20. "Influence and Individuality. Some Further Conversation with William Hart," *Art Union* 1 (May 1884): 105.
21. Eleanor Phillips Brackbill, "*Modern Art*: An American Magazine of the 1890s" (unpublished seminar paper, City University of New York Graduate School, 1981).
22. "The Critical Triumvirate" [Hamlin Garland, Lorado Taft, Charles Francis Browne], *Five Hoosier Painters* (Chicago: Central Art Association, 1894).
23. Otto Stark, "The Evolution of Impressionism," *Modern Art* 3 (Spring 1895): 53–54.
24. Caroline C. Mase, "John H. Twachtman," *International Studio* 72 (January 1921): lxxiii.
25. See, for instance, "The American Artists' Supplementary Exhibition," *Art Amateur* 7 (June 1882): 2; "The Society of American Artists," *Art Journal* 8 (New York, 1882): 191; "Society of American Artists," *New-York Times*, 4 May 1882, 5; "Society of American Artists. Second Exhibition.—I," *New York World*, 8 May 1882, 2.
26. M(ariana) G. van Rensselaer, "Society of American Artists, New York—II," *American Architect and Building News* 11 (20 May 1882): 231.
27. Private collection.
28. Indianapolis Museum of Art.
29. For Steele, see Selma N. Steele, Theodore L. Steele, and Wilbur D. Peat, *House of the Singing Winds* (Indianapolis: Indiana Historical Society, 1966); and Judith Vale Newton, "Theodore C. Steele," in *The Hoosier Group: Five American Painters* (Indianapolis: Eckert Publications, 1985).
30. William A. Coffin, "Jean-Charles Cazin," *Century* 55 (January 1898): 395.
31. "Jean Charles Cazin," *Art Interchange* 31 (December 1893): 158.
32. National Gallery of Ireland, Dublin.
33. Quoted by Charles Teaze Clark in *Bruce Crane (1857–1937): American Tonalist*, exh. cat. (Old Lyme, Connecticut: Lyme Historical Society, 1984), 7.
34. "The Academy of Design (Third Notice)," *Studio and Musical Review* 1 (16 April 1881): 178.
35. Charles H. Davis, "Notes Upon Out-of-Door Life by One of Our Students in France," *Art Student* 1 (December 1884): n.p.
36. A[rchibald] S[tandish] Hartrick, *A Painter's Pilgrimage Through Fifty Years* (Cambridge: University Press, 1939): 28.
37. Sadakichi Hartmann, *A History of American Art*, 2 vols. (Boston: L. C. Page, 1902), 85–86.
38. Private collection.
39. *The Wave*, Pennsylvania Academy of the Fine Arts; "The American Artists' Exhibition," *Art Amateur* 18 (May 1888): 130.
40. "Society of American Artists," *Art Interchange* 20 (21 April 1888): 130.
41. Hartmann, *History of American Art*, 180–82.
42. Yale University Art Gallery.
43. "The Water Color Society," *Studio*, n.s. 1 (14 February 1885): 160.
44. "The National Academy of Design. The Sixtieth Annual Exhibition. I," *Studio*, n.s., no. 18 (11 April 1885): 209–10.

45. Lady Elizabeth Longman Collection.

46. Philip Hale, "Artists' Little Games," *Modern Art* 4 (Summer 1896): 72.

47. William R. Johnston, "W. H. Stewart, the American Patron of Mariano Fortuny," *Gazette des Beaux-Arts* 77 (March 1971): 182–88.

48. Avery to Johnston, 31 July 1872, in Archives of the Metropolitan Museum of Art, New York City; quoted in Madeleine Fidell Beaufort and Jeanne K. Welcher, "Some Views of Art Buying in New York in the 1870s and 1880s," *Oxford Art Journal* 5, no. 1 (1982): 54.

49. Lloyd Goodrich, *Thomas Eakins: His Life and Work* (New York: Whitney Museum of American Art, 1933), 19.

50. Private collection.

51. Portland Museum of Art, Maine.

52. For illustrations of such works by these artists, see David Sellin, *Americans in Brittany and Normandy 1860–1910,* exh. cat. (Phoenix Art Museum, 1982).

53. "The Acadmy of Design," *New-York Times,* 30 April 1882, 3.

54. Daniel B. Grossman Fine Arts, New York.

55. Philip Gilbert Hamerton, *Art Essays,* 2 vols. (New York: A. S. Barnes & Co., 1880), 63.

56. Private collection.

57. Sylvester R. Koehler, "III—Second Annual Exhibition of the Philadelphia Society of Artists," *American Art Review* 2 (First Division, 1881): 111.

58. "Art Hints and Notes," *Art Amateur* 15 (October 1886): 96.

59. Pennsylvania Academy of the Fine Arts.

60. See this author's *American Impressionism* (New York: Abbeville Press, 1984). Much of the following material is drawn from this study.

61. Ogden N. Rood, "Art. XVI—On a new Theory of Light, proposed by John Smith, M. A.," *American Journal of Science and Arts* 30 (September 1860): 186.

62. Toledo Museum of Art.

63. Minneapolis Museum of Art.

64. Private collection.

65. Clara T. MacChesney, "Frieseke Tells Some of the Secrets of His Art," *New York Times,* 7 June 1914, 6:7.

66. M(abel) Urmy Seares, "Richard Miller in a California Garden," *California Southland* 38 (February 1923): 10–11.

67. Nancy Boas, *The Society of Six California Colorists* (San Francisco: Bedford Arts, 1988), 69.

68. I am most grateful to Kathleen Burnside for sharing her research on Hassam in California with me.

69. Ottorino D. Ronchi, "A Guide to Hassam," *Argus* 4 (February 1929): 4.

70. Stark, "Evolution of Impressionism," 55.

DIJKSTRA, *The High Cost of Parasols*

1. Arthur Hoeber, "Concerning Our Ignorance of American Art," *Forum,* 39 (January 1908): 353.

2. Ibid.

3. Ibid., 355.

4. [Charles J. Sprague], "The Darwinian Theory," *Atlantic Monthly,* 18 (October 1866): 420.

5. Ibid., 424.

6. Ibid., 423.

7. Medium, size, and current location unknown.

8. Otto Weininger, *Sex and Character* (London: W. Heinemann; New York: G. P. Putnam's Sons, 1906): 286.

9. August Strindberg, "De l'infériorité de la femme," *La Revue Blanche* (January 1895): 14.

ENGSTRAND, *In Search of the Sun*

1. Richard Henry Dana's *Two Years Before the Mast,* first published in 1840, sold ten thousand copies the first year and remained constantly in print after that time; the widely read journals of John Fremont's travels to the Pacific Coast were published by the United States Government Printing Office in 1845, 1848, and 1849 and, after the discovery of gold near Sacramento in 1848, all travel literature on California was in great demand. See David Wyatt, *The Fall into Eden: Landscape and Imagination in California* (Cambridge: Cambridge University Press, 1986), chapter 1.

2. An ensuing tariff war lowered fares to unheard-of rates. For a few days, the price of a ticket from Kansas City to Los Angeles was just a dollar. See Judith W. Elias, *Los Angeles: Dream to Reality, 1885–1915* (Northridge, California: Santa Susana Press, 1983), 13–32, and Edna M. Parker, "The Southern Pacific Railroad and Settlement in Southern California," *Pacific Historical Review,* 6 (1937), 103–19. Titles of railroad promotional literature included *California: Its Attractions for the Invalid, Tourist, Capitalist, and Homeseeker* (1892).

3. For an excellent survey of the period, see Glenn S. Dumke, *The Boom of the Eighties in Southern California* (San Marino: The Huntington Library, 1970); see also Kevin Starr, *Americans and the California Dream* (New York: Oxford University Press, 1973), 365–414.

4. Charles Nordhoff, *California for Health, Pleasure and Residence* (New York: Harper & Brothers, 1873).

5. Ibid., 116–17. John E. Baur, *The Health Seekers of Southern California* (San Marino: The Huntington Library, 1959), 34–35, points out some of the unpleasant results of so many sick people searching for cures, but a large number encouraged their healthy families to join the migration.

6. At the founding of the University of Southern California in 1880, the new president promised that Los Angeles and the surrounding region would develop an atmosphere of education that would keep pace with the growth of population. By the mid-1890s, when USC had sent the lamp of learning to branch campuses in the San Fernando Valley, La Cañada, Ramona, and Escondido, and founded a School of Fine Arts in San Diego, it had to cut back its expansion in view of the need to consolidate its resources in Los Angeles. Occidental College grew out of three fledgling institutions in 1887. See Dumke, *Boom of the Eighties,* 248.

7. Carey McWilliams in his *Southern California Country: An Island on the Land* (New York: Duell, Sloan & Pierce, 1946), 98, commented that "so widespread was the enthusiasm for 'climatology' that the enthusiasm itself was dubbed 'the Southern California fever.'"

8. Elias, *Los Angeles: Dream to Reality,* 29.

9. *Picturesque California with Historical and Descriptive Notes* (Chicago: Knight and Leonard, 1887), 9–10.

10. *Ramona: A Story* (Boston: Roberts Brothers, 1884).

11. *The Land of Poco Tiempo* (1893) and *The Spanish Pioneers* (1893).

12. Daniela P. Moneta, editor. *Chas. T. Lummis—The Centennial Exhibition Commemorating His Tramp Across the Continent* (Los Angeles: Southwest Museum, 1985), 56. Lummis changed the name of the magazine, which enjoyed a broad circulation, to *Out West* in 1902, because of its ever-widening range of interests.

13. Lummis gave encouragement to local artists such as Elmer Wachtel, who lived nearby in the Arroyo Seco. William Wendt and his wife Julia Bracken bought the studio-home of the Wachtels on Sichel Street in 1906. Lummis's home served as a meeting place for artists, writers, and important public figures such as Theodore Roosevelt, Williams Gibbs McAdoo, and David Starr Jordan.

14. Franklin Walker, *A Literary History of Southern California* (Berkeley and Los Angeles: University of California Press, 1950), 139; and Moneta, ed., *Chas. T. Lummis,* 54. While serving at the library, Lummis modernized procedures and expanded the reference section, especially in regard to Southwestern history and art. Lummis devoted his attention mainly to San Diego, San Juan Capistrano, and San Fernando. See also Dudley Gordon, *Charles F. Lummis: Crusader in Corduroy* (Los Angeles: Cultural Arts Press, 1972).

15. *Our Italy* (New York: Harper and Brothers, 1891), 18. In "Italy in California," his introduction to *Romantic California* (New York: Charles Scribner's Sons, 1910), 4, Ernest Peixotto wrote that "even when you look more closely, the comparison holds. In the gardens, the gorgeous hybiscus [*sic*] blooms beside the agapanthus, the heliotrope, and hedges of strawberry guava; [and] the bougainvillea transforms prosaic cottages into Sicilian villas."

16. Stephen Powers, *Alone and on Foot: A Walk from Sea to Sea by the Southern Route* (Hartford, Connecticut: Columbian Book Company, 1872), 322.

17. Charles Van Dyke, *The Desert: Further Studies in Natural Appearances* (New York: Charles Scribner's Sons, 1901), 227.

18. Ibid., 227–28.

19. In that same year, Antony Anderson began to write a regular art column for the *Los Angeles Times* in which he offered encouragement and constructive criticism to local artists. The column continued to appear for over twenty years.

20. Walker, *Literary History of Southern California*, 233, talks about "the Old Mission Trip which mixed orange trees and ostriches with Mission San Gabriel; and the Triangle Trip, down to Long Beach, Balboa, and Santa Ana, with glimpses of forests of oil derricks, fields of sugar beets . . . and groves of almonds, lemons, and oranges."

21. David Clark, *Los Angeles: A City Apart* (Woodland Hills, California: Windsor Publications, 1980), 75–76. The nation's first gas station opened at the corner of Wilshire and La Brea in 1909 and sold gasoline for ten cents a gallon.

22. Karen Turnbull, "Laguna Beach and South Laguna," in *A Hundred Years of Yesterdays: A Centennial History of the People of Orange County and Their Communities* (Santa Ana: The Orange County Register, 1988). The deaf artist Granville Redmond, who became widely known for his "acute powers of observation regarding the transmittal of light from various sources," painted twenty-five pictures of Laguna Beach and eleven of Catalina Island in the summer of 1903. See Harvey L. Jones, Introduction, xii, and Mary Jean Haley, *Granville Redmond: A Triumph of Talent and Temperament* (Oakland: The Oakland Museum, 1989), 19.

23. The year of Wendt's move to Laguna can be deduced from information in his death certificate. For other material on Laguna see Thomas Kenneth Enman and Ruth Westphal, "Earliest Days of the Laguna Beach Art Colony," in *Plein Air Painters of California* (Irvine: Westphal Publishing, 1982), 122–23, and Carl S. Dentzel, *Southern California Artists 1890–1940* (Laguna Beach: Laguna Beach Museum of Art, 1979), 11–12.

24. Enman and Westphal, "Earliest Days of the Laguna Beach Art Colony," 12.

25. Henri G. de Kruif, "Art at Laguna Beach," *Los Angeles Times*, 28 September 1919, pt. 3, p. 2, col. 5.

26. Iris Engstrand, *San Diego: California's Cornerstone* (Tulsa, Oklahoma: Continental Heritage Press, 1980), 72–73.

27. Emmett A. Greenwalt, *California Utopia: Point Loma: 1897–1942* (Point Loma: Point Loma Publications, 1978), 19. Edith White (1855–1946), who grew up in Northern California, directed the art department.

28. Martin Peterson, "Maurice Braun: Master Painter of the California Landscape," *Journal of San Diego History* (Summer 1977): 24–25. Among Braun's first students to attain national recognition was Alfred R. Mitchell (1888–1972). Braun, although retaining his theosophical interests, helped encourage the broader cultural growth of the San Diego community. The San Diego Art Guild was organized in 1915, and Braun became its first treasurer. A San Diego Academy of Fine Arts was founded in 1921 by Eugene and Pauline DeVol.

29. Engstrand, *San Diego*, 92.

30. Florence Christman, *The Romance of Balboa Park* (San Diego: The San Diego Historical Society, 1985).

31. Martin Peterson, "San Diego's Beginnings," in Westphal, ed., *Plein Air Painters of California*, 180. At the end of the decade, in August 1929, eleven San Diego artists, including Maurice Braun and Alfred Mitchell, formed a professional organization given the name Contemporary Artists of San Diego.

32. The California Fruit Growers Exchange, founded in 1905, developed the Sunkist label to promote its products. Orange crate labels featured colorful mission scenes, stalwart Indians, beautiful Spanish ladies, bright sunshine, and deep blue skies. The Sunkist slogan was "Oranges for Health—California for Wealth." See Elias, *Los Angeles: Dream to Reality*, 38–39.

33. Born just a year before Lummis in 1858, growing up in a similar Methodist family, and arriving in the West about the same time, James became a prolific writer. Although Lummis accused him of faking articles, James produced a number of worthwhile works. See Walker, *A Literary History of Southern California*, 144–50; see also Kevin Starr, *Inventing the Dream: California through the Progressive Era* (New York: Oxford University Press, 1985), 99–127.

34. The Craftsman movement in America grew out of the English Arts and Crafts movement that began to take hold in Southern California at the turn of the century. As a reaction against the ornate, machine-made, Victorian styles and as a result of the increased interest in the visual arts, architects and artists began to prefer simple, clean lines. The "mission style" paralleled the Craftsman movement and shared some of its values, even though its form was quite different.

35. George Wharton James, *California, Romantic and Beautiful* (Boston: The Page Company, 1914), 2–3.

36. Ibid., 394–95. James discusses California's influence upon literature, art ("a full orchestra of colour"), and domestic architecture.

37. Ruth Westphal, ed., "The Development of an Art Community in the Los Angeles Area," in *Plein Air Painters of California*, 29–30.

38. Ibid., 29.

39. Howard J. Nelson, *The Los Angeles Metropolis* (Dubuque: Kendall/Hunt Publishing Company, 1983), 180–81, points out that petroleum was in great demand as a source of fuel for automobiles and energy for homes and factories. Both the Santa Fe and the Southern Pacific converted their locomotives from coal to oil and even began to promote oil fields as a tourist attraction.

40. Quoted by T. H. Watkins, *California: An Illustrated History* (Palo Alto: American West Publishing Company, 1973), 352. Evangelist Aimee Semple McPherson, who, after a stop in San Diego where she may have received her inspiration from Katherine Tingley, arrived in Los Angeles in 1922 with one hundred dollars and a broken-down automobile. There, she took advantage of the climate and a host of newcomers to promote outdoor revival meetings, emerging within a few years as the most prominent religious figure in Southern California. She established "lighthouses" of her Four Square Gospel from San Diego to San Bernardino. Recognizing the beauty of Southern California's beaches, Aimee built a temple overlooking the surf at Dana Point. See McWilliams, *Southern California Country*, 259–62.

41. Edgar Lloyd Hampton, "Los Angeles as an American Art Centre," *Current History*, 24 (September 1926), 860. See also Nelson, *Los Angeles Metropolis*, 181–82.

42. Pasadena Board of Trade, *Pasadena, California: The Ideal Home City* (Pasadena: Board of Trade, 1913), 2.

43. "The Development of an Art Community in the Los Angeles Area," 30; and advertising brochure, Stickney Memorial Art School, Pasadena Historical Society Library, Pasadena, California.

44. The stock market crash of 1929 forced the closing of many commercial galleries and artists often turned to other occupations. A new and distinctive period of art resulted from the projects of the Southern California Works Progress Administration during the Depression years of the 1930s.

SMITH, *The Splendid, Silent Sun*

1. Carey McWilliams, *Southern California: An Island on the Land* (Salt Lake City: Gibbs M. Smith/ Smith Peregrine Books, 1983), 7.

2. Ibid., 97.

3. Robert Hendrickson, *The Facts on File Encyclopedia of Word and Phrase Origins* (New York and Oxford: Facts on File Publications, 1987), 96.

4. McWilliams, *Southern California*, 105.

5. Elna Bakker, *An Island Called California* (Berkeley: University of California Press, 1971). See preface: about 1510, García Rodríguez Ordóñez de Montalvo of Spain wrote of an Amazon queen who ruled over "an island called California, very near the Terrestrial Paradise." Early explorers believed they saw an "island" (the Baja Peninsula) from mainland Mexico across the Sea of Cortez. Bakker states that "there is ecological validity in thinking of California in insular terms."

6. McWilliams, *Southern California*, 107.

7. Kevin Starr, *Americans and the California Dream, 1850–1915* (1973; reprint New York/Oxford: Oxford University Press, 1986), viii.

8. McWilliams, *Southern California*, 351.

9. Lundgren quoted in ibid., 366.

10. Francisco quoted in ibid., 336.

11. McWilliams, 336.

12. Antony Anderson, "Of Art and Artists," *Los Angeles Sunday Times*, 25 February 1917, p. 7.

13. Local weathercasters are notoriously inconsistent when describing Southern California's periodic fog, mist, or drizzle. See McWilliams, "The Citrus Belt," in *Southern California*, 205, and Bakker's "California Kansas," in *An Island*, 147, for experiences similar to the author's.

14. Alfred Noyes, "The Fairest Fruit," quoted in McWilliams, *Southern California*, 223.

15. McWilliams, *Southern California*, 363.

16. Geoffrey Montgomery, "Color Perception: Seeing with the Brain," *Discover*, vol. 9, no. 12 (December 1988):55.

17. J. E. Cirlot, *A Dictionary of Symbols* (New York: Philosophical Library, 1971), 52–60.

18. *Unnature* is Goethe's word for Newton's concept of light.

19. E. Cassirer, *The Philosophy of the Enlightenment* (Princeton: Princeton University Press, 1951), 41.

20. Arthur Koestler quoted in Lawrence Leshan and Henry Margenau, *Einstein's Space and Van Gogh's Sky* (New York: Macmillan, 1982), 246.

21. Werner Heisenberg, *Physics and Philosophy* (New York: Harper, 1958), 70.

22. Henry Margenau, *Open Vistas: Philosophical Perspectives of Modern Science* (New Haven: Yale University Press, 1961), 284. A general source for this section of this essay is Michael I. Sobel, *Light* (Chicago: University of Chicago Press, 1987).

23. Leshan and Margenau, *Einstein's Space*, 200.

24. John Alan Walker, "William Wendt, 1865–1946," *Southwest Art*, vol. 4, no. 1 (June 1974): 43.

25. Wendt to Stendahl 10 December 1923. Stendahl Art Galleries Papers, Archives of American Art, Smithsonian Institution, Gift of Alfred Stendahl, roll 2724.

26. Jim Sleeper, *Orange County Almanac, 1889–1976* (Trabuco Canyon, California: OCUSA Press / Privately Printed by Jim Sleeper, 1974 [sic]), 21.

27. William A. Griffith, Foreword to the catalogue of the *William Wendt Retrospective Exhibition*, Los Angeles County Museum in Exposition Park, Los Angeles, California, 14 February–12 March 1939.

28. Los Angeles County Museum of Art.

29. Wendt's letters to his dealer, during February and March 1926, are written in his slashing, serif-like, Gothic hack—a handscript exactly like his brushstroke. He writes: "Can't meet my bills," "Am unable to work and never want to see a canvas again," "Have not worked in seven weeks," and "this is the third night running of practically no sleep" after taking "ten tablets of Lumisol." He signs himself, "Billy, a tired thing" or "the Melancholy Dane," in one case ending, "Oh, hell, hell, hell—." He writes of taking "electric treatments," although the doctor's diagnosis reads "angina pectoris" from "physical strain." Stendahl Art Galleries Papers, Archives of American Art, roll 2724.

30. George B. Bridgman, *Constructive Anatomy* (Pelham, N.Y.: Bridgman Publishers, 1920) and George B. Bridgman, *The Human Machine* (Pelham, N.Y.: Bridgman Publishers, 1939).

31. Recuperating at Morro Bay with Griffith, Wendt wrote Stendahl on 6 June 1926: "It is hard to finish anything with a kick in it." Stendahl Art Galleries Papers, Archives of American Art, roll 2724.

32. Joseph Le Conte quoted in Kevin Starr, *Americans and the California Dream, 1850–1915* (New York: Oxford University Press, 1973), 247.

33. Ibid., Starr, 247.

34. Bernice Eastman Johnston, *California's Gabrielino Indians* (Los Angeles: Southwest Museum, 1962), 73. Johnston suggests that native California Indian twilight songs "carry a rich stimulus . . . with a brilliant and profound luminousness" when the faith is chanted at twilight: "Tavi hetekriny atavin tuvangnar (God has placed the whole world)." Also see Alfred L. Kroeber, *Handbook of the Indians of California*, 2d ed. (Berkeley: University of California Press, 1953); Thomas C. Blackburn, *December's Child: A Book of Chumash Oral Narratives* (Berkeley: University of California Press, 1975); and William D. Strong, *Aboriginal Society in Southern California*, vol. 26 (Berkeley: Publications in American Archeology and Ethnology, 1929).

35. See Robert R. Preato and Sandra L. Langer, *Impressionism and Post-Impressionism . . .* (New York: Grand Central Art Galleries, 1988), cat. 86, ill. p. 73.

36. In a letter of 15 February 1920, to his former student and friend Alfred R. (Fred) Mitchell, Braun wrote: "A great point is, never to doubt your ability or the certainty of success, no matter what happens. You understand of course that by success I do not mean financial success only, that may come, but success in attaining to your ideal. Mr. Hassam has certainly attained much of both." Braun's admiration for Hassam was further verified by a conversation with Braun's daughter Charlotte White in San Diego, 2 July 1989.

37. Quoted in Philip P. Wiener, *Dictionary of the History of Ideas*, vol. 3 (New York: Charles Scribner's Sons, 1973), 393.

38. Payne's "Tamarack" is the lake beneath the northwest flank of 12,205 foot Mt. Stewart on the Great Western Divide. There are *two* Tamarack Lakes in the California Sierra. Payne's lake is the one in Sequoia National Park (Mineral King quadrangle), *not* the one in the Desolation Wilderness near Echo Summit southeast of Lake Tahoe.

39. Antony Anderson, "Of Art and Artists," *Los Angeles Sunday Times*, 25 February 1917, pt. 3.

40. During a trip through the East, Braun wrote from New York City to Alfred R. Mitchell on 14 February 1922: "I am still hard at work on some of the motives that I got there"—in Missouri where Braun especially favored "the difference in character of the landscape" from that of Southern California.

41. The author worked at Disney Studios in Burbank when Disney's multiplane animation camera was first used in the film "Bambi." The landscape was photographed through several separate planes of glass on which parts of the landscape were painted. As the camera panned through the landscape, the planes moved past the screen at different rates, giving the illusion of depth. Disney's multiplane camera was unique for its time, and it illustrates the principle of flatness and space in painting.

42. One classic example of the chauvinist Eastern critic is Henry L. Mencken, the sage of Baltimore, who made one obligatory trip out to "the coast" to report that "the whole place stank of orange blossoms."

43. Braun wrote a consoling letter on 12 February 1917 to his former student and friend, Alfred R. (Fred) Mitchell, whose work was rejected from a New York exhibition: "Don't feel disappointed if your pictures are rejected." In time, he suggested, Mitchell's work would acquire more complex and varied characteristics of "particular moods."

44. Antony Anderson, "Of Art and Artists," *Los Angeles Sunday Times*, 14 November 1914, p. 2.

45. Antony Anderson, "In the Realm of Art," *Los Angeles Sunday Times*, 20 January 1918, pt. 3.

46. Martin E. Peterson, "Maurice Braun: Master Painter of the California Landscape," *Journal of San Diego History*, vol. 23, Summer 1977.

47. Theosophy borrows much of its view of emptiness from the Prásangika-Mádhyamika tradition of Tibetan Buddhism. For the most cogent and complete exposition of this philosophy in English see Jeffrey Hopkins, *Meditation on Emptiness* (London: Wisdom Publications, 1983). For the relationship between silence and emptiness, and between ideation and form, see *Theosophical Tenets* and Blavatsky's *The Voice of the Silence* (both Santa Barbara: Concord Grove Press, Universal Theosophy Fellowship, 1987 and 1989).

48. H. P. Blavatsky, *The Theosophical Glossary* (1892; reprint Los Angeles: The Theosophy Company, 1973), 126.

49. H. P. Blavatsky, *The Secret Doctrine* (1888; reprint Los Angeles: The Theosophy Company, 1982), 579.

50. "Light and Space" is a relatively new term designating a Southern California genre. With the curatorial enthusiasm of Melinda Wortz and skilled documentation by Jan Butterfield, the "Light and Space" artists of Southern California are now beginning to enter the art-historical canon.

FORT, *The Cosmopolitan Guy Rose*

1. Basic to any study on Rose are *Guy Rose, Paintings of France and America*, exh. cat. (Los Angeles: Stendahl Galleries, 1922), essays by Antony Anderson and Earl Stendahl; Rose V. S. Berry, "A Painter of California," *International Studio* 80 (January 1925): 332–34, 336–67; and *Catalogue of the Guy Rose Memorial*, exh. cat. (Los Angeles:

Stendahl Galleries, 1926), essays by Peyton Boswell and Antony Anderson. Anderson's essay in the 1926 publication is only a slightly altered version of Earl Stendahl's essay in the 1922 exhibition catalogue. Throughout this essay references to these two exhibition catalogues will be noted whenever reproductions of unlocated paintings can be found in either publication.

2. Rose's paintings generally have been dated according to locale. To avoid repeating dates that sometimes are based on misidentification of locale or are not much more than a guess, the author will only use dates that can be verified by exhibition records or similar material.

3. San Francisco Art Association Collection, School Committee Meetings/Awards Minute Book, 1873–1905, 285. Information courtesy of Jeff Gunderson, Librarian, San Francisco Art Institute.

4. Rose's *Still Life of Plums on a Table* is in the collection of Roy Rose. Carlsen was such a significant influence on Rose that years later he would dedicate the catalogue of his 1922 exhibition at Stendahl Galleries to Carlsen.

5. Catherine Fehrer, "List of Students Enrolled at the Julian Academy," *The Julian Academy, Paris, 1868–1939*, exh. cat. (New York: Shepherd Gallery, 1989), unpaginated.

6. In the 1890 Salon, Rose showed *Lutin* (no. 2078) and *La ménagère* (no. 2079), and in 1891 *La fin de la journée* (no. 1429) and *Les ramasseuses de pommes de terre* (no. 1430). To the 1894 Salon, he contributed *Saint Joseph demandant asile pour la Vierge* (no. 1582) and *La teigne* (no. 1583), and to the 1900 Salon, *L'Annunciation* (no. 1144).

7. *The Housewife* is in a private collection. *Madame Pichaud* is in the collection of Roy Rose. The latter was listed as *La Mère Richaud* in the catalogue of the 1926 memorial Rose exhibition at Stendahl Galleries (p. 52), but an inscription on the back of the canvas states that the model's name was Pichaud, rather than Richaud. Information courtesy of Roy Rose, 27 July 1989.

8. *Potato Gatherers* is in the collection of Mrs. John Dowling Relfe.

9. The Louvre, Paris.

10. Formerly the Mann Galleries, Miami.

11. Its inscription reads "Paris. 1891." However, when recently sold at auction (Butterfield and Butterfield, San Francisco, 6 October 1988, lot 4153), information supplied by Roy Rose and Jean Stern stated that the painting was begun in Crécy, probably Crécy-en-Ponthieu, a village north of Dieppe near the English Channel.

12. Katherine Kinsella, a young American artist painting in Giverny in 1890, places Rose there in July and September of that year. According to her letter of 14 July to Philip Hale, Rose was accompanied by his mother and sisters. (Kinsella to Hale, 14 July and 23 September 1890, Philip Leslie Hale Papers, Archives of American Art, Smithsonian Institution, roll D98.

13. William H. Gerdts, *American Impressionism* (New York: Abbeville Press, 1984), 271.

14. Richard Brettell has recently discussed the issue of whether the stacks were of hay, oats, or other grain. See his entry on Monet's Grainstacks series in *A Day in the Country: Impressionism and the French Landscape*, exh. cat. Los Angeles County Museum of Art, 1984), 260 and 262.

15. Brettell notes in *A Day in the Country* (242–47) that very few Impressionist landscapes included imagery of or allusions to the mechanical modernization of French agriculture.

16. The Detroit Institute of Arts.

17. Rose's interest in light effects would be of major importance in the success of *Flight into Egypt* (unlocated), a nighttime scene with large figures that brought Rose much attention in 1896 when it was exhibited at the Salon and served as the frontispiece of the Christmas issue of the popular *Harper's Monthly Magazine* 96 (December 1896). The same interest is also apparent in the magazine illustrations Rose did at mid-decade. The drawings of Athens indicate time of day by long shadows, and the Venice scenes include two night images. See William Doane, "A Visit to Athens," *Harper's New Monthly Magazine* 93 (June 1896): 3–14, for the Athens illustrations; and A. Symons, "Venice in Easter," *Harper's New Monthly Magazine* 90 (April 1895): 738–51, for the Venice illustrations.

18. The author would like to thank Roy Rose for sharing information concerning the dates when Ethel and Guy Rose met and married.

19. The author would like to thank Margo Karp, Reference Librarian, Pratt Institute, for providing the dates of Rose's association with Pratt Institute.

20. Rose's summer activities for 1896 are mentioned in *Pratt Institute Monthly* 5 (October 1896): 22 and (December 1896): 106. His plans for the summer of 1897 are mentioned in *Pratt Institute Monthly* 5 (June 1897): 322.

21. *July Afternoon* also has a narrow, elongated format atypical of Rose's paintings (*The End of the Day* notwithstanding) but characteristic of Dow's landscapes.

22. *Guy Rose: Paintings of France and America*, 1922, 7; and Claire Joyes, "Giverny's Meeting House, The Hôtel Baudy," in *Americans in Brittany and Normandy, 1860–1910*, exh. cat. (Phoenix Art Museum, 1982), 98.

23. Guy Rose, "At Giverny," *Pratt Institute Monthly* 6 (December 1897): 81. This important article seems to have been overlooked in all the literature on Guy.

24. Ibid., 82. Rose already complained of the changes, which he attributed to the English.

25. Claire Joyes, *Claude Monet: Life at Giverny* (New York: Vendome Press, 1985), 56.

26. Sylvie Gache-Patin in Brettell's *A Day in the Country*, 207.

27. William H. Gerdts, *Down Garden Paths: The Floral Environment in American Art* (Rutherford, N.J.: Fairleigh Dickinson University Press, 1983), 15 and 27–32.

28. Bram Dijkstra, *Idols of Perversity: Fantasies of Feminine Evil in Fin-de-Siècle Culture* (New York: Oxford University Press, 1986), 13–16.

29. Another example of such a treatment is Rose's *The Green Parasol* (Stendahl 1926, no. 38). The "lady with a parasol" was a popular subject for most Giverny artists.

30. *Lady in the Garden* is in the Terra Museum of American Art, Chicago, and *Woman in a Garden* is in a private collection.

31. Rose did at least two nude studies (Bowers Museum, Santa Ana, California), and *By the Fireside* (collection of Roy Rose) but under the effect of indoor firelight. While examples of Frieseke's nudes are well known to present-day collectors and public, Parker's are not. For examples of Parker's nudes, see the reproductions in *Paintings by Lawton Parker*, exh. cat. (Art Institute of Chicago, 1912).

32. Private collection.

33. *Boating at Argenteuil* is in the Metropolitan Museum of Art.

34. Stendahl Galleries, 1922, no. 11.

35. Private collection.

36. Joyes, *Claude Monet: Life at Giverny*, 1985, 67.

37. *Morning Mists* is in the collection of Roy Rose, and *Early Spring, Giverny* is number 19 in the catalogue of the Stendahl Galleries 1926.

38. The two paintings were compared when Rose exhibited them in a 1917 exhibition at the Battey Gallery in Pasadena. See Antony Anderson, "Of Art and Artists: Guy Rose's Impressions," *Los Angeles Times*, 8 April 1917, 3: 4. The earlier painting, *Low Tide at Honfleur*, is in the collection of James and Linda Ries and the location of the later one is unknown.

39. Both paintings of the Blue House were exhibited at Steckels in Los Angeles in Rose's first solo exhibition in California during February 1918 and mentioned in Antony Anderson's review of the show ("Art and Artists: Guy Rose Again," *Los Angeles Times*, 21 February 1915, 3A: 5). The winter version is in the collection of Mr. and Mrs. Thomas B. Stiles II.

40. Collection of the National Arts Club, New York.

41. *Tamarisk Trees, Southern France*, at George Stern Fine Arts. *Tamarisk Trees in Early Sunlight* (Stendahl 1926, no. 18) is a similar scene but minus the figures. It also has a delicate sky, the pearly white of early morning.

42. Medora Clark, "Reminiscences of Alson Skinner Clark. Part 2," an interview conducted by Margaret Hunter (Pasadena, California, 1956–57, typescript), 54.

43. *Paintings by Guy Rose*, 14–28 February 1916, consisted of twenty-one paintings from France and Southern California; *Exhibition of Paintings by Guy Rose*, 16–21 March 1918, featured eighteen paintings; and *Catalogue of Paintings by Guy Rose*, 1–15 May 1919, included sixteen figure and landscape paintings.

44. Rose to Macbeth Gallery, 5 April [1917?], Macbeth Gallery Papers, Archives of American Art, roll 2628.

45. When Antony Anderson first mentioned Rose's arrival in the *Los Angeles Times* (27 December 1914, 3: 6), the critic began by stating, "We haven't an 'artists colony' in Los Angeles—our artists are scattered to the four winds . . .—but the phrase has a metropolitan ring, and therefore many Angelinos [*sic*] like to see it. . . . Undoubtedly there will be a genuine 'colony' some day."

46. Rose to Macbeth Gallery, 5 April [1917?], Macbeth Gallery Papers, Archives of American Art, roll 2628.

47. Antony Anderson, "Art and Artists: Paintings by Guy Rose," *Los Angeles Times*, 20 February 1916, 3: 4.

48. Stendahl Galleries 1922, no. 3.

49. Antony Anderson, "In the Realm of Art: Pictures by Guy Rose," *Los Angeles Times*, 30 June 1918, 3: 6.

50. It is not known exactly how many paintings of the Monterey Peninsula area Rose painted. Based on the published Stendahl catalogues and the Stendahl Art Galleries Papers, Archives of American Art, Gift of Alfred Stendahl, roll 2722, as well as on located works, it seems that Rose created at least two dozen and perhaps more than three dozen paintings of the area.

51. Rose was definitely at Carmel in summer 1918, and the spring 1919 exhibition was originally organized to show the Carmel paintings he had done the previous season in Carmel. However, when realized, half the exhibition included paintings from other locales. See *Los Angeles Times*, 30 June 1918, 3: 6; and Guy Rose–Frank Daggett [director, Los Angeles Museum] correspondence, 9 October 1918–15 April 1919, in Joseph Moure Papers, Archives of American Art (not microfilmed).

52. Eunice T. Gray, "Chase Summer Art School," *American Art News* 13 (17 October 1914): 2.

53. Townsley's positions at the Carmel-by-the-Sea School and Stickney Memorial School of Fine Arts are listed in the *American Art Annual*, vols. 11–13 (1914–16).

54. This tendency of Monet was noted by John House in his *Monet: Nature into Art* (New Haven: Yale University Press, 1986), 24.

55. Antony Anderson, "Of Art and Artists: Guy Rose's Impressions," *Los Angeles Times*, 8 April 1917, 3: 4.

56. Fleischer Museum Collection.

57. *Catalogue of the Guy Rose Memorial*, 1926, 34–35.

58. The author's discussion of Monet's series is indebted to Grace Seiberling's *Monet Series* (New York: Garland Publishing, 1981).

59. Collection of the Pushkin Museum, Moscow.

60. *Point Lobos, Trees*, Stendahl Galleries 1926, no. 88.

STERN, *Alson Clark: An American at Home and Abroad*

AUTHOR'S NOTE: Since the publication of my last essay on Alson Skinner Clark in 1983 additional material has been made available by Alson Clark III, son of the artist. This has necessitated the revision of dates as well as other information. This essay reflects the revisions based on these primary sources, generously brought to my attention by Dr. Patricia Trenton and selected by Jeanne D'Andrea, who has insightfully edited my manuscript. I would also like to thank Edward Maeder, Curator of Textiles and Costumes, Los Angeles County Museum of Art, for his enlightening examination of costume in several of Alson Clark's paintings.

1. Archival material on Alson Clark has been made available through the generous cooperation of Alson Clark III. Included in the collection of Carol and Alson Clark are Alson Clark's Diaries, Sketchbooks, Photograph Albums, Scrapbooks, and a Souvenir Album of drawings by artist friends; and Medora Clark's Diaries and "Reminiscences of Alson Skinner Clark," an interview conducted by Margaret Hunter, in 2 parts (Pasadena, California, 1956–57, typescript).

2. Alson Clark's official transcript was kindly provided by Mary McIsaac, Office of the Registrar, The School of the Art Institute of Chicago.

3. Frances Lauderbach, "Notes from Talks by William M. Chase," *American Magazine of Art*, vol. 8, no. 2 (September 1917): 432–38.

4. A rectangle cut from the back cover of Alson Clark's Sketchbook 1904–9 made a convenient finder.

5. Alson Clark Diary, 13 November 1897, Archives of American Art, Smithsonian Institution.

6. Alson Clark Diary, 14 June 1898.

7. Ibid., 19 January 1898.

8. Ibid., 23 November 1898.

9. See the chapter "The Académie Whistler" in Stanley Weintraub's *Whistler: A Biography* (New York: E. P. Dutton, 1988).

10. Alson Clark Diary, 30 November 1898.

11. Alson Clark Diary, 1 January 1899.

12. Henry E. Huntington Library and Art Galleries. Gift of the Virginia Scott Steele Foundation.

13. Fleischer Museum Collection.

14. Present location unknown.

15. The sketch, dated 1905, is in the collection of Robert Winter.

16. *Chicago Record Herald*, 16 October 1906.

17. Eugen Neuhaus, *The Galleries of the Exposition* (San Francisco: Paul Elder, 1915), 83.

18. The Panama pictures have been dispersed and are now in museum and private collections.

19. Alson Clark Diary 1919, month-end entry.

20. Young's Fine Arts, Santa Barbara, California.

21. Medora Clark, "Reminiscences" 2, 45.

22. Medora Clark, "Reminiscences" 2, 55.

23. The Gardena High School Collection, Gardena, California.

24. The Hyland Collection.

25. *La Jolla Cove* was reproduced on the cover of *Touring Topics* in September 1928.

26. Harriet Monroe, *Chicago Tribune*, 5 March 1910.

TRENTON, *Joseph Kleitsch: A Kaleidoscope of Color*

1. *Topics of the Town* (Los Angeles), 19 April 1931. Sonia Wolfson was a free-lance writer, who worked as a publicist at the Stendahl Galleries for several years in the early 1930s. Her first article on Kleitsch, in *California Graphic*, 7 February 1925, discussed his mission paintings.

2. Information on Kleitsch's ancestors provided by Robert Kleitsch and Mrs. Lubomir Hykel. See Steven Béla Vardy, *History of the Hungarian Nation* (Astor Park, Florida: Danubian Press, 1969), 85–93.

3. Biographical information on Kleitsch is from his petition for naturalization, #11831, signed 30 January 1924, Los Angeles, United States Court, Southern District Court, Southern District of California, and from his passport application, signed 18 January 1926, New York City. Courtesy of F. J. Carmona, Acting Chief Research and Liaison Branch, Office of Program Support, Passport Services, United States Department of State, Washington, D.C. The naturalization petition also indicates that Kleitsch had brown eyes and hair, a fair complexion, and was 5′8″ tall and weighed 165 pounds. The author wishes to express her appreciation to researchers Phil and Marion Kovinick, who worked in close concert with her in obtaining many documents on the artist.

Published and unpublished biographical data on the artist usually give his birthdate as 1885, 1886, or 1887, and his birthplace as Banad. Kleitsch gave the press biographical information that presented him as younger than he was. We can only conjecture that because he was eight years older than his second wife, Edna, he was anxious to project a virile, youthful image. On Kleitsch's death certificate, Edna gave his age as forty-six and his birthdate as 1886, which suggests that she was unaware of his true age.

Kleitsch had a limited command of English and probably misspelled the region (or province) of his birthplace, Banat. None of his accounts includes the village in Banat where he was born. Indeed, Kleitsch embroidered his background considerably.

4. Banat lies between three rivers: the Danube to the south, Maros (today called Mures) to the north, and Tisza to the west; in the east, the Retyezat mountains occupy one-third of the region, while the western two-thirds are fertile plains. Geographical and historical information on Temesvar and the Banat region were provided by Athos Thiery, Ph.D., who was born in the same region as

5. Theresa (Kleitsch) Haynel to her nephew William Kleitsch, undated (before 1984). Theresa Haynel (d. 1984) also provided a family tree for her nephew. Most of her information on Kleitsch and his ancestry is correct, except for the artist's birthdate, given as 1881. The author is indebted to Mrs. William (Marjorie) Kleitsch for sharing this letter.

6. Anthony Kastner, a distant cousin of the artist, to Trenton.

7. Athos Thiery to Trenton, 29 September 1989.

8. Kleitsch is not listed on the student roster of the Royal Munich Academy for 1900, 1901, and 1902. Academy records are incomplete, however, because they were partially destroyed during World War II (Dr. Cornelia Erdl, Akademie der Bildenden Kunste, Munich, to Trenton, 7 June 1989).

9. Verification of Kleitsch's departure date for America is validated by two dated charcoal drawings by the artist: one of his cousin, Johann Kleitsch of Hungary, dated 1901; and the other of Johann's wife, Karoline, dated 1899. Thus Kleitsch could not have left the country earlier than 1901.

10. It was a popular Victorian practice in Europe and America to work from photographs for commissioned portraits.

11. According to Theresa Kleitsch Haynel, when Kleitsch was seventeen years old he painted a religious picture for his "Beppi Tante" (Aunt Barbara) to hang in the Szilas Catholic church (Nemet Szent Mihaly was called Szilas by the local inhabitants). The painting, *Flight into Egypt*, was obviously copied from an engraving. A plaque under the picture was inscribed "Gift of Barbara Kleitsch" (Beppi Tante).

12. Anthony Kastner to Trenton. Kastner stated that Kleitsch not only visited Munich but also Vienna and Paris before his departure for America. There is, however, no other evidence to support this statement.

13. Emma Multner appears in the Cincinnati city directory from 1879 through 1903 but is not listed in 1904.

14. Emma Multner died in Chicago, on 10 August 1913, and was buried in Cincinnati. According to Spring Grove Cemetery's burial records, she was fifty-six years old at the time of her death.

15. Robert Klcitsch to Trenton, 28 August 1989. Robert Kleitsch's father, Joseph's cousin, was given a landscape (now the property of Robert Kleitsch) by the artist, executed during the time he was painting landscapes for the Union Pacific Railroad. The author thanks Robert Kleitsch for providing information about Kleitsch's employment with the railroad. Unfortunately, the Union Pacific's archival records are incomplete, and the association cannot be verified.

16. M. Sheryl Bailey, Art Institute of Chicago, has generously shared the data furnished by Kleitsch in 1925 or 1927, for a biographical form now in the archives of the AIC. Kleitsch mentioned painting a portrait of "Senetor [sic] George J. Kendal of Denver." A George J. Kindel is listed in Percy Stanley Fritz's *Colorado: The Centennial State*, Appendix to Colorado Government Officials (New York: Prentice-Hall, 1941), 495. Kindel served in the United States House of Representatives in Denver from 1913 to 1915. The archivist of the Colorado Archives in Denver has informed Phil Kovinick that neither a Kendal nor a Kindel served as senator of Colorado from 1880 through 1925. The artist probably confused the two branches of government.

The Reithmann portrait is in the collection of the Colorado Historical Society in Denver. A photograph has been provided through the courtesy of Georgianna Contiguglia, Curator of Decorative and Fine Arts.

An undated and untitled newspaper article from Hutchison, Kansas [1907], states that Kleitsch, "late of Denver," painted the secretary of the State of Colorado and the portrait "now" hangs in the State Capitol (Nardone-Baker Collection, Laguna Art Museum). The present location of this portrait is unknown.

17. Jonathan Nardone, a nephew of William C. Baker, has generously given photographs and the letter, originally in his uncle's possession, to the Laguna Art Museum. Kleitsch presumably gave Baker the paintings and drawings, and Baker took the photographs of Kleitsch. The author is indebted to Mr. Nardone for this material, which fills a gap in Kleitsch's chronology.

18. Information given to the census-taker contains certain inaccuracies—in particular, the age of Kleitsch's wife. She is listed as "30 years old," and she died at the age of fifty-six (see n. 14). Thus she was twenty-five years Kleitsch's senior, which gives additional credence to an arrangement for his immigration to Cincinnati and their subsequent marriage.

19. Robert Kleitsch to Trenton (see n. 15).

20. Kleitsch to W. C. Baker [1912], states his intention to paint Madero (Nardone-Baker Collection, Laguna Art Museum). On his biographical form for the Art Institute of Chicago, Kleitsch listed paintings of Madero and his wife. Some newspaper accounts and a journal (1919) mention only Kleitsch's portrait of Señora Madero.

21. See the artist's naturalization petition (n. 3). A postcard from Kleitsch to Baker with a photograph of the *Monterey* mentions a departure date for New York (Nardone-Baker Collection, Laguna Art Museum).

22. Kleitsch to Baker [1912] (Nardone-Baker Collection, Laguna Art Museum).

23. Edna Kleitsch to Earl Stendahl, 14 February 1926, Herald Square Hotel, New York City, Stendahl Art Galleries Papers, Kleitsch Correspondence, Archives of American Art, Smithsonian Institution, Gift of Alfred Stendahl, roll 2720.

24. Quoted from Esther Sparks, "A Bibliographical Dictionary of Painters and Sculptors in Illinois, 1808–1945" (Ph.D. diss., Northwestern University, 1971), vol. 1 of 3, 99. The history of Chicago's art activities is also from this source.

25. *Fine Arts Journal* (Chicago), vol. 26, no. 1 (January 1912): 25–43. Information on art activities in Chicago in the early twentieth century is from James William Pattison's review of the Annual Exhibition of American Art at the Art Institute of Chicago.

26. The author is indebted to the school's archivist, Mary McIsaac, who kindly shared this information with me. No further information exists regarding Kleitsch's studies as scant records were maintained for part-time students. Biographical data furnished by Kleitsch to the Art Institute of Chicago states, without dates, that he was a "Professor" [teacher] of art in the Chicago high schools. Thus, one might conjecture that he enrolled in the Saturday Classes to brush up on teaching techniques.

27. Theresa Haynel's letter to William Kleitsch, undated (before 1984).

28. The spelling of Edna's maiden name varies. The date and place of her birth are from her death certificate and the date of Eugene's birth from Joseph Kleitsch's naturalization petition.

29. Information furnished by Mary McIsaac.

30. Wendy Greenhouse, Curator of Painting and Sculpture, Chicago Historical Society to Trenton, 23 February 1989. The author expresses her gratitude to Ms. Greenhouse.

31. Diana Haskell to researcher Phil Kovinick 7 July 1989. The author is indebted to Ms. Haskell, Lloyd Lewis Curator of Midwest Manuscripts, Newberry Library, Chicago, Illinois, for her contribution on Kleitsch's involvement with the Palette and Chisel Club of Chicago. Ms. Haskell searched the club's logbooks from 1909 to 1920 as well as all other available resources for information on the artist and constructed a brief history of the club's early years from newspaper articles of the period. Only a small portion of the club's archives is now at the Newberry.

32. The Palette and Chisel Club logbook.

33. M. Sheryl Bailey, 20th Century Painting and Sculpture, Art Institute of Chicago, to Robert Ehrlich, 11 April 1985. All other Art Institute exhibition records come from this source.

34. Awarded the grand prize for a figural painting at the Laguna Art Association exhibition in 1923.

35. Arthur K. Wheelock, Jr., *Jan Vermeer* (New York: Harry N. Abrams, 1981), 78.

36. *Ambition* and *Studio Interior* (1915, oil on canvas, 30×40", Russak Collection) are also from this series. These works are known only from reproductions.

37. *Los Angeles Times*, 20 June 1926. Current location unknown.

38. Collection of Mr. and Mrs. Thomas B. Stiles II. An unlocated second version is described by Pattison in the *Fine Arts Journal* (Chicago) of 1919.

39. *Los Angeles Times*, 17 June 1923.

40. See M. K. Wisehart, "'Try Giving It Up' says Wayman Adams," *American Magazine* 106 (October 1928): 26.

41. See "Impressions of Fall Exhibit at the Laguna Art Gallery," *South Coast News* (Laguna Beach), 10 October 1930.

42. Miss Ketchum's costume was described by Edward Maeder, Curator of Textiles and Costumes, Los Angeles County Museum of Art.

43. Pattison, 47–53.

44. Kleitsch's German heritage was verified by Mrs. Lubomir Hykel, whose mother is Theresa Haynel's sister-in-law.

45. Pattison, 47.

46. The question was raised by the critic Antony Anderson in the *Los Angeles Times*, 23 June 1922, pt. 3, 42: 1–2.

47. The commission is mentioned in Kleitsch's obituary. Kleitsch probably knew Simon William Straus, president of S. W. Straus, a powerful bonding house in New York and Chicago, and president of Franklin Trust and Savings Bank in Chicago (see *Who's Who in New York, 1918*).

The Ambassador Hotel opened on 1 January 1921 (see Margaret Tante Burk, *Are the Stars Out Tonight? the story of the famous Ambassador and Cocoanut Grove, "Hollywood's Hotel"* (Los Angeles: Round Table West, 1980), 31.

48. The *Register* (Santa Ana) chronicles Kleitsch's activities of the 1920s as follows: 20 January, 4 February, 4 and 13 March, 3 April, 27 May, and 7 June, when the artist and his family left for New Orleans.

49. See *Saturday Night*, 29 July 1922, 9:1–2.

50. The contract is in the Stendahl Art Galleries Papers (see note 23). The contract gave Earl Stendahl 50% of sales and Mrs. Kleitsch a 15% commission for sales outside the gallery.

51. *Impressions of the Art at the Panama-Pacific Exposition* (New York: John Lane Company, 1916), 149.

52. The author wishes to express her gratitude to Dewitt Clinton McCall, who has conserved many of Kleitsch's paintings, for the insight into the artist's working methods.

53. For a biographical sketch of George Turner Marsh, see *Who's Who in California, 1928–29*, 299. G. T. Marsh & Company is listed in the Los Angeles city directory and featured in an article in *Saturday Night*, 12 November 1932, p. 2. The House of Marsh had branch stores in Coronado, Los Angeles (at the Ambassador), Santa Barbara, and Monterey. Through the fine sleuthing of the Kovinicks, the location of the Oriental shop in Kleitsch's picture was identified.

54. *Los Angeles Times*, 14 May 1922; the painting was illustrated in the same newspaper on 30 April 1922 (news clipping in the "scrapbooks" of the Archives of the Natural History Museum, Los Angeles). The author expresses her gratitude to archivist Gretchen Sibley for her assistance. The painting is in the possession of David and Sons Fine Arts and Michael Kizhner Fine Arts.

55. No. 55, p. 26.

56. 24 August 1924. William Wendt to Earl Stendahl, 15 January 1924, inquired if Kleitsch were still his portrait painter; if not, Wendt offered to recommend a woman portraitist. There is no evidence that Stendahl was disenchanted with Kleitsch nor that he had inquired about other portraitists.

57. The last venue is not confirmed; it was only suggested that it might be exhibited there. Dalzell Hatfield worked briefly for Earl Stendahl and then they came together in a short-lived partnership.

58. The celebrated photographer George Hurrell, who first came to Laguna with Edgar Payne from Chicago, relates that "Kleitsch placed his easel in the middle of the road leading back to Laguna Canyon so that the cars would have to stop, and in that way his paintings did not get full of dust from cars rushing by" (Hurrell to Trenton).

59. *Los Angeles Times*, 20 June 1926.

60. *Laguna Beach Life*, 23 April 1926.

61. Mrs. Katherine Petty, daughter of the deceased artist William Griffith who lived in Laguna in the 1920s, shared this anecdote with the author. Her sister, Mrs. Ida Griffith Hawley, posed for Kleitsch and recalls how rapidly he worked. *Highlights* was exhibited in Kleitsch's Memorial Exhibition, Los Angeles County Museum of Art, June 1933. The critic Arthur Millier called it "one of the most sumptuous pictures in the show" (*Los Angeles Times*, 18 June 1933).

62. *Lifeguard*, collection of Mrs. Ida Griffith Hawley; the two portraits of women, locations unknown; and the third portrait, collection of Evelyn Moodey.

63. *El Peon* was reproduced in the Spanish-language periodical, *Mundial* (Los Angeles), 20 June 1926. The *Spanish Officer* is in the collection of the Maxwell Art Gallery: photograph courtesy of Michael Kelley, Kelley Gallery.

64. *Fine Arts Journal* (Chicago), vol. 30, no. 1 (January 1914): 17.

65. Information on Kleitsch's European trip (1926–27) is based on correspondence between Joseph and Edna Kleitsch and Earl Stendahl (Stendahl Art Galleries Papers, Kleitsch Correspondence).

66. Correspondence in the Stendahl Art Galleries Papers confirms that Edna remained in the states; we also know that she never applied for a foreign passport (Loretta A. Alfaro, Chief, Research & Liaison Branch, Passport Services, United States Department of State, Washington, D.C., to Phil Kovinick, 20 October 1989). Edna Kleitsch finally moved to Columbus, Ohio, where she made largely unsuccessful efforts to sell her husband's paintings.

The author is unaware of any special problems Eugene may have been experiencing at this time, but later in his life there was conjecture on his sanity and on alcohol addiction. In 1951, the year after Edna's death, Eugene was committed to Metropolitan State Hospital, Norwalk, California, and he died there on 20 May 1971 as a ward

of the state. On his death certificate his occupation was given as "laborer as ceramicist."

67. His departure is confirmed in his passport application. Edna Kleitsch to Earl Stendahl, 14 February 1926 (Stendahl Art Galleries Papers, Kleitsch Correspondence).

68. Stendahl had come with good news about Kleitsch's current exhibition of forty-five paintings at the Ambassador Hotel, from 15 June to 15 July. Among the key paintings in this show were *Oriental Still-Life*, *The Garden of Capistrano*, *In My Studio*, *Major Walker*, and *Portrait of Mrs. Kleitsch*.

69. Highlights of Kleitsch's trip are from J. C. Bulliet, *Stendahl's Art Review, Summer 1928*. The midwestern painter Abel Warshawsky mentions in his autobiography *Memories of an American Impressionist* (Kent, Ohio: Kent State University Press, 1980) that Kleitsch accompanied him to Vernon in summer 1926.

70. Collection of Marcel Vinh.

71. There are several versions of *The Blue Thread*, one of them in the collection of the Laguna Art Museum.

72. Collection of James and Linda Ries.

73. *South Coast News, Laguna*, 10 October 1930.

74. Why Kleitsch chose to exhibit a limited number of his major works is puzzling. His outstanding paintings, such as *Problematicus* and *The Oriental Shop*, were still in his studio when he died, and they were sold at auction in 1953. Perhaps the depression dampened his expectations of sales and he chose not to sacrifice his important paintings.

75. In March 1935 the estate of Joseph Kleitsch was finally settled. A. P. Jones of Chicago, Edna Kleitsch's brother-in-law, loaned her $3,000 dollars, secured by paintings and property, to effect the closing.

76. The auction was held at the Kleitsch studio on Legion and Through Streets in Laguna on 10 and 11 April 1953 from 11:00 A.M. to 5:00 P.M. The sale was conducted by Oswell L. Jackson, Curator of the Laguna Beach Art Gallery, who received a fee of $751.84 (15%). The proceeds of the sale were $5,012.25, for 124 paintings, books, art materials, and miscellaneous household furniture.

77. I wish to express my gratitude to my friend and colleague Professor Joachim Smith, who made the connection between Kleitsch and the pluralistic Post-Modernists.

STERN, *Franz Bischoff: From Ceramist to Painter*

The author is indebted to several individuals who contributed to Bischoff's biography. Dr. Patricia Trenton assisted in sorting out inaccuracies and gaps in the artist's biography, which was reconstructed by a family member in the 1970s from articles in the *China Decorator* published in Pasadena in the 1950s and 1960s. Researchers Marian Kovinick and Phil Kovinick were

instrumental in compiling accurate documents to substantiate the artist's biography. For their untiring professionalism we are most grateful.

1. Biographical information on Bischoff is from the *Detroit Journal*, 17 May 1893; *Foothill Review* (South Pasadena), 8 February 1929; and Arthur Hopkins Gibson, *Artists of Early Michigan* (Detroit: Wayne University Press, 1975). Bischoff's middle name is omitted from his application for naturalization, his death certificate, and all other documents located at this time. None of his paintings or ceramics carries his middle name. In *The Paintings of Franz A. Bischoff* (Los Angeles: Petersen Publishing Company, 1980), the author gave the artist's middle name as Arthur, based on personal communication with family members. This is apparently incorrect, since the obituary in *Foothill Review* gave his full name as Franz Anthony Bischoff.

2. Bischoff quoted in the *Detroit Journal*, 17 May 1893; *Graphic* (Los Angeles), 13 August 1910.

3. The United States Census of 1900 gives the year of entry as 1884, while the artist's obituary in *Foothill Review* cites 4 August 1885.

4. Bischoff's naturalization papers, Pittsburgh, Allegheny County, Pennsylvania. The next few years remain somewhat unclear because of contradictory information provided by an aging Mrs. Bischoff and her son for articles that appeared in the March 1959 and January 1963 issues of the *China Decorator*. Based on other data and findings, the chronology for this period presented in the 1959 publication is probably the correct one.

5. United States Census, 1910; marriage application, Seneca County, Ohio; and *Fostoria Democrat*, 29 May 1890. Bischoff was referred to as a "former Fostorian" who, with his wife, would make his home in Michigan.

6. Bischoff moved to Detroit in time to be listed in the 1889–90 city directory. Their association was recorded in the *China Decorator*, January 1963.

7. Detroit City Directory, 1891–92.

8. *Detroit Times*, 15 October 1890.

9. *China Decorator*, October 1966.

10. *China Decorator*, March 1959.

11. *Detroit Journal*, 17 May 1893.

12. *Detroit Journal*, 17 November 1893.

13. *Detroit Journal*, 7 May 1894.

14. *Los Angeles Times*, 9 November 1924.

15. *Detroit Journal*, 12 January 1895; United States Census, 1900; and sources for the children's birthdates from their death certificates as well as the United States Census for 1900 and 1910.

16. *Detroit Journal*, 23 November 1899. This view is supported by several articles, although apart from family accounts primary documentation has not been found.

17. *Graphic* (Los Angeles), 1 December 1906; Los Angeles County Recorder; and *China Decorator*, October 1966.

18. *Los Angeles Times*, 17 February 1907.

19. Bischoff turned to easel painting and for several years continued his china decorating in addition to holding summer classes in San Francisco and Seattle (see *Graphic* [Los Angeles], 9 May 1908).

20. *Los Angeles Times*, 23 February 1908.

21. *Graphic* (Los Angeles), 13 August 1910.

22. *Los Angeles Times*, 14 March 1909.

23. *Los Angeles Times*, 29 January and 5 February 1911.

24. *Graphic* (Los Angeles), 23 March 1912. The painting is in a private collection; photograph courtesy of Petersen Galleries.

25. Bischoff quoted in *Graphic* (see n. 24).

26. *Los Angeles Times*, 15 September 1912. Apparently the trip was supposed to last for two years (see *Los Angeles Times*, 22 September 1912), but Bischoff and his daughter were back in South Pasadena on Sunday, 11 May 1913 (*South Pasadena Record*, 16 May 1913).

27. Bischoff's copies were originally in the artist's estate but were sold by the family.

28. Fleischer Museum Collection and The Fieldstone Company Collection.

29. *Los Angeles Times*, 4 October 1914.

30. San Diego Historical Society, Archives, information courtesy of Bruce Kamerling. Whether the artist exhibited ceramics in either of the two expositions is unknown at this time. However, it is possible that by 1915 Bischoff was no longer decorating china, for in a later newspaper article (see *Los Angeles Times*, 9 November 1924) critic Antony Anderson states that he had "kissed ceramics goodbye" some time ago.

31. Information from the Archives of American Art, Smithsonian Institution, roll D-13.

32. James and Linda Ries Collection.

33. Untitled still life in the James and Linda Ries Collection.

34. Janet Blake Dominik, *Early Artists in Laguna Beach* (Laguna Art Museum, 1986), 10.

35. See Nancy Dustin Wall Moure, *Artists' Clubs and Exhibitions in Los Angeles before 1930* (Los Angeles: Dustin Publications, 1984), B-83.

36. Fleischer Museum Collection.

37. *Los Angeles Times*, 30 November 1924.

38. For an example of Smith's Cambria pictures, see *Masterworks of California Impressionism: The FFCA, Morton H. Fleischer Collection* (Tulsa, Oklahoma: Thomas Gilcrease Institute of American History and Art, 1986), 113, pl. 47.

39. Paul and Kathy Bagley Collection. Private collection; illustrated on the cover of the Franz Bischoff catalogue (Petersen Galleries).

40. Moure, *Artists' Clubs*, B-4.

41. *Saturday Night*, 4 February 1928.

42. *Los Angeles Times*, 7 October 1928.

DOMINIK, *Patrons and Critics in Southern California*

1. Arthur Millier, "Growth of Art in California," in *Land of Homes* by Frank J. Taylor (Los Angeles: Powell Publishing, 1929), 334. Millier was comparing the intimacy of these landscapes with the grand landscapes on a panoramic scale by artists such as Bierstadt and Moran.

2. Ibid.

3. Alma May Cook, "What Art Means to California," in *Art in California* (San Francisco: R. L. Bernier, 1916), 74.

4. When artist Benjamin Brown inquired about career possibilities for the artist in the 1880s, he received a most discouraging letter from the Chamber of Commerce. Benjamin Chambers Brown, "The Beginnings of Art in Los Angeles," *California Southland* (January 1924): 7.

5. Carey McWilliams, *Southern California: An Island on the Land*, 2d ed. (Santa Barbara and Salt Lake City: Peregrine Smith, 1973), 150–51.

6. Winifred Haines Higgins, "Art Collecting in the Los Angeles Area: 1910–1960" (Ph.D. diss., University of California, Los Angeles, 1963), 8.

7. *Ebell of Los Angeles* 4 (May 1930): unpaginated. By 1924 the club had over three thousand members and was able to construct a permanent home at 743 South Lucerne on the corner of Wilshire Boulevard, where it is still located today. See also Higgins, 6–7.

8. *Graphic*, 8 November 1913.

9. *Los Angeles Times*, 6 and 9 November 1913.

10. *Los Angeles Times*, 9 November 1913. See also "65 and Still Growing," *Terra* 16 (Winter 1978), 8–9.

11. Extensive bibliography and exhibition listings may be found in Nancy Dustin Wall Moure, *Publications in Southern California Art 1, 2 & 3* (Los Angeles: Dustin Publications, 1984).

12. Higgins, "Art Collecting," 23, 56–57. See also Kathryn W. Leighton, "The Harrison Collection of Paintings," *California Southland* 8 (February 1926): 14–16.

13. Higgins, 25–26. Higgins notes that the more modernist works did not sell well in Los Angeles; that they were "too advanced for most Angelenos, including Preston Harrison," p. 24. Apparently, Antony Anderson too, although he found modern work "interesting," failed to understand it (*Los Angeles Times*, 13 February 1920).

14. Porter Garnett, *The Nation*, 3 May 1919, quoted in Gene Hailey, editor, *Abstract from California Art Research*, W.P.A. Project 2874, O.P. 65-3-3632, vol. 7 (San Francisco: Works Progress Administration, 1937), 104.

15. Archival records of Jannette Kanst Mathewson.

16. In addition, in 1927 and 1928 Stendahl published *Stendahl's Quarterly Art Review*, edited by Antony Anderson.

17. See for example "The God of the Mountains," *Los Angeles Times*, 22 May 1927, on Edgar Payne, and "A Hungarian Artist," *Los Angeles Times*, 25 June 1928, on Joseph Kleitsch. Hogue's reviews were

fair analyses, although like those of Antony Anderson essentially laudatory. Hogue remarked in his article on Payne that "it is not for me to pass upon the merits of Payne as an artist."

18. *Los Angeles Times*, 31 July 1916; *Los Angeles Times*, 10 September 1916. See also M. Urmy Seares, "Richard Miller in a California Garden," *California Southland* (February 1923), 10–11. Information on Eva Fenyes from Phil Kovinick to Dominik, 24 July 1989.

19. *California Art Club Bulletin* 1 (December 1925), unpaginated.

20. *Los Angeles Times*, 11 August 1929.

21. Just a few of the many articles discussing modern art during this period are: "What's the Matter with the Modernists?" *American Magazine of Art* 17 (April 1926): 198–99; Arthur Wesley Dow, "Modernism in Art," *American Magazine of Art* 8 (January 1917): 113–16; Duncan Phillips, "Fallacies of the New Dogmatism in Art," *American Magazine of Art* 9 (December 1917): 43–49, and (January 1918): 101–7; Hamilton A. Wolf, "Modernism in Painting," *Argus* 2 (December 1927): 1–2. For a discussion of critical response to the Armory Show, see Milton W. Brown, *The Story of the Armory Show* (New York: Abbeville Press, 1988), 153–86.

22. Martin E. Petersen, unpublished manuscript, 1989.

23. Willis Polk, "A Brilliant Future for American Art," in *Art in California* (San Francisco: R. L. Bernier, 1916), 77.

24. Antony Anderson, "Six Landscape Painters of Southern California," in *Art in California* (San Francisco: R. L. Bernier, 1916), 67.

25. Michael Williams, "The Pageant of California Art," in *Art in California* (San Francisco: R. L. Bernier, 1916), 62. California's attraction for the landscape painter was described at length by William Howe Downes in "California for the Landscape Painter," *American Magazine of Art* 11 (December 1920): 491–502.

26. Arthur Millier, "An Age of Innocence: Southern California Art in the Twenties," in Nancy Dustin Wall Moure, *Los Angeles Painters of the Nineteen-Twenties* (Claremont, California: Pomona College Art Gallery, 1972), unpaginated.

27. Christian Brinton, "American Painting at the Panama-Pacific Exposition," *International Studio* 56 (August 1915): xxxii.

28. Christian Brinton, *Impressions of the Art at the Panama-Pacific Exposition* (New York: John Lane Company, 1916), 10–11.

29. Ibid.

30. J. Nilsen Laurvik, "Art in California: The San Francisco Art Association's Annual Exhibition," *American Magazine of Art* 9 (May 1918): 275.

31. Ibid.

32. *Los Angeles Times*, 19 November 1916.

33. Mabel Urmy Seares, "Modern Art and Southern California," *American Magazine of Art* 9 (December 1917): 58.

34. *Los Angeles Times*, 8 April 1917.

35. On his retirement from the *Times* in 1926, Anderson was honored by the California Art Club for bringing the works of California artists to the attention of the public in Southern California. They noted that as an artist himself, Anderson understood what he saw and wrote with a sense of responsibility to both the artist and the public. *Los Angeles Times*, 18 April 1926.

36. Antony Anderson, *Los Angeles Times*, 23 March 1919.

37. Ibid., 20 January 1924.

38. Ibid., 8 April 1917.

39. Ibid.

40. Rose V. S. Berry, "California and Some California Painters," *American Magazine of Art* 15 (June 1924): 285. Berry was Chairman of the Fine Arts Department of the General Federation of Women's Clubs in San Francisco. She wrote and lectured on California artists.

41. *Los Angeles Times*, 27 November 1927.

42. Ibid.

43. *Los Angeles Times*, 21 August 1927. Most of the leading painters, however, certainly had cultured backgrounds, having been educated in the East and/or in Europe.

44. Ibid.

45. Ibid.

46. Ibid.

47. *Argus* 1 (May 1927).

48. *Argus* 2 (February 1928). In December 1927 the *American Magazine of Art* noted that "Los Angeles is . . . fortunate in possessing such live art critics as Arthur Millier, whose constructive writing is building up a very fine attitude toward art among the reading public and at the same time opening broader vistas for the artists themselves" (*American Magazine of Art* 18, p. 676).

49. *West Coaster* 1 (1 September 1928). See also *Los Angeles Times*, 16 September 1928.

50. Hanson Puthuff's obituary referred to him as the "last of the Eucalyptus painters," a comment that his friend and fellow artist Sam Hyde Harris hotly decried in his tribute in Puthuff's autobiography, published shortly after the artist's death in 1972. There was, in fact, no "Eucalyptus School," and the term should not be applied to the serious, professional artists who painted the landscape of Southern California in an impressionistic style during the first decades of this century.

51. *California Art Club Bulletin* 2 (November 1926): unpaginated.

52. *California Art Club Bulletin* 4 (June 1928): unpaginated.

LIST OF PLATES

*Works in exhibition

1. *Maurice Braun Painting in the San Diego Back Country*. 1916. Photograph. Braun Family Album.

2. *Edgar Payne Painting in the High Sierra*. 1945–46. Photograph reproduced from Ralph Payne's documentary film, "Sierra Journey." Photograph courtesy of Evelyn Payne Hatcher.

3. Edgar Payne. "Forms of Composition," reproduced from *Composition of Outdoor Painting*. Photograph courtesy of Evelyn Payne Hatcher.

4. *Granville Redmond in His Studio*. Photograph. Collection of Paula and Terry Trotter.

5. *Donna Schuster at Home*. Photograph. Ray Redfern, Redfern Gallery, Laguna Beach.

*6. Granville Redmond. *California Landscape*. 1907. Oil on canvas, 45 × 80½". The Los Angeles Athletic Club Collection.

*7. Donna Schuster. *On the Beach*. 1917. Oil on canvas, 29 × 29". Ray Redfern, Redfern Gallery, Laguna Beach.

*8. Donna Schuster. *In the Garden*. 1917. Oil on canvas, 39½ × 39½". Private collection.

9. Sanford Gifford. *Kauterskill Falls*. 1862. Oil on canvas, 48 × 39⅞". The Metropolitan Museum of Art. Bequest of Maria De Witt Jesup, 1915.

10. Thomas Eakins. *The Biglin Brothers Turning the Stake*. 1873. Oil on canvas, 45 × 65". The Cleveland Museum of Art. Purchase Hinman B. Hurlbut Collection.

11. Winslow Homer. *The Rustics*. 1874. Oil on canvas, 16 × 22½". Photograph courtesy of Coe Kerr Gallery, New York.

12. Giovanni Fattori. *The Lookouts (The White Wall)*. Oil on canvas, 14½ × 20". Marzotto Collection, Rome. Soprintendenza Beni Artistici e Storici di Firenze.

13. Frank Duveneck. *Old Town Brook, Polling, Bavaria*. Oil on canvas, 30⅞ × 49⅛". Cincinnati Art Museum. Gift of Frank Duveneck.

14. Carl Schuch. *Approaching Storm at Ferch*. Oil on canvas, no measurements. Germanisches Nationalmuseum, Nürnberg.

15. J. Frank Currier. *Moors at Dachau*. 1875. Oil on canvas, 51 × 81". George Cooke White Collection.

16. Theodore C. Steele. *Pleasant Run*. 1885. Oil on canvas, 19¼ × 32¼". Indianapolis Museum of Art. Gift of Carl B. Shafer.

17. Charles Harold Davis. *Evening*. Oil on canvas, 38½ × 57⅞". Richard Manoogian Collection, Grosse Pointe, Michigan.

18. William Picknell. *On the Borders of the Marsh*. 1880. Oil on canvas, 79 × 59½". Pennsylvania Academy of the Fine Arts, Philadelphia. Gift of Joseph E. Temple.

19. Edward Simmons. *Night, St. Ives Bay*. Oil on canvas, 50¼ × 66½". Hardwick Simmons. Photograph courtesy of Hirschl & Adler Galleries, Inc., New York.

20. Walter Gay. *Le Bénédicité*. 1898. Oil on canvas, approximately 88 × 50". Musée de Picardie, Amiens, France. Photograph courtesy of Gary Reynolds.

21. John Twachtman. *Arques-la-Bataille*. Oil on canvas, 60 × 78⅞". The Metropolitan Museum of Art. Morris K. Jesup Fund, 1968.

22. Mariano Fortuny y Carbo. *Gypsy Caves, Granada*. Oil on wood panel, 7½ × 5⅛". The Corcoran Gallery of Art. William A. Clark Collection.

23. Thomas Eakins. *Sailboats Racing on the Delaware*. 1874. Oil on canvas, 24 × 36". Philadelphia Museum of Art. Given by Mrs. Thomas Eakins and Miss Mary Adeline Williams.

24. Frank Duveneck. *Italian Courtyard*. 1886. Oil on canvas, 22¼ × 33³⁄₁₆". Cincinnati Art Museum. Gift of the artist.

25. William Picknell. *The Road to Concarneau*. 1880. Oil on canvas, 42⅜ × 79¾". The Corcoran Gallery of Art. Museum Purchase Gallery Fund.

26. Childe Hassam. *Grand Prix Day*. Oil on canvas, 24 × 34". Museum of Fine Arts, Boston. Ernest Wadsworth Longfellow Fund.

27. Childe Hassam. *In the Garden (Celia Thaxter in Her Garden)*. 1892. Oil on canvas, 22⅛ × 18⅛". National Museum of American Art, Smithsonian Institution. Gift of John Gellatly.

28. John Singer Sargent. *A Morning Walk*. 1888. Oil on canvas, 26⅜ × 19¾". Photograph courtesy of Coe Kerr Gallery, New York.

29. Frederick Frieseke. *The Garden Parasol*. c. 1909. Oil on canvas, 57 × 76⅝". North Carolina Museum of Art, Raleigh. Purchased with funds from the State of North Carolina.

30. Richard Miller. *Reverie*. c. 1916. Oil on canvas, 36 × 34". Museum of Art, Rhode Island School of Design, Providence. Gift of Mrs. William C. Baker.

31. Alson Clark. *Summer, Giverny*. 1910. Oil on canvas, 26 × 32". Mr. and Mrs. Thomas B. Stiles II Collection.

32. Charles Eaton. *The Strip of Pines*. 1908. Oil on canvas, 30½ × 36¼". Montclair Art Museum, New Jersey. Gift of William T. Evans.

33. Joseph Boston. *After the Rain*. c. 1900. Oil on canvas, 30 × 40". Bram and Sandra Dijkstra.

34. Claude Monet. *In the Field* (detail). 1876. Oil on canvas, 23⅝ × 32¾". Reproduced from *Sotheby's Preview* June/July 1988. Photograph copyright © Sotheby's 1989.

35. Guy Rose. *The Moth*. c. 1892. Reproduced from the *Pennsylvania Academy of the Fine Arts Catalogue of the Sixty-Sixth Annual Exhibition*, 21 December 1896–22 February 1897, ill. 286.

36. Lawton Parker. *Spring Blossoms*. Oil on canvas, 30¼ × 24⅛″. Pfeil Collection. Photograph courtesy of R. H. Love Galleries, Inc., Chicago.

37. Frederick Frieseke. *Reflections*. Oil on canvas, 32 × 31⅞″. Location unknown. Photograph courtesy of Hirschl & Adler Galleries, Inc., New York.

38. Childe Hassam. *Tanagra (The Builders, New York)*. 1918. Oil on canvas, 58¾ × 58¼″. National Museum of American Art, Smithsonian Institution. Gift of John Gellatly.

39. Frederick Frieseke. *Youth (La Toilette)*. c. 1912. Oil on canvas, 51 × 54¼″. Private collection, Texas. Photograph courtesy of Meredith Long & Company, Houston.

40. Richard Miller. *The White Shawl*. 1904. Oil on canvas, 79 × 45½″. The Whittle Collection. Photograph courtesy of Hirschl & Adler Galleries, Inc., New York.

41. Guy Rose. *Marion*. Oil on canvas, 15 × 18″. Roy C. Rose Collection.

42. Guy Rose. *On the River*. 1909. Oil on canvas, 29 × 24″. Roy C. Rose Collection.

43. Lawton Parker. *The Orange Parasol*. Oil on canvas, 22 × 25½″. Geist Collection. Photograph courtesy of R. H. Love Galleries, Inc., Chicago.

44. Frederick Frieseke. *Lady with Parasol (Green Umbrella)*. c. 1909. Oil on canvas, 25½ × 32″. Collection of Mr. and Mrs. Meredith J. Long, Houston.

*45. Joseph Kleitsch. *Miss Ketchum*. c. 1918. Oil on canvas, 42 × 36″. Private collection.

46. Donna Schuster. *On the Veranda*. c. 1917. Oil on canvas, 30½ × 30½″. Location unknown. Photograph courtesy of Ray Redfern, Redfern Gallery, Laguna Beach.

*47. Donna Schuster. *Girl in a Hammock*. 1917. Oil on canvas, 29½ × 29½″. Ray Redfern, Redfern Gallery, Laguna Beach.

48. *Frank Felt as Father Salvedierra; Victor Jory as Alessandro*. [In: Hemet-San Jacinto Ramona Pageant Souvenir Program. Hemet: 1928]. Photograph. The Huntington Library, San Marino, California.

49. *Orange Grove, Southern California*. c. 1900–10. Photograph. Seaver Center for Western History Research, Natural History Museum of Los Angeles County.

50. *Pacific Electric Railway Pamphlet*. 1895–1915. Photograph. The Huntington Library, San Marino, California.

51. *The Old Coast Road (Arch Beach Road), Laguna Beach*. c. 1905. Photograph. Seaver Center for Western History Research, Natural History Museum of Los Angeles County.

52. *Laguna Beach Art Association, First Art Gallery, Old Town Hall, Laguna Beach*. 1918. Photograph. Laguna Art Museum, Laguna Beach.

53. *California Building Art Gallery, Panama-California Exposition, 1915, Balboa Park, San Diego*. Photograph. San Diego Historical Society. Ticor Collection.

54. *Stickney Memorial Art Institute*. Photograph. Pasadena Historical Society, Photograph Collection.

55. George Hurrell. *William and Julia Wendt at Home in Highland Park, Los Angeles*. 1939. Photograph: "Christmas Greetings to Earl and Enid [Stendahl]." Stendahl Galleries, Los Angeles.

*56. William Wendt. *Days of Sunshine*. 1925. Oil on canvas, 40 × 50″. National Museum of American Art, Smithsonian Institution. Bequest of Henry Ward Ranger through the National Academy of Design.

*57. William Wendt. *To Mountain Heights and Beyond*. 1920. Oil on canvas, 40 × 50″. Collection of Joseph L. Moure.

*58. William Wendt. *Where Nature's God Hath Wrought*. 1925. Oil on canvas, 50⁵⁄₁₆ × 60¹⁄₁₆″. Los Angeles County Museum of Art. Mr. and Mrs. Alan C. Balch Collection.

59. George Hurrell. *William Wendt with "Where Nature's God Hath Wrought" on Easel*. 1925. Photograph courtesy of the Grand Central Galleries, Inc., New York.

*60. William Wendt. *There is No Solitude Even in Nature*. 1916. Oil on canvas, 34 × 36″. Redfern Gallery, Laguna Beach.

*61. William Wendt. *The Silent Summer Sea*. 1915. Oil on canvas, 40 × 50″. Private collection.

*62. William Wendt. *Old Coast Road*. 1916. Oil on canvas, 30 × 36″. Collection of Mr. and Mrs. Richard Jahraus.

*63. Maurice Braun. *Moonrise over San Diego Bay*. 1915. Oil on canvas, 22 × 28″. Private collection.

*64. Granville Redmond. *Silver and Gold*. Oil on canvas, 30 × 40″. Laguna Art Museum, Laguna Beach. Gift of Mr. and Mrs. J. G. Redmond.

*65. Maurice Braun. *El Cajon Mountain [El Capitan Mountain]*. c. 1917. Oil on canvas, 36 × 46″. The Buck Collection.

*66. William Wendt. *The Big Tujunga*. 1930. Oil on canvas, 30 × 36″. Redfern Gallery, Laguna Beach.

*67. William Wendt. *Sycamore Entangled*. 1923. Oil on canvas, 32 × 36″. Collection of Joseph L. Moure.

*68. Edgar Payne. *Adriatic Cargo Boats*. 1923. Oil on canvas, 28 × 34″. Collection of Mr. and Mrs. Martin Medak.

69. Edgar Payne. *Adriatic Cargo Boats*. 1923. Photograph. Collection of Evelyn Payne Hatcher. Photograph courtesy of Dewitt McCall.

*70. Edgar Payne. *Breton Tuna Boats, Concarneau, France*. c. 1924. Oil on canvas, 40 × 50″. Collection of Joseph L. Moure.

71. Edgar Payne. *Breton Tuna Boats, Concarneau, France*. c. 1924. Photograph. Collection of Evelyn Payne Hatcher. Photograph courtesy of Dewitt McCall.

*72. Edgar Payne. *Fifth Lake*. Oil on canvas, 40⅜ × 50⅛″. National Museum of American Art, Smithsonian Institution. Bequest of Henry Ward Ranger through the National Academy of Design.

*73. Edgar Payne. *Rugged Slopes and Tamarack*. c. 1919. Oil on canvas, 45 × 45″. Collection of Mr. and Mrs. Thomas B. Stiles II.

*74. Edgar Payne. *The Matterhorn from Zermatt*. c. 1923–24. Oil on canvas, 52 × 48″. George Stern Fine Arts, Encino, California.

75. *Edgar Payne in the Swiss Alps*. 1923. Photograph. Collection of Evelyn Payne Hatcher.

76. Edgar Payne. *The Restless Sea*. 1917. Oil on canvas, 43 × 51″. Indianapolis Museum of Art. Gift of Mrs. James Sweetser.

*77. Maurice Braun. *California Valley Farm*. c. 1920. Oil on canvas, 40 × 50″. Collection of Joseph L. Moure.

*78. Maurice Braun. *Southern California Landscape*. c. 1920. Oil on canvas, 40 × 50″. San Diego Museum of Art. Gift of Mr. and Mrs. Lloyd Baldridge.

*79. Maurice Braun. *Southern California Hills*. 1915. Oil on canvas, 45½ × 40″. Collection of Dr. and Mrs. Richard Smith.

*80. Maurice Braun. *San Diego Bay*. 1910. Oil on canvas, 30 × 34″. Private collection.

81. *Maurice Braun Painting on a San Diego Beach*. 1918. Photograph. Braun Family Album.

82. *The Braun Studio Living Room Hearth, Point Loma, California*. 1934. Photograph. Braun Family Album.

83. *Maurice Braun Painting in his Studio Living Room, Point Loma, California*. 1940. Photograph. Braun Family Album.

*84. Maurice Braun. *San Diego Hills*. c. 1920. Oil on canvas, 30 × 40″. Orr's Gallery, San Diego.

85. Guy Rose. *The End of the Day*. c. 1890–91. Oil on canvas, 39¼ × 98″. Private collection.

86. Jules Bastien-Lepage. *Joan of Arc*. 1879. Oil on canvas, 100 × 110″. The Metropolitan Museum of Art. Gift of Erwin Davis.

87. Theodore Robinson. *Study*. 1890. Oil on canvas, 12 × 16¼″. Whitney Museum of American Art, New York. Gift of Mr. and Mrs. Raymond J. Horowitz in honor of John I. H. Baur.

88. Guy Rose. *July Afternoon*. 1897. Oil on canvas, 15¼ × 29¼″. Collection of Roy C. Rose.

89. Arthur Wesley Dow. "Landscape exercise," in *Composition* (Boston: Joseph Bowles, 1899), 26. Photograph courtesy of University of California, Los Angeles, Art Library.

90. Alson Clark, *Giverny*. 1910. Photograph. Alson Clark Photo Album. Collection of Carol and Alson Clark.

91. Alson Clark. *Tennis Court, Hôtel Baudy, Giverny, France* (left to right: Frederick Frieseke, Guy Rose, and others). 1910. Photograph. Alson Clark Photo Album. Collection of Carol and Alson Clark.

*92. Guy Rose. *The Blue Kimono*. c. 1909. Oil on canvas, 31 × 19″. Collection of Terry and Paula Trotter.

93. Lawton Parker. *Day Dreams* (or *Alfresco Tea*). 1914. Oil on canvas, 40 × 50″. Collection of James Zidell.

*94. Guy Rose. *The Difficult Reply*. Before 1918. Oil on canvas, 29¼ × 24¼″. Collection of Jason Schoen.

*95. Guy Rose. *The Model*. Oil on canvas, 24 × 20″. The Buck Collection.

*96. Guy Rose. *Marguerite*. Oil on canvas, 15 × 18¹⁄₁₆″. Bowers Museum Foundation, Santa Ana, California. Martha C. Stevens Memorial Art Collection. Gift of Sherman Stevens.

*97. Guy Rose. *Fig Trees, Antibes, France*. Oil on canvas, 23½ × 28¾″. Collection of Joseph L. Moure.

*98. Guy Rose. *The Valley of the Seine*. 1907. Oil on canvas, 24 × 29″. Redfern Gallery, Laguna Beach.

*99. Guy Rose. *Late Afternoon, Giverny*. c. 1907–09. Oil on canvas, 23¾ × 28¼″. San Diego Museum of Art. Purchase by the Fine Arts Society through special gift from members.

*100. Guy Rose. *November*. Oil on canvas, 23¾ × 29″. Private collection.

101. Claude Monet. *The Seine at Giverny, Morning Mists*. 1897. Oil on canvas, 35 × 36¼″. North Carolina Museum of Art, Raleigh. Purchased with funds from the Sarah Graham Kenan Foundation and the North Carolina Art Society (Robert F. Phifer Bequest).

102. Guy Rose. *Bowling on the Riviera*. Oil on canvas, 25 × 31″. Location unknown. Photograph courtesy of the Los Angeles County Museum of Art.

103. Guy Rose. *Moonlight, Carmel*. c. 1918. Oil on canvas. 24 × 29″. Location unknown. Photograph courtesy of the Stendahl Galleries, Los Angeles.

*104. Guy Rose. *Indian Tobacco Trees, La Jolla*. Oil on canvas, 24 × 29″. The Fieldstone Company, Newport Beach.

*105. Guy Rose. *Incoming Tide*. c. 1915. Oil on canvas, 24 × 29″. The Buck Collection.

106. Guy Rose. *Carmel Hills* (formerly *Carmel Beach*). Oil on canvas, 20⅞ × 24″. The Cleveland Museum of Art. Bequest of Mrs. Henry A. Everett for the Dorothy Burnham Everett Memorial Collection.

*107. Guy Rose. *Carmel Dunes*. Oil on canvas, 24 × 29″. Los Angeles County Museum of Art. Gift of Mr. and Mrs. Reese H. Taylor.

*108. Guy Rose. *Carmel Coast*. Oil on canvas, 33 × 40″. Collection of Jason Schoen.

*109. Guy Rose. *Point Lobos, Carmel* (formerly *Rocks and Sea, Point Lobos*). c. 1918. Oil on canvas, 24 × 28″. Private collection.

110. Childe Hassam. *Point Lobos, Carmel*. 1914. Oil on canvas, 28⁵⁄₁₆ × 36³⁄₁₆″. Los Angeles County Museum of Art. Mr. and Mrs. William Preston Harrison Collection.

111. *The William Merritt Chase School, Class Photo, New York City*. 1897. (Left to right, top row: second figure, Alson Clark.) Alson Clark Photo Album. Collection of Carol and Alson Clark. Photograph courtesy of Petersen Galleries, Beverly Hills.

112. *Alson Clark (seated far right) with friends, Paris Studio*. c. 1901. Photograph. Alson Clark Photo Album. Collection of Carol and Alson Clark. Photograph courtesy of Petersen Galleries, Beverly Hills.

*113. Alson Clark. *The Black Race*, 1902. Oil on canvas, 30 × 38″. Private collection.

114. Alson Clark. *The Black Race, Watertown, New York*. 1902. Photograph. Alson Clark Photo Album. Collection of Carol and Alson Clark.

*115. Alson Clark. *From Our Window, Paris*. 1903. Oil on canvas, 25¼ × 31¾″. Fleischer Museum Collection. Photo courtesy of Petersen Galleries, Beverly Hills.

*116. Alson Clark. *The Necklaces (Les Colliers)*. 1905. Oil on canvas, 38⅜ × 30⅛″. David and Sons Fine Arts, Laguna Beach.

117. James Abbott McNeill Whistler. *Symphony in White, No. 2: The Little White Girl*. 1864. Oil on canvas, 29⅞ × 20¼″. Tate Gallery, London.

*118. Alson Clark. *Carson Pirie Scott Department Store*. 1905. Oil on canvas, 24½ × 31¼″. Collection of Robert Hall.

*119. Alson Clark. *The Coffee House*. Before 1906. Oil on canvas, 38 × 30″. The Art Institute of Chicago. Gift of Mr. and Mrs. Alson E. Clark, 1915.

120. Robert Henri. *Snow in New York*. 1902. Oil on canvas, 32 × 25¾″. National Gallery of Art. Chester Dale Collection 1954.

*121. Alson Clark. *The Green Parasol* (formerly *The Green Umbrella*). 1906. Oil on canvas, 32 × 21½″. Collection of James and Linda Ries.

122. Alson Clark. *Medora in Clark's Watertown, N.Y., Studio*. 1906. Photograph. Alson Clark Photo Album. Collection of Carol and Alson Clark.

*123. Alson Clark. *Plaza of the Puerta del Sol, Madrid*. 1909. Oil on canvas, 30 × 38″. Collection of Paul and Kathy Bagley.

124. Alson Clark. *Plaza of the Puerta del Sol, Madrid*. 1909. Watercolor and pencil, 3 × 5″. Alson Clark Sketchbook, Spain, 1909. Collection of Carol and Alson Clark.

125. Alson Clark. *Plaza del Sol at Night*. 1909. Oil on panel, 7½ × 9½″. Private collection. Photograph courtesy of Petersen Galleries, Beverly Hills.

126. James Abbott McNeill Whistler. *Nocturne in Black and Gold, the Falling Rocket*. c. 1875. Oil on oak panel, 23⅝ × 18⅜″. The Detroit Institute of Arts. Gift of Dexter M. Ferry, Jr.

127. Alson Clark. *Medora Clark* [left], *Sadie and Frederick Frieseke, Giverny*. 1910. Photograph. Alson Clark Photo Album. Collection of Carol and Alson Clark. Photograph courtesy of Petersen Galleries, Beverly Hills.

128. William Merritt Chase. *At the Seashore*. Oil on canvas, 20 × 34″. The Metropolitan Museum of Art. Bequest of Miss Adelaide Milton de Groot, 1967.

*129. Alson Clark. *On the Beach, Urville, Normandie*. 1910. Oil on canvas, 25 × 31″. Collection of Renée Hanson.

130. Eugène Boudin. *The Beach at Bénerville, Marée Basse*. 1892. Oil on canvas, 19½ × 29¼″. Dixon Gallery and Gardens, Memphis. Mr. and Mrs. Hugo N. Dixon.

131. Alson Clark. *Ullman Children, Urville, Normandy*. 1910. Photograph. Alson Clark Photo Album. Collection of Carol and Alson Clark. Photograph courtesy of Petersen Galleries, Beverly Hills.

*132. Alson Clark. *Thousand Islands, New York*. 1911. Oil on canvas, 25 × 31″. Collection of Mr. and Mrs. John B. Parker.

*133. Alson Clark. *Frozen River, Jackson, New Hampshire*. 1916. Oil on board, 26 × 32″. Collection of Paul and Kathy Bagley.

134. Alson Clark. *Moonlight, San Juan Capistrano Mission*. 7 April 1919. Pencil and white chalk on gray paper, 5 × 7″. Alson Clark Sketchbook, 1919–21. Collection of Carol and Alson Clark.

135. Alson Clark. *Alson Clark's House and Studio at 1149 Wotkyns Drive, Pasadena*. c. 1920. Photograph. Alson Clark Photo Album. Collection of Carol and Alson Clark.

*136. Alson Clark. *Reverie* (formerly *Medora on the Terrace*). 1920. Oil on canvas, 36 × 46″. Collection of Roy C. Rose.

137. Alson Clark. *Medora on the Terrace*. August 1920. Photograph. Alson Clark Photo Album. Collection of Carol and Alson Clark.

*138. Alson Clark. *Reflections*. 1920. Oil on artists' cardboard, 17¾ × 14⅞″. Collection of Carol and Alson Clark.

139. *Alson Clark Painting at Lone Pine near Owens Valley in the High Sierra.* c. 1921. Photograph. Alson Clark Photo Album. Collection of Carol and Alson Clark.

*140. Alson Clark. *The Fruit Pickers.* 1922. Oil on canvas, 36×46″. Collection of Jane Fonda.

141. Alson Clark. *Two Sketches of Trees.* 29 April 1920. Pencil and white chalk on gray paper, 5×7″. Alson Clark Sketchbook, 1919–21. Collection of Carol and Alson Clark.

*142. Alson Clark. *California Picnic.* c. 1922. Oil on canvas, 36×46″. Collection of Bram and Sandra Dijkstra.

*143. Alson Clark. *Chicago in Winter.* 1910. Oil on canvas, 36×46″. Collection of Bram and Sandra Dijkstra.

*144. Alson Clark. *La Jolla Cove.* 1928. Oil on canvas, 38×33½″. Collection of the Automobile Club of Southern California.

145. William C. Baker. *Joseph and Emma Kleitsch in Mexico.* 1907. Photograph. Laguna Art Museum, Laguna Beach. Gift of Jonathan Nardone.

146. *Joseph Kleitsch in Mexico City.* c. 1912. Photograph. Laguna Art Museum, Laguna Beach. Gift of Jonathan Nardone.

147. *Joseph Kleitsch and Other "Band Members," December 1914.* Photograph reproduced from the Palette and Chisel Club Logbook, 1914. Newberry Library, Chicago.

148. Joseph Kleitsch. *In My Studio.* 1917. Oil on canvas. Location unknown. Photograph courtesy of Laguna Art Museum, Laguna Beach. Stendahl Galleries Collection.

*149. Joseph Kleitsch. *Problematicus.* 1918. Oil on canvas, 60×55″. Private collection.

*150. Joseph Kleitsch. *The Attic Philosopher.* c. 1918. Oil on canvas, 36×28″. Collection of Mr. and Mrs. Thomas B. Stiles II.

151. Wayman Adams. *Portrait of William Preston Harrison.* 1924. Oil on canvas, 52×40″. Los Angeles County Museum of Art. Mr. and Mrs. William Preston Harrison Collection.

*152. Joseph Kleitsch. *The Oriental Shop.* 1922. Oil on canvas, 32×40″. David and Sons Fine Arts, Laguna Beach.

*153. Joseph Kleitsch. *The Oriental Shop (or Jade Shop).* 1925. Oil on canvas, 32×26″. Collection of Dr. and Mrs. Marvin Kantor.

*154. Joseph Kleitsch. *Creek—Laguna Canyon.* 1923. Oil on canvas, 32×40″. Collection of Mr. and Mrs. Thomas B. Stiles II.

155. John Singer Sargent. *Alpine Pool.* Oil on canvas, 27½×38″. The Metropolitan Museum of Art. Gift of Mrs. Francis Ormond, 1950.

*156. Joseph Kleitsch. *Garden Fence.* c. 1923. Oil on canvas, 36×40″. Collection of Mr. and Mrs. Thomas B. Stiles II.

*157. Joseph Kleitsch. *Morning, Laguna* (formerly *California*). 1924. Oil on canvas, 36×40″. Collection of City of Laguna Beach.

*158. Joseph Kleitsch. *Highlights.* c. 1925. Oil on canvas, 38×46″. David and Sons Fine Arts, Laguna Beach.

159. *Edward Vysekal, Earl Stendahl, and Joseph Kleitsch, Paris.* 1926. Photograph. Collection of Stendahl Galleries, Los Angeles.

160. Joseph Kleitsch. *Lunch Hour.* 1926. Oil on canvas, 18×21″. Photograph courtesy of Michael Kelley, The Kelley Gallery, Pasadena.

*161. Joseph Kleitsch. *Reflections, Vernon, France.* 1927. Oil on canvas, 34×34″. Collection of Dr. and Mrs. Edward Boseker.

162. Joseph Kleitsch. *Madonna and the Apples, Paris, France.* 1927. Oil on canvas, 28×36″. Private collection.

*163. Joseph Kleitsch. *Sunday, Laguna Beach (Main Beach).* 1929. Oil on canvas, 34×42″. Collection of Mr. and Mrs. Jack Kenefick.

*164. Franz Bischoff. *Vase Painted with Roses.* (Front and back views.) Before 1910. Porcelain, 16½×11″. Collection of Dr. and Mrs. Edward Boseker.

*165. Franz Bischoff. *Plate Painted with Three Roses.* Before 1910. Porcelain, diameter 9⅛″. Private collection.

166. Henri Fantin-Latour. *Roses.* Oil on canvas, 26 1/16×22 11/16″. The Armand Hammer Collection.

167. *Franz Bischoff in His Laboratory, Dearborn, Michigan.* c. 1900–5. Photograph courtesy of Petersen Galleries, Beverly Hills.

168. *Interior of Franz Bischoff's Studio Gallery, South Pasadena, California.* c. 1928. Photograph courtesy of Petersen Galleries, Beverly Hills.

169. Franz Bischoff. *Canna Lilies.* Oil on panel, 26×19″. Petersen Galleries, Beverly Hills.

170. Franz Bischoff. *Roses.* c. 1912. Oil on canvas, 40×50″. Private collection. Photograph courtesy of Petersen Galleries, Beverly Hills.

*171. Franz Bischoff. *Peonies.* Oil on canvas, 30×40. Collection of Dr. and Mrs. Marvin Kantor.

*172. Franz Bischoff. *Mums.* Oil on canvas, 30×40″. Collection of Roy C. Rose.

*173. Franz Bischoff. *Summer—A California Woodland.* Oil on canvas, 30×40″. Collection of Jon R. Stuart. Photograph courtesy of Petersen Galleries, Beverly Hills.

*174. Franz Bischoff. *Amidst the Cool and Silence.* Oil on canvas, 30×40″. Young's Fine Arts, Santa Barbara.

175. Franz Bischoff. *The Bridge, Arroyo Seco.* 1915. Oil on canvas, 30×40″. Collection of Kleinwort, Benson, Inc.

*176. Franz Bischoff. *Cambria—A Peaceful California Village.* 1927. Oil on canvas, 24×30″. Collection of Mr. and Mrs. Thomas B. Stiles II.

*177. Franz Bischoff. *Emerald Cove, Carmel.* Oil on canvas, 25×30″. Collection of Mr. and Mrs. Thor Stensrud.

*178. Franz Bischoff. *Carmel Coast.* Oil on canvas, 40×50″. Private collection.

*179. Franz Bischoff. *Monterey Trees.* Oil on canvas, 24×30″. Collection of Paul and Kathy Bagley.

180. *Interior of Kanst Art Gallery at 826 South Hill Street, Los Angeles, with John Kanst.* c. 1917–23. Photograph. Collection of Jannette Kanst Mathewson.

181. *Interior of Kanst Art Gallery, Hollywoodland, Opening Day, April 1924.* Photograph. Collection of Jannette Kanst Mathewson.

182. *First Art Exhibition in the Museum of History, Science, and Art, Opening Day, November 6, 1913.* Photograph. Natural History Museum of Los Angeles County.

183. *First Art Exhibition in the Museum of History, Science, and Art, Opening Day, November 6, 1913* (detail). Photograph. Natural History Museum of Los Angeles County.

184. *Interior View: William Wendt Exhibition, Stendahl Art Galleries, Los Angeles.* April 1939. Stendahl Galleries, Los Angeles.